Set in Stone: The Face in Medieval Sculpture

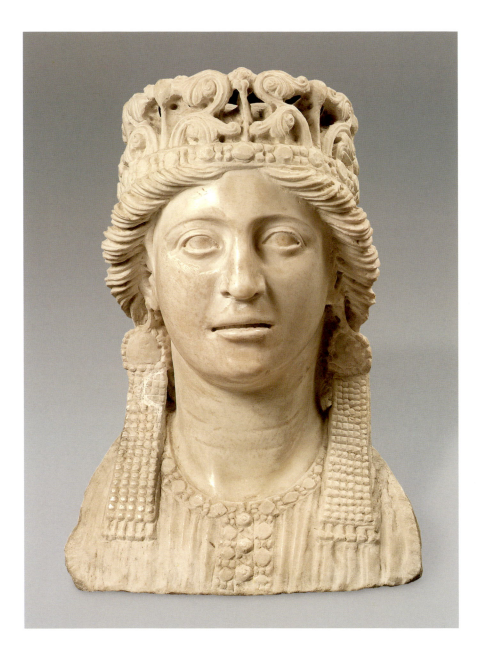

SET IN STONE

THE FACE IN MEDIEVAL SCULPTURE

Edited by Charles T. Little

Including an essay by Willibald Sauerländer

THE METROPOLITAN MUSEUM OF ART, NEW YORK

YALE UNIVERSITY PRESS, NEW HAVEN AND LONDON

This volume has been published in conjunction with the exhibition
"Set in Stone: The Face in Medieval Sculpture," held at The
Metropolitan Museum of Art, New York, from September 26,
2006–February 18, 2007.

The exhibition is made possible by The Florence Gould Foundation.
Additional support is provided by the Michel David-Weill Fund.

Published by The Metropolitan Museum of Art, New York
John P. O'Neill, Editor in Chief and General Manager of Publications
Dale Tucker, Senior Editor
Antony Drobinski, Designer
Douglas J. Malicki, Production
Jane Tai, Photography and Permissions Coordinator
Philomena Mariani, Bibliographic Editor
Susan DeRenne Coerr, Indexer

New color photography by Oi-Cheong Lee, The Photograph Studio,
The Metropolitan Museum of Art

Typeset in Dante
Printed on 150 gsm R-400
Color separations by Professional Graphics, Inc., Rockville, Illinois
Printed by Brizzolis Arte en Gráficas, Madrid
Bound by Encuadernación Ramos, S.A., Madrid
Printing and binding coordinated by Ediciones El Viso, S.A., Madrid

Jacket illustrations: front, detail of *Head of an Apostle* (cat. no. 11); back,
Head of a Magus (cat. no. 32)
Frontispiece: Nicola di Bartolomeo da Foggia, *Crowned Bust of a Woman*
(cat. no. 66)

Library of Congress Cataloging-in-Publication Data

Set in stone : the face in medieval sculpture / edited by Charles T. Little ;
including an essay by Willibald Sauerländer.
 p. cm.
 Issued in connection with an exhibition held Sept. 26, 2006-Feb. 18, 2007,
Metropolitan Museum of Art, New York.
 Includes bibliographical references and index.
 ISBN 1-58839-192-2 (Metropolitan Museum of Art : hardcover) —
 ISBN 0-300-11781-7 (Yale University Press : hardcover)
 1. Face in art—Exhibitions. 2. Head in art—Exhibitions. 3. Sculpture,
Medieval—Exhibitions. I. Little, Charles T. II. Sauerländer, Willibald.
III. Metropolitan Museum of Art (New York, N.Y.)
NB1932. S48 2006
734—dc22 2006020906

Contents

Director's Foreword

IN A MUSEUM whose holdings are as vast and diverse as those of the Metropolitan, there is always the possibility that a visitor might take for granted some of the extraordinary elements of the permanent collection. Many treasures are hidden in plain sight, as it were, on continual view in the galleries, and may thus sometimes be passed by with no or too little notice taken of them. The Museum takes seriously its primary mission of preserving and studying its permanent collection, and thus we are constantly developing new ways of kindling the public's awareness of these diverse riches. "Set in Stone: The Face in Medieval Sculpture" brings a specific focus to our superb collection of medieval art, as it also expands on important aspects of the collection through marvelous and generous loans. This is not the Museum's first exhibition to use the sculpted head as a theme. In 1940 an exhibition titled simply "Heads in Sculpture" drew on the Metropolitan's holdings of works from Egypt, China, and western Europe.

In light of the chronological extent of the exhibition, which includes sculptures dating from the end of the Roman Empire to the Renaissance, the works gathered together are presented according to thematic and aesthetic criteria, rather than in chronological or geographic order, so that we may view this material through fresh eyes. While the holdings of the Department of Medieval Art and The Cloisters provide the core thread of the narrative, the story of the sculpted human face in the Middle Ages is augmented by key loans from public institutions in the United States and Europe. In particular, the exhibition affords several opportunities to reunite dispersed elements, some newly identified, from the cathedral of Notre-Dame in Paris and from the royal abbey of Saint-Denis. I wish to acknowledge the generosity of these lenders and express the Museum's hope that the featured juxtapositions mutually enhance our appreciation of the works of art. In addition, a number of private collectors kindly agreed to lend important sculptures, and to them I express our special gratitude.

The exhibition was conceived and organized by Charles T. Little, Curator in the Department of Medieval Art and The Cloisters, who also established the intellectual foundations of its themes. He was fortunate to have the able assistance of Wendy A. Stein, Research Associate; to both of them, I offer the Museum's heartfelt thanks. The exhibition also recognizes the fiftieth anniversary of the International Center of Medieval Art, whose offices are located at The Cloisters. This is a particularly fitting celebration of this fruitful collaboration among scholars and collectors of medieval

art, many of whom have contributed to the catalogue or offered timely and most welcome advice.

Although the exhibition includes sculpture from the Early Byzantine world, England, Italy, and elsewhere, the majority of the works are French in origin and date to the Gothic period. For that reason, it is especially gratifying that the exhibition is made possible by The Florence Gould Foundation, whose commitment to French cultural awareness in America is both visionary and timely. Additional support is provided by the Michel David-Weill Fund. I want to specially acknowledge Michel David-Weill, a trustee of the Museum and chair of the Visiting Committee of the Department of Medieval Art and The Cloisters, for his enthusiasm and generosity. Finally, The Metropolitan Museum of Art is grateful to the Robert Lehman Foundation for making the Robert Lehman Wing galleries available for the exhibition.

Philippe de Montebello
Director
The Metropolitan Museum of Art

As this catalogue was going to press, new information came to light regarding the *Crowned Bust of a Woman* from Ravello (cat. no. 66 and the frontispiece to this volume). During examination of the sculpture in preparation for shipment to New York, the office of the Soprintendente, Salerno, ascertained that the bust is most likely a recarved Antique sculpture: an excellent example of how the study of objects loaned to exhibitions can lead directly to valuable new insights and discoveries.

Statement from the International Center of Medieval Art

IN 1956 a group of scholars and collectors of medieval art formed a North American branch of the French organization Centre International d'Études Romanes, naming it the International Center of Romanesque Art. The interests of the group expanded considerably over the next decade to include a much broader sweep of medieval art, and in 1966 the growing organization, now independent of its French affiliations, was renamed the International Center of Medieval Art (ICMA). At first headquartered at New York University's Institute of Fine Arts, in 1969 the ICMA accepted the hospitality of The Metropolitan Museum of Art and moved its office to The Cloisters, where they remain to this day. As Eugene Kleinbauer, former president of the ICMA, indicated at The Cloisters' fiftieth anniversary in 1988, the collaboration has proved a felicitous one, including joint-sponsorship of a host of distinguished symposia, lectures, publications, and exhibitions.

In this spirit, and in part to celebrate the fiftieth anniversary of the ICMA, the Metropolitan has organized the current exhibition—curated by Charles T. Little of the Museum's Department of Medieval Art and The Cloisters, who is also a past president of the ICMA—as testament to the productive cooperation between the two institutions. The works in the exhibition represent the broad chronological and geographic boundaries of the Middle Ages, reflecting several aspects of the ICMA's mission: namely, to promote the study, understanding, appreciation, and preservation of art works in Europe, the Mediterranean region, Scandinavia, and the Slavic world from about A.D. 300 to 1500. These include monuments, objects, and sites, both sacred and secular, from Christian, Jewish, Islamic, and other religious traditions.

The ICMA wishes to take this opportunity to express its deepest gratitude to The Metropolitan Museum of Art for its continuing hospitality and invaluable support.

<div style="text-align:center">

Mary B. Shepard
President
The International Center of Medieval Art

Charles T. Little
Stephen K. Scher
Wendy A. Stein
Christine Verzar
Exhibition Committee

</div>

Acknowledgments

T HE IMPETUS FOR "The Face in Medieval Sculpture" grew out of conversations with Stephen K. Scher, an independent scholar, professor, collector, guest curator, and longtime friend of the Department of Medieval Art and The Cloisters who is also a contributor to this catalogue. In our discussions of new ways to present different aspects of the Museum's medieval collection, particularly in conjunction with selected loans from public and private collections, the theme of the face and the head in the Middle Ages emerged as a natural subject that would allow for a significant latitude of interpretation. The exhibition is also in part a celebration of the fiftieth anniversary of the International Center of Medieval Art (ICMA), an organization dedicated to the promotion, study, and appreciation of the art of the Middle Ages and whose headquarters are located at The Cloisters. The programs and publications of the ICMA are a great benefit to scholars, teachers, and students as well as to those in the general public who are interested in the Middle Ages.

The exhibition could not have been brought to fruition without the help of a good number of people within the Metropolitan Museum's Department of Medieval Art and The Cloisters. For her devotion, enthusiasm, and insight, I am tremendously grateful to Wendy A. Stein, who made the project come alive on a daily basis. Peter Barnet, Barbara Drake Boehm, Sarah T. Brooks, Lisbeth Castelnuovo-Tedesco, and Helen C. Evans provided essential advice as well as contributions to the catalogue. I am also indebted to Christine Brennan, Theo Margelony, Thomas Vinton, and Nancy Wu. Johanna G. Seasonwein, our graduate intern, was a valued researcher, assistant, and catalogue contributor. Christine Verzar has also become a trusted adviser and was a contributor to the catalogue; I am grateful to her and to the other authors outside of the department who provided texts reflective of their expertise, scholarship, and professionalism. My special thanks to Willibald Sauerländer, whose abiding interest in the meaning of physiognomy in the visual arts is made wonderfully manifest in his provocative introductory essay.

During the preparation of the exhibition and its accompanying catalogue, the excellent staff of the Metropolitan Museum performed magnificently in all regards, from the initial research in Watson Library to the final lighting of the installation. I wish to express my deep appreciation to everyone involved: Ian Wardropper, European Sculpture and Decorative Arts; Laurence Kanter, Robert Lehman Collection; Aileen Chuk and Willa Cox, Registrar; Elyse Topalian and Egle Žygas, Communications; Lucretia Kargere, Fred Sager, Jack Soultanian, and Alexandra Walcott, Objects

Conservation; George Wheeler, Department of Scientific Research; Aimee Dixon, Elizabeth Hammer-Munemura, Christopher Noey, and Teresa Russo, Education; Douglas Hegley, Michele Lussier, Jonathan Munar, Koven Smith, and Osamu Takahashi, Information Systems and Technology; Robyn Fleming, Linda Seckelson, and Ken Soehner, Thomas J. Watson Library; Taylor Miller and Crayton Sohan, Buildings; and Barbara Bridgers and Mark Morosse, The Photograph Studio, with a special thanks to Oi-Cheong Lee, whose color photography enhances the record of many objects illustrated herein. In the Design Department, I am indebted to Michael Langley and Sue Koch for the splendid design of the exhibition and graphics, respectively; to Clint Coller and Richard Lichte for the subtle lighting; and to Linda M. Sylling and Patricia Gilkison for their invaluable advice and coordination.

With his customary vigilance and welcome support, John P. O'Neill, Editor in Chief and General Manager of Publications, made this catalogue a reality. We were fortunate to have Dale Tucker as our patient and exacting editor; he helped improve every page. The elegant design is the product of the talents of Antony Drobinski of Emsworth Design, and the volume was skillfully produced by Douglas Malicki. Jane Tai helped to acquire many photographs and to obtain permission to publish them.

The generosity of lenders both public and private greatly enriched the substance of the exhibition, and we are most appreciative to all of the following for the loan of wonderful works of art. In the United States: Gary Vikan and Griffith Mann, The Walters Art Museum; Stephen H. Morley and Bret Bostock, Glencairn Museum; James Cuno and Christina Nielsen, The Art Institute of Chicago; Timothy Rub, Cincinnati Art Museum; Charles L. Venable and Holger Klein, The Cleveland Museum of Art; Kimerly Rorschach and Sarah Schroth, Nasher Museum of Art at Duke University; Katy Kline, Bowdoin College Museum of Art; and Paul Warwick Thompson and Cynthia Trope, Cooper-Hewitt, National Design Museum. In Europe: Henri Loyrette, Geneviève Bresc-Bautier, and Pierre-Yves Le Pogom, Musée du Louvre; Élisabeth Taburet-Delahaye and Xavier Dectot, Musée National du Moyen Âge, with a special remembrance of the late Viviane Huchard and Julia Fritsch; Renate Eikelmann and Matthias Weniger, Bayerisches Nationalmuseum; S. E. Monsignor Gerardo Pierro and Giuseppe Zampino, Soprintendente di Salerno, Duomo di Santa Maria Assunta, Museo del Duomo, Ravello. The inclusion of twelve objects from private collections added an important dimension to the exhibition, and we are particularly grateful to those lenders for temporarily parting with their treasured works.

Recognition is owed to a number of individuals who offered timely assistance and who took a genuine interest in such diverse aspects of the project as planning, loan negotiations, advice, and support: Françoise Baron, Pamela Z. Blum, William W. Clark, Xavier Dectot, Danielle Gaborit-Chopin and Jean-René Gaborit, Dorothy Glass, Danielle V. Johnson, Lorenzo Lazzarini, Valentino Pace, Elisabeth Parker,

Mary Shepard, Katy Spurrell, Neil Stratford, Paul Williamson, William D. Wixom, Georgia Wright, and Michaël Wyss. For their substantial contributions to the Limestone Sculpture Provenance Project since the first pilot study by chemists Pieter Meyers and Lambertus van Zelst, then with the Metropolitan Museum, I wish to acknowledge Annie Blanc, John Bruestle, Michael D. Glascock, Garman Harbottle, David Holmes, the late Lore L. Holmes, and Robert J. Speakman.

Emily K. Rafferty, President, and Nina McN. Diefenbach, Vice President for Development and Membership, provided integral support for the exhibition, and I am grateful to them and to their respective staffs, especially Christine Coulson, Claire Gylphé, and Andrea Kann. I am likewise indebted to Doralynn Pines, Associate Director for Administration, and Mahrukh Tarapor, Associate Director for Exhibitions, for their advocacy and for the fine work of their staffs, including Martha Deese, Emily Vanderpool, and Heather Woodworth. Our deep gratitude goes to John Young of The Florence Gould Foundation and to Michel David-Weill for their generous support. Finally, I want to express my profound thanks to Peter Barnet, Michel David-Weill Curator in Charge, Department of Medieval Art and The Cloisters, for his constant encouragement, and to Philippe de Montebello, Director, for his unwavering support of the project.

CTL

Contributors to the Catalogue

Peter Barnet (PB)

Michel David-Weill Curator in Charge, Department of Medieval Art and The Cloisters, The Metropolitan Museum of Art, New York

Janetta Rebold Benton

Distinguished Professor of Art History, Pace University, Pleasantville, New York

Pamela Z. Blum (PZB)

Independent scholar, New Haven, Connecticut

Barbara Drake Boehm (BDB)

Curator, Department of Medieval Art and The Cloisters, The Metropolitan Museum of Art, New York

Sarah T. Brooks (STB)

Research Associate, Department of Medieval Art and The Cloisters, The Metropolitan Museum of Art, New York

Lisbeth Castelnuovo-Tedesco (LCT)

Senior Research Consultant, Department of Medieval Art and The Cloisters, The Metropolitan Museum of Art, New York

William W. Clark (WWC)

Professor of Art, Queens College and the Graduate Center, City University of New York

Helen C. Evans (HCE)

Curator, Department of Medieval Art and The Cloisters, The Metropolitan Museum of Art, New York

Dorothy Gillerman (DG)

Professor Emerita, Tufts University, Boston

Lore L. Holmes

Project Chemist, The Limestone Sculpture Provenance Project, Brookhaven National Laboratory, Upton, New York

Jacqueline E. Jung (JEJ)

Assistant Professor, History of Art Department, University of California at Berkeley

Holger A. Klein (HAK)

Robert P. Bergman Curator of Medieval Art, The Cleveland Museum of Art

Charles T. Little (CTL)

Curator, Department of Medieval Art and The Cloisters, The Metropolitan Museum of Art, New York; Co-Director, The Limestone Sculpture Provenance Project

Robert A. Maxwell (RAM)

Assistant Professor, Department of the History of Art, University of Pennsylvania, Philadelphia

Stephen Perkinson

Assistant Professor of Art History, Bowdoin College, Brunswick, Maine

Willibald Sauerländer

Former Director, Zentralinstitut für Kunstgeschichte, Munich

Stephen K. Scher (SKS)

Independent scholar, New York

Johanna G. Seasonwein (JGS)

Graduate Intern, Department of Medieval Art and The Cloisters, The Metropolitan Museum of Art, New York

Wendy A. Stein (WAS)

Research Associate, Department of Medieval Art and The Cloisters, The Metropolitan Museum of Art, New York

Christine Verzar (CV)

Professor Emerita, The Ohio State University, Columbus

Georgia Wright (GW)

Co-Director, Limestone Sculpture Provenance Project, Berkeley, California

Lenders to the Exhibition

FRANCE
Paris, Musée du Louvre 4, 18, 27
Paris, Musée National du Moyen Âge, Thermes et Hôtel de Cluny 6, 7, 29

GERMANY
Munich, Bayerisches Nationalmuseum 79

ITALY
Ravello, Duomo di Santa Maria Assunta, Collocazione Museo del Duomo 66

UNITED STATES
Baltimore, Maryland, The Walters Art Museum 25, 28, 30
Brunswick, Maine, Bowdoin College Museum of Art 34
Bryn Athyn, Pennsylvania, Glencairn Museum, Academy of the New Church 26
Chicago, Illinois, The Art Institute of Chicago 14, 74
Cincinnati, Ohio, Cincinnati Art Museum 2
Cleveland, Ohio, The Cleveland Museum of Art 8, 12, 47–52, 60, 61, 68, 70
Durham, North Carolina, Nasher Museum of Art at Duke University 15, 21, 22
New York, Cooper-Hewitt, National Design Museum, Smithsonian Institution 43
New York, The Metropolitan Museum of Art 1, 3, 5, 10, 11, 13, 16, 17, 19, 20, 23, 31, 37, 39–42, 53–59, 64, 65, 67, 69, 71–73, 75–78, 80, 81

PRIVATE COLLECTIONS
Lionel Goldfrank III 38
Isabelle Golovin (The Willard Golovin Collection) 62
Eric R. Kaufman 44, 45
Charles and Alexandra Van Horne Collection 46

ANONYMOUS LENDERS
9, 24, 32, 33, 35, 36, 63

Introduction: Facing the Middle Ages

Charles T. Little

"SET IN STONE: THE FACE IN MEDIEVAL SCULPTURE" offers a glimpse of the art of the Middle Ages that is at once narrow and extraordinarily diverse. The faces presented here are mostly fragments from monumental settings, many altered in one way or another by time, revolution, neglect, or the vicissitudes of taste. Even as fragments, however, they retain some viable part of their past—a memory or purpose if you will—and have thus become not unlike living remnants of an age. It is appropriate, then, that we should attempt to establish a dialogue with this particularly vivid type of fragment, the sculpted head, by sampling works from across the expansive and heterogeneous period known as the Middle Ages.

There is unquestionably abundant material for comparison. The heads in the exhibition span more than fifteen hundred years in date, represent a broad geographic area, and range from the highly idealized to the generalized: in short, they constitute a cross section of the era's evolving styles. Our objective was to ask new questions of these fascinating works and, in some cases, to suggest new answers. The germ of this process was the Metropolitan Museum's exceptional collection of heads and faces in stone, metal, and wood; these core works were then complemented by crucial loans from private and public collections. Each of the eighty-one sculptures has become separated from its original context, and thus from much of its original meaning, by the seemingly endless destruction and displacement of art works in Europe during and after the Middle Ages. The French Revolution, in particular, witnessed legions of stone figures losing their heads in a systematic course of demolition that paralleled the work of the infamous guillotine. Out of this wreckage arose a new class of sculpture, the collectible object, that by the simple virtue of having survived the maelstrom of European history became integral to the genesis of collecting and exhibiting medieval art.

Many of these heads exist today as pure forms without historical context: silent witnesses to history whose artistic merits are sometimes all that remains of their original meanings and significance. In fact a good number have survived, albeit in their current mutilated states, precisely because of their innate beauty, or perhaps out of reverence for the grand monuments to which they once belonged. In attempting to retrace the history of these fragments, we find ourselves asking what sculptures of the human head can reveal to us about those who produced them, and about how those people perceived themselves.

Part of the answer lies in the fact that for millennia the head has been understood to be a center of power, the core of individual identity, and the primary vehicle

for human expression, emotion, and character. In antiquity and throughout the Middle Ages, it was generally believed that the soul resides in the head, as articulated by Plato in the *Timaeus* (44d), where he explains that the head is dominant and divine and thus survives death: "and so in the vessel of the head, they first of all put a face in which they inserted organs to minister in all things to the providence of the soul, and the appointed part, which has authority, to be by nature the part which is in front." Following Plato, many medieval theologians—such as Chalcidius in the fourth century and, in the twelfth century, the Scholastic philosopher William of Conches as well as the Islamic philosopher Averroës—believed that the soul resides in the head. (The other theological view, after Aristotle's *On the Soul,* favored the heart.)

One of the striking characteristics of the heads in "Set in Stone" is that most reveal little or no expression. The complex tension between this apparent absence of emotion and the otherwise grossly distorted faces and countenances that abound in medieval art is explored in the following essay by Willibald Sauerländer. One might expect, for example, that an innocent feature such as a smile, first convincingly represented about 1200 (see cat. no. 17), would reflect the growing naturalism evident in art of the Gothic period. Yet explications of medieval physiognomy are seldom that simple, and the seeming dearth of expressivity may be linked to other concerns. One possible reason is that most of the heads belong to sculptures of holy figures (apostles, saints, or prophets) or personifications of religious concepts (the theological Virtues), and as such they may be visual representations of a serene state or transcendent happiness. "It is not right for the servant of God to show sadness and a dismal face," Saint Francis reminds us, and indeed these heads convey a dignified aura through what at the time was a new and powerfully sculptural presence. This characteristic may have had underpinnings in some of the principal theological debates of the Gothic age. Thomas Aquinas, for instance, asks in his *Summa contra Gentiles* whether happiness can ever be found on earth. "The final happiness," he proclaims in Book 3 (48:8), "will be in the knowledge of God, which the human soul has after this life... ." Aquinas finds assurance in his belief in the famous passage from Saint Paul's First Epistle to the Corinthians (13:12), "For now we see through a glass darkly; but then face to face."

Many a conundrum greets the modern scholar seeking to investigate the ideological, cultural, artistic, and provenance questions raised by these *membra disjecta,* from issues of attribution and localization to meaning and date. "Set in Stone" addresses such puzzles in a variety of ways, drawing on connoisseurship, archaeology, history, and science to let the sculptures, as much as possible, tell their own stories. In order to frame these diverse topics, the exhibition has been organized into seven thematic sections.

The first is *Iconoclasm,* which examines the ways in which many medieval sculpted heads were violently separated from their original contexts. In addition to political upheavals such as the French Revolution, religious fervor, especially the Reformation, was often a source of ruination. We have seen in our own recent political history the dramatic power ascribed to images and the sometimes brutal force brought to bear on them because of this power, exemplified by the Taliban's destruction of the ancient Buddhas at Bamiyan in 2001. The second theme concerns the *Limestone Sculpture Provenance Project,* an ongoing interdisciplinary effort that employs neutron activation analysis (NAA) to reunite fragments of limestone

sculpture with their original sites. The technique was pioneered by the Metropolitan Museum in the 1970s, originally in collaboration with Brookhaven National Laboratory, Upton, New York, and now with the University of Missouri, Columbia. Because several of the sculpted heads in the exhibition come from Notre-Dame Cathedral in Paris, in some ways this section echoes the clarion call of Victor Hugo in the nineteenth century to restore and preserve Notre-Dame for the ages. It was Hugo, in his *Notre-Dame de Paris* (1831), who praised the cathedral, then a sad reflection of its past glory, as "a vast symphony in stone...the tremendous sum of the joint contributions of all the forces of an entire epoch."

The third theme is the *Stone Bible*, a reference to the rich iconographic programs that adorn (or once adorned) medieval cathedrals and churches. Sculptures of characters from the Bible and church history were made to enact stories on such monuments, and thus in this section can be found many heads known to represent specific individuals, from Old Testament prophets and kings to apostles, the Virgin Mary, and Christ. *Marginalia,* the exhibition's fourth theme, examines what recent scholarship has suggested might be a counterpoint to the "official" iconographic responsibilities of the Stone Bible. Placed in high or otherwise obscure locations, these varied works—including carved architectural elements such as capitals, corbels, and misericords—inhabited the literal edges of medieval monuments, part of a seeming playground for the energized human imagination. Not necessarily considered "high" art, these occasionally cartoonlike and fanciful objects were often vehicles for formal experimentation or whimsy.

The fifth theme, *Portraiture*, examines how the conventions for depicting specific individuals shifted during the Middle Ages. Defined by John Pope-Hennessy in his *Portrait in the Renaissance* (1966) as "the depiction of an individual in his own character," portraiture in the medieval period was, arguably, an altogether more complicated concept that challenges the sufficiency of traditional representational strategies such as likeness and verisimilitude. *Gothic Italy*, the sixth theme, reflects on the tenacity of the classical tradition in that country. In southern Italy, for example, rulers such as the Hohenstaufen Emperor Frederick II appropriated elements of Italy's Roman past to enhance their own images; in other Italian regions, the prevalence of classical ruins had a more direct influence on medieval artists.

The final theme concerns sculptures that can be broadly labeled *Objects of Devotion*. Perhaps more than any other works in the exhibition, these pieces are imbued with an almost palpable power. In the case of Celtic votive heads, whose shadowy origins are difficult to reconstruct, this is a totemic potency. Reliquary busts, a product of the cult of the saints in the High Middle Ages, were similarly invested with great importance. Beautifully crafted from wood or metal and sometimes elaborately decorated, these busts—some of which contain fragments of the skull of the individual saint they depict (see cat. no. 78)—are evocative yet elegant testaments to the power of the head as a holy relic. The closing image illustrated in the catalogue is a poignant statue of Saint Firmin—the first bishop of Amiens, who was martyred by decollation in A.D. 287—shown holding his own head. Not without irony, then, is the opening celebration for "Set in Stone" scheduled for September 25, Saint Firmin's feast day.

Set in Stone: The Face in Medieval Sculpture

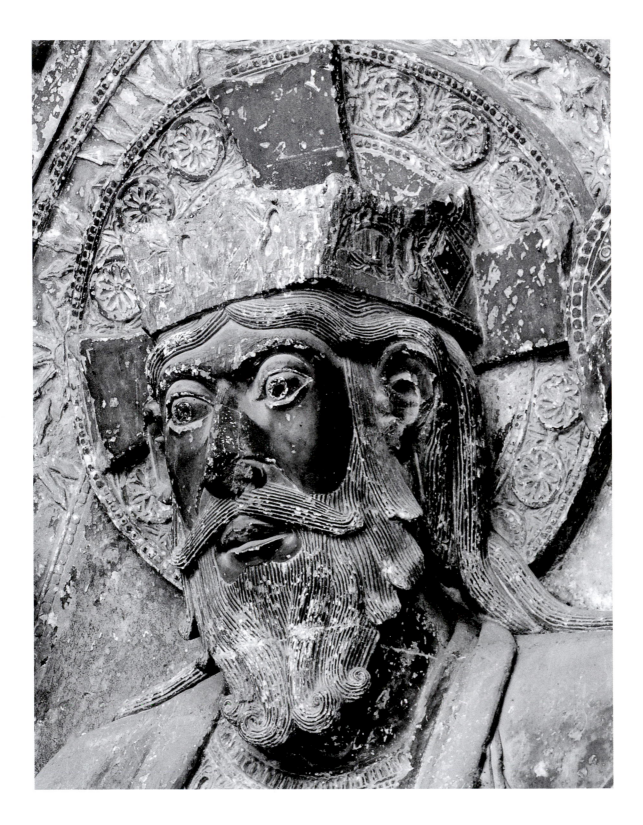

Fig. 1. *Head of Christ, south porch, Abbey Church of Saint-Pierre,*
Moissac (Tarn-et-Garonne), ca. 1120–35

The Fate of the Face in Medieval Art

Willibald Sauerländer

ALTHOUGH we no longer speak of the "Dark Ages," even with all our romantic or modern enthusiasm for Romanesque sculpture or Gothic cathedrals, we cannot deny that many achievements of classical art were either lost or given up during the Middle Ages. Medieval art fascinates us with its spirituality, but it shows us little of the exterior world. We see no lovely landscapes enlivened by light and shadow, as in the illusionistic wall paintings in Roman villas. The rendering of buildings and trees, plants and beasts, is reduced to abstract formulas. The physical appearance of human beings, whose portrayal had been one of the glories of ancient art, became at the hands of medieval craftsmen distorted and galvanized by expressive exaggerations or impoverished by sheer lack of technical skill. Most striking, perhaps, is the near-complete disappearance of individual facial likenesses in medieval painting and sculpture before the fourteenth century.

Medieval art is full of faces. Some haunt the beholder by grinning or staring; others are exalted, expressive masks. Still others strike awe in the viewer by virtue of their stern solemnity: holy faces that show no expression because passion was regarded as evil, and as a sin. Medieval physiognomy always seems to be torn between heaven and hell. Yet from the time of Charlemagne (r. as emperor 800–814) to the days of Dante (1265–1321), we encounter not a single portrait in the modern sense. We know the faces of Roman emperors from Augustus to Diocletian by numerous portrait busts, and by studying such works we have even come to believe we can estimate the character of these sovereigns. Images of medieval rulers likewise appear on great numbers of seals, coins, miniatures, and tombstones, but their identities are conveyed through crowns, scepters, vestments, and coats of arms, not by the indications of facial likeness. Whereas the ancients made innumerable portraits of their famous philosophers, orators, and poets, we have not even the shadow of a portrait of Anselm of Canterbury, John of Salisbury, Thomas Aquinas, or Albertus Magnus that dates from their lifetime. It is an odd phenomenon. Entering medieval sanctuaries we literally come face-to-face with innumerable images of saints, prophets, demons, and devils, but these visages do not belong to our world; they are like ghosts. If we seek out real human faces—if we want to know what Eleanor of Aquitaine, Héloïse and Abélard, Bernard of Clairvaux, or Abbot Suger of Saint-Denis really looked like—we find either a void or a schematic rendering whose exterior appearance teaches us nothing. Like nature, the natural face was considered unworthy of transmission to posterity. The soul would be raised to heaven, and the

body resurrected to eternal life, but flesh and bones, it was believed, would turn to dust and ashes, and thus the earthly faces of mortals were not remembered in portraiture.

Another problem concerning the fate of the face in medieval art is the representation of the emotions, or the "passions," on the human visage. The rendering of pathos through the depiction of facial movements had been the supreme achievement of Hellenistic sculpture, the most famous example of which is the group of the suffering Laocoön and his sons, admired in later ages as the unsurpassed *exemplum doloris* (example of suffering). Ancient philosophy, medicine, and rhetoric all took an interest in the supposed correspondence between the appearance of the face and the character of the human being, and conversely between the passions of the soul and the movements of facial features. The "science" of physiognomy was a Greek invention. "Physiognomy," said Aristotle, "is only possible if one accepts that the emotions change both body and soul, and if one accepts moreover that each emotion is reflected by peculiar signs on the face."[1] To that end, the ancients developed a comprehensive semiology of the human face and its different movements under the influence of the passions. But those texts, in Greek or Arabic, were unknown before the second half of the twelfth century, and little read before their systematic reception in the thirteenth century by scholars such as Albertus Magnus (ca. 1200–1280). In the meantime, medieval philosophy and theology—fixated on the moral dimensions of facial expression—had developed no physiognomic system of its own. The passionate physiognomy was regarded simply as sinful, and in the realm of sin there can be no order. According to the eighth-century Anglo-Saxon scholar Alcuin, "The face should be orderly, the lips should not be distorted, no immeasured opening should extend the mouth, nor should the eyebrows be raised or cast down."[2] Nearly four hundred years later, the theologian Hugh of Saint-Victor (1096–1141) wrote, "The face is the mirror of discipline which must be guarded the more because what appears as the sign of sin on the face cannot be concealed."[3] Ironically, it was this very absence of any system of physiognomy, and a concomitant fear of the passions, that gave rise in the Middle Ages to the veritable explosion of distorted and inflamed heads, faces, and masks as appears in no other period of Western art.

Hundreds if not thousands of distorted heads populate the exteriors of Romanesque and Gothic churches in France, Spain, and Italy: under roofs and cornices; beside windows and on portals; and sometimes as capitals on columns. Ill-proportioned and convulsed, they scream, cry, stick out their tongues, show us their teeth, and very rarely they laugh, although—as we shall see—in this moralizing context laughter was most often viewed with suspicion at best. Christ, so the church fathers had taught, did not laugh, nor did he ever smile. As the forbidding cleric Bernard of Clairvaux explained, "Laughter and useless jokes are the indication of a false conscience."[4]

Since the nineteenth century these heads have often been dismissed as merely decorative or marginal, a kind of joke at the periphery of otherwise solemn ecclesiastical buildings and sanctuaries. The French writer Champfleury (Jules-François-Félix Husson, 1821–1889), a friend and advocate of Courbet's, had a vivid interest in popular imagery and regarded these works as the caricatures of the Middle Ages. Others saw them as depictions of the insane or as faces possessed by evil spirits that had been expelled from the sacred church interiors. The trouble is, we cannot really

read these facial farces. They cannot be connected to any literary text, and they obey no iconographic rule; they belong to the illiterate segment of the medieval world. In social terms, these "mugs" represented the villains and outlaws of the Middle Ages, as in the saying from medieval French that "Villain vient de Vilanie" (villain comes from villainy). Countless texts describe villains as appearing suitably hideous, dirty, or clumsy. In moral terms, they also seem to have represented the evil ones and the sinful, but one has to be careful making such precise distinctions. Looking at these haunting, but also amusing, faces, one is never sure if they are hellish or carnivalesque, because the boundary between devilry and buffoonery is uncertain. What *is* certain is that these "mugs" or masks, be they sinners or jesters, are the most original physiognomic inventions of the art of the Middle Ages.

Hell, of course, makes sense only if there is also a heaven, and thus we find in medieval sculpture the opposite of such villainous faces in the regular, quiet countenances of the holy persons: the Savior, the saints, and the blessed. There are many different faces of Jesus in medieval art, from the suffering Christ of the late Middle Ages to the overpowering, terrible features of the Christ of the Apocalypse on the Romanesque tympana of Saint-Pierre in Moissac (fig. 1). Perhaps the most significant example of moral medieval physiognomy is the solemn image of Christ modeled on the Byzantine Mandylion (Holy Towel) or the so-called Vera Icon ("true image")—which according to legend were miraculously imprinted with the face of Christ—on statues of the Beau Dieu on Gothic cathedrals, as at Amiens (fig. 2). This representation of Christ is absolutely regular and measured, with no indication of either movement or passion. The stark contrast between the purity of the Savior's features and the convulsed expressions on the villains' mugs reveals the extremes of physiognomic tension in medieval art. Physiognomy and pathognomy were not

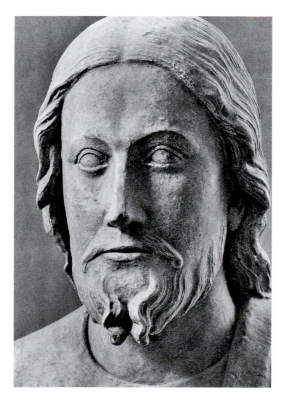

Fig. 2. Plaster cast of the "Beau Dieu," west facade, Amiens Cathedral (Somme), ca. 1220–30

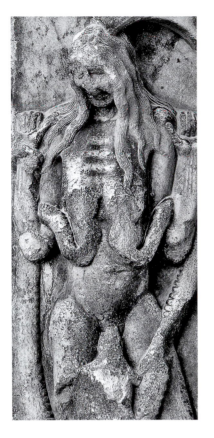

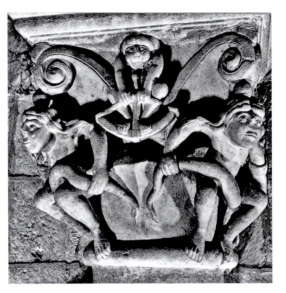

neutral phenomena of semiotics, as they had been for Aristotle and as they became again for the seventeenth-century French painter and theorist Charles Le Brun (1619–1690), who attempted to codify the artistic representation of the passions in his famous 1668 conference on physiognomy. Rather, they were concepts with moral, even theological, dimensions.

The most illuminating example of medieval physiognomy's moral ambivalence is the treatment of the female face. "Femina lyra diaboli" (woman is the lyre of the devil), Saint Augustine had declared, and, accordingly, fear of carnal temptation and sin manifested in terrible disfigurements of the female visage. The physiognomy of the statue of Luxuria (lasciviousness) on the porch at Moissac, for instance, is haggard, with sunken eyes and cheeks and loose strands of hair that hang limply over her shoulders (fig. 3). This is the face of the "femina putrida et foetida" (stinking and rotten woman) described in contemporary tracts against carnal lust.[5] Similarly repulsive female faces can be found on twelfth-century Spanish churches, such as San Isidoro at León (fig. 4) and Santiago de Compostela. But the twelfth century also witnessed the florescence of courtly love and the amorous poetry of the troubadours, and the female visage in art was not unaffected by this new attachment to sensuous beauty. Thus the faces on the famous statues of biblical queens on the Royal Portal at Chartres are faultless and perfect, with symmetrical features, smooth foreheads, nicely curved eyebrows, round cheeks, and small mouths and chins (fig. 5). Here the entire face is discreetly gracious and lovely. Seeing them, the American historian and educator Henry Adams and the great French art historian Émile Mâle, who had been an adviser to Proust, dreamed of the beauty and the majestic appear-

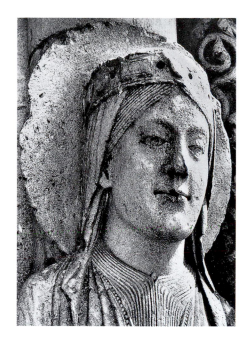

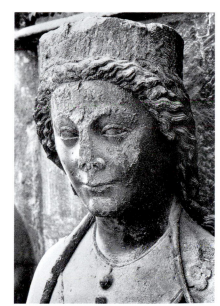

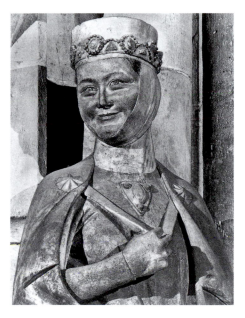

Fig. 7. Countess Reglindis, west choir, Naumburg Cathedral (Saxony-Anhalt), ca. 1249–55

Fig. 5. Queen, "Porte Royale," west facade, Chartres Cathedral (Eure-et-Loir), ca. 1145–50

Fig. 6. Queen of Sheba, west facade, Reims Cathedral (Marne), ca. 1255–65

ance of Eleanor of Aquitaine.[6] One must keep in mind, though, that about the time the Chartres queens were carved, Bernard of Clairvaux still thundered, "Mulier secularis organum est satanae" (the worldly wife is the musical instrument of Satan). The Chartresian statues demonstrate how medieval art, by about the middle of the twelfth century, had just begun to integrate the beauty of the female face into its imagery, a process that continued into the thirteenth century with a seeming parade of beautiful, even seductive female physiognomies, including the face of the Queen of Sheba at Reims Cathedral (fig. 6); Queen Ingeborg of France on her tombstone at Saint-Jean-en-Isle, in Corbeil; Queen Beatrix of Castile in the cloister at Burgos; and the Saxon princess Reglindis in Naumburg Cathedral (fig. 7). Their shining faces represent the triumph of courtly love over ecclesiastical misogyny.

The rediscovery of the beauty of the female face was connected to the emergence of the smile and laughter in medieval art. Laughter, as noted earlier, had been regarded by the church fathers as vain or sinful, and it had long been absent from representations of the human face. To the best of my knowledge, there is no indication of laughter, not even a smile, in medieval art until the end of the twelfth century, with one notable exception: the *cachinnus*, or roaring laughter, of the devil. The contorted face of the devil is one of the most astonishing but also terrifying physiognomic inventions of medieval art. Monstrous because it conflates human and bestial features and signs, the contorted physiognomy of the devil may be described as a moralizing and demoniac transformation of the face of the pagan satyr (fig. 8). With his glaring eyes, flaming hair, and gaping maw, the devil is uninhibited in his expression of passion, demonstrating all of the facial movements condemned in the eccle-

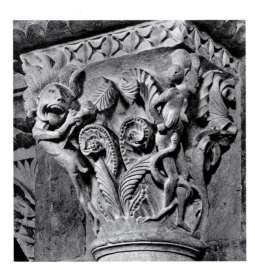

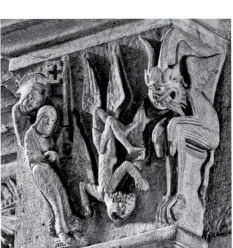

Fig. 8. *Capital, nave, Abbey Church of Saint-Madeleine, Vézelay (Yonne), ca. 1125–40*

Fig. 9. *Capital with Simon Magus and the Devil, Abbey Church of Saint-Lazare, Autun (Saône-et-Loire), ca. 1130–45*

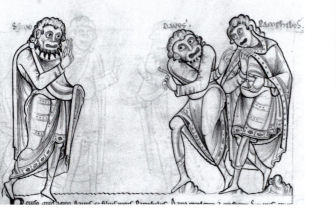

Fig. 10. *Scene from* The Comedies of Terence, *mid-12th century. Bodleian Library, Oxford University (Auct. F.2.13, fol. 16r)*

siastical literature. On a capital from Saint-Lazare at Autun we see him roar with derisive laughter as he watches Simon Magus fall to his death and into hell (fig. 9), his *cachinnus* horrible and terrifying indeed. It is possible that his features were inspired by the masks of comic actors in Roman theaters (fig. 10), considering that spectacles and acting had long been condemned by ecclesiastical authorities, from the church fathers of early Christianity to medieval theologians such as Isidore of Seville (560–636).

The transformation of the devil's laugh into the smile on the face of a young woman—or on the features of angels, the blessed, and courtly ladies—occurred after the second quarter of the thirteenth century, during the reign of King Louis IX (r. 1226–70), or Saint Louis, of France. The oldest examples of this transformation seem to be French, although the figure of Daniel on the Pórtico de la Gloria at Santiago de Compostela (ca. 1188) may foreshadow this evolution. Among the thirteenth-century heads on the choir and transept of Reims Cathedral, we find the face of a girl opening her features in a refreshing smile (fig. 11). She has loose hair, and she shows her teeth. These heads at Reims, the so-called masks, seem to have been a fascinating laboratory for physiognomic and pathognomic experimentation. All of the old motifs known from the exteriors of Romanesque churches reemerge on this Gothic cathedral, still screaming, yelling, and sticking out their tongues (fig. 12).

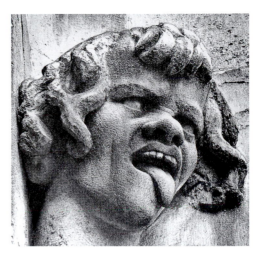

Fig. 12. Corbel Head, exterior of
southeast tower, Reims Cathedral
(Marne), ca. 1230–33

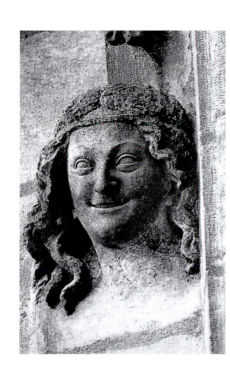

Fig. 11. Mask of Laughing Girl, choir,
Reims Cathedral (Marne), 1230s

About 1200, however, the Greek and Arabic texts on physiognomy had finally become
accessible in the West. Michael Scot (d. 1231) and Roger Bacon (1221–1292) cultivated
an interest in physiognomy and added their own observations to the stock of the
ancient treatises. This was the joyful moment when laughter was integrated into the
physiognomic spectrum of medieval art. In the same spirit, the expressive heads at
Reims were also enlivened and animated by a new, close observation of nature, or as
some would say the study of "real" physiognomies. And yet even now we cannot
decide if the laughter on the face of that charming girl from Reims is an uninhibited
expression of joie de vivre or if it still conveys some negative moral implication. The
old moral verdict against the *risus* (laughter) seems to have been overthrown, but
medieval physiognomy remained ever equivocal.

Describing an early encounter with his beloved, Beatrice, Dante proclaimed,
"Vincendo me col lume d'un sorriso" (she won me by the light of a smile), and
indeed the *Paradiso* of the *Divine Comedy* resounds with words such as *ridere* and *riso*
(laugh and laughter), *sorridere* and *sorriso* (smile and smiling). "Vid'io più di mille
angeli festanti…Vidi a lor giochi quivi e a lor canti / ridere una bellezza, che
letizia / era ne li occhi a tutti li altri santi" (I saw more than a thousand celebrating
angels…at their games and at their songs I saw them smile with a beauty which
beamed as a joy in the eyes of all other saints).[7] This is perhaps the most glorious

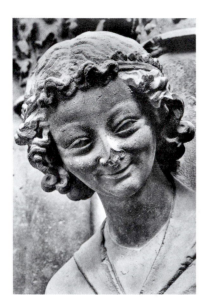

Fig. 13. *Angel of the Annunciation, west facade, Reims Cathedral (Marne), ca. 1255–65*

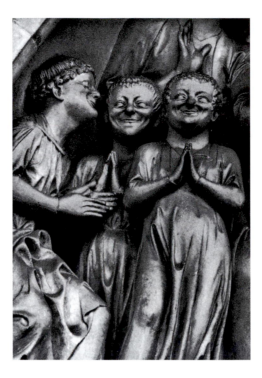

Fig. 14. *The Blessed, tympanum of the Portal of Princes ("Fürstenportal"), Bamberg Cathedral (Bavaria), ca. 1233–35*

Fig. 15. *Foolish Virgin, west portal, Strasbourg Cathedral (Bas-Rhin), ca. 1280–90*

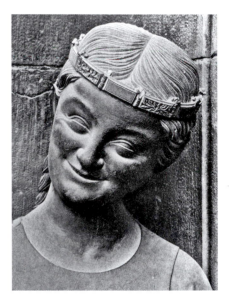

evocation of the famous Gothic smile that first emerged at Reims on the gracious angels of the royal cathedral's majestic portal, who are seen accompanying the martyrs to paradise (fig. 13). Whereas in earlier representations of the Last Judgment the blessed had been rendered as emotionless, solemn figures—free from any passion, be it sadness or joy—paradise was now filled with beaming faces (fig. 14). About 1250, on the portals of Bamberg and Bourges, the blessed began to smile, and soon the Gothic grin appeared on many other types of faces (see cat. no. 17). We see it in Cologne Cathedral on the features of the angels in the choir playing musical instruments, and in Magdeburg, where the Wise Virgins reveal their happiness at being brides of Christ by opening their faces into broad grins.

Not only do the angels and saints smile, the smile itself becomes an indication of female gentility, albeit one still subject to restrictions. "Femme doit rire a bouche close" (a woman must laugh with her mouth closed), we are told in the *Roman de la Rose*: a woman's smile must remain discrete and moderate.[8] It is a courteous but circumspect smile, then, that shines on the faces of Beatrix in the cloister at Burgos and on Reglindis in the choir at Naumburg, for the gesture remained an ambivalent one, loaded with meaning. On the western portals of Strasbourg Cathedral, for example, a Foolish Virgin dances before the seductive, elegant figure of the Prince of the World (Satan), and on her coquettish face this lascivious mam'selle displays a lustful, shameless smirk (fig. 15). Although some two hundred years had passed since Hildebert of Lavardin wrote, "Cupabilis est risus, si muliebre sonans" (laughter is guilty, if it sounds womanlike), the moralizing tendency of medieval Christian physiognomy was never fully extinguished.[9]

The representation of the *motus animae*—of emotions and passions—in narrative images of the twelfth and thirteenth centuries is probably inextricably linked to the

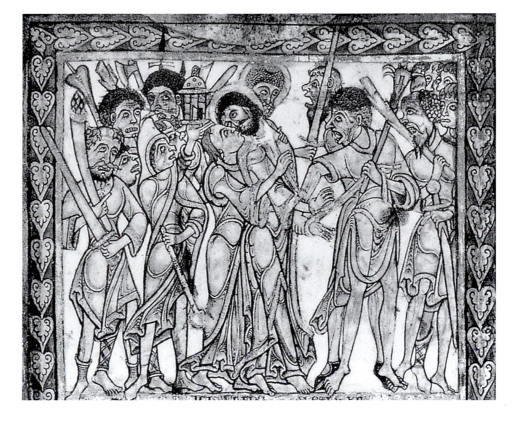

rise of religious theater in the same period, even if the exact relation between the drama of the mystery play on the stage and the dramatic image on a wall, manuscript, or choir screen remains difficult to grasp. Clearly the theater and the narrative image had a similar intention—to move the beholder to compassion—and it was through narrative images that a new physiognomic characterization of the figure-in-action emerged in the twelfth century. A good example of this is a miniature in an English psalter from about 1150 that depicts the Arrest of Christ (fig. 16). Surrounding the central figures of Christ, Peter, and Judas is a huddle of repulsive men with horrible, disgusting faces, embodying all of the negative particularities one finds enumerated repeatedly in the ancient physiognomic texts (and later expounded upon by medieval writers). They have oversize deformed heads with oblique eyes, distorted noses, and large mouths, and once again they scream, shout, and show their teeth. Only the face of Christ is symmetrical and tender. Judas has red hair, and red hair, as Michael Scot wrote, indicates a fraudulent character. In fact, the "mugs" of the bailiffs exhibit an accumulation of the negative characteristics codified by Scot: declining eyebrows for the *valde maliciosum* (very malicious); slanting, oblique eyes for the *iracandum, in multis maliciosum* (violent fit of temper, multiple maliciousness); a thick tip of the nose for the *iracundum* (wrathful); a large mouth for the *bellicosum* (pugnacious); and long, sharp teeth for the *impium* and *falsum* (impious and false).[10] Although it would be naive to assume that this miniature was directly dependent on any text about physiognomy rather than on a visual tradition of such imagery, this narrative and even theatrical image no doubt derives from the same stock of physiognomic judgments and prejudices as the physiognomic texts. And despite a ludicrous fascination with rendering the "bad face," the miniature exhibits

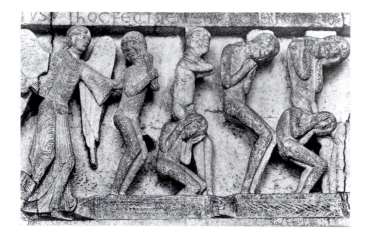

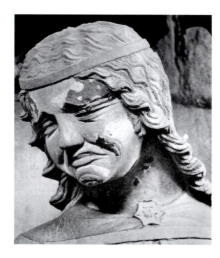

Fig. 17. *The Damned, west portal, Abbey Church of Saint-Lazare, Autun (Saône-et-Loire), ca. 1130–45*

Fig. 18. *Fragment of choir screen, Notre-Dame Cathedral, Paris, mid-13th century. Musée du Louvre, Paris (R.F. 991)*

Fig. 19. *Foolish Virgin, north portal, Magdeburg Cathedral (Saxony-Anhalt), ca. 1250–60*

an astonishing, almost admirable physiognomic inventiveness, albeit focused on the moral denouncement of vulgar and malign characters.

The medieval interest in physiognomy, never neutral, was in fact often quite gruesome. Nowhere is this negative proclivity more tangible than in certain representations of the Last Judgment. As we have seen, with rare exceptions (such as the laughing faces on a tympanum at Bamberg), the figures of the blessed have no physiognomic pointedness. The damned, however, erupt in a veritable pathognomic paroxysm. On the tympanum at Autun they scream, screw up their mouths, and wretchedly cover their features with their hands (fig. 17). On the choir screen of Notre-Dame in Paris, made a hundred years later, we see the face of one of the damned literally surrounded by the flames of hell, his disembodied visage taking on the appearance of a tragic mask (fig. 18). Every feature is disfigured, from the eyes and the eyebrows to the cheeks and the mouth. Here physiognomy becomes a kind of terror, and the convulsed face becomes the means of threatening punishment and hell. The weeping faces of the Foolish Virgins from the twelfth and thirteenth centuries are well-known examples of this strategy. Once again, the influence of the stage and the mimic art of the actor may help explain their extraordinarily convulsed appearances, such as the Foolish Virgins on the cathedral at Magdeburg (fig. 19), whose mouths, chins, eyebrows, and eyes—all the muscles of the face—are

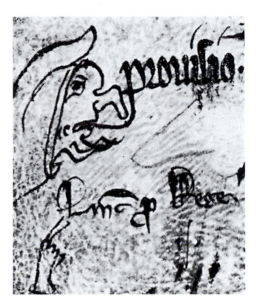

Fig. 20. *Arrest of Christ (detail),*
choir screen, Naumburg Cathedral
(Saxony-Anhalt), ca. 1255

Fig. 21. *English tax roll (detail),*
ca. 1261–62. Public Record Office,
London (E 159/46, Mem. 4d)

tense and distorted. There is a moral pressure implicit in such grotesque exaggerations of facial movement: a warning against sin and sluggishness.

The representation of non-Christians constitutes yet another aspect of medieval moralizing physiognomy. Derogatory depictions of the Jewish face that emerged during the thirteenth century are perhaps the vilest examples of what may be called physiognomic intolerance. In scenes of the Passion, as on the choir screen at Naumburg, the tormentors of Christ are shown with stereotypical hooked noses and hirsute beards (fig. 20). The message of such physiognomic defamation is clear: the Jews murdered Christ. But it was on the margins of financial documents, in reference to debts and taxes, where the medieval physiognomic campaign to vilify Jews became frankly vituperative. An English charter of 1271–72 obliging Jews to deposit all contracts dealing with loans to a special office shows the head of a Jewish man, which is deformed and complete with the infamous hooked nose and hirsute beard; out of his mouth comes the telling word "Provisio," probably a reference to a business transaction involving interest payments (fig. 21). Such an image was charged with a destructive hostility that implicitly grouped the "alien" ethnic group with the likes of the devil and monsters.

Jews were not the only ethnic group denounced through physiognomy. Europe was invaded in the 1240s by the Mongols, who were described by Ivo of Narbonne as

uesa minime dignabant. ajulieres aū uetulas
7 deformes antropofagif q pro uulgo reputat: in
esca qñ pro diarrio dabant. ñ formosis uescebat.
set eas clamantes 7 eiulantes inistitudie cohituū
suffocabant. Vgiet q usq ad exanimā cōm oppri-
miebant. 7 tandē abscisif eaf papilt qf magistra-
tilz pro delicus refuabant: ipsif uirginef corpori-
bz lautius epulabantur. Videntilz uirim ipsoz
speculatoribz edam promontozu summitate: duce

narū per suof friorez infligendarū: 'a uirgut
7 mulnuf decepeacōibz 7 semicuf. tunce cōhcente.
Principia suaf thuū: deof uocant. 7 eū colut
tēporibz solēnuzatef eoz. ajultaf qd pericularef-
fz tmū uñ gualef. Cr qp se solef: onita credut cē
creara. Ju ercendo semicidm ō rebellef: uillin esse
credunt pcm. Dabut aū pectora dura: 7 robefta
facief macraf: 7 pallidaf. Scapulaf rigidaf: refesaf
nasof distorto's 7 breues. Menta pemmnientia 7 n
cura.

Elephandi tartari uf tartari
humanif carnibuf uescentef

Equi tartaroz qui sunt ua-
pacissimi cum desint uberiori
pabula frondilz 7 folus sinon
7 cortichz arboz suf grenri.

*Fig. 22. Matthew Paris (English,
d. 1259).* Chronica majora *(detail),
ca. 1236–59. Corpus Christi College,
Cambridge University (Ms. 16,
fol. 166r)*

having "short and distorted noses, sharp and prominent chins, teeth long and few.
Their eyebrows grow from the hairline to the nose, their eyes are shifty and black."[11]
And this is exactly how the English chronicler and illuminator Matthew Paris por-
trayed them in his scene of the Tartars as cannibals (fig. 22). To the list of the phys-
iognomically maligned we must also add the Arabs, or Saracens, as they were called.
A capital at the Palacio Real de los Reyes de Navarra in Estella shows a fight between
a crusader and a Saracen, the latter represented as a giant with an enormous head
and squashed nose (fig. 23). Interestingly, the depiction of black Africans in medieval
art is more ambivalent. A servant of the Queen of Sheba on the transept at Chartres
has the stereotyped face of a Moor, with great protruding eyes, a broad nose, and
thick lips (fig. 24), but this physiognomy likely had more significance as an exotic
image than as a negative one. Remember, we are approaching the days of Albertus
Magnus and Roger Bacon, when physiognomic description and representation, lib-
erated from moralizing prejudices and denouncements, became aims in and of
themselves. At Magdeburg, the face of Mauritius (Maurice), the black African who
became a saint and the patron of that famous cathedral, is portrayed with the flat-
tened nose and thick lips of the Moor (fig. 25), but the glow of sanctity has also
spread over him. Apparently his conversion to Christianity was enough to silence
the physiognomic denouncement of a foreign ethnic group—yet another example
of how the representation of physiognomic characteristics and aberrations in
medieval art was always colored by moral or religious evaluation.

Compared with the excesses and distortions discussed thus far, the faces assembled
in the present exhibition, many of them from the monumental portals of Roman-
esque and Gothic sanctuaries, are mostly solemn and lofty in character. They show
no physiognomic denouncements, nearly no emotions, and especially no passions.

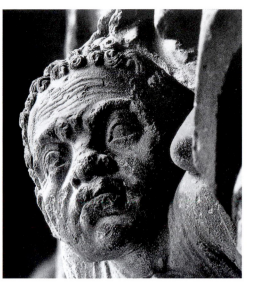

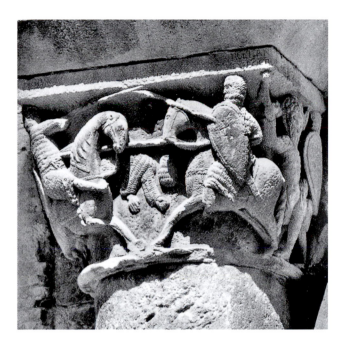

Fig. 23 (above). *Capital, exterior of Palacio Real de los Reyes de Navarra, Estella, ca. 1200*

Fig. 24 (above, right). *Marmoset beneath the Queen of Sheba, north transept, Chartres Cathedral (Eure-et-Loir), 1245–50*

Fig. 25 (right). *Saint Maurice, choir, Magdeburg Cathedral (Saxony-Anhalt), ca. 1245*

They represent the faces of Old Testament kings, saints, and the apostles, who since the early Christian era had been represented with serious expressions and bearded heads recalling depictions of the ancient philosophers. On the entrances to Gothic cathedrals, the faces of the apostles, the columns of faith, became graver than ever. For example, with his high forehead and protruding eyes and cheeks, the head of an apostle now in the Art Institute of Chicago (cat. no. 14), probably from Notre-Dame in Paris, is at once noble and gloomy. Two heads of apostles from the destroyed cathedral at Thérouanne (cat. nos. 8, 9) have furrowed brows and stern countenances, lest we forget that these sculptures come from portals depicting the Dies Irae, the Last Judgment, and thus announce a grave and fateful moment.

The twelfth and thirteenth centuries witnessed the rise of the Capetian monarchy in France, when the cathedrals and abbeys around Paris were decorated with

states of biblical kings who may have been regarded as prefigurations of, or models for, the country's medieval Christian rulers. This exhibition contains numerous examples of such royal heads, including three kings from the royal abbey at Saint-Denis (cat. nos. 4, 28, 30); two from the cathedral of Notre-Dame in Paris (cat. nos. 6, 13); and two more from the royal priory at Mantes (cat. nos. 18, 19). Although styles changed significantly from 1140 (the date of the earlier of those examples) to the reign of Saint Louis (the date of the later ones), all of these royal heads possess an imposing, majestic character. They show no physiognomic experimentation and no aberrations. The monarch does not laugh, he shows no emotion at all, in fact; his face is stern, and it commands respect.

Of the heads of saints included in the exhibition, perhaps the most impressive are the reliquary busts of Saint Yrieix (cat. no. 72), venerated in the Limousin region, and the Italian Saint Juliana (cat. no. 73). They, too, exhibit neither passion nor emotion, but in other respects they are quite different from the heads of the kings. Saint Yrieix appears ardent, with shining eyes, while Juliana's face reflects an immaculate sweetness: part of a dream of virginal perfection and harmony. Saints are supposed to be in heaven, and accordingly they were made to appear heavenly.

With the faces of the prophets we reach a more pathetic aspect of the representation of physiognomy in medieval art. There is of course the miraculous but horrific subject of the head of Saint John the Baptist on a charger, which the executioner hands to Salome (cat. nos. 79, 80). According to these images, the Baptist, even after being beheaded, still seems able to speak, and his face is beautiful: a shining triumph over cruelty and death. In this regard the Baptist's decapitated head could be considered a type of anti-Laocoön, in which the face of the pagan priest expresses pain, and the face of the beheaded Baptist expresses peace. Such triumph over death found similar expression in statues of those martyrs referred to as the Cephalophoroi. Saint Firmin, for example, venerated as the apostle of Amiens, is shown holding his own decapitated head in his hands (cat. no. 81). He still wears his bishop's miter, but his eyes are closed: a moving physiognomic evocation of martyrdom, death, and resurrection.

On tombs, the images of the dead almost never show a "dead" face; they all seem to be still alive, the beauty and peace of their features reflecting hope for eternal life. The bust of Princess Marie de France (cat. no. 58) is a shining example of this tradition. Chiseled in marble, it is as much a mirror of ideal feminine beauty as it is a discreet intimation of a true portrait. Here again we see how the physiognomy in medieval art wavers between heaven and earth, life and death, idealized perfection and reality.

There are in the exhibition a few of those masks—those grotesque and distorted heads—discussed at length at the beginning of this essay: a corbel of a female face from the parish church in Frías, near Burgos (cat. no. 42), and an even more expressive grotesque head with huge eyes, a thick nose, and an animal-like expression that may come from a church in Champagne (cat. no. 41). The most revealing examples of these are English: a curious Romanesque head with magically glaring eyes (cat. no. 38), and a fourteenth-century misericord from Wells Cathedral that shows a furious male face full of pathos and excitement, with contracted eyebrows and flaming hair (cat. no. 43). There are also several Romanesque heads from narrative contexts whose speaking visages reveal the *motus animae*: a charming head in marble that may come from the destroyed western portal of Saint-Sernin at

Toulouse (cat. no. 1), and an equally fascinating head of an Elder of the Apocalypse from Saint-Lazare at Autun, tiny in size but fierce in expression (cat. no. 26). There is even a capital with four heads from Troia (cat. no. 64) that demonstrates the previously discussed interest of medieval artists in the exotic faces of foreign peoples and races. It is certainly not by chance that this impressive piece comes from southern Italy, a region well known as a melting pot of Greek, Arab, Norman, and indigenous Italian populations.

There is only one smiling face in the exhibition (cat. no. 17), but fortunately for our purposes it probably comes from the right place, Paris, and from the right moment, the later part of the reign of Saint Louis. Perhaps it was part of a statue of an angel, a Parisian relative of the famous *anges au sourire* at Reims Cathedral. Finally, there are two faces of Christ. On a capital from northern Italy, two angels display the Vera Icon (or Veronica), the "true portrait" of Christ, which is symmetrical, motionless, solemn, and holy (cat. no. 57). The other is the head of a dead Christ with the crown of thorns, probably a fragment from a Netherlandish Pietà (cat. no. 37). It is a pathetic image of Christ's suffering from the late Middle Ages, a period when the representation of the face had once again become a means of evoking compassion.

"Set in Stone: The Face in Medieval Sculpture" is an exhibition that both advances and revives the long-standing interest of American collectors, museums, and scholars in medieval art, an interest that dates back to the days of Henry Adams and Arthur Kingsley Porter. Indeed, there was a time when the cathedrals, castles, and cloisters of the Middle Ages were something of an American dream, and many of the heads assembled here come from American collections, where they were (or are) trophies of an enthusiastic medievalism. But these works also speak to an interest in the appearance, expression, and manipulation of the human face, which in our modern era of television and omnipresent publicity images has become nothing less than a public obsession. To learn about "the fate of the face" in the past, then, and specifically in the Middle Ages—a period torn by strife, faith, and fear—may prove today to be more than a mere art-historical concern.

NOTES

1. Foerster 1893, vol. 2, p. 256.

2. "Recta sit facies, ne labra detorqueantur, ne immodicus hiatus distendat rictum . . . neque elata aut depressa supercilia." Alcuin, *De rhetorica et virtutibus*, in PL 1844–91, vol. 101, cols. 942–945.

3. Hugh of Saint-Victor, *De institutione novitiorum*, in PL 1844–91, vol. 176, col. 942.

4. Traditionally attributed to Bernard of Clairvaux (*De modo bene vivendi*, in PL 1844–91, vol. 184, col. 1295), today this text is sometimes attributed to Thomas of Froidmont.

5. Honorius of Autun (Augustodunensis), *Opera omnia*, in PL 1844–91, vol. 172, col. 1058.

6. See Adams 1913, p. 77.

7. *Paradiso*, Canto XVIII:19, XXXI:133–135.

8. *Roman de la Rose*, Morgan Library, M. 948 f. 131 r, L. 13329; Guillaume de Lorris and Jean de Meun, *The Romance of the Rose*, translated by Harry W. Robbins (New York, 1962), ll. 13345–6.

9. Hildebert of Lavardin, *De quattuor virtutibus vitae honestae*, in PL 1844–91, vol. 171, col. 1061.

10. Michael Scot, *Liber physionomiae* (1477), chaps. 59–68.

11. The text of the letter of Ivo of Narbonne, who is supposedly describing the physical appearance of the Tartars, is included in Matthew Paris's chronicle entry for the year 1243. See Strickland 2003, p. 193.

Iconoclasm: A Legacy of Violence

Stephen K. Scher

CAPABLE of producing works of art of the most exquisite beauty and profound meaning, humanity, regrettably, has in almost equal measure demonstrated the ability to destroy with intense passion these same products of its most noble attributes. Many are the motives behind this legacy of violence, as are the means chosen to effect the sad results. Most of the objects in this exhibition are mute, often battered survivors of a multitude of violent events that occurred over a long period of time. Ripped from their original contexts, scattered, passed from hand to hand, and bartered and sold, they have now, finally, come to rest in public and private collections, where they can be studied by scholars and appreciated by a wider audience to whom such fragments communicate, in some fashion, the beliefs and values of a distant civilization.

What are these seemingly inexorable events and unfortunate proclivities of the human condition? War, both international and civil; revolution; religious fanaticism; mindless vandalism; changes in taste; neglect; greed; theft; ambition; ignorance; financial necessity; and, finally, that which is often beyond human control, natural disaster. To compound the problem, these factors often coincided in ways that served to intensify the emotions behind the destruction.

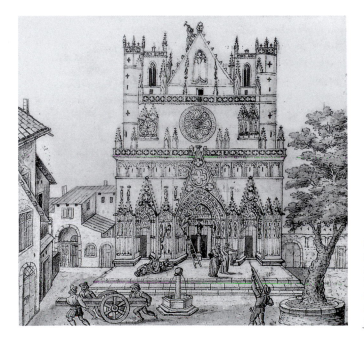

Fig. 26. Iconoclasts before the church of Saint-Jean, Lyons. Pen and ink with gray wash, from De Tristibus Galliae, Carmen in Quator Libros *(after 1572). Bibliothèque Municipale, Lyons (Ms. 156, fol. 3)*

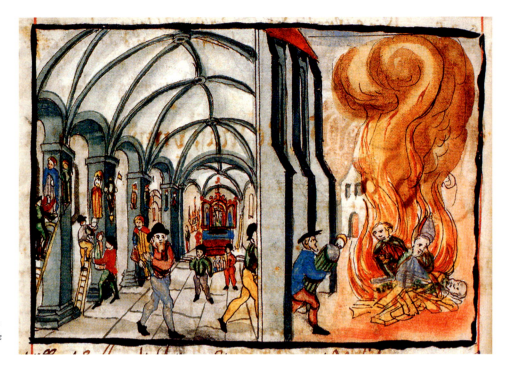

Since the majority of the sculptures included in this exhibition came originally from France, we must first look there for some of the more prominent events that helped dislodge these works of art and send them on often circuitous journeys to their current locations. Major early conflicts such as the Hundred Years War (1337–1453) between the English and French, which included bitter internecine struggles for power within the French royal family, particularly the so-called Armagnac-Burgundian rivalry (1392–1407), did not leave important monuments untouched. The intense emotions accompanying the Wars of Religion in the sixteenth century (1562–98) and further religious antagonism in the seventeenth century likewise caused extensive damage to both religious and civil monuments. An excellent witness to this kind of systematic and wanton destruction is a 1572 engraving that depicts the removal of the sculptural decoration on the church of Saint-Jean in Lyons (fig. 26); similarly, a watercolor from 1605 shows the vandalism of Bern Cathedral (fig. 27). In addition, shifts in taste that occurred with the introduction into France of Italian Renaissance art in the sixteenth century and with the development of Baroque and Rococo art in the seventeenth and eighteenth centuries engendered a contempt for, and neglect of, medieval art. Continuing revolutionary eruptions—in 1830, 1848, and, of course, the Commune in 1870–71—would also abet the disappearance or deterioration of art works. Finally, the potent means of destruction developed by military forces in the twentieth century and unleashed across most of Europe in two world wars made certain that, except in very rare cases, little remained that was not severely damaged.

Many works in this exhibition were reduced to their current states at the time of the French Revolution (1789–1800), especially during the Reign of Terror (1793–94), when revolutionary fervor peaked and when a reaction against the church and the aristocracy resulted not only in the beheading of human victims by means of the infamous guillotine but also in the systematic destruction of all symbols of the ancien régime, especially on churches, whose decoration and contents were

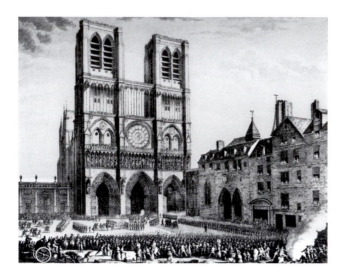

Fig. 28. Alexandre Moitte (French, 1750–1828). "View of exterior of Notre-Dame Cathedral, taken at the moment of the arrival of the French and Swiss guards, on the day of the Benediction of the Flags," 1787. Pen and ink with wash. Destailleur Collection, Cabinet des Estampes, Bibliothèque Nationale, Paris

attacked with an especial fury (fig. 28). For the sculpture that covered abbey churches and cathedrals, most often this meant decapitation, a vivid analogy to the effects of the guillotine on the regime's living remnants. In one noteworthy instance, the head of a seated funerary statue of the Carolingian King Lothair (r. 954–86) in the church of Saint-Remi, Reims, was symbolically lopped off the body and buried on the same day Louis XVI was decapitated in Paris.[1]

Of course the French Revolution was not an isolated source of the destruction or displacement of works of art; neither was physical abuse the only means, nor France the only stage upon which such tragedies were enacted. Even a partial list of the various disruptions and cataclysms and the rationales behind them dating from the medieval era to our own is so extensive that one wonders how anything survived at all. These include the Thirty Years War (1618–48), which devastated Germany, as did the secularization of religious monuments; the Wars of the Roses (1455–85) in England, followed by the dissolution of the monasteries under Henry VIII (1536 and 1539) and the Puritan depredations during the English Civil War (1642–46); the Eighty Years War for Dutch independence (1568–1648) and the actions of Calvinists, which did not spare the Low Countries. And Italy, of course, as it had been since the barbarian invasions beginning in the fifth century A.D., was a constant battleground for ambitious princes.

Of the twelve heads in this section of the exhibition, two (cat. nos. 2, 3), both from Saint-Gilles-du-Gard, were damaged as a result of Huguenot actions in the seventeenth century, whereas two from the destroyed cathedral of Thérouanne (cat. nos. 8, 9), were displaced when that city was leveled in 1553 for vengeful political purposes. Still others, such as the head from Toulouse (cat. no. 1), were removed as a direct result of architectural renovations, particularly those undertaken in the nineteenth century. Although the original locations of many other sculptural fragments are uncertain—and thus the means by which these works attained their present states cannot be described—wherever possible, some attempt has been made to narrate their plaintive histories.

NOTE

1. Paris 2005, p. 345, no. 261.

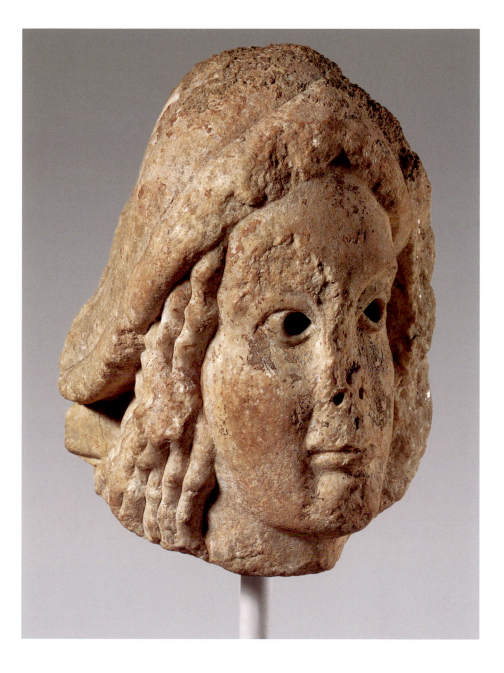

1. Head of a Youth

France, Toulouse (Haute-Garonne), ca. 1100–1120
Church of Saint-Sernin
Marble, H. 7¹¹⁄₁₆ in. (19.5 cm)
The Metropolitan Museum of Art, New York; Gift of Ella
Brummer, in memory of Ernest Brummer, 1976 (1976.160)

Charmingly expressive despite considerable damage, this head, carved in high relief, portrays a young boy. The youth's long stylized hair, resembling twisted rope, is covered by a Phrygian cap that slopes down the back of his neck. The face is sensitively modeled, with gently rounded cheeks that are especially noticeable when viewed from the front. From that vantage one is also immediately struck by the head's unusual asymmetrical structure as well as the pupils of the eyes, which are drilled and inset so deeply that the face seems almost to stare out in a somewhat whimsical, even cross-eyed, manner.

These exceptional features connect the head with the sculpture of two great pilgrimage centers of the Middle Ages—Santiago de Compostela, in northern Spain, and Toulouse, in southern France—but the head can be directly linked to the latter center, in particular to the famous marble relief from the church of Saint-Sernin of the Two Women with a Lion and a Ram (fig. 29).[1] Both the head and the relief are carved from the same type of marble, and the heads on

both sculptures correspond exactly in terms of technique, style, size, and depth of carving (about 4 cm).

Since the exact context of the New York head is unknown, we must rely on what we know of the Toulouse relief in order to attempt to determine the head's original placement, meaning, and possible function. In the sixteenth century, a local historian described the Two Women relief as being "attached to the third column of the great porte [de Comtes]" on Saint-Sernin's south transept.[2] It is unlikely, however, that such a large relief was originally intended for that position on a portal apparently conceived without any other large-scale figurative sculpture. The Two Women relief, along with several other marble fragments in the Musée des Augustins, Toulouse, has also been linked to the decoration of the western portals of Saint-Sernin, which were stripped of virtually all sculpture during the French Revolution.

There has been little consensus regarding the original appearance and decorative program of the double portals of Saint-Sernin's western entrance, traditionally dated just prior to the death of Raymond Gayrard, master of the works, in 1118. The proposed reconstruction of D. W. Scott—based primarily on the nineteenth-century descriptions of Alexandre Du Mège and others as well as on the extant marble fragments

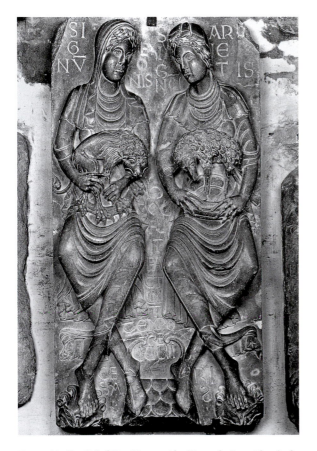

Fig. 29. Marble relief of Two Women with a Lion and a Ram, Church of Saint-Sernin, Toulouse (Haute-Garonne), ca. 1120. Musée des Augustins, Toulouse (RA 502)

in the Musée des Augustins—envisioned that the reliefs were placed symmetrically above the cornice level, filling the spandrel areas. But it is possible that the Two Women relief was not part of the original concept for the west facade program.[3] A subsequent study by Marcel Durliat demonstrated how a careful reading of historical texts and descriptions suggests that sculpture also existed on the jambs; other descriptions imply that there were some reliefs placed asymmetrically on the facade, and that additional subjects were also present.[4] The focus of the facade program must have been, in part, devoted to the life and martyrdom of Saint Sernin, patron saint of Toulouse, but the iconography is still poorly understood.

In the mid-nineteenth century there were additional relief fragments, possibly associated with the Passion of Christ, fastened to the upper facade of Saint-Sernin, which were subsequently lost or destroyed during renovations. Writing in 1854, Du Mège mentions a figure carved in high relief with the inscription "FIT CORPUS VICTIMA XPI...," referring to the sacrificial body of Christ.[5] Baron F. de Guilhermy, in his 1853 "Description des localités de la France," recorded seeing "11th century sculptural fragments at the height of the nave, of an angel, and a person carrying an animal, probably a lamb, on his shoulders."[6] It is possible that the New York head was among these miscellaneous fragments. The cap worn by the youth is found in several contexts at Saint-Sernin, such as on the south flank portal, known as the Porte Miègeville, where it can be seen on some of the console figures and on the figure of Simon Magus appearing before Saint Peter. Still, the exact identity of the New York head, and how it relates to the rest of the sculpture on the church and to the reputed former decoration on the west facade, must for now remain open questions.

CTL

NOTES

1. See Rupprecht 1984, pl. 21, and Durliat 1990, pp. 412–15.

2. Noguier 1556, p. 52.

3. Scott 1964.

4. Durliat 1965.

5. Alexandre Du Mège, in Saint-Saturnin 1854, pp. 64–66.

6. Bibliothèque Nationale, Nouv. Acq. fr. 61110 fol. 129. My thanks to Marcel Durliat for this citation; see his letter of October 14, 1975, in the files of the Department of Medieval Art and The Cloisters, The Metropolitan Museum of Art.

EX COLLECTIONS

[Lucien Demotte, Paris and New York]; [Joseph Brummer, Paris and New York]; Ernest and Ella Brummer, New York

LITERATURE

Charles T. Little, in Notable Acquisitions, 1975–1979, New York, The Metropolitan Museum of Art (1979), pp. 22–23; Little et al. 1987, pp. 63–64, no. 4, fig. 4; New York 1993–94, pp. 207–8, no. 88 (entry by Elizabeth Valdez del Álamo)

2. Head of a Bearded Man

South France, Provence, third quarter of the 12th century
Church of Saint-Gilles-du-Gard (?)
Limestone, H. 7¹¹⁄₁₆ in. (19.6 cm)
Cincinnati Art Museum; Gift of Mr. and Mrs. Philip Adams
(1958.548)

The association of this attractive head with the abbey church of Saint-Gilles-du-Gard is based primarily on its appearance in a photograph, published in 1910, of a group of sculptural fragments stored in the crypt of Saint-Gilles said to have come from a statue originally located in one of the church's lateral portals.[1] This head and two others later disappeared from the crypt; of those, only the Cincinnati head and a head now in the Victoria and Albert Museum, London, have resurfaced.[2]

The monastery of Saint-Gilles had prospered in the twelfth and thirteenth centuries, but by the fifteenth century there were no longer sufficient funds to complete the abbey church, which threatened to fall into total ruin. Far more serious, however, were the effects of the Wars of Religion of the sixteenth century. On September 27, 1562, the Catholic army that held the town was defeated by Protestant forces, who proceeded to burn the monastery along with its library and archives. The church remained in a ruined state for many years, with repair efforts stymied by continuing violence

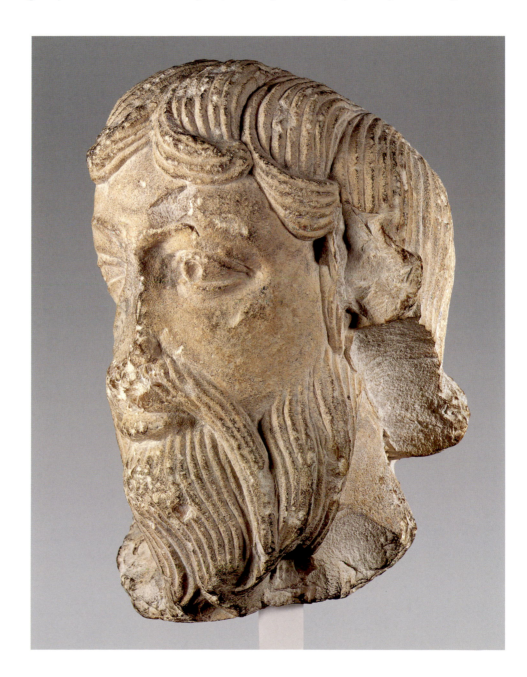

associated with the religious conflict. In 1622, having begun to transform the church into a fortress, the duc de Rohan, a Protestant, gave orders that the church buildings be demolished in order to prevent them from being used by the approaching royal troops. Although royal forces arrived in time to save the crypt and the west facade, the destruction of the center tower by the Protestants had seriously damaged the walls and piers of the church, and the two towers of the facade had been razed; volleys of musket fire had also mutilated the sculpted friezes on the west facade. The final demolition of the choir and further damage to the facade occurred in 1791 during the French Revolution.[3] Major restorations to the facade were carried out in both the seventeenth and nineteenth centuries, further complicating the task of determining the original location of the Cincinnati head from its stylistic associations with the sculpture still in situ.

Both the construction history and the identification of sculptural styles at Saint-Gilles have been studied extensively and have engendered considerable controversy.[4] At least three major hands can be identified for the facade work, one of them associated with an actual signature on the apostle Matthew: "Brunus me fecit." It is also possible to follow the work of these masters to other churches either in Saint-Gilles (Saint-Martin) or nearby (Saint-Guilhem-le-Désert). In relation to one of the basic premises of this exhibition—that the head is the seat of identity and character—it is interesting to note that most of the sculptures on the facade of Saint-Gilles, including the monumental jamb figures and those in the frieze that runs along the lintels, have had their heads systematically and deliberately destroyed, so it is difficult to find any material for comparison with the Cincinnati head. Nonetheless, a few examples have survived, particularly in the center portion of the frieze, where a corresponding, but not exactly matching, style is found in the scenes of Christ's Prediction of Peter's Denial and the Washing of the Feet. The Cincinnati head also relates stylistically to an apostle on the facade (one of the few with its head intact, identified by some as Saint Andrew), a sculpture Whitney Stoddard has assigned to the so-called Soft Master.

The original location of this head remains something of a mystery, however, since it is made of limestone and all of the figural sculpture of the facade is made of white marble (see also cat. no. 3). If the head is indeed from Saint-Gilles, as seems to be the case, it might have come from one of two lateral north and south portals that originally opened into a transept. The collection of fragments kept in the local Musée Lapidaire, which relate stylistically to the west facade, suggests that at least one of the two side portals was, in fact, decorated with limestone sculpture.

Although there has also been little agreement on the dating of the church and its facade—there are few ensembles of Romanesque architecture and sculpture as varied or complex as the facade of Saint-Gilles—the most recent arguments suggest that the Cincinnati head was most likely carved in the third quarter of the twelfth century.[5] The strong underlying influence of ancient Roman forms, both in the basic design of the portals and in the organization and specific drapery patterns of the sculpture, is combined with an admixture of local and neighboring Romanesque sculptural dialects: Burgundian and Languedocian, even, perhaps, a whisper of the Early Gothic developments to the north. Rich acanthus leaves combined with pilasters and actual Roman columns frame the severe yet complex, richly carved linear drapery and the lively narrative movement of the sculpture. Individual nuances of style are also evident, depending on the hands of the different masters and their ateliers. Despite the losses to the Cincinnati head, and considering the inherent Romanesque abstraction of physiological detail, the sculpture conveys a surprising degree of expressiveness through the modeling of the eyes and the projecting lower lip. There is also a softness and incipient naturalism that justifies its association with Stoddard's Soft Master, qualities that simultaneously reinforce the undeniable association of Provençal Romanesque with ancient art but also confirm the influence of a new approach.

SKS

NOTES

1. Charles-Roux 1911, p. 295, as cited in Diemer 1978, pp. 10–11.

2. Reported in Hamann 1955, vol. 1, p. 67, vol. 2, pls. 173–174. Both heads were included in the 1969 exhibition *The Renaissance of the Twelfth Century* at the Museum of Art, Rhode Island School of Design; see Providence 1969, nos. 43, 44 (entries by Linda Seidel). The head in the Victoria and Albert Museum was formerly in the Neil Phillips Collection, New York and Washington, D.C.; see Williamson 1991, p. 877, pl. III; Williamson 1996, p. 43 (ill.).

3. Réau 1959, pp. 94, 358; Fliche 1961, pp. 32–33.

4. The most recent bibliography may be found in the entry by Kathryn Horst in Cahn 1999, pp. 175–76. For a more extensive treatment of the head, with additional bibliographic material, see Horst 1982. The sculpture of the facade was studied extensively by Whitney Stoddard; see W. Stoddard 1973.

5. For the relevant bibliography, see Horst 1982, p. 113.

EX COLLECTION

[Piero Tozzi, New York]

LITERATURE

Charles-Roux 1911, p. 295; Ithaca–Utica 1968, no. 55; Providence 1969, no. 43; W. Stoddard 1973, pp. 106–7; Diemer 1978, pp. 10–11; Horst 1982, pp. 111–13; Oklahoma City 1985, pp. 82–83; Cahn 1999, pp. 175–76 (entry by Kathryn Horst)

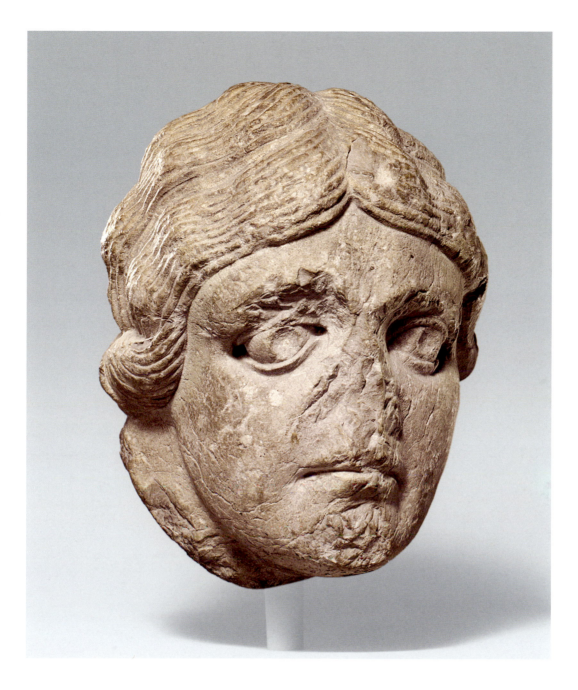

3. Head of a Youth

South France, Provence, third quarter of the 12th century
Church of Saint-Gilles-du-Gard (?)
Limestone, H. 7 1/16 in. (18 cm)
The Metropolitan Museum of Art, New York; Bequest of
Meyer Schapiro, 1996 (1997.146)

Unlike the head of a bearded man now in the Cincinnati Art
Museum (cat. no. 2), for which there is fairly convincing evi-
dence linking it to Saint-Gilles-du-Gard, this head can be
associated with that Provençal church based only on stylistic
grounds. Nonetheless, the comparisons are compelling
enough for most scholars to place this head either at Saint-
Gilles or at a related church in the region.

Various hands can be associated with the facade sculpture
of Saint-Gilles. Stylistically, the work of the sculptor dubbed
the Michael Master by Whitney Stoddard appears closest to the
Metropolitan's head.[1] However, because of the extraordinary
richness of the facade sculpture at Saint-Gilles, the church's
complicated construction history, and a series of disastrous
attacks and reconstructions, both the church itself and its
decoration have proved difficult and contentious in terms of
dating and attribution. Stoddard identified five different
hands in the major apostle and angel figures, with additional

Fig. 30. Saint Michael, north portal of west facade, Abbey Church of Saint-Gilles-du-Gard (Gard), ca. 1125–50

NOTES

1. W. Stoddard 1973, p. 106.

2. Lasteyrie du Saillant 1902; Porter 1923; Horn 1937; Gouron 1951; Hamann 1955.

EX COLLECTION

Meyer Schapiro, New York

LITERATURE

New York 1968–69, no. 25; New York 1999, pp. 72–73, no. 86 (entry by Charles T. Little); Wixom 2005, p. 16, no. 4

4. Head of a King

France, Saint-Denis, 1150–60
Abbey Church of Saint-Denis, archivolts of the north transept portal (Porte des Valois)
Limestone, H. 7⅞ in. (20 cm)
Musée du Louvre, Paris (RF 553)

sculptors responsible for the smaller elements, but earlier scholars offered such widely differing opinions that the matter is still open to study.[2] One of the major reasons for this diversity of views is the strong common influence underlying all of the various styles discernible in the facade sculpture: that is, overlapping similarities in the carving of details such as drapery, hair, and eyes derived from a regional style that also embraced imported influences.

Comparing the Metropolitan's head with the beardless head of the Archangel Michael still in situ (fig. 30), there are so many corresponding details of carving—such as the broad, flat planes of the face and the handling of the hair and eyes—that the association of the head with the regional style of Saint-Gilles can raise few doubts. In both works one sees the strong influence of the locally available ancient Roman sculpture, which in the present piece was transformed by the Romanesque artist through the simplification and stylization of facial details, especially the enlarged and expressive eyes, the planes of the cheeks, the lines of the hair, and the intense, almost melancholy expression of the lips. Although it is impossible that this limestone head was originally part of the marble sculpture on the facade of Saint-Gilles, it may, like the Cincinnati head, have come from a side portal there or from another nearby church, such as Saint-Martin at Saint-Gilles-du-Gard or Saint-Guilhem-le-Désert (Hérault).

SKS

During the French Revolution, the heads of all of the statues wearing crowns in the north transept portal at Saint-Denis, known as the Porte des Valois, were either damaged or knocked off on the assumption—probably correct for this portal—that those figures represented the hated monarchs of France. This royal head originally belonged to one of the thirty kings in the archivolts surrounding the tympanum of the portal. With the martyrdom of Saint Denis, patron saint of France and protector of the monarchy, depicted in the tympanum, the archivolt kings surrounding the scene, and the six statue-columns of kings framing the entrance, the portal's sculptural program seems to canonize in stone the ardent desire of Abbot Suger (1081–1151) to forever associate the abbey and the saint with the monarchy.

In 1817 a campaign was begun to restore the sculptures on the portal, and by 1830 the workshop at the abbey had repaired and remounted all but three of the surviving twelfth-century archivolt heads and had replaced missing ones with newly carved substitutes.[1] In 1881 the three heads not used in the restoration were sent from the Saint-Denis workshop to the Musée du Louvre, Paris, along with two nineteenth-century heads that had been discarded by the restorers.[2] Of the three original heads, this one alone escaped restoration, providing us with one of the best examples of the idealized facial style that characterizes many of the twelfth-century heads now in situ. It compares especially well with the somewhat restored head of the sixth king in the second archivolt on the right (fig. 31); similarities include the broad, high forehead beneath bangs formed by pin curls; the high, widely spaced cheekbones; the almond-shaped

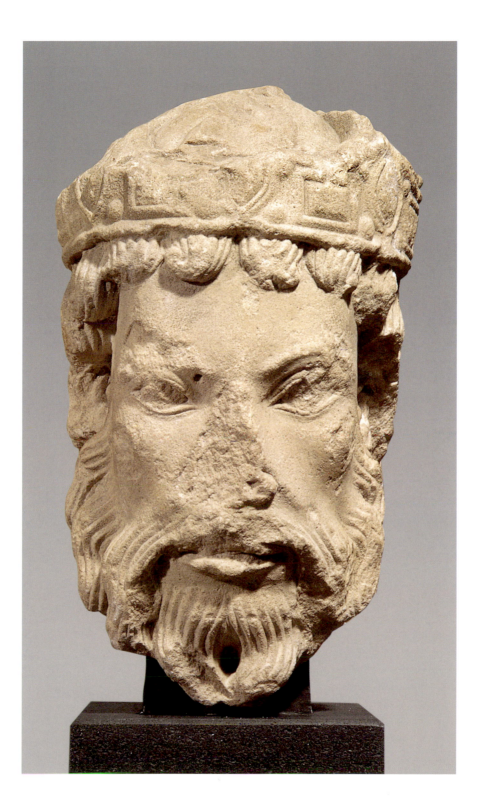

Fig. 31. King, archivolt of the "Porte des Valois," north transept, Abbey Church of Saint-Denis, ca. 1170

between the statue-columns has revealed that the stone best matches the compositional profile of the limestone used for the western portals, dedicated in 1140 (see "The Limestone Project" by Georgia Wright and Lore L. Holmes, in this catalogue).[7] Surprisingly, the samples from the plinth level did not match the profile of the Porte des Valois reference group, composed of samples taken from the statue-columns themselves, the tympanum carvings, and the archivolt kings.[8] These findings indicate that the Porte des Valois was created in two campaigns, the first of which was begun in the mid-1140s. The second campaign, marked by the arrival of a new workshop using a different quarry source, may well date to the 1150s, about two decades earlier than the traditional dating, thus establishing the priority and influence of the portal in the formation of the Early Gothic style in the monuments north of Paris in the second half of the twelfth century.[9]

PZB

NOTES

1. See "Seine. Saint-Denis. Registre des attachements de Serrurerie; de Menuserie, de Marbrerie; de Plomberie; de Sculpture," Carton 27 (1812–1842): "Statuaire et Sculpture," Paris, Archives de la Patrimoine de la Commission des Monuments Historiques; Germain (1813–1834), "Savoir," Notes des ouvrages fais dans le moi de septembre 1817; ibid., "Notes," 1817–1820, 1827, 1830.

2. Courajod 1878–87, vol. 3, pp. 400–401. The five heads were mistakenly associated with the Elders of the Apocalypse on the center portal of the west facade.

3. Crosby 1987, pp. 267–77.

4. Sauerländer 1958, pp. 136–59.

5. For the earlier bibliography, see Bruzelius 1985, pp. 7, 179 n. 33.

6. Crosby 1972, pp. 56–67.

7. The analysis was processed at the Brookhaven National Laboratory, Upton, New York.

8. Blum 1998, pp. 21–25; and Blum et al. 1994, pp. 23–24.

9. The priority of the Porte des Valois was first suggested by Ludden 1955, pp. 56, 66–68, 221–23. Brouillette 1981, pp. 386–89, accepted that priority.

EX COLLECTIONS

Probably Musée des Antiquités et Monuments Français, Paris, 1796; *magasins* of Saint-Denis, until 1881

LITERATURE

Courajod 1878–87, vol. 3, pp. 400–403; Aubert and Beaulieu 1950, p. 61, no. 70; Ludden 1955, pp. 56, 66–68, 221–23; Umasugi 1978; Brouillette 1981, p. 392; Baron 1996, p. 71; Erlande-Brandenburg 1999a, p. 201, fig. 13; Gaborit et al. 2005, p. 211, fig. 226; Châlons-en-Champagne 2005–6, p. 62 (entry by Jean-René Gaborit); Françoise Baron, "La restauration de la Porte des Valois à Saint-Denis et les vestiges conservés au Musée du Louvre," in Blum et al. 2006, fig. 26; Pamela Z. Blum, "The Porte-des-Valois at Saint-Denis: Restorations and Survivals," in ibid.

eyes accented by finely incised lines; and the closed, full lips below generous, drooping mustaches. The Louvre head's refined features also reflect a new realism that contrasts with the powerful stylization and monumentality of earlier heads surviving from the western portals (see cat. no. 27).

The Porte des Valois was originally intended to be the north entrance to a twelfth-century transept that was begun about 1144 but never finished.[3] Based on evidence of the classicizing influence of metalwork—a widely proliferated trend seen in other Early Gothic portals that have been dated to about 1170[4]—the date traditionally assigned to the portal ranges from about 1160 to 1175.[5] Yet at Saint-Denis that influence can be documented as early as the 1140s, for example, in the Labors of the Month on the south portal of the west facade and in the bas-relief discovered by Sumner Crosby during excavations in the south transept in 1947.[6] The figure and drapery style of the Porte des Valois kings reflects that influence, and the Louvre head provides an elegant example of the emergent facial style.

Neutron activation analysis (NAA) of limestone samples taken from the frieze of monsters along the plinth of the Porte des Valois and from the bases of the colonnettes

5. Head of a Bearded Man

France, Paris or Saint-Denis, 1150s
Limestone, H. 5⅞ in. (15 cm)
The Metropolitan Museum of Art, New York; Purchase,
Rogers Fund, Ronald R. Atkins and Levy Hermanos Foundation Inc. Gifts, and funds from various donors, 1999
(1999.97)

With its tight spiral curls across the forehead, symmetrical, stylized beard, and curled mustache framing a bare chin, this small head reflects a style that emerged in Paris about the mid-twelfth century, first seen in some of the sculpture assembled in the Saint Anne portal of Notre-Dame Cathe-

dral (see cat. no. 13).[1] This fragment, actually only the front half of the head, is broken off at the top of the neck. The nose has been repaired, probably in the early nineteenth century, indicating that the head remained in place through at least one restoration, only to be subsequently removed. The evidence of restoration, together with the sensitivity and delicate modulation of the surface and the parted lips, suggest that the face comes from one of the least-known major portals of the mid-twelfth century, the so-called Porte des Valois, an Early Gothic portal now installed in the thirteenth-century north transept facade of the abbey church of Saint-Denis.

The Porte des Valois was heavily damaged during the French Revolution and was subjected to two complete restorations, the first by François Debret in 1822 and the sec-

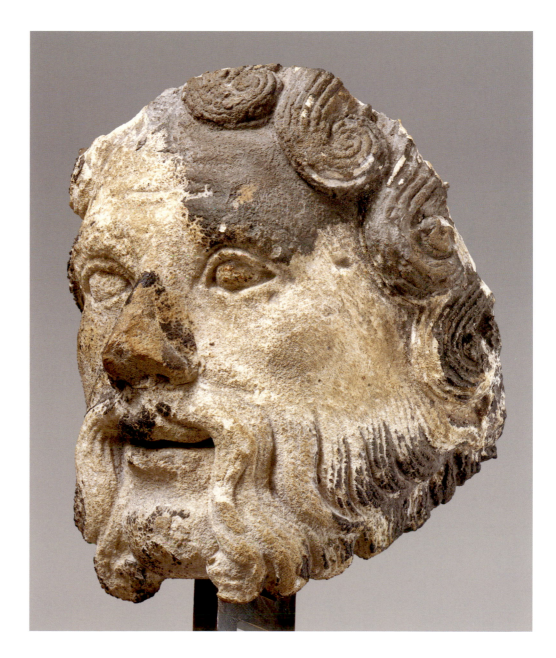

ond by Louis Villeminot in 1872, under the architect Eugène-Emmanuel Viollet-le-Duc (1814–1879). Pamela Z. Blum's recent study of the portal is the first that has been made since the portal was cleaned in the 1980s and early 1990s, when several pieces from the storage *"dépôt"* were reattached.[2] Blum's study, which involved a stone-by-stone archaeological analysis that differentiated the original sculptures on the portal from the restorations and repairs, vindicates Franklin Ludden's faith in the originality of the style—he was the first scholar to recognize and analyze its significance in the history of Early Gothic sculpture[3]—as it also thoroughly investigates the unusual and very specific iconography of the scenes.[4] Although indebted to Ludden's pioneering work, Blum's new research is nothing less than the recovery of an all-but-lost sculptural ensemble of major importance.

Three of the portal's original heads still in situ and another head now in the Musée du Louvre, Paris, are comparable in style to this male head.[5] All have the same gentle surface modulation, sensitive but expectant facial expression, large tight curls in the hair, and elegantly styled mustaches and beards; they also have broken noses with early-nineteenth-century restorations made of the same dark-colored material (still intact on the three in situ). Blum has noted stylistic similarities between the present piece and the one remaining original head on the Saint-Denis lintel—third from the left in the group of saints being hauled before the Roman prefect (fig. 32)—especially in terms of size, hair curls, eyes, and broad face. They also compare closely in terms of condition. The Metropolitan's head could belong to the torturer holding the scourge in the next group on the lintel, but unfortunately the entire head of that figure was replaced, so there is no surviving back half to which the Metropolitan's front half might be fitted.

A major problem with the identification of this head with the Porte des Valois is that neutron activation analysis (NAA) indicates that the Metropolitan's head is apparently not made of the same limestone found in the portal, although the stone does fall within the parameters of the Val-de-Grâce quarry group in Paris.[6] The limestone used at Saint-Denis is not uniform, however, as it is at Notre-Dame.[7] For Blum, despite her earlier comparisons of the head to the Porte des Valois figures, the NAA result is dispositive proof that such an identification is untenable. There may yet emerge an explanation for the contradiction of the art-historical evidence with the limestone analysis—which might be clarified by the examination of more limestone samples—but at present we are faced with a dilemma that may, ultimately, prove unresolvable.

WWC

NOTES

1. The head was acquired by the Metropolitan Museum in 1999 from Parisian dealers, who had purchased it from a Saint-Denis bookseller and who presented it as being from the abbey church.

2. Pamela Z. Blum, "The Porte-des-Valois at Saint-Denis: Restorations and Survivals," in Blum et al. 2006.

3. Ludden 1955, pp. 55–72, 305–19.

4. Blum's study precisely identifies the remaining original heads in the archivolts, lintel, and consoles on which the statue-columns stand.

5. The original heads in the portal include a saint from the lintel (see fig. 32); the keystone of Christ in the archivolts; and a reattached marmoset head. For the fourth head, which is from another marmoset and is now in the Louvre, see Baron 1996, p. 72. The restored nose on the Louvre head was removed.

6. Forty-nine samples from the Porte des Valois were tested. Of those, thirty were determined to be twelfth-century limestone and were treated as the reference group for the portal, but only two of those were taken from the lintel.

7. For example, the Metropolitan Museum's column figure of an Old Testament king (20.157), documented as being in the cloister at Saint-Denis, is carved of stone from the Paris basin whose compositional profile relates to Notre-Dame Cathedral. See Holmes et al. 1986, pp. 430–32.

EX COLLECTIONS

Private collection, Saint-Denis; [Charles Ratton and Guy Ladrière, Paris]; [Les Enluminures, Paris]

LITERATURE

Hindman 1998, pp. 22–23; Barnet 1999; Pamela Z. Blum, "The Porte-des-Valois at Saint-Denis: Restorations and Survivals," in Blum et al. 2006

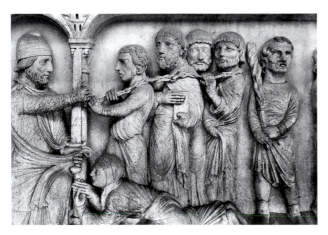

Fig. 32. Lintel of the "Porte des Valois" (detail), north transept, Abbey Church of Saint-Denis, ca. 1150–70

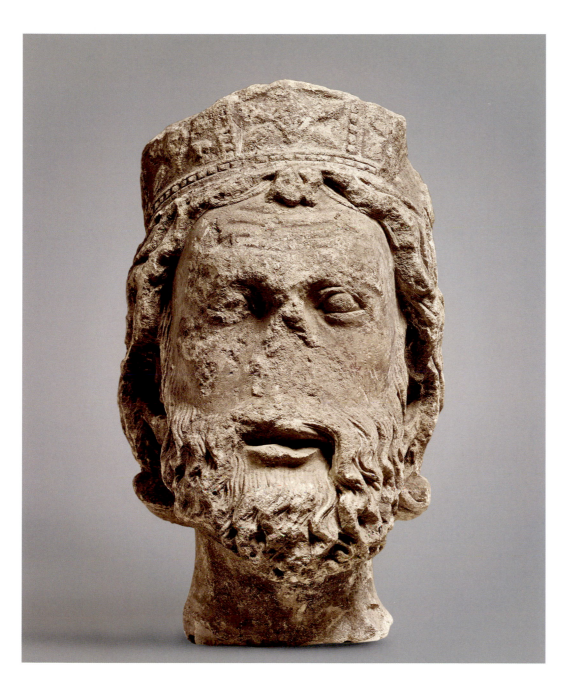

6. Head of a King of Judah

France, Paris, ca. 1220–30
Notre-Dame Cathedral, west facade
Limestone with traces of polychromy, H. 28 in. (71.1 cm)
Musée National du Moyen Âge, Thermes et Hôtel de Cluny,
Paris (Cl. 22988)

At the time of the French Revolution, and as far back as the thirteenth century, the kings in the gallery on the west facade of Notre-Dame Cathedral had been understood to be depictions of the kings of France, but they were actually the twenty-eight biblical kings of Judah, described in the book of Matthew as the ancestors of Christ (Matthew 1:1–17).[1] A 1699 drawing shows the colonnade of statues above the three portals; below them is a sculpture of the Virgin Mary with the Christ Child and angels.[2] Christ's royal lineage was thus established, through his mother, to the kings of the Old Testament. This head belonged to a statue of one of those biblical monarchs.

The misidentification of the Notre-Dame sculptures contributed to their destruction during the iconoclastic fury of the Revolution. Days after the uprising of the Paris Commune in August 1792, despite the Legislative Assembly's declaration that "all monuments containing traces

Fig. 33. Notre-Dame Cathedral, Paris, 1699. Gouache. Cabinet des Estampes, Bibliothèque Nationale, Paris (Va. 419)

brightly painted. The hair sweeps back from a central forelock in thick waves to cover the ears, and the beard is carved in similar S-shaped locks. The style is different from that of the other kings, suggesting it is the work of another artist, and there is also a cowlick. Hair became more fully developed later in the thirteenth century, situating this head as a link between some of the more conservatively carved examples, such as the head of an apostle from one of the cathedral's portals (cat. no. 14), and later Gothic sculpture.

JGS

NOTES

1. The statues now in situ are replacements carved under the direction of Eugène-Emmanuel Viollet-le-Duc in the nineteenth century. The thirteenth-century text *Manières de vilains* refers to the kings as Pepin and Charlemagne; quoted in Fleury 1977, p. 24.

2. Drawing by V. Antier, 1699, Bibliothèque Nationale, Paris, Cabinet des Estampes.

3. *Archives parlementaires* XLVII, 110.

4. *Le Moniteur Universel* 34 (October 25, 1793), reproduced in Gallois 1847, vol. 17, p. 25. For an account of the state of the statues in 1796, see Mercier 1994, pp. 835–36.

5. Aubert 1932–33, p. 290.

EX COLLECTION

Banque Française du Commerce, Paris

LITERATURE

Idzerda 1954; Giscard d'Estaing et al. 1977a, 1977b; Erlande-Brandenburg and Kimpel 1978; New York–Cleveland 1979–80; Florence 1980; Erlande-Brandenburg 1982a; Emmet Kennedy, "Vandalism and Conservation," in Kennedy 1989; Erlande-Brandenburg 1998; Caviness 2003

of feudalism" had to be destroyed, the cathedral sculpture was, for the most part, left alone (fig. 33).[3] One year later, however, the destruction was extended to include the cathedral, and all royal insignia were chipped off the sculptures. In October the general council of the Commune decreed that the statues had to be "toppled and destroyed," and accordingly they were removed and piled on the north side of the cathedral, where they sat for three years covered in filth.[4]

Like the head of Louis XVI, which had been severed by the guillotine the previous January, the heads of the Notre-Dame kings were cut from their bodies (it is not known whether this occurred before or after their removal from the gallery). Pierre-François Palloy, the demolitionist of the Bastille, sent three of the Notre-Dame heads to nearby districts as trophies,[5] but many of the remaining heads were eventually sold as building material. In April 1977, during excavations at 20 rue de la Chaussée-d'Antin, a pit was unearthed containing sculpture from the cathedral, including twenty-one heads of kings found buried together facedown and cushioned with plaster. This head was among those finds (see also cat. no. 7). Although no surviving documentation explains who buried the sculptures, or why, it is believed that Jean-Baptiste Lakanal bought some of the vandalized stonework for the construction of his home (now known as the Hôtel Moreau) and then buried the heads after separating them from the rubble.

This head is missing its nose and the fleurs-de-lis that once adorned the crown, but it retains most of its neck. Traces of polychromy remind us that the sculpture was once

7. Head of a Bearded Man

France, Paris, ca. 1240
Notre-Dame Cathedral, north transept portal
Limestone, H. 10¼ in. (26 cm)
Musée National du Moyen Âge, Thermes et Hôtel de Cluny, Paris (Cl. 23606)

This head was discovered in Paris toward the end of 1979, two years after the primary excavation in front of the Hôtel Moreau had recovered 364 sculptural fragments from the cathedral of Notre-Dame (see cat. no. 6). The figure has a high domed forehead above almond-shaped eyes that are framed by crow's-feet. The hair falls in spiral waves over the ears to the base of the neck, and the mustache and beard, which have similar S-shaped locks, part to reveal lips upturned in a slight smile. Based on the head's style and size, it is believed to come from the north transept portal,[1] but it is unclear what or whom the figure represented because there are no defining attributes or insignia.

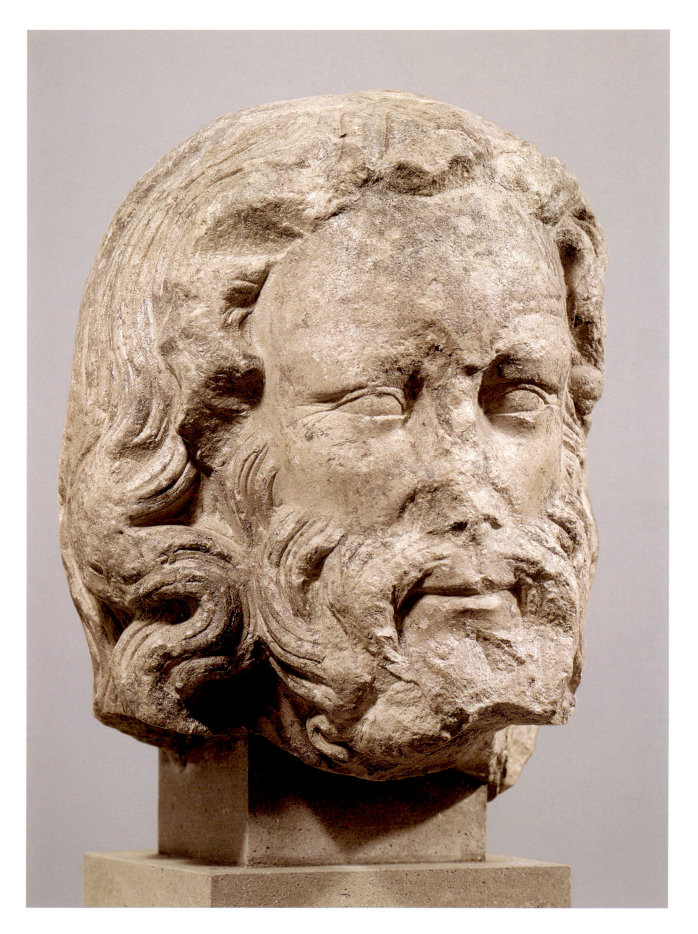

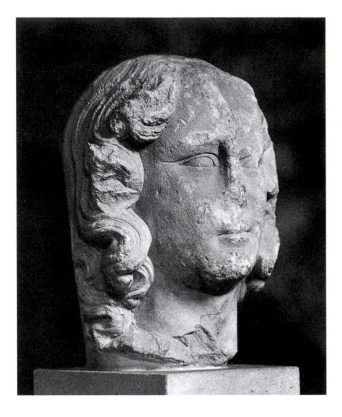

Fig. 34. Female Head (Theological Virtue?), north transept portal, Notre-Dame Cathedral, Paris, ca. 1240. Musée National du Moyen Âge, Thermes et Hôtel de Cluny, Paris

(fig. 34). That female head and the present head of a bearded man exhibit similar sculptural characteristics, such as S-shaped locks and almond-shaped eyes. Although the male head is smaller than the female, it is about the same size proportionally as the Virgin on the trumeau. Scholars have also placed these sculptures in the broader context of other works by the cathedral workshop, which made changes to the west facade in the 1240s and constructed the south transept in the 1260s. Alain Erlande-Brandenburg has linked the style of the bearded man to the contemporary head of Christ from the Last Judgment in the tympanum over the west facade's center portal.[4] Dieter Kimpel has attributed the female head to an artisan he calls the Master of the Childhood Scenes, whom he believes was responsible for the "schoolboy scenes" on the south portal as well as a female head in the Brummer collection at Duke University (cat. no. 15; see also cat. no. 16).[5] It is possible that this same artisan also carved the bearded figure, but the head's original placement and exact meaning are still unknown.

JGS

NOTES

1. For the most complete discussion of this sculpture, see Erlande-Brandenburg 1982b.

2. Sauerländer 1972, p. 472.

3. See ibid. and Dieter Kimpel, "A Parisian Virtue," in Bruzelius and Meredith 1991, p. 127.

4. Erlande-Brandenburg 1982b.

5. Kimpel, in Bruzelius and Meredith 1991, p. 134.

EX COLLECTION

Banque Française du Commerce, Paris

LITERATURE

Sauerländer 1972; Erlande-Brandenburg and Kimpel 1978; Gnudi 1981; Erlande-Brandenburg 1982a, 1982b; Dieter Kimpel, "A Parisian Virtue," in Bruzelius and Meredith 1991, pp. 124–39; Erlande-Brandenburg 1998; Paris 2006, pp. 34–35 (entry by Sophie Lagabrielle)

The north portal of Notre-Dame was dedicated to the Virgin, and although in its current state it is devoid of any jamb decoration, the original trumeau sculpture of the Virgin and Child remains intact. Six shallow niches directly below the archivolts and six more niches topped by baldachins flank the portal. In his mid-eighteenth-century history of Paris, Abbé Lebeuf identified the six statues in these outer niches as the Three Magi, to the east, and as personifications of the three theological Virtues (Faith, Hope, and Charity), to the west. The combination of Marian iconography with the Virtues is found in the tympana and archivolts of the left doorway at Laon Cathedral and in the north portal at Chartres, but the combination of Mary and the Virtues with the Magi is unusual.[2] The north portal of Notre-Dame is also notable as the first example of the use of large-scale figures of the theological Virtues as well as niches (rather than consoles or shafts) for sculpted figures.[3]

Some of the fragments discovered in 1977 have been identified as belonging to the north portal group, including a female head that might have represented one of the Virtues

8. Head of an Apostle

France, Artois, Thérouanne (Pas-de-Calais), ca. 1230
Thérouanne Cathedral
Oolitic limestone, H. 18¾ in. (47.5 cm)
The Cleveland Museum of Art; Leonard C. Hanna, Jr. Fund
(1978.56.2)

9. Head of an Apostle

France, Artois, Thérouanne (Pas-de-Calais), ca. 1230
Thérouanne Cathedral
Oolitic limestone, H. 17½ in. (44.5 cm)
Private collection

In 1923 these two heads (along with three others) were dis-covered in the wall of a house in Saint-Omer (Pas-de-Calais) and were attributed to the destroyed cathedral of Thérouanne.[1] Analysis of the stone has shown that all of the heads were carved from the same white limestone with inclusions. Except for losses to the nose and lips and some ero-sion of the contours of the beard, they are in good condition and exhibit weathering consistent with an exterior location.

Unlike the more famous heads of kings from the cathe-dral of Notre-Dame in Paris, which were trophies of Revo-lutionary antiroyalism, these sculptures were wrenched from their original context during the sixteenth century, vic-tims of the struggles among the great powers of Europe for political and religious dominance in the region. The suffer-ings and eventual annihilation of medieval Thérouanne were in many ways the result of its unfortunate geographic situation as a French enclave within Belgian Flanders.[2] From 1191 the region had been part of the royal domain, and in the mid-thirteenth century Louis IX (r. 1226–70) installed his brother Robert as the first comte d'Artois. The dislocation of the Burgundian state, which followed the marriage of Mary of Burgundy to Maximilian of Austria in 1477, ushered in almost a century of wars in northern France, and Thérouanne, a major center of French Artois, was a verita-ble thorn in the side of Habsburg ambitions for its northern empire. The town was besieged during the Hundred Years War (1337–1453), partially destroyed in 1513, and was once again under siege in 1537 by the troops of Holy Roman Emperor Charles V (r. as emperor 1519–56). The final assault began in the spring of 1553; by the end of June, the city offered its unconditional surrender. The citizens of nearby Artois and Flanders, loyal to the emperor and glad to see the French outpost defeated, joined the demolition squad and helped level the city, block by block. The Treaty of Cateau-Cambrésis (1559) between Philip II of Spain (Charles's son) and Henri II stipulated that the city would never be rebuilt.

Medieval Thérouanne is known to us today only through documents, a few images, and three major archaeological campaigns.[3] The town occupied an elevated site and was fortified by thick walls, its prosperity based on its position within a network of roads connecting major centers to the south and east. Part of the archdiocese of Reims, Thérouanne was also an important religious center, maintaining through-out the medieval period close relations with the archbishops of Reims and with the Capetian monarchy.[4] The Gothic cathedral—which, according to the "Grand Cartulaire de l'Abbaye de Saint-Bertin," was considered among the most beautiful of the Pays-Bas—was under construction between 1136 and 1157, by which time the choir, at least in its lower stories, was probably complete.[5] At some point the main altar was moved to the north side of the cathedral, presum-ably to prepare for the westward expansion of the building.

In the course of excavations conducted during the 1980s, Honoré Bernard noted that sections of foundation located beneath the south transept terminal wall were consistent with building techniques current in the region about the mid-thirteenth century. Debris found earlier at the site had already suggested to Camille Enlart and Pierre Héliot that construction at the cathedral was continuous during the first decades of the thirteenth century.[6] Furthermore, the late-thirteenth-century epitaph of Henricus de Moris, bishop of the cathedral from 1276 to 1286, mentions the erection of a "grand portal."[7] That portal is identified in a town plan dated 1560 as the south transept entrance,[8] whose appearance can be assessed in a panoramic view of the town and cathedral that dates from 1539 (fig. 35).[9] In it we see a monumental entrance opening onto the main square; there is a double doorway with trumeau, which is surmounted by a gable and preceded by a deep tunnel-vaulted porch. Above the gable, one can make out the figures of Christ between the kneeling Mary and John the Baptist. Documents concerning the destruction of the town inform us that Charles V gave the Deësis group, known as the Grand Dieu de Thérouanne, to the canons of Saint-Omer for reinstallation in their own building, still incomplete at the time. The sculptures turned out to be too large for the tympanum, however, and today are visible in the transept of the cathedral of Saint-Omer.

Bernard uncovered the foundations for the south transept doorway and for the porch, including a portion of the steps that led up to it. Yet the accuracy of the 1539 drawing has been challenged by Paul Williamson, who, noting the small degree of weathering on the Saint-Omer Deësis, insists that the figures could never have been mounted in such an exposed position.[10] Also, in agreement with most scholars, Williamson dates the figures to the 1230s, much too early to have been part of Bishop Henricus's donation. He envisions that the Deësis group, along with the five heads discovered in 1923, formed part of the Last Judgment portal originally installed under a porch on the west facade of the cathedral, a configuration that reflected the facade at Amiens.

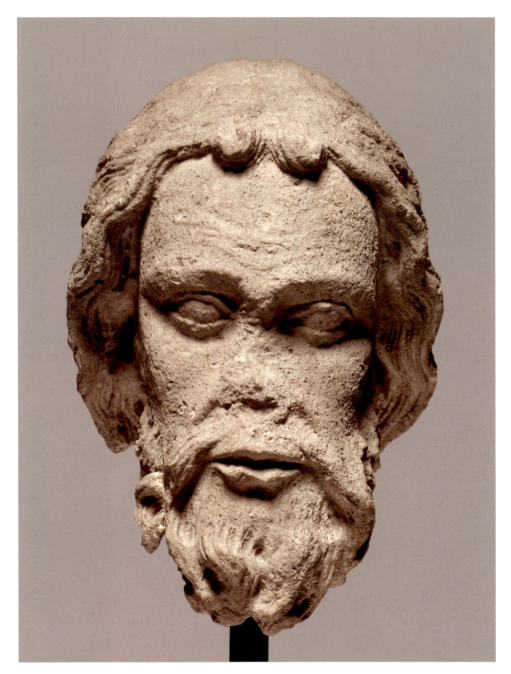

8

The situation is even more complicated because Bernard's excavations necessarily terminated at the eastern section of the transept; west of that point, the ruins of the cathedral lie under the rue Saint-Jean. Thus we know the nave only from the plan already mentioned; from a painting now in Hampton Court, which shows the cathedral from the north; and from a drawing made after the painting, which illustrates the siege of 1537.[11] In the drawing it appears that the west facade was hedged in by the episcopal complex, and comparison with these sources indicates the degree to which the panoramic view of 1539 misinterpreted the style of the choir. Nevertheless, the drawing's account of the south por-

tal, evidently of particular interest to the artist, appears to be quite precise.

How can all this conflicting evidence be reconciled? One might speculate that Henricus's contribution to this doorway comprised the completion of an existing south transept portal and the installation of sculpture that had been executed for a planned but never completed west facade program. As seen in the drawing, the architecture of the upper transept certainly cannot be contemporary with the sculpture, but it fits comfortably into a 1270s context. Moreover, the Deësis, which would have been too large for the modest lower doorway, is mounted in an unusual position over the gable instead

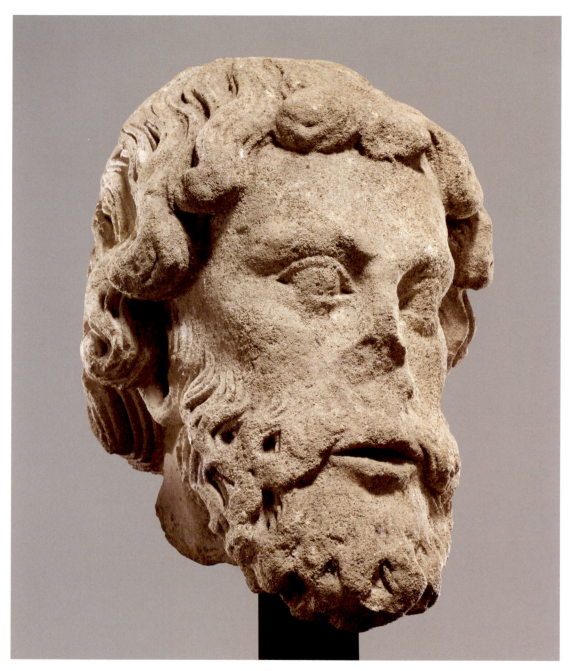

9

of on the tympanum. The integration of such an impressive sculpture would certainly have contributed to the prestige of this entrance, earning it the title of "grand portal" and making it, in effect, the primary entrance to the church.

As for the heads from the portal, contemporary accounts record that citizens fleeing Thérouanne in 1553 took with them pieces of wood and stone, possibly from various sites, which they apparently preserved as relics of the martyred town.[12] The heads, then, may not have been among the sculpture ceded to the canons of Saint-Omer and, although their general style and material seem to link them to the Saint-Omer Deësis, and thus to Thérouanne Cathedral, they may have come from a separate ensemble altogether.[13] In addition to the inconsistencies in patterns of weathering already mentioned, measurements suggest that the heads belonged to significantly smaller and differently proportioned figures than those of the Deësis.[14] Compared with the rigidity and the rather dry modeling of the Saint-Omer Christ, the heads are also more expressive. Their shadowed eyes are sunk more deeply into the skull, and their lips are more subtly shaped. And while it is impossible to compare drapery styles, the hair on the heads, particularly on catalogue number 8, is more organic than the rather inert tresses of the Deësis Christ.

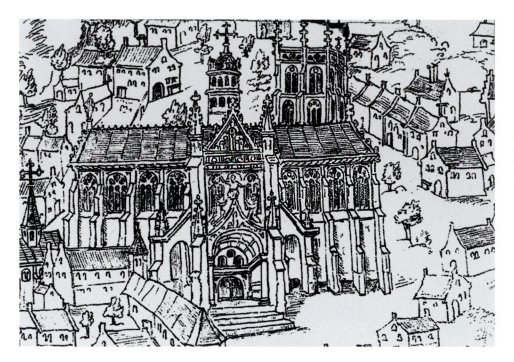

More so than the other Thérouanne heads, catalogue number 8 seems to recall the kings' heads from the upper gallery of Notre-Dame (1220–30), particularly in the definition of the eyes and the pursed lips.[15] The somewhat less-refined catalogue number 9 can be compared with heads now in the Musée Départemental de l'Oise that have been attributed to the facade program at Saint-Étienne at Beauvais (ca. 1220).[16] These comparisons suggest that the Thérouanne heads should be dated no later than 1230.

DG

NOTES

1. Lanselle 1923. Eventually acquired by the dealer René Gimpel, they were on loan to the Victoria and Albert Museum, London, from 1973 to 1978; see Williamson 1982. The Victoria and Albert acquired one in 1979 (A.25–1979), and in 1978 the four others were offered on the New York art market. One (cat. no. 9) was purchased for a private collection, and two were acquired by the Cleveland Museum of Art (cat. no. 8 and Cleveland 1978.56.1); see Wixom 1979, pp. 96–100. The fifth went to the Museum of Fine Arts, Houston (80.148); see Davezac 1983.

2. For the history of Thérouanne's long martyrdom, see Coolen 1969, Bernard 1975, and Vissière 2000.

3. For the excavations of 1898–1906 conducted by Camille Enlart, see Enlart 1920, pp. 15–29, esp. p. 25; Bernard 1983. At present the site is directed by the École Nationale des Chartes; see its website, *http://perso.wanadoo.fr/therouannearcheo/fouillesarcheo.htm*, and Lesage 2000, p. 126.

4. Tock 2000.

5. These remarks were made at the time of the destruction of the cathedral. Benjamin Guérard, ed. *Cartulaire de l'abbaye de Saint-Bertin* (Paris, 1840), as cited in Coolen 1969, p. 194.

6. Enlart and Héliot 1950.

7. Bled 1904.

8. The plan is in the archives of Pas-de-Calais and is reproduced in Coolen 1962.

9. The drawing is a facsimile of a manuscript destroyed in 1915 (Archives Départementales du Pas-de-Calais, 6 Fi B 88).

10. Williamson 1982.

11. Baker 1929, no. 339, pl. 31. The drawing (Rijksmuseum, Amsterdam) is by Cornelius Anthonisz. (ca. 1505–after 1553); see Bernard 1975, p. 43.

12. The situation was remarked upon by Venetian ambassadors in northern France; see Tommaseo 1838, vol. 2, p. 133.

13. Gil and Nys 2004, pp. 32–37.

14. The standing figures would have been about 2.5 m tall, the kneeling one about 3.5 m tall.

15. See, for example, Giscard d'Estaing et al. 1977a, p. 43, no. 14.

16. See Henwood-Reverdot 1982, pp. 165–67.

EX COLLECTIONS

[Audomarois, France]; [René Gimpel, London]; [Gimpel Fils, London]; [Artemis, London and New York, 1978]

LITERATURE

Lanselle 1923; Gimpel 1966, p. 355; Coolen 1969; Sauerländer 1972, p. 522; Wixom 1979, pp. 96–110; Williamson 1982; Gillerman 2001, pp. 292–4; Marc Gil, "Dans le sillage des grands chantiers de cathédrales," in Gil and Nys 2004, pp. 31–46

10. Head of a King

France, Paris, ca. 1230–35
Limestone, H. 13½ in. (34.3 cm)
The Metropolitan Museum of Art, New York; Fletcher
Fund, 1947 (47.100.55)

This head of a king is the finest example outside France of the widely influential style indelibly associated with the reign of Louis IX, or Saint Louis (r. 1226–70). Created in Paris about 1230–35, the style is related to the Rayonnant phase in architecture, which spread the Gothic across all of western Europe during the course of the thirteenth century.

The head has been damaged—the nose, part of the beard, and the fleurons of the crown have been lost, and there are slash marks across the forehead and left cheek—and erosion from prolonged exposure to the elements has darkened and pitted the surface. (The neck fracture has the same surface character, indicating considerable exposure after the head was separated from the body.) The elongated face has high cheekbones and small, delicately carved, almond-shaped eyes, and there is a graceful continuous curve from the nose area through the arched eyebrows emphasized by carving that creates areas of shadow. The hair, with its short bob that extends to mouth level, follows Parisian fashion of the 1230s and 1240s, particularly in its symmetrical rolling waves and curls. Especially telling of the style are

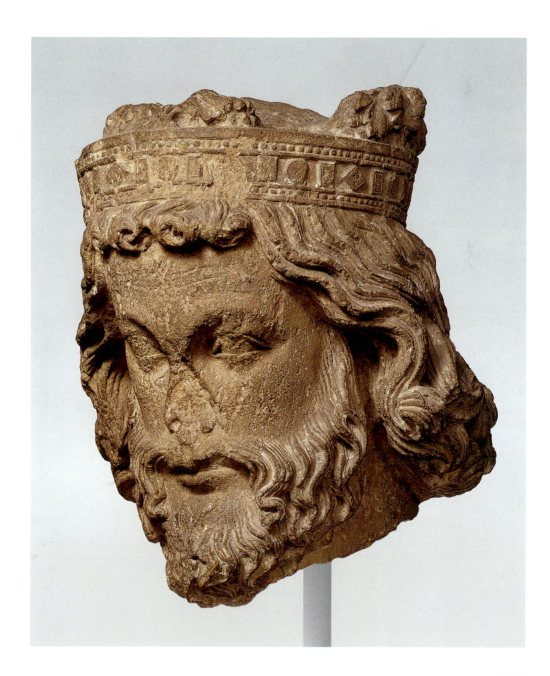

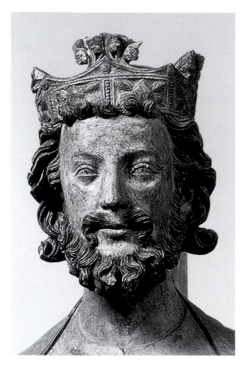

Fig. 36. King Childebert I, trumeau of refectory door, Abbey of Saint-Germain-des-Prés, Paris, 1239–44. Musée du Louvre, Paris (M.L. 93)

Sainte-Chapelle in Paris, which are considered quintessential examples of Parisian style in the mid-thirteenth century.

Given the head's roughly carved back and the indications that it was once attached to a column, there are two possibilities for its original use. The most obvious is that the head belonged to a statue-column from a major Parisian church portal. The problem is, even with our detailed knowledge of Parisian monuments, there is no known mid-thirteenth-century portal to which this figure can be assigned based on either style or iconography. The other logical consideration is that this king, like the figure of Childebert, founder of the abbey of Saint-Germain-des-Prés, functioned as a doorpost or trumeau figure. One could reasonably envision that the New York king, again like Childebert, was also a royal founder.[4] If that is the case, the New York king could represent Clovis, and the statue's original location might have been a portal somewhere in the abbey complex of Sainte-Geneviève, whose refectory had been completed about 1200–1210, some twenty-five years before the head was carved.[5] Recent repairs to the walls of the refectory, remodeled several times to become the chapel of the Lycée Henri IV, have revealed more of the late-twelfth- and early-thirteenth-century capitals and keystones of the vaults, but nothing from the 1230s. Thus, as attractive as this hypothesis may be, it remains no more than a suggestion until additional evidence, if it exists, comes to light. Perhaps neutron activation analysis of some of the nearly contemporary pieces from the abbey might help establish a more precise context for the Metropolitan's head of a king.

WWC

the big flaring waves pulled back from the sides of the face, a device that allowed the sculptor to avoid carving the ears, and the tight corkscrew curls across the forehead. Even the beard and mustache have elegantly carved, symmetrical curls, which fall in individual locks framing the mouth. The fullness of the hair and beard allows the rich, varied carving to enhance the play of light and shadow across the dramatically modulated surface. The equally full lips suggest both a slight parting and the hint of a smile.

The head can be traced back to an architect named Wagner of Orléans, who supposedly acquired it in the first half of the nineteenth century from a postrevolutionary *"dépôt"* of sculpture either at Notre-Dame in Paris or at Saint-Denis (in another version of the story, the depot was in Orléans).[1] Neutron activation analysis (NAA) has ruled out an origin in Orléans, however, since the limestone is Parisian,[2] and there was no such cache of destroyed sculpture at Notre-Dame, whose fragments were quickly dispersed. The depot at Saint-Denis remains a possibility, since it served as the repository for sculptures after the closure of Alexandre Lenoir's Musée des Antiquités et Monuments Français, which had contained works of art from the churches of Paris he had managed to save from Revolutionary vandalism.

The style of this head corresponds most closely to that of the doorpost or trumeau figure of Childebert from the entrance to the destroyed refectory of the abbey of Saint-Germain-des-Prés in Paris, dated 1239–44 (fig. 36).[3] Roughly the same size, the two heads are also stylistically similar, although the Childebert sculpture, because it is slightly later in date, is closer to the apostles ornamenting the interior of

NOTES

1. Files of the Department of Medieval Art and The Cloisters.

2. Little 1994, pp. 30–31, fig. 2.

3. That association was recognized by Willibald Sauerländer and was argued most persuasively by William D. Wixom; see Sauerländer 1971, p. 509; Wixom 2005, p. 24.

4. Baron 1996, p. 83; Lombard-Jourdan 1997.

5. It should be noted that the well-known trumeau figure of Saint Geneviève, universally dated to the 1220s and now in the Musée du Louvre, Paris, is believed to have originated in the abbey complex, but its original location is still debated; see Crépin-Leblond 1996, p. 36; Echalier 2005, pp. 41–43. Whatever its original location, it is highly unlikely to have been the refectory portal, given the Parisian preference to depict royal founders, not patron saints, in that location. See Baron 1996, p. 79.

EX COLLECTIONS

Wagner, Orléans; Henri Petit, Paris; Malfay, Paris; [Raphael Stora, New York]; [Durlacher, London and New York]; Arthur Sachs, New York; [Joseph Brummer, Paris and New York]

LITERATURE

New York 1970, vol. 1, p. 18, no. 22; Sauerländer 1971, p. 509; Schmidt 1972, p. 135 (ill.); Little 1994, p. 31; Baron 1996, p. 83; Echalier 2005; Wixom 2005, p. 24

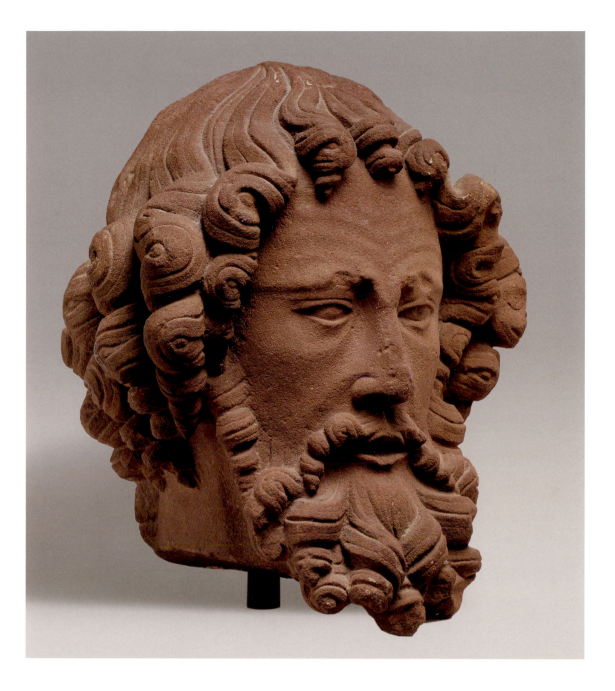

11. Head of an Apostle

Upper Rhineland, probably Strasbourg, ca. 1280–1300
Sandstone, H. 11 ¹³/₁₆ in. (30 cm)
The Metropolitan Museum of Art, New York; The Cloisters
Collection, 2004 (2004.453)

This imposing lifesize head is carved in the distinctive red sandstone of the Upper Rhineland. With its long, deeply carved ringlets framing the face, thick curling mustache, and prominent beard, it most likely represents an apostle, although the possibility that it depicts another saint, or a figure from the Old Testament, cannot be ruled out. Undoubtedly the head originally surmounted a statue-column, which probably featured an attribute that would have allowed for a precise identification. An uncarved vertical section protrudes from the back, and the underside of the neck has a relatively smooth surface. Other than an aggressive cleaning at an unknown date and a few small losses, the sculpture is in good condition, suggesting that it was located either inside or in a sheltered exterior position.

Strasbourg, the most important artistic center in the Upper Rhineland, was already producing Gothic sculpture of high quality by about 1225–30, when the south transept portals of the cathedral and the famous Angels' Pillar inside

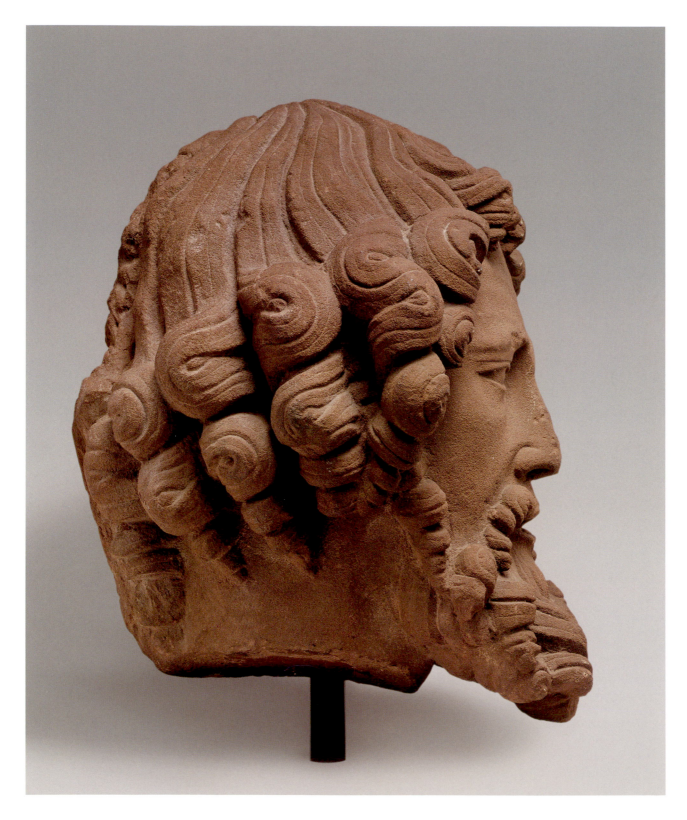

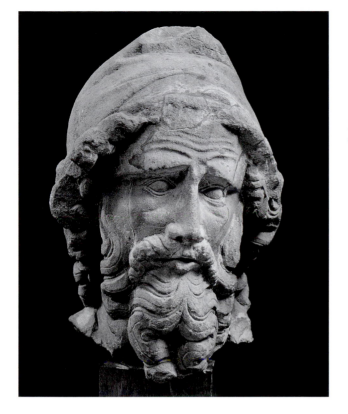

Fig. 37. *Head of a Prophet, west facade, Strasbourg Cathedral (Bas-Rhin), ca. 1300. Museum of Fine Arts, Boston; William E. Nickerson Fund (56.506)*

the south transept were carved.[1] While these early-thirteenth-century carvings were heavily influenced by the sculpture of the Chartres transepts, the Strasbourg choir screen, which dates from the middle of the thirteenth century, was influenced by Parisian work.[2] By the end of the thirteenth century, Strasbourg thus had a long-standing local tradition but was also proving receptive to new influences from the Île-de-France. The iconographic program of Strasbourg's west facade was, in fact, derived in large part from the transepts of Notre-Dame in Paris, but the style also combined local traits with characteristics of Parisian carving as well as that of Reims Cathedral.

Noted for its mixture of French and German artistic elements, Strasbourg suffered greatly during the religious wars of the sixteenth century as well as during and after the French Revolution.[3] It is possible that this head was originally part of the sculptural program of the cathedral or of another local site dating from the end of the thirteenth century that has since been destroyed. In the treatment of the hair, the furrowed brow defined by nesting chevrons, and the parted lips revealing the upper front teeth, the Metropolitan's head is remarkably similar to the late-thirteenth-century sculptures from the center portal of the cathedral's west facade. In particular, the head compares closely to the bearded prophet statues on the jambs, dated to the last two decades of the thirteenth century, some of which also have parted lips and carefully carved teeth.[4] It also compares

closely with a head now in the Museum of Fine Arts, Boston (fig. 37),[5] which, although made of a gray sandstone, has the same brow, hair, and beard treatment found on the cathedral sculpture and on the Metropolitan's head. Like the Strasbourg Virgin in the Metropolitan's collection (47.101.11), these two heads are important examples of thirteenth-century Strasbourg sculpture that, after being removed from their original contexts, found their way into museum collections.

PB

NOTES

1. On the Gothic sculpture of Strasbourg, see O. Schmitt 1924, Beyer 1955, and Reinhardt 1972. For more recent studies of the statue-columns of the west facade, see Gramaccini 1994 and Bossche 2005.

2. See Sauerländer 1966.

3. See Bern–Strasbourg 2000–2001; Bossche 2002.

4. See O. Schmitt 1924, vol. 2, pl. 110.

5. For the Boston head, see Gillerman 1989, pp. 19–21. It has been badly damaged and is heavily restored.

LITERATURE

Barnet 2005

12. Head of an Apostle

Southwest France, second quarter of the 14th century
Calcite limestone with traces of polychromy,
H. 14¼ in. (36.2 cm)
The Cleveland Museum of Art; Purchase from the
J. H. Wade Fund (1960.170)

The mature facial type, heavy hair, and full curling beard as well as the absence of any head covering suggest that this powerful head, presumably from a lifesize figure, represents an apostle. Although it is in no sense a portrait, or even necessarily based on a specific model, individualization is achieved through the concentrated gaze and the detailed treatment of wrinkles, which crease the brow, radiate from the corners of the eyes, and descend from the nose to the edges of the mouth. In this respect, the head strikes a balance between the idealized or typical representations characteristic of the High Gothic period and the more overt,

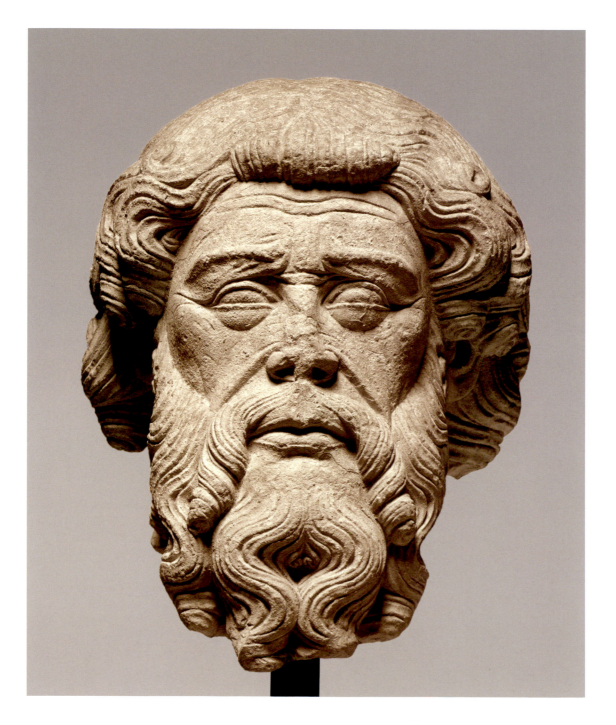

convincing naturalism that emerged in figures executed by André Beauneveu (ca. 1335–ca. 1401) and Claus Sluter (ca. 1360–before 1406) toward the end of the fourteenth century.

The nose and upper lip have been damaged, and there are small losses to the beard. The head has also undergone some modern interventions, including recarving, probably in order to make it more marketable.[1] Red and gray pigments seem to have been applied over the fresh surfaces in order to disguise the modern recarving. A deep vertical groove runs up the back of the head, and there is a dowel hole in the neck containing fragments of copper or bronze.

Similarities have been noted between this head and the suite of figures commissioned in 1333–34 by Jean Tissendier, the Franciscan bishop of Rieux, for his sepulchral chapel in the church of the Cordeliers in Toulouse.[2] The career of the Master of Rieux remains somewhat mysterious. Certain elements of his style have been detected in sculpture from the choir of Saint-Nazaire at Carcassonne (1322), and there are hints that he may have been active in Bordeaux during the 1320s, when sculpture was executed for the south portal, but neither of these ensembles prepares us for the highly individualized statues of Rieux.[3] Sculpture attributable to the Rieux workshop has also been identified at later sites in Toulouse, some of which clearly demonstrate how the master's style became diluted in the output of his collaborators. Outside Toulouse, the influence of the Rieux workshop is evident in works that eventually devolve into a regional style that was current in Languedoc from about 1320 to 1350.[4]

Although the Cleveland head fits firmly into the larger Toulousian context, an attribution to the Rieux ensemble can no longer be supported. The head lacks the attenuated feeling of the Rieux apostles; the face is more robust, the coiffure less exaggerated, and the expression more forthright. In addition, the carving is more cursory; the eyes are not as subtly shaped, and the hair and beard are defined by grooved lines, whereas at the chapel in Rieux the tresses are more three-dimensional. Closer comparisons can be made to a series of keystones carved for the choir of Saint-Étienne Cathedral, the most important sculptural remains of what must originally have been a rich interior program executed probably between 1319 and 1350. But the cathedral was not the only site in the region undergoing construction in the first half of the fourteenth century. Workshops were also busy at the church of the Cordeliers and at the Dominican church of the Jacobins, and there was also building at the Carmelite church and Saint-Sernin.[5]

Artistic activity virtually ceased in Toulouse during the Hundred Years War (1337–1453), and in 1463 a disastrous fire engulfed the city center.[6] Although Renaissance Toulouse witnessed a renewal of the urban fabric and increased building activity, the city suffered prolonged and bloody agony during the Wars of Religion. As a stronghold of Catholicism in a predominantly Protestant region, Toulouse was repeatedly attacked and its churches looted. Repressive measures taken by Catholics eventually ended the Huguenot presence in the city, but Toulouse's conservative religious atmosphere later made it a focus of Revolutionary rage. The dechristianization campaigns of the 1790s particularly targeted the various religious orders, whose convents were sold and possessions dispersed.

Little remains of the numerous sculptural programs that appear to have been ongoing during the first half of the fourteenth century in Toulouse. The quality of the architectural sculpture, however, found today principally on keystones, suggests that large-scale works were also created for exterior and interior settings. It is likely, therefore, that this impressive head came from one of these programs, which perhaps included a group of standing apostles or saints similar to those that decorated the choir of Saint-Nazaire at Carcassonne or the ensemble created for the chapel of Rieux.

DG

NOTES

1. The surface of the sculpture, which is made of a warm gray stone, is uniformly pitted and weathered. An incrustation of lichen present before the head was cleaned suggests that it lay for some time outside, but otherwise the very limited degree of weathering and the microscopic traces of paint point to an original interior installation. A fragment of the stone was tested and proved to be a fossiliferous, fine-grained limestone containing unusual components, including quartz, feldspar, hornblende, and clay.

2. Cleveland 1966–67, no. V-11; Mundt 1967; Gillerman 2001, pp. 301–3.

3. Pradalier-Schlumberger 1998, pp. 183–86.

4. Prin 1976; Paris 1981–82, esp. nos. 53–56, 58, 59, 73.

5. Pradalier-Schlumberger 2002.

6. For the history of Toulouse, see the articles by Marcel Durliat, Philippe Wolff, Bartolomé Bennassar, and Jacques Godechot in Wolff 1988; and Wolff 1983, chs. V and VIII.

EX COLLECTION

Mrs. Paul Mallon, Paris

LITERATURE

Cleveland 1966–67, no. V-11

The Limestone Project: A Scientific Detective Story

Georgia Wright and Lore L. Holmes

A RELATIVELY new scientific procedure called neutron activation analysis (NAA) is helping to determine the original sites of medieval limestone sculpture—frequently heads but also other fragments—dispersed among museums and other public and private collections.[1] These fragments are by and large French, and thus the example of Notre-Dame in Paris, from which many such fragments have been found, is illustrative both in terms of the possible applications of NAA as well as for the history of the vandalizing of the cathedral.

On January 17, 1793, during the vote on the fate of Louis XVI, a citizen approached Parisian Commune officials to report that there were *kings* represented on the portals of the cathedral.[2] Most of the statues in public squares that could be identified as specific rulers had already been destroyed, many on August 10, 1792, when Louis XVI was deposed and imprisoned. This new "discovery" was referred to the Commission des Arts, which ordered them removed, and over an extended period Paris and other cities and towns hired contractors to behead statues not only of kings and queens but also, during the dechristianization campaigns of late 1793 and 1794, of religious figures as well, including apostles, saints, Old Testament monarchs, and angels.

The "cleansing" of religious imagery at Notre-Dame necessitated two campaigns. First the fleurons on crowns and scepters were knocked off, and later the figures were cut up and thrown down from all of the portals and from the gallery of kings high above the west facade, until the cathedral doors were obscured behind piles of stone. In a speech before the National Convention, the painter Jacques-Louis David (1748–1825) proposed that the fragments be piled together as the base for an enormous monument to the French people to be erected on the Pont-Neuf.[3] Horses and carts were in short supply, however—many had been requisitioned by the military for the war with Austria and Prussia—and so much of the removed stonework was sold by the cubic yard as building material. Some fragments nevertheless found their way into the hands of Catholics who, considering them part of a consecrated building, rescued the pieces and gave them Christian burial. Many heads from the facade of Notre-Dame were found during excavations in the courtyard of the Hôtel Moreau in Paris in 1977. Similarly, figures of apostles from Saint-Jacques-aux-Pélerins in Paris and from Saint-Pierre in Jumièges were discovered laid out with care when they were unearthed about a century after the Revolution. Some were reburied at that time, but many were dispersed and continue to reappear today. Still other frag-

ments from destroyed monuments, having found their way into the hands of the faithful and antiquarians, turned up as orphans: sculptures in private collections and museums whose identities have been lost.

How do we know, then, if a fragment comes from a specific church, especially when little sculpture of comparable style remains in situ? NAA has proved extremely helpful in this regard, particularly when a hypothesis has already been put forward as to a fragment's original site.

The Procedure

The calcite matrix of limestone contains trace chemical elements—residue from clay, soil, and fossilized plants and animals—that vary in concentration from quarry to quarry. Ultimately these different concentrations of elements, which are present in extremely small quantities (parts per million or billion), can help identify a specific quarry source much like a fingerprint does a person. The fingerprint of limestone is referred to as a compositional profile.

To create a compositional profile, a one-gram sample is drilled out of a sculpture fragment, monument, or quarry source and sent to a laboratory, where the limestone powder is dried, weighed, and sealed in a quartz ampoule before being bombarded with neutrons in a nuclear reactor. Thus irradiated, the trace elements in the sample become radioactive isotopes: for example, Co-59 (Cobalt) becomes Co-60. As these isotopes decay into stable forms, they emit gamma-ray photons at characteristic energies that can be measured. A spectrum of these photons will reveal which elements are present in the sample, and in what quantities. The results are then stored in the searchable database of the Limestone Sculpture Provenance Project, available online at *www.limestonesculptureanalysis.com*, which to date contains some 2,200 profiles.[4]

Based on the hypothesis that like composition implies like stone source, the database allows scholars to group sculptures together and to test the possibility of a common quarry origin. Sculptures of unknown origin can also be associated with a region, a quarry, or even a specific monument, since many sites, including Notre-Dame, used a single quarry source for specific periods of time. The chronologies of building campaigns can also be refined, given that changes in building materials and quarry sources are often assumed to indicate either breaks in construction history or later restorations.

The Unknown Head or Fragment

Ideally, an art historian first proposes a source for an unknown sculpture fragment, either from a site already represented in the database or from one that can be sampled. For example, in 1964 a head of an apostle now in the Art Institute of Chicago (cat. no. 14) was associated by Eleanor Greenhill with the center portal of Notre-Dame's west facade.[5] Other scholars countered at the time that the head might also have come from Sens Cathedral, whose sculptors, after working there about 1190, presumably staffed the workshop for the Notre-Dame center portal (and, in fact, the reliefs below the jamb figures of the center and left portals of Notre-Dame are stylistically related to those at Sens).[6]

NAA was performed on the Chicago head and on twenty-five samples taken from Notre-Dame sculpture. Thirty-seven samples from Sens Cathedral and two

Sens churches were also analyzed. The results showed, first, that Sens had not used the same quarry as Notre-Dame, and second, that the Chicago head is made of the stone that was commonly used at Notre-Dame during this period. Greenhill's hypothesis could then be accepted. Conversely, analysis showed that a torso in the Musée Carnavalet, Paris (see fig. 44), which Greenhill thought might also have come from Notre-Dame and perhaps belonged to the Chicago head, was not made of Notre-Dame stone, and so the exact origin of the torso remains a mystery.

While the Chicago apostle had long been linked to Notre-Dame, two heads in the Walters Art Museum, Baltimore, confounded expectations when they were tested with NAA. The head most like those from Saint-Pierre, Jumièges (27.351), was shown to be made of Parisian stone, but not that of Notre-Dame. The other head (27.350), which is stylistically similar to some Paris sculpture, is made of the same stone used for the apostles and saints at Jumièges. Figure 38 shows how NAA clearly distinguishes the chalky stone of Jumièges from the stone of Paris, and that the two heads correlate with the Paris and Jumièges reference groups, respectively. Figure 39 shows the concentrations of several elements in the Walters head made of Jumièges stone (27.350) and the standard deviation from the mean for all of the other samples in the Jumièges reference group (the dots represent concentrations in the Walters head).

There are limitations, of course, to the application of NAA. If no origin has been suggested for a fragment, then the entire database must be searched, a process that limits the potential matches to sites that have already provided well-defined groups for comparison. The database contains good representations of samples from quarries in the Paris Basin and Normandy as well as monuments from those two regions and Burgundy. Searching the entire database may not necessarily identify the quarry or monument where a sculpture fragment originated; it may yield a broader classification, such as Paris Basin, or it may be unknown. Also, if church builders used several quarries, as is the case with Saint-Denis, or if the quarry provided several churches with sculpture in the same period, the analysis becomes more complicated.

NAA results can be expressed only in terms of statistical probabilities, not certainties. NAA also assumes that the stone's quarry source is homogeneous, and that

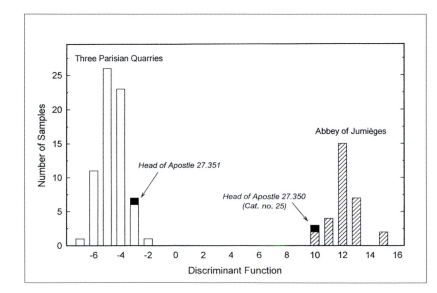

Fig. 38. Discriminant analysis plot comparing limestone from catalogue number 25 (27.350), from the vicinity of Jumièges, to another head in the Walters Art Museum (27.351), from the Paris region. Included in the statistical analysis were 30 samples from Jumièges and 68 samples from quarries near Paris.

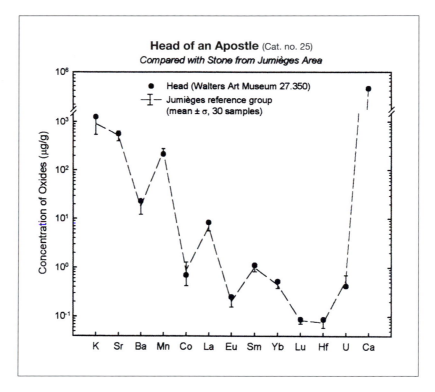

Fig. 39. Profile plot comparing concentrations of 13 elements in limestone from catalogue number 25 to limestone from the Jumièges area

a sample taken from a sculpture or monument is characteristic of the entire work (sample sites on objects are often chosen to minimize visible damage, thereby introducing the small possibility of statistical error). Nevertheless, NAA is the best method currently available to analyze the composition of limestone because it determines the concentrations of many elements simultaneously; it is precise enough to test very small samples of sculpture; and it is sensitive to minute concentrations of elements. The method will also prove increasingly useful as the database expands. This exhibition includes almost thirty heads that have been tested using NAA, and it is hoped that this innovative procedure will continue to provide a valuable tool in determining the provenance of heads as well as many other fragments of medieval limestone sculpture.

NOTES

1. See the website of the Limestone Sculpture Provenance Project, *www.limestonesculptureanalysis.com*. Portions of this essay are based on the Project's website, which was written by Lore L. Holmes, Garman Harbottle, and others.

2. *Le Moniteur Universel*, January 20, 1793, on proceedings of January 17; Gallois 1847, vol. 15.

3. Reproduced in Guillaume 1894.

4. For a bibliography of the procedure, see Holmes and Harbottle 1994 (this article may be downloaded from the Bibliography section of the Project website).

5. Greenhill 1967.

6. Pressouyre 1969.

13. Head of King David

France, Paris, ca. 1145
Notre-Dame Cathedral, south portal of west facade (Saint Anne portal)
Limestone, H. 11¼ in. (28.6 cm)
The Metropolitan Museum of Art, New York; Harris Brisbane Dick Fund, 1938 (38.180)

This forceful yet finely carved head of a king originally decorated the Saint Anne portal of Notre-Dame, on the cathedral's west facade. Soon after the head entered the Museum's collection in 1938, curator James J. Rorimer identified it as belonging to the column figure of King David from the jamb of that portal, based in part on its stylistic affinities with the carvings on the lintel (fig. 41).[1] Rorimer also recognized that the head corresponds closely to an engraving of that column figure published by Dom Bernard de Montfaucon in his *Monumens de la monarchie françoise* (after the now-lost drawings by Antoine Benoist from 1725–28), which shows David holding his attributes, a violin and a scepter (fig. 40). Recently this connection has been supported by neutron activation analysis (NAA), which has shown that the limestone the head is carved of has the same compositional profile as the stone found in other parts of the Saint Anne portal.[2]

The head of King David was the only monumental head known to survive from the west facade decoration of Notre-Dame until 1977, when more than 350 fragments of statuary that had originally adorned the celebrated Gothic cathedral were unearthed in Paris.[3] Among the fragments was the exquisitely carved lower torso of the King David column figure. Even after those dramatic discoveries, the David head is still the only head of a column figure from the Saint Anne portal to survive. The figures of David and the other Old

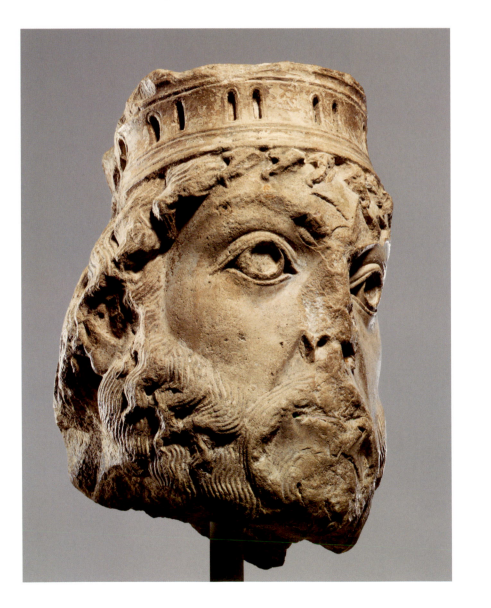

Fig. 40. *King David. Engraving after drawing by Antoine Benoist, from Dom Bernard de Montfaucon,* Les monumens de la monarchie françoise *(Paris, 1729–33), pl. VIII*

Fig. 41. Lintel of Saint Anne portal (detail), west facade, Notre-Dame Cathedral, Paris, ca. 1150

Testament kings and queens on the portal had represented the royal and spiritual ancestors of Christ, part of a visual program that included the Incarnation scene depicted in the tympanum above. They were identified as such by Abbé Lebeuf only in 1863, however; when Montfaucon published his engravings, they were thought to represent the Merovingian founders of the cathedral, glorifying its antiquity, and thus in 1793, at the height of the French Revolution, the Commune ordered them destroyed.[4]

Although the damage sustained during the Revolution has accentuated the flatness of the face, in terms of overall type and crown style the David head is strikingly similar to that of Herod, who appears on the lintel with the Magi. The eyes, originally inlaid with lead, now seem widely dilated. They are surrounded by carefully incised lines that are strongly emphatic, but essentially there is no facial expression. Nevertheless, remembering that all such sculpture was originally brightly colored, one can imagine what must have been a daring visual effect.

The head's geometric solidity and precise form are characteristic of the first phase of Gothic sculpture in the Île-de-France, a period when large column figures first began to appear as facade decoration. The Saint Anne portal is believed to have been carved toward about 1150 either as part of a refurbishment of the earlier structure or as the start of a new church, but one smaller than the present cathedral. A more ambitious project was then envisioned, and the Saint Anne sculpture was installed only after the current High Gothic facade was constructed, in the first decades of the thirteenth century.

Despite the losses, one can still appreciate the eloquent line and shape of the head, which retains the forcefulness and solidity of the Romanesque tradition and yet has been softened and made elegant by subtle modeling, reflecting the beginning of the naturalistic tendency of the Gothic style. Such solid geometry and formal precision appear to have developed out of tendencies in the Île-de-France and in the Oise Valley, but the stylistic origins of the David head

have never been fully explored.[5] At Saint-Lucien in Bury, near Beauvais, the early-twelfth-century nave vaulting contains crowned figures that act as pseudo-supports, which were probably installed about 1140.[6] They have the same widely dilated eyes and flat, round face, suggesting they might be precursors of the David head type. Artistically and technically, the David head is closer to some of the heads on the west facade of Saint-Denis, dedicated in 1140 (see cat. no. 28), while the linear drapery patterns on the surviving lower portion of the David torso are quite similar to some of the stained-glass figures in the Saint-Denis ambulatory, which was dedicated in 1144.

CTL

NOTES

1. Rorimer 1940. According to the dealer Jacques Seligmann, the head was found near Saint-Germain-des-Prés in 1890. It is described in a review of the 1930 exhibition *Sculptured Portraits* at the Lucien Demotte gallery in New York as "a magnificent XIIth century head of a king of French facture which was recently brought to light in Paris during some excavations. While marred by certain scarring, the innate majesty of this Romanesque relic is at once apparent and it holds its own as an example of sculptural perfection." See "Demotte" 1930.

2. Holmes et al. 1986.

3. New York–Cleveland 1979–80.

4. For a summary of the iconographic interpretations of the portal and its dates, see Gelfand 2002, esp. n. 4.

5. See Brouillette 1981, pp. 356–71.

6. Prache 1983, pp. 195–97, pl. 69.

EX COLLECTIONS

S. Licorchi, Paris; [Lucien Demotte, Paris and New York, 1906–34]; [Seligman, Rey and Co., New York]

LITERATURE

New York 1930, no. 9, pl. 9; Rorimer 1940; Cleveland 1966–67, no. III, 25, pp. 94–95; Providence 1969, pp. 159–62, no. 55; New York–Cleveland 1979–80, pp. 14–16; Erlande-Brandenburg 1982a, pp. 15–18; Holmes et al. 1986, fig. 7A, p. 431; Moscow–Saint Petersburg 1990, no. 35 (entry by Charles T. Little); Little 1994, fig. 1; Thirion 2000; Laclotte 2003, p. 116; Dectot 2005, pp. 80–83, no. 81; Wixom 2005, p. 17

14. Head of an Apostle

France, Paris, ca. 1210
Notre-Dame Cathedral
Limestone with traces of polychromy, H. 17 in. (43.2 cm)
The Art Institute of Chicago; Kate S. Buckingham
Endowment (1944.413)

In 1964 Eleanor Greenhill proposed that this powerfully characterized head—long and ascetic, concerned but unfocused—came from the cathedral of Notre-Dame in Paris. She had found in the files of the Art Institute of Chicago a note by a former curator (presumably based on oral communications with Jacob Hirsch, the head's former owner) indicating that it had been found in the 1850s during the building of the boulevards in Paris. Analyzing the style of the head, Greenhill distinguished it from the one head from Sens Cathedral that was known at the time (fig. 42) and described the work as an example of the "style of 1200," which was influenced by classical and Byzantine sculptural remains. Notre-Dame in Paris thus seemed a reasonable hypothesis.

In 1969 French scholar Léon Pressouyre, noting the treatment of the eyes, the wrinkles high on the forehead, and the elongated skull, compared the head to similar examples

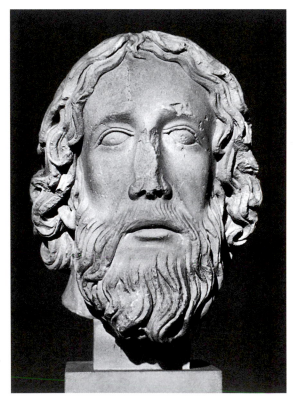

Fig. 42. Head of an Apostle, Sens Cathedral (Yonne), ca. 1190. Musée de Sens, Palais Synodal

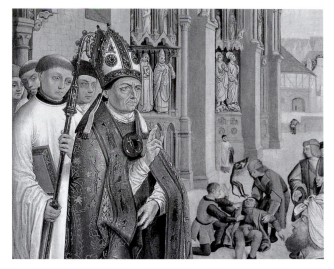

Fig. 43. Master of Saint Giles (Franco-Flemish, active ca. 1500), Episodes from the Life of a Bishop Saint (detail), ca. 1500. Oil on panel. National Gallery of Art, Washington, D.C.; Samuel H. Kress Collection (1952.2.14)

from Sens Cathedral dated about 1190, even though the hair and beards of the Sens heads are not as sophisticated as that seen here. At the time these theories were put forward, no other Paris heads from the period (ca. 1210) were known, and so the provenance remained unresolved.

The 1977 discovery of a large cache of Notre-Dame sculpture fragments, including heads from the Kings' Gallery, bolstered the arguments for a Paris provenance. Like the dado reliefs on Notre-Dame, which had long been considered slightly later works by the Sens workshop, the Kings' Gallery heads and the Chicago head clearly revealed a further refinement of the Sens style. Today, neutron activation analysis (NAA) performed on numerous samples of limestone sculpture from Notre-Dame and Sens has shown, first, that Sens did not use the same quarry as Notre-Dame, and second, that the limestone of the Chicago head falls conclusively within the reference group for Notre-Dame.

The marked asymmetry of the Chicago head conveys a sense of life and movement: the pupils in the globular eyes are not parallel; the mustache rises to the right, where the open mouth widens slightly; and the hair, punctuated by a widow's peak, emphasizes the imbalance of the forehead and sides. The hair, roughened so that it differs coloristically from the flesh, sweeps up from the widow's peak on the right and tucks behind the ear, whereas on the left it falls in a heavy hank, as if it had swung forward as the figure turned sharply to his left. Fragments of a garment on the left shoulder, along with the hint of a straining muscle on the right side of the neck, also suggest such a turn. The back of the head is scarred on the left where the head was once attached to the column. The beard adheres to the neck on the left but is undercut on the right.

In a panel from a dismantled altarpiece by the Master of Saint Giles (fig. 43), we can see several column figures from

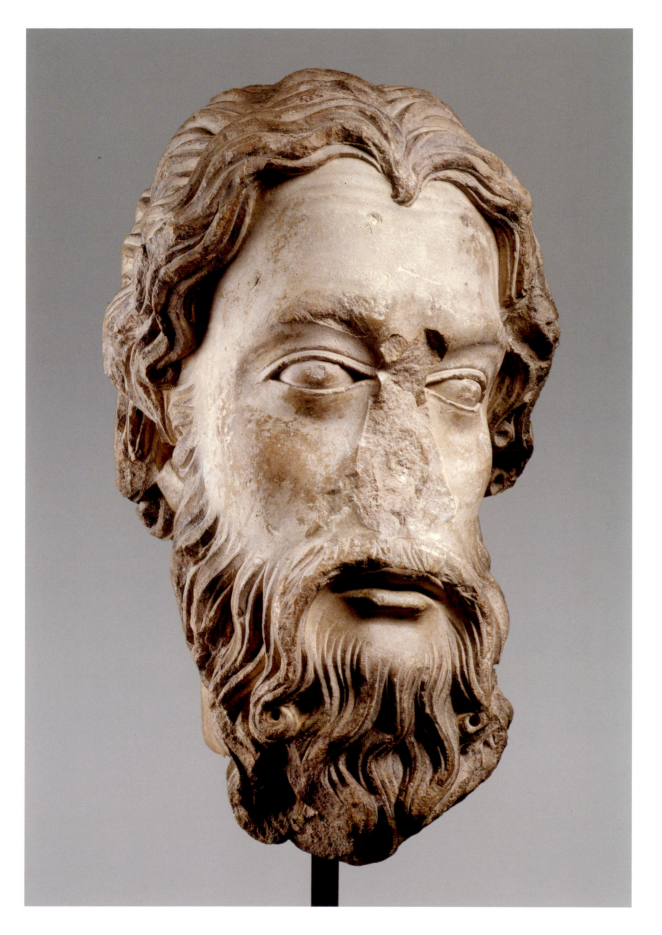

Notre-Dame's west facade that are possible sites for this work: the Coronation portal (at left), and the Last Judgment portal (center portal, visible at right). The sets of column figures in each portal are clearly differentiated by the painter.[1] The two from the Last Judgment stand on marmosets and twist about, while the two Coronation figures stand frontally on flat bases, which were just then becoming the standard. The fine folds of the apostles' garments in the Last Judgment portal contrast with the severe, broad pleats of the bishop and woman in the Coronation portal. We do not know whether the Chicago apostle looked out and down at the visitor, as the Coronation figures do, or if it gazed up at the Last Judgment, but we can be sure that the movement of his head was generated by some such motion in his body.

Greenhill also identified a torso in the Musée Carnavalet, Paris (fig. 44), with the Last Judgment portal, and she believed that the Chicago head might belong to it. But neutron activation analysis (NAA) has shown that the torso, retrieved from the Seine near the cathedral, is not carved of the same stone as the reference group of Notre-Dame limestone samples. There is the possibility, however, that it is made of limestone from a distant section of the Notre-Dame quarry with a different elemental profile, suggesting that additional NAA sampling might be in order.[2]

GW

NOTES

1. Greenhill 1967.

2. Another torso fragment probably made of the same stone—recorded as being in the Carnavalet in the 1830s and now in the Musée National du Moyen Âge, Paris—is more volumetric, and its toga more serenely classical in style, than the Carnavalet torso, but the two may have been carved by different sculptors for the same portal.

EX COLLECTION

Jacob Hirsch, New York, 1944

LITERATURE

Boston 1940, no. 175; Rogers 1947, p. 53; Cleveland 1966–67, no. IV-1; Greenhill 1967; Pressouyre 1969; Maxon 1970, pp. 221–22; New York 1970, vol. 1, pp. 12–13, nos. 15, 22; Little 1994; Gillerman 2001, pp. 9–11, no. 7; Chicago 2004–5, p. 38, no. 18

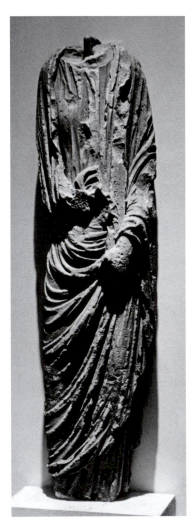

Fig. 44. Torso, possibly from center portal, Notre-Dame Cathedral, Paris, ca. 1210. Musée Carnavalet, Paris

15. Head of an Angel

France, Paris, mid-13th century
Notre-Dame Cathedral, north transept (?)
Limestone, H. 12 in. (30.5 cm)
Nasher Museum of Art at Duke University, Durham, North Carolina; Brummer Collection (1966.179)

16. Head of an Angel

France, Île-de-France, possibly Paris, mid-13th century
Limestone, H. 11 9/16 in. (29.3 cm)
The Metropolitan Museum Art, New York; Purchase, Audrey Love Charitable Foundation Gift, 2006 (2006.41)

These two heads display a nearly identical carving technique that is characteristic of the classic or so-called Precious Style of Paris toward the middle of the thirteenth century. Carved fully in the round, both works have thick, wavy elastic locks of hair that frame the face and cascade elegantly down the back of the neck. The eyes are articulated with an outward swelling, the lips are thin, and the chin (more damaged on the Duke head) projects slightly. The Duke head is carved of a soft oolitic limestone that is from the same source as sculptures at or from Notre-Dame Cathedral in Paris, possibly the nearby quarry of Charenton.[1] The Metropolitan's head, whose face is pockmarked by natural fossil inclusions, is currently undergoing conservation treatment but appears to be made of a different stone, possibly quarried at Vernon (Eure)

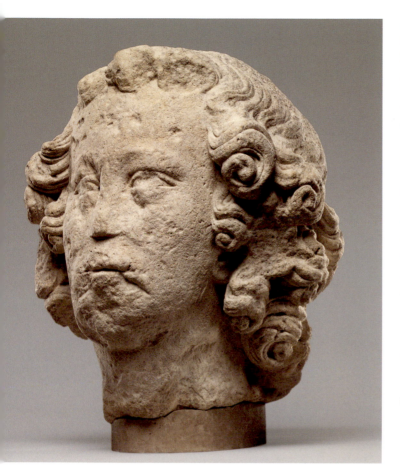

the supposed coronet mountings are actually eroded fossil inclusions. Instead of a Virtue, the Duke head could have belonged to one of the lifesize angels that once framed the north transept portal and continued along the apsidal flank.[7] These angels, of which numerous empty socles remain, were contained within a series of niches. Similar angels can still be seen framing the north transept rose window.[8]

Although both of these heads were subject to exposure, vandalism, and some restoration, the underlying aesthetic quality in each sculpture is still intact. Also, they belonged to figures that were intended to be seen from a considerable distance and height, which partly explains the tendency toward the summary treatment of some forms. The heads nonetheless reveal considerable detail and refinement, and their sumptuous locks of hair compare very favorably to the celebrated sculpture of Adam from the interior of the cathedral's south transept (see fig. 45).[9]

CTL *and* WAS

NOTES

1. Neutron activation analysis (NAA) of the stone confirms that it matches the Notre-Dame reference group. Little 1994, pp. 31–32; Meredith 1994, pp. 38–40.

2. NAA (see report by Robert J. Speakman and Michael D. Glascock, June 13, 2006, in the files of the Department of Medieval Art and The Cloisters) neither confirms a Parisian origin nor identifies another site or monument for cat. no. 16. Another case of inconclusive NAA results

on the Seine, an otherwise unknown source of stone for the Parisian cathedral.[2]

Both works were forcibly detached from freestanding or semidetached figures at the neck, just below the hair line. The Duke head has been convincingly linked by Dieter Kimpel to the sculptural decoration of the north transept portal of Notre-Dame.[3] (Another head, discovered in Paris in 1977 among the fragments found in the rue de la Chaussée d'Antin, may be from the same location.) The numerous stylistic and technical similarities between the Duke head and the Metropolitan's could suggest that the latter was carved by a sculptor trained at the cathedral site who was applying his talents elsewhere, and thus disseminating the Paris style.

Alain Erlande-Brandenburg has proposed that the Paris head (fig. 34), now in the Musée National du Moyen Âge, belonged to one of the three theological Virtues (Faith, Hope, and Charity).[4] (The figures once on the right jamb were identified as the Virtues by Abbé Lebeuf in his eighteenth-century description of the north transept portal.[5]) Kimpel has proposed that the Duke head is also one of the Virtues, based in part on indentations in the back of the head that he suggests might indicate the presence of a now-lost coronet, a common attribute for standing statues of Virtues.[6] Recent study has shown that this cannot be the case, however, since

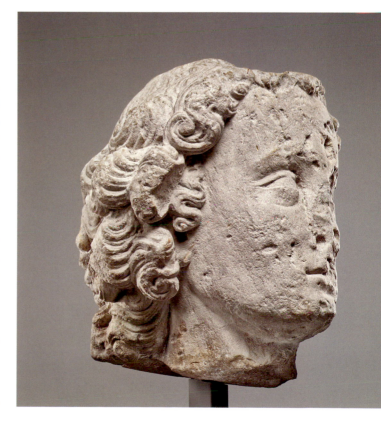

concerns the torso in the Musée Carnavalet (fig. 44), which was found in 1880 in the Seine adjacent to the cathedral but does not have the compositional profile of the limestone used at Notre-Dame.

3. Dieter Kimpel, "A Parisian Virtue," in Bruzelius and Meredith 1991, pp. 124–39.

4. Erlande-Brandenburg 1982a, p. 88.

5. Ibid.

6. Kimpel, "A Parisian Virtue," pp. 134–35. If this were correct, the heads would originally have decorated the niches to the right of the Virgin and Child on the trumeau; on the left would have been the Magi, one of whose heads, it has been proposed, is now in the Musée National du Moyen Âge, Paris (Cl. 23127).

7. The transept facade, whose architectural originality is well known, has been assigned to the master mason/architect Jean de Chelles and dated to about 1246/47–58, but the extent of Jean's involvement in the sculptural decoration is unknown.

8. Kimpel 1971, figs. 101, 102.

9. Erlande-Brandenburg 1982a, pp. 117–18.

EX COLLECTIONS

Cat. no. 15: Madame Chassot, Paris; [Joseph Brummer, Paris and New York]. *Cat. no. 16:* [Mathias Komor, 1980]; private collection, New York; [sale, Sotheby's, New York, January 27, 2006, lot 404]

LITERATURE

Cat. no. 15: Dieter Kimpel, "A Parisian Virtue," in Bruzelius and Meredith 1991, pp. 124–39; Little 1994; Meredith 1994. *Cat. no. 16:* Sotheby's 2006, lot 404, ill.

17. Head of an Angel (?)

France, Paris, ca. 1250
Notre-Dame Cathedral (?)
Limestone, H. 9⅝ in. (24.5 cm)
The Metropolitan Museum of Art, New York; Purchase,
Michel David-Weill Gift, 1990 (1990.132)

The sweet, engaging smile on this head marks it as a product of mid-thirteenth-century High Gothic Parisian style.[1] Deeply carved locks of wavy hair frame the face and set off the smooth, rounded modeling. Nothing is known of the circumstances of the head's discovery, some time in the twentieth century, but neutron activation analysis (NAA) has revealed that the composition of the stone matches that of the limestone used for sculpture at Notre-Dame in Paris. Notre-Dame appears to be remarkably homogeneous in terms of the limestone used for its carvings, even over successive building campaigns.[2] Unlike many of the other sculptures attributed to Notre-Dame, however, this piece does not show signs of weathering and wear associated with an exterior location. If the head came from the cathedral's interior, there are two plausible sculptural programs where it could have originated: the jubé (choir screen), or the interior south transept.

The great stone choir screen of Notre-Dame was built in the thirteenth century, covered over in a redecoration campaign in the early seventeenth century, and destroyed by the architect Jules Hardouin Mansart beginning in 1699.[3] Drawings and written descriptions indicate that its sculptural program was a Passion cycle capped by a large Crucifixion. A fragment preserved in the Musée du Louvre, Paris, which shows Adam and Eve leaving hell (from a Descent into Limbo) gives us an idea as to the quality and scale of the work, which would seem to accord with this head (see fig. 18).[4]

The other interior location known to have had a sculptural program dating from the middle of the thirteenth century is the end of the south transept, where there was a schematic representation of the Last Judgment: Christ high on the center gable below the rose window, flanked at a lower level by angels and, lower still, figures of Adam and Eve in niches.[5] (Today the figure of Adam [fig. 45] is preserved in the Musée National du Moyen Âge, Paris; it was always known to have come from Notre-Dame, but the statue was recognized as the Adam from the interior south transept after the studies published by Dieter Kimpel [1971] and Alain Erlande-Brandenburg [1975].) The Last Judgment group was accompanied by several angels. Two were on outer gables of the transept end holding the Instruments of the Passion; trumpeting angels appeared on the side walls of the transept arm, one of which is still in situ. This head could have belonged to one of those angels. The manner in which the hair frames the face of both the head and the Adam figure is similar; tight curls and spirals encircle the visage, but the hair just behind is considerably straighter and carved in lower relief. The curls are also comparable to those of the

Fig. 45. Adam (detail), interior of south transept, Notre-Dame Cathedral, Paris, ca. 1260. Musée National du Moyen Âge, Thermes et Hôtel de Cluny, Paris (Cl. 11657)

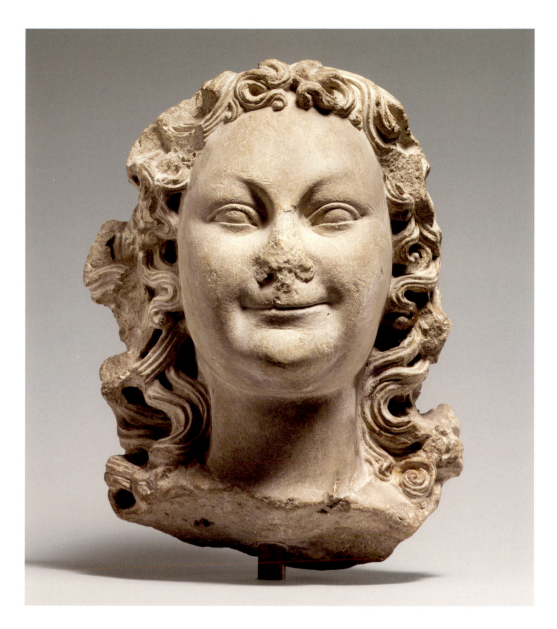

Childebert statue from Saint-Germain-des-Prés, however, so other Parisian churches cannot be ruled out (see fig. 36).

While there is no firm proof that this head represents an angel, the winning smile certainly makes that identification attractive. The reappearance of the smile in French Gothic art was an expressive revolution that originated in Reims in the 1230s. By the mid-thirteenth century, smiles graced the faces of many types of figures, but angels were particularly associated with happy expressions. In 1240, for example, Henry III of England ordered sculpture for a chapel in the Tower of London, including "two fair cherubim of joyous and cheerful countenance."[6]

WAS

NOTES

1. Little 1994, pp. 31–32; New York 1999, pp. 104–5, no. 126 (entry by Charles T. Little).

2. Little 1994, p. 29.

3. Gillerman 1977, p. 14.

4. Louvre inv. no. RF 991; illustrated in Baron 1996, p. 91.

5. The program is known from an early-eighteenth-century drawing by Robert de Cotte (1656–1735); see Erlande-Brandenburg 1975, p. 82.

6. Binski 2004, p. 236.

EX COLLECTION

[Joseph Altounian, Mâcon]

LITERATURE

Kimpel 1971; Erlande-Brandenburg 1975; Gillerman 1977; Little 1994; Baron 1996; New York 1999, pp. 104–5, no. 126 (entry by Charles T. Little); Binski 2004

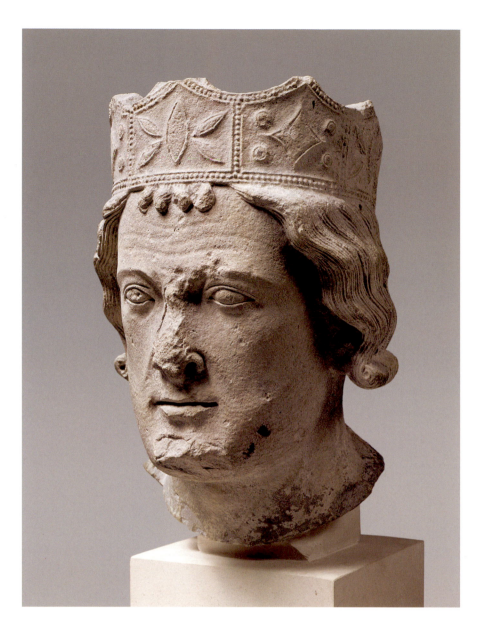

18. Head of a King

France, Mantes (Yvelines), ca. 1220–30
Collegiate Church of Notre-Dame
Limestone, H. 14⅛ in. (36 cm)
Musée du Louvre, Paris (RF 2308)

19. Head of a King

France, Mantes (Yvelines), ca. 1220–30
Collegiate Church of Notre-Dame
Limestone, H. 12¼ in. (31.1 cm)
The Metropolitan Museum of Art, New York; H. O.
Havemeyer Collection, Bequest of Mrs. H. O. Havemeyer,
1929 (29.100.29)

Virtually identical in many respects, these two remarkable heads were for many years thought to be copies of one another, with opinions differing as to which was the original and which was the copy. Now neutron activation analysis (NAA) has shown definitively that they are carved of the same limestone—from a quarry near Veronnet—and that they are thus both original works: a fascinating example of "twins" in Gothic sculpture.

When catalogue number 19 entered the collection of the Metropolitan Museum in 1929 as part of the Havemeyer bequest, it had been abusively restored by the notorious Parisian dealer Lucien Demotte. (A more reliable French dealer, Joseph Altounian of Mâcon, claimed to have found it at Mantes.) Catalogue number 18, which is in very good condition, also belonged to Demotte and had been on the New York art market in 1929. About that time Metropolitan

curator James J. Rorimer arranged to have both sculptures examined together under ultraviolet light and photographed (fig. 46). It was Rorimer who first articulated the issue of the heads' dramatic parallels, fueling the ensuing controversy. Indeed, despite the damage to the Metropolitan's head, many details confirm the overwhelming similarity of the two works, including the crown decoration; the general shape of the face, with identical wrinkles in the forehead; the style of the hair and the closely cropped beard; even the carving of the eyes. The face of the Metropolitan's king appears to be slightly broader than that of the Louvre king, but such distinctions are almost inconsequential. For Rorimer, the closeness of the two heads precluded any possibility that one could be a contemporary of the other.

In 1934 Rorimer reexamined catalogue number 18, by that time recently acquired by the Louvre. His assessment that the Louvre head was a copy, published in the *Gazette des Beaux-Arts* in 1944, prompted the curators there to remove it

Fig. 46. Catalogue numbers 18 and 19 (in reverse order) in the gallery of Lucien Demotte, ca. 1925–30. Photograph: Department of Medieval Art and The Cloisters, The Metropolitan Museum of Art, New York

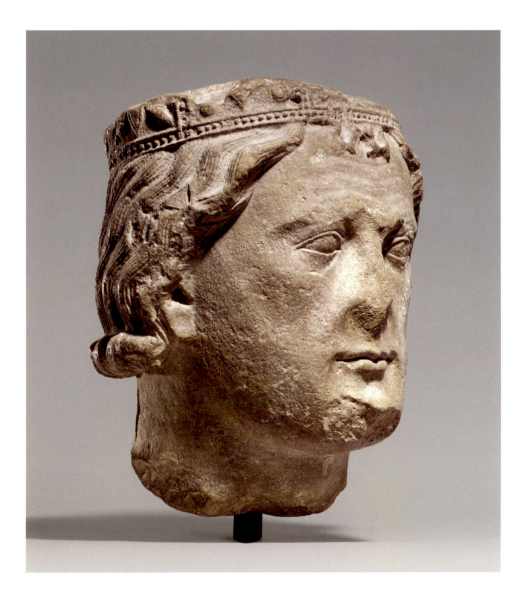

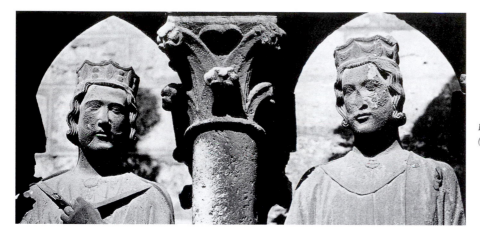

from display and effectively ended the debate for thirty years. The question of which head was original was revisited in 1973, however, by French scholar Léon Pressouyre, who traced the Louvre head back to its discovery in 1852 by the Mantois architect Alphonse Durand (1813–1882). Durand had found the head, along with two kings' torsos and four heads from the collegiate church of Notre-Dame in Mantes, during his rebuilding of the prison there. By 1876 the heads and the torsos were being stored in the gallery of Notre-Dame, where they were inventoried in 1884, and where the heads were photographed in 1908.[1] Not only could Pressouyre document the Louvre head in the collection at Mantes, he could match its broken neck joint to one of the torsos in the church gallery. Pressouyre concluded that the Louvre head was unquestionably genuine and, logically, that the New York head must be the fake. But since we now know that both are original, the question is: how can we have two Gothic heads that are close enough to pass for twins, especially when in most cases even deliberate copies have greater apparent differences?

One possible answer can be found at Chartres, where in the upper gallery between the gables and around the ends of the south transept porch there are figures of kings that might best be described as "cousins" to those at Mantes (fig. 47). Usually overlooked amid the sculptural richness of the cathedral, these eighteen monarchs are all quite similar to one another as well as to the lower, more prominent figures of kings in both of the transept porches. None of them, however, are as close to one another as are the two kings from Mantes; even the two torsos are practically identical.

Also, while the Mantes kings seem closer stylistically to the kings in the upper gallery at Chartres, that correlation provides no clue as to their original location in the church of Notre-Dame. The Mantes heads and torsos are all fully carved in the round, eliminating any possibility that they were installed in portals. Notre-Dame at Mantes does have a gallery across the upper level of the west facade, but it is a tracery screen based on the screen at the top of the facade of Notre-Dame in Paris, and it never contained figures. There are, in addition, no other locations around the exterior of the church that might have held these lifesize works.

At present our knowledge of other possible locations in or around Mantes is inadequate to suggest an original site for the two kings. And even though we have the second king's torso at Mantes, the upper part of it is too damaged to determine if the Metropolitan's head, like the Louvre head, fits to the king's body (nor can we be sure that there were only two kings on the original monument). But we can recognize, at long last, that both of these heads are authentic works, and as we accept the existence of such unusual twins in Gothic sculpture, we will also continue to search for their original location.

WWC

NOTE

1. The inventory, dated 1880 but published in 1886, mentions six twelfth-century heads, four of them crowned. This suggests the possibility that both kings' heads were then at Mantes. By the time the heads were photographed by Jean LaFond in 1908, the Metropolitan's head was no longer in the group. The Louvre king may have been the head that, according to a still vivid local tradition, was stolen during World War I, only to turn up on the art market about 1930. Pressouyre (1973) suggested that the Metropolitan head appeared on the market about 1925.

EX COLLECTIONS

Cat. no. 18: Alphonse Durand, Mantes, 1852; Collegiate Church of Notre-Dame, Mantes, by 1876; [Lucien Demotte, Paris and New York, before 1930]; [Henriette Lobert, Mâcon, by 1934]. *Cat. no. 19*: [Simon, Beauvais]; [Lucien Demotte, Paris and New York, ca. 1925]; [Dikran Kelekian, New York]; H. O. Havemeyer, New York

LITERATURE

Durand and Grave 1884; Durand and Grave 1886 (dated July 15, 1880); New York 1930; Rorimer 1944, p. 199, figs. 7, 8; Pressouyre 1973; Holmes et al. 1986; Mexico City 1993, p. 68, fig. 22; Baron 1996, p. 85; Alain Erlande-Brandenburg, "Les portails du XIIe siècle: Un program ambitieux," in Mantes 2000–2001, pp. 96–103; Agnès Barruol, "Les collections lapidaires de Notre-Dame de Mantes," in ibid., pp. 150–58; Châlons-en-Champagne 2005–6, pp. 76–77, no. 32 (entry by Jean-René Gaborit)

20. Head of a King

North France, Picardy, Amiens (?), ca. 1180
Limestone, H. 13 in. (33 cm)
The Metropolitan Museum of Art, New York;
H. O. Havemeyer Collection, Bequest of
Mrs. H. O. Havemeyer, 1929 (29.100.28)

Perhaps the most unusual feature of this handsome but damaged head of a king is the polygonal crown, a rarity in Early Gothic sculpture. Although the top finials are missing, the crown's lower elements, including the carved jewels, are still in place, making it possible to reconstruct the general

arrangement of the original decoration. The head is also distinguished by the precise handling of the eyes and the subtle surface modulation, still appreciable despite losses. The hair and beard, composed of separate locks marked by broad, parallel strokes, terminate in tiny curls.

When the head entered the collection of the Metropolitan Museum with the Havemeyer bequest in 1929, the nose had been restored to look like those found on figures from the west facade at Chartres (ca. 1142–50/55), certainly one of the more discreet restorations perpetrated by the Parisian dealer Lucien Demotte. But this head cannot have been carved at such an early date.[1] Konrad Hoffmann drew parallels to the head of King David from the center portal of the church of Notre-Dame in Mantes, then dated to the 1180s

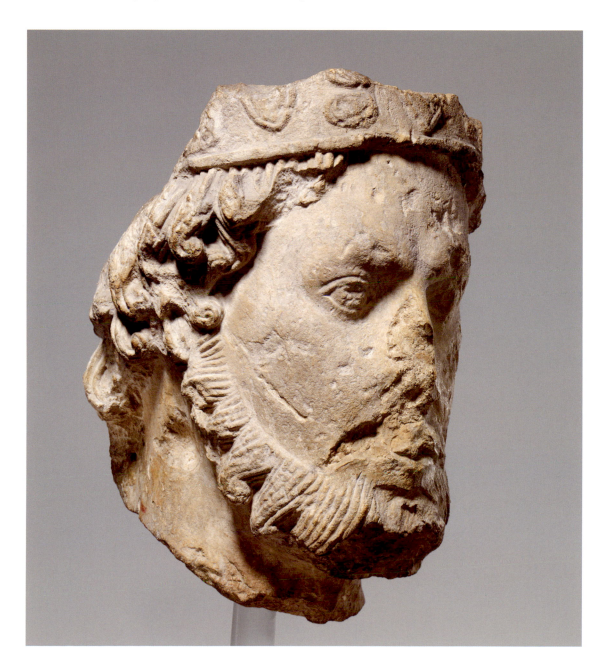

Fig. 48. Pierre Nicolas Ransonnette (French, 1745–1810). Saint Nicholas Portal, Amiens Cathedral (Somme). Engraving, from Aubin-Louis Millin, Antiquités nationales *(Paris, 1790–99), vol. V, pl. LI, 2*

but now dated more accurately to the 1170s.[2] But Hoffmann based his comparisons on old photographs of the Mantes David, and direct comparisons are unconvincing; the Havemeyer king is less graphically presented and has more subtle transitions between the planes of the face. Hoffmann also cited similarities with the sculptures of the Porte des Valois at Saint-Denis, one of the portals he believed, correctly, to be related to the center portal at Mantes. The most recent and thorough study of the Porte des Valois argues convincingly for a date in the 1150s, though, which again is too early for this head.[3] Perhaps because Hoffmann based his date for the king on the later dates then accepted for both the Mantes and Porte des Valois sculptures, he did not mention the pivotal monument in this group: the west portal of the cathedral at Senlis, dated to the 1160s.

Neutron activation analysis (NAA) has thrown new light on the subject and has ruled out Mantes, Senlis, Saint-Denis, and even Paris as the origin of this king's head, which is made of limestone most closely related to that used for the portal sculpture of Amiens Cathedral. The earliest sculpture at Amiens is dated to the 1230s and is associated with figures more than twice the size of this head, so the source of the Havemeyer king must be somewhere else in Picardy, but close to Amiens and to the quarries used for its sculpture.

We have knowledge of two sculpted portals in that area dating from the late twelfth or early thirteenth century that are potential sources: the destroyed collegiate church of Saint-Nicholas, in Amiens itself, and the church of Saint-Étienne

at the old monastery of Corbie, just outside Amiens. Both had portals dedicated to the Triumph of the Virgin, a subject fully developed for the first time in the west portal at Senlis and shortly thereafter at Mantes. The head was certainly influenced by this style, which emanated from Paris, and it, too, probably belonged to a portal exhibiting the Triumph of the Virgin.

The portal at Corbie can be ruled out immediately because the head is much too large for the single column figure remaining there, whose head cannot have measured more than 20 cm in height. The problem with the portal of Saint-Nicholas is that documentary evidence assembled by Pierre Héliot, albeit meager, suggests that the church was begun only after a donation of land in 1193 and was still under construction in 1207. (The church was destroyed between 1781 and 1783 and is now known only from engravings, the best of which, by Pierre Nicolas Ransonnette, show the ruins of the nave and the doorjambs and lintel of the portal [fig. 48].) Jacques Vanuxem has noted that both the arrangement and the iconography of the column figures on the portal jambs of Saint-Nicholas as well as the dual scenes on the lintel follow those of the center portal of the north transept at Chartres (which postdate the 1194 fire there), not the earlier sequence followed at Senlis and Mantes.

In the final analysis, the Havemeyer head may be the only known fragment of a major but as-yet-unidentified portal in or near Amiens that relied on quarries exploited half a century later for the sculpture at the cathedral. This Picard portal had stylistic characteristics that developed out of Paris, through Senlis, and must have dated to the late 1170s or 1180.

w w c

NOTES

1. Both editions of the catalogue of the Havemeyer collection date it to the thirteenth century; see Havemeyer 1930, 1958.

2. New York 1970, vol. 1, p. 8, no. 9.

3. See Pamela Z. Blum, "The Porte-des-Valois at Saint-Denis: Restorations and Survivals," in Blum et al. 2006.

EX COLLECTIONS

[Lucien Demotte, Paris and New York]; H. O. Havemeyer, New York

LITERATURE

Havemeyer 1930; Vanuxem 1945; Havemeyer 1958; Héliot 1966; New York 1970, vol. 1, p. 8, no. 9; Sauerländer 1971, p. 509; Oklahoma City 1985, pp. 94–95

21. Head of a King

France, Paris, mid-12th century
Abbey Church of Saint-Germain-des-Prés (?)
Limestone, H. 9⅞ in. (25.1 cm)
Nasher Museum of Art at Duke University, Durham, North
Carolina; Brummer Collection (1966.125)

Although this head is missing its nose, has been damaged on the brow above the right eye, and is broken off just below the lower lip, it has several other distinctive features that can still be clearly observed: prominent cheekbones; large eyes, with carving that emphasizes the surrounding facial area;

short wavy locks of hair pulled across the forehead and tucked behind the large ears; and a limp mustache that frames the upper lip. The sense of monumentality, the angle of the neck, and the back of the head confirm that the piece was originally part of a column figure in an Early Gothic portal, although the short hair and beard contrast with those of the usually long-haired and long-bearded column figures of kings from the mid-twelfth century.

Bought by the Brummer Gallery from the Parisian dealer Lucien Demotte on February 14, 1936, and given to Duke University in 1966, the head has been the subject of considerable scholarly speculation and no little amount of frustration. In 1967 Robert Moeller identified it as northern French, from a column figure in an Early Gothic portal dating to

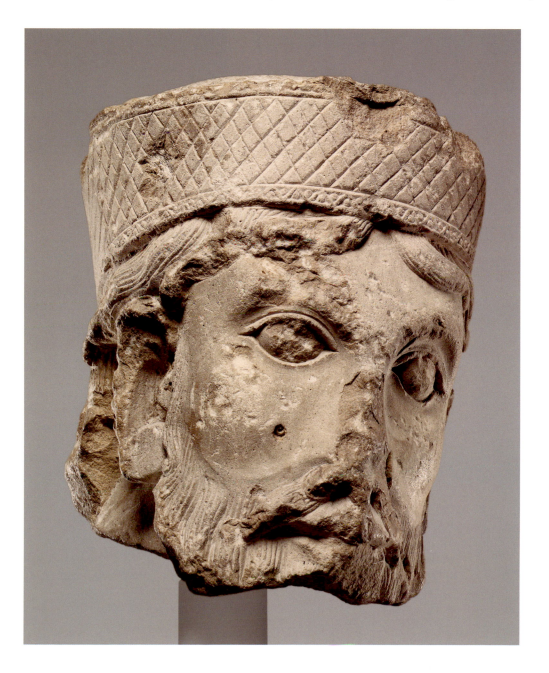

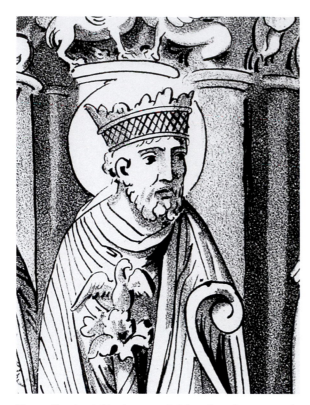

Fig. 49. Albert Lenoir (French, 1801–1891). Column figure from west portal (detail), Abbey Church of Saint-Germain-des-Prés, Paris. Engraving after Montfaucon 1729–33, from Statistique monumental de Paris (Paris, 1867), pl. XX

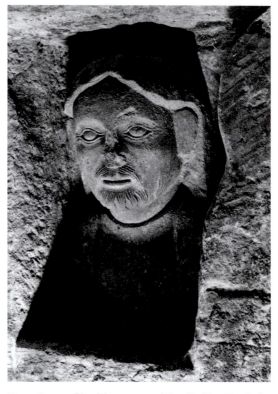

Fig. 50. Reverse of lintel from west portal (detail), Abbey Church of Saint-Germain-des-Prés, Paris, ca. 1150

about 1150.[1] While he saw no resemblance to the statues from Saint-Denis, the first large-scale royal portal figures, he pointed out some general associations between the head and those of the kings in the Royal Portal at Chartres. Robert Calkins also noted similarities with several kings at Chartres, associations that have been vigorously refuted by Stephen K. Scher.[2] Caroline Bruzelius was more circumspect; she called attention to areas that might have been retouched by the unscrupulous Demotte, in particular the cross-hatched pattern on the center band of the crown and the areas immediately below the eyes.[3] She did not, however, advance any suggestions as to the head's original location.

The head was thus an ideal candidate for neutron activation analysis (NAA), which indicated that its limestone is Parisian, most likely from the open quarries at Charenton, a finding that suggests some of the earlier, sweeping judgments might have been too hasty. It now seems reasonable to suggest that the Duke king may, in fact, be the sole surviving head from the column figures that once decorated the Early Gothic portal inserted beneath the old western tower of the abbey church of Saint-Germain-des-Prés. Defaced during the French Revolution, those column figures are now known only from engravings after the drawings of the portal published by Dom Bernard de Montfaucon and Jacques Bouillart and copied by Albert Lenoir in 1867 (fig. 49).[4]

Philippe Plagnieux has traced the history of the Saint-Germain-des-Prés portal in conjunction with the recently revealed back side of the lintel, which contains an abandoned, unfinished version of the Last Supper: the same scene that appears in a completed version on the front of the lintel.[5] Concealed since the lintel's installation in the 1150s, the incomplete scene is a valuable document of twelfth-century carving techniques. The one nearly completed apostle (fig. 50) is stylistically similar to the Duke head, specifically in the short wavy beard and limp mustache, but also in the way the sculptor roughed out the hair, pulling it over and around the ears. The sculptor also framed the eyes of the apostle in carved double lines to indicate lids, and he slightly drilled the corners of the eyeballs, which might indicate the original handling of the eyes that Demotte restored in the Duke head. It has the same double lines above the eye and the drilled corners, but most of the lower lid was removed, leaving only traces visible at the outer edge of the right eye.[6]

The resemblance of the Duke head to the unfinished apostle warrants a reexamination of the kings in the engravings. All six kings in the Montfaucon and Bouillart engravings of the portal have shorter hair and beards than are common in the portals at Saint-Denis and Chartres, and two of them have crowns decorated with cross-hatched bands of ornament (fig. 51). The cross-hatching could be an engraver's device,

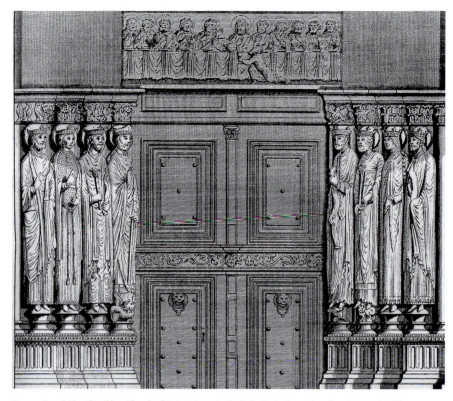

Fig. 51. Portal (detail), Abbey Church of Saint-Germain-des-Prés, Paris. Engraving, from Jacques Bouillart,
Histoire de l'abbaye royale de Saint-Germain-des-Prez *(Paris, 1724)*

yet it bears noting that the crowns on all of the figures
except for the bishop have angled, zigzagged, or cross-hatched
ornamental bands. In other words, Demotte's restorer
might have only "touched up" the original ornament on the
crown. Moreover, both the artists and the engravers seem to
have taken great care in rendering the hair and the distinc-
tive manner in which it is pulled above and around the ears,
suggesting that the drawings are, in fact, reliable.

The height of the Duke head (25.1 cm) also supports an
attribution to this group. When added to the proportional
height of the figures in the drawings made for Bouillart, it
would create a column figure about 228 cm tall, very close to
the 233 cm height of the columns currently in the portal.
The head could have belonged to the king in the second
position (standing between the queen and the bishop) on the
left-hand jamb of the portal, as seen in the engraving pre-
pared for Montfaucon. (In the somewhat less-detailed
engraving prepared for Bouillart, the head of the king in the
second position on the right-hand jamb is a closer match, a
warning against reading too much into such depictions.)
The date of about 1150 already assigned to the head coin-
cides with the date this Early Gothic portal was installed in
the west tower at Saint-Germain-des-Prés, part of the addi-
tions made to the old church in the aftermath of the 1144
dedication of the east end at Saint-Denis.

<div style="text-align:center">WWC</div>

NOTES

1. Raleigh 1967, pp. 26–27.

2. Ithaca–Utica 1968, pp. 140–41; Providence 1969, pp. 156–58.

3. Bruzelius and Meredith 1991, pp. 170–71.

4. On Saint-Germain-des-Prés, see Erlande-Brandenburg 1999b.

5. Plagnieux 1989.

6. The removal of the lower lines left a sharp-edged lower lid and an
enlarged area below the eye that suggests an obvious effort to make the
Duke head resemble the head of King David from the Saint Anne portal
of Notre-Dame (cat. no. 13), which Demotte owned and exhibited in 1930.

EX COLLECTIONS

[Lucien Demotte, Paris and New York]; [Joseph and Ernest Brummer,
Paris and New York, 1936]

LITERATURE

Bouillart 1724, pl. 4; Montfaucon 1729–33, vol. 1, pl. 7; New York 1930;
Raleigh 1967, pp. 26–27; Ithaca–Utica 1968, pp. 140–41; Providence 1969,
pp. 156–58; Oklahoma City 1985, pp. 80–81; Plagnieux 1989; Bruzelius and
Meredith 1991, pp. 170–71

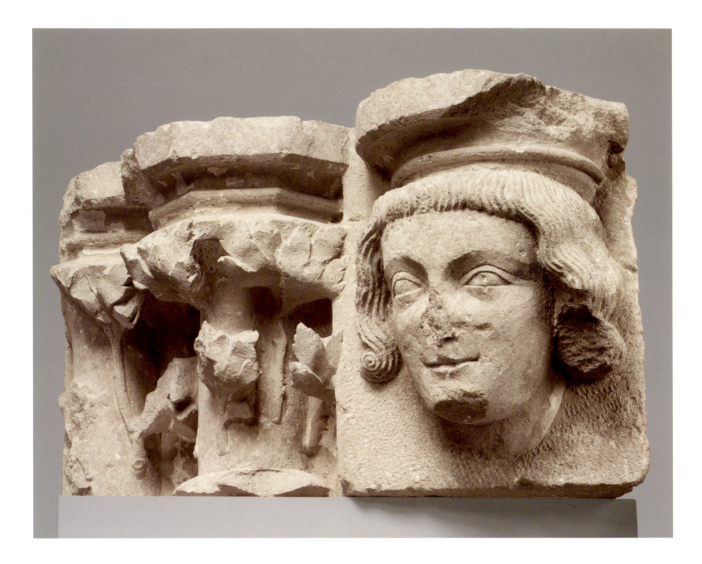

22. Foliate Capital with Head

France, Burgundy, last third of the 13th century
Abbey of Moutiers-Saint-Jean, near Dijon (Côte-d'Or)
Limestone, 9¼ x 17⅜ in. (23.5 x 44 cm)
Nasher Museum of Art at Duke University, Durham,
North Carolina; Brummer Collection (1966.256)

Neutron activation analysis (NAA) was essential in localizing this capital, whose style reveals little about its possible origins. Earlier suggestions of Normandy or Champagne were wildly speculative, since the head on the capital has a somewhat generic appearance, and such architectural pieces were often produced by an apprentice sculptor training for more ambitious work. Indeed, the eyes are rather flat, the modeling is rudimentary, and the hair is repetitively drawn. The winsome smile is attractive nonetheless, and the obvious care given to the carving hints at the potential of an unknown artisan.

NAA revealed that the capital's limestone came from the same source that provided material for the Gothic portal of the ancient abbey of Moutiers-Saint-Jean in western Burgundy, now in The Cloisters, New York (fig. 52). That finding focused attention on other similarities between the head and The Cloisters' portal. These include the eyes, which have straight lower lids and curved upper lids, like those of the two large kings from the portal, and the even strands of hair with a tight whorl on the proper right, also similar to the two young monarchs from Moutiers-Saint-Jean. The heavily undercut leaves as well as the fragments of leaves in the recessed area of the capital likewise echo the portal's rich foliage, both on the capitals and in the unusual trefoil arch of the tympanum. Another capital with a head very similar to the Duke piece is now embedded in a wall of the *hôpital* at Moutiers and may have been carved by the same sculptor, possibly as the other half of a pair that included the Duke capital.[1] Joseph Brummer, whose heirs gave the present work to Duke, sold a corbel or capital head of a king to the Wadsworth Atheneum (1949.184) that is attached to a simple

block of stone divested of all architectural ornament. That piece is, in some respects, a crude version of the Duke head and may have been carved by a younger apprentice.

Moutiers-Saint-Jean, founded about the end of the fourth century, was the oldest monastery in Burgundy and gained numerous dependencies in the western part of the region. In 1567, during the Huguenot wars, the monastery was attacked by an armed mob and the heads of the two large kings from the portal now in The Cloisters were lopped off. The monastery was attacked again in 1595 and 1629, and worse was yet to come. In 1797, during the French Revolution, and after several years of serving as a parish church, the entire Moutiers-Saint-Jean complex was sold as building material. An 1898 photograph published by William H. Forsyth shows the remains of the portal, divested of the two kings, at the back of a shed being used to store farm implements. In the 1920s the farmer sold the portal to a dealer in Vézelay, who sold it to Brummer in 1929. The Duke capital also came from the Brummer collection, but the Vézelay dealer seems not to have identified its source to Brummer. Most of the Romanesque program of capitals from Moutiers, housed in the Fogg Art Museum, Harvard University, and the Musée du Louvre, Paris, are carved from the same type of stone, as are two reliefs of Saint Michael in the spandrels

under fragments of oculi, now in the Davis Museum and Cultural Center, Wellesley College.

Today the two kings from Moutiers-Saint-Jean have been restored to their respective positions on the portal. At the time they were vandalized they were believed to be the Merovingian monarchs Clovis and Clothar. Although William Forsyth (1978) thought they might have been intended to represent David and Solomon, the large scrolls they hold, like the scrolls held by the kings on the Porte des Valois at Saint-Denis, are attributes associated not with Old Testament figures but rather with the privileges the abbey wished to publicize: in this case, Clovis's founding document, releasing the abbey from oversight by local lords, and Clothar's confirmation of it.[2]

In 1256 Duke Hugues IV of Burgundy attempted to seize a third of the revenues of Moutiers. To stave off the duke's depredations and underscore the old privileges, Hugues de Tonnerre, the local lord, donated one hundred solides to the abbey in 1257, a reasonable date for the beginning of the sculptural campaign and one that accords with the style of the portal. The portal's figures reflect Parisian artistic developments of the period, but they also exhibit the broad modeling typical of Burgundian work. And while the famous smile associated with the sculpture of Notre-Dame in Paris and Reims Cathedral clearly had some influence on the Duke capital and on the portal, the precious, courtly quality of Parisian work is absent, as it is in most other Burgundian sculpture.

GW

NOTES

1. That capital was brought to Jill Meredith's attention by Neil Stratford; see Meredith 1994, p. 44.

2. The kings are also identified as donors by their purses.

EX COLLECTIONS

[Lucien Demotte, Paris and New York, 1936]; Joseph and Ernest Brummer, Paris and New York

LITERATURE

Bruzelius and Meredith 1991, pp. 196–97; Meredith 1994

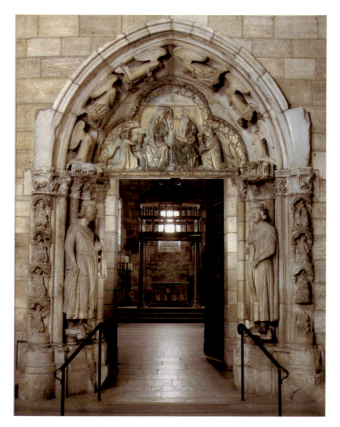

Fig. 52. Doorway, monastery of Moutiers-Saint-Jean (Côte-d'Or), ca. 1250. The Metropolitan Museum of Art, New York; The Cloisters Collection, 1932 (32.147)

23. Face of a Youth

France, Saint-Denis, ca. 1230–50
Abbey Church of Saint-Denis, cloister
Limestone, H. 6⅞ in. (17.5 cm)
The Metropolitan Museum of Art, New York; The Cloisters
Collection, 2002 (2002.211)

Severe features lend this clean-shaven face an almost Antique appearance. The lips are pursed, the hair is loosely cropped, and the almond-shaped eyes are articulated with multiple ellipses around the lids, a trait also found on heads from Mantes (see cat. nos. 18, 19). The pate is chiseled with a fine pattern suggestive of a callote or skullcap, but in fact it looks more like a tonsure, similar to the jamb figure of Saint Laudomarus on the south transept at Chartres (ca. 1235).[1] Various heads at Reims Cathedral are likewise ambiguous as to whether they are tonsured or wearing a cap.[2] Although aggressively cleaned, the sculpture retains a pleasing quality,

especially in the way it was conceived in geometric rather than more naturalistic terms, and judging from the overall surface condition it appears to have never been exposed to the elements.

The youthful appearance and the serious, frontal gaze of the face suggest it was a mask, not a full head, that was excised from a larger context. Engaged corbels with masks are characteristic of a number of ecclesiastical monuments in the Île-de-France in the thirteenth century, and if the youth is indeed tonsured, then a monastic setting would seem likely. This work bears a particularly striking resemblance to faces that adorn an engaged corbel still in situ on the south flank of the abbey church of Saint-Denis in the vicinity of the chapter house (fig. 54). The faces on that corbel are about the same size as the present piece (16–17 cm in height) and are apparently carved of the same fine-grained limestone (*pierre de liais*). The south transept arm and the wall adjoining the north cloister walk originally contained a series of such tricephalic corbels. Recent archaeological explorations and restorations of the walls along the south

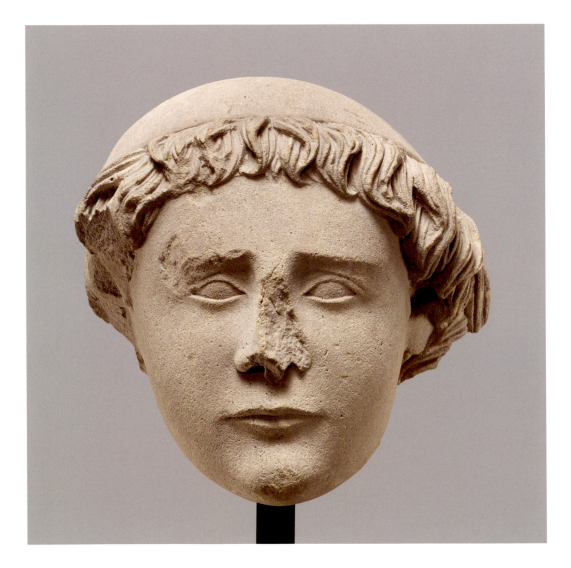

Fig. 53. Elevation of south flank, Abbey Church of Saint-Denis, showing locations of a remaining corbel (O), illustrated below (fig. 54), and partial corbels (X). Drawing by Michaël Wyss

flank leading to the chapter house and cloister have revealed three other engaged corbels with the remains of the arches partially immured (fig. 53).[3]

The attribution of this face to the abbey's cloister is further supported by neutron activation analysis (NAA). Although the reference group for the stone used in this area is limited (comprising six samples), tests show that the stone the face is carved of is consistent with the larger reference group used for the decoration of the twelfth-century Porte des Valois.[4]

Saint-Denis underwent significant rebuilding in the thirteenth century, particularly during the abbacy of Eudes Clément (1231–45),[5] and it is probable that work on the Gothic cloister was in progress at this time. Willibald Sauerländer has dated the south transept portal on stylistic grounds to about 1240–45,[6] and the adjoining cloister walk must have immediately followed. The chapter house has been dated by Michaël Wyss to the middle or third quarter of the thirteenth century.[7]

There is a variety of face types at Saint-Denis, and it is unclear whether such works had specific meaning or were purely decorative. A closely related tricephalic corbel (also reputedly from the abbey) now in the Musée du Louvre, Paris, has both clean-shaven and bearded faces.[8] It is possible that the present face, if it indeed comes from this part of the monastic complex, conveyed through its youthful visage and tonsured pate the appropriate appearance of entering novices. In his *Liber officialis*, Amalarius of Metz (d. ca. 850), writing after Gregory the Great, had this to say about the tonsure: "The hairs on the head signify thoughts in the mind...We should shave it of superfluous thought in order that the eye of our intellect can look at eternal things." There was concern, he continues, that the hair should not be allowed to grow too long, "lest they should cover the ears of the heart and impede the eyes."[9] In this context, then, cutting the hair symbolized a renewal of the spirit.

CTL

Fig. 54. Tricephalic Corbel, south flank, Abbey Church of Saint-Denis, ca. 1230–50

NOTES

1. Sauerländer 1972, fig. 120.

2. Kurmann 1987, figs. 535, 656; Hamann-Mac Lean and Schüssler 1993, fig. 3571.

3. The main issues of the cloister are summarized in Pressouyre 1986.

4. Lore L. Holmes, memorandum of November 18, 2003, in the files of the Department of Medieval Art and The Cloisters, The Metropolitan Museum of Art.

5. See Bruzelius 1985, pp. 124–30.

6. Sauerländer 1972, pp. 470–71, pl. 183.

7. Wyss 2004, fig. P. 85. See also Wyss and Meyer-Rodrigues 2000.

8. Baron 1996, RF 458, p. 88.

9. Amalarius of Metz, *Liber officialis*, II, 5, 1–7, in *Amalarii episcopi opera liturgica omnia*, vol. 2, edited by J. O. Hanssens (Vatican City, 1948), pp. 210–12; as cited in Huygens 1985, p. 71.

EX COLLECTION

[Brimo de Laroussilhe, Paris]

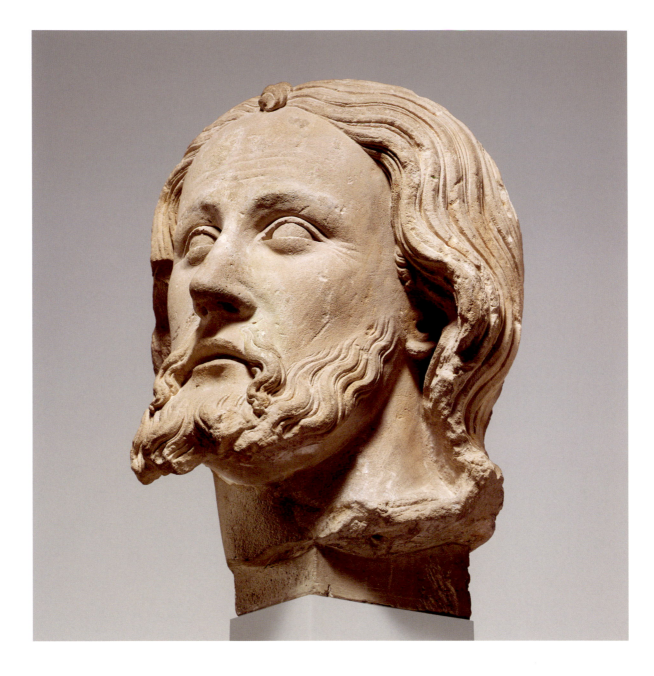

24. Head of Christ or an Apostle

France, Amiens (Somme), ca. 1230–50
Amiens Cathedral (?)
Limestone, H. 12⅝ in. (32 cm)
Private collection

This bearded head was once thought to have come from the destroyed medieval town of Thérouanne, possibly because of its size and general stylistic traits that relate it to the series of apostles' heads known to have come from Thérouanne that are now in various American and British collections (see cat. nos. 8, 9). However, neutron activation analysis (NAA)

has shown that the limestone the head is carved of is consistent with the quarry that supplied material for the west facade of Amiens Cathedral.

At once majestic and serene, the head is carved fully in the round. Its excellent, unweathered condition suggests that the complete figure must have been a pivotal component of a decorative program from a protected portal or interior ensemble. The swelling around the eyes, the thin, wavy locks of hair, the distinctively curly beard, and the slight projection of the lower lip offer striking parallels to the famed Beau Dieu figure on the trumeau of the west, or Last Judgment, portal at Amiens Cathedral (ca. 1230–35), or to the hand of a closely related sculptor working there (see fig. 2). As a worthy contemporary to the Beau Dieu, whose

beauty was famously extolled by John Ruskin, the head reflects many of the stylistic hallmarks of the figures from the cathedral's jubé sculpture, especially the head of Christ from the Arrest relief (fig. 55).[1] This compassionate figure is probably a depiction of Christ as well, and, like the Beau Dieu, its countenance is at once triumphant and searching, but with no outward display of emotion. Here we see an idealized humanity portrayed with nobility and pride, indicating that the head likely came either from an important setting within the cathedral or from a closely related monument in the vicinity of Amiens that has disappeared without a trace. Perhaps these qualities are also the very reasons the head was saved for posterity.

CTL

NOTE

1. See Gillerman 1981; Little 1999, fig. 4.

EX COLLECTIONS

[Paul Gouvert, Paris]; L. Salavin, Paris; [sale, Hôtel Drouot, Paris, November 14, 1973, lot 89]; [Bresset, Paris]

LITERATURE

Salavin 1973, lot 89; Little 1999, fig. 7

Fig. 55. Arrest of Christ (detail), choir screen, Amiens Cathedral (Somme), ca. 1240–60. The Metropolitan Museum of Art, New York; Mr. and Mrs. Isaac D. Fletcher Collection, Bequest of Isaac D. Fletcher, 1917 (17.120.5)

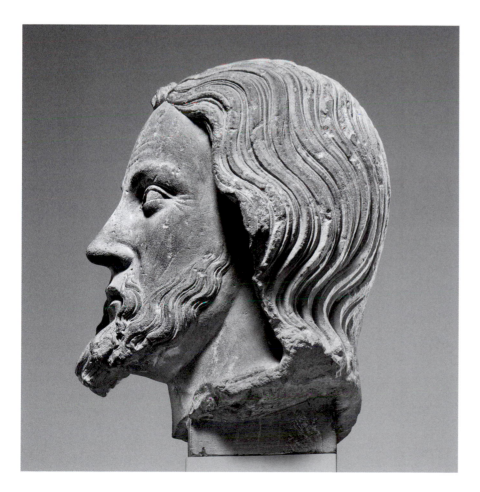

25. Head of an Apostle

France, Normandy, Jumièges (Seine-Maritime), 1332–35
Limestone, 11 ⅝ in. (29.5 cm)
The Walters Art Museum, Baltimore (27.350)

Philippe Verdier, curator of medieval art at the Walters Art Museum, believed that this beautifully preserved head was perhaps from one of the apostles carved for the interior of Saint-Jacques-aux-Pèlerins, Paris, between 1319 and 1327.

Françoise Baron contested Verdier's idea and even voiced her suspicions about the work's authenticity.[1] We now know that the head is indeed authentic,[2] but it is not from Saint-Jacques. It does, however, share affinities with the work of Guillaume de Nourriche (active 1297–1324), who carved two of the apostles for Saint-Jacques, one of which is preserved in the Musée National du Moyen Âge, Paris. The Walters head resembles the Saint-Jacques apostle in its exuberant beard, which is separated into four elaborately curled ringlets, the outer ones overlapped by countercurving mustaches; the two buttonlike curls over the forehead; the curls

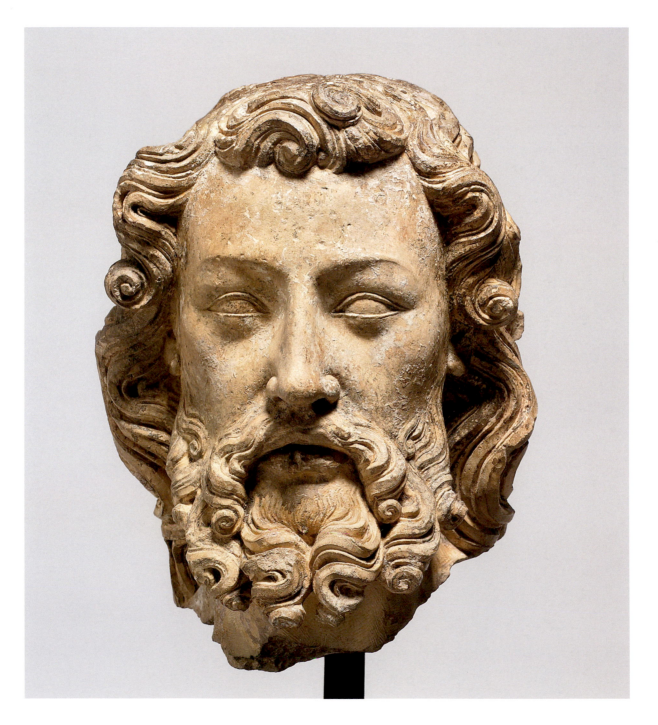

framing the face; the fleshy lower lip; and the prominent cheekbones and overall firm structure. The pouches below the apostle's eyes are not as prominent in the Walters head, though, and the expression of the latter conveys serenity rather than deep concern.

Neutron activation analysis (NAA) has revealed that the stone of the Walters head best matches that of the statues and masonry of the abbey of Jumièges, in Normandy. Between 1332 and 1335, Abbot Guillaume le Jeune rebuilt the church of Saint-Pierre at Jumièges, next to the much larger Romanesque church of Notre-Dame, and commissioned the carving of a college of apostles for the interior in emulation of that in Saint-Jacques-aux-Pèlerins, which in turn was modeled on Saint Louis's Sainte-Chapelle of the 1240s. It is possible that Guillaume de Nourriche was called to Jumièges to produce a model for the local sculptors from which the Walters head was later detached. If so, that model was likely once attached to a column, like several of the Jumièges figures now in the abbey museum; a scar on the left of the back of the head indicates that the figure stood stiffly upright and turned his head slightly to its proper left.

One of two or more sculptors at Jumièges emulated the sworls over this figure's forehead, the S-curved locks of the hair, and the four strands of the beard, although, unlike Guillaume, that unknown artist did not separate them. All of the sculptors seized upon the device of the pouches below the eyes and even enlarged them, as they also copied the fleshy lower lip and fattened the upper one so that the mouth appears swollen. The proportion of head to figure in the Jumièges group is 1:6 rather than the typical 1:8, making the bodies appear thin. The draperies support the figures with large tubular folds, in contrast to the multiple fine pleats of the Saint-Jacques group.

In 1792 the last monks were forced to leave Jumièges when the abbey was nationalized and its sculptures were dispersed. The statue of Saint James the Greater went to the church in Duclair, and the rest were sent to a church in Sainte-Marguerite, towns less than ten kilometers away. In the nineteenth century all but four of the sculptures in Sainte-Marguerite were taken out and buried. In 1923 eight bodies, one with a head still attached, and three detached heads were unearthed before the excavation was abandoned.[3] Some of these were apostles, some bishop or abbot saints. For a 1954 exhibition in Rouen, these works as well as the figures still displayed at Sainte-Marguerite and Duclair were shown together.[4] Heads were rather arbitrarily affixed on seven of the eight apostles, while the four bishop or abbot saints were left headless, and note was taken as to which figures had been freestanding and which had been addorsed to one or three colonnettes.[5] The affinities between this group and the Walters head, in addition to the NAA results, reinforce the argument that the latter originated in Jumièges.

GW

NOTES

1. Baron 1975, pp. 44f.; and Paris 1981–82, p. 72, no. 14b.

2. The antiquity of the head was recently confirmed by analysis of paint fragments; see Holbert et al. 2001.

3. See Bailly 1960, with illustrations of the figures and heads.

4. Rouen 1954.

5. The statues were later returned to Duclair and the abbey museum, and the heads were removed.

EX COLLECTION

Henry Walters, Baltimore

LITERATURE

Baron 1975; Holbert et al. 2001

The Stone Bible: Faith in Images

Jacqueline E. Jung

> To adore images is one thing; to teach with their help what should be adored is another. What Scripture is to the educated, images are to the ignorant, who see through them what they must accept; they read in them what they cannot read in books.
>
> — Pope Gregory the Great, ca. 600[1]

> I'm just a poor old woman / Who knows nothing and can't read. / On the walls of my parish church I see / A paradise painted with harps and lutes / And a hell where they boil the damned. / One gives me fright, the other great bliss and joy. / Let me have the good place, Mother of God, / To whom sinners all must turn. / Filled with faith, sincere and eager, / In this faith I want to live and die.
>
> — François Villon, ca. 1460[2]

THE nearly nine centuries between Gregory the Great's justification of sacred images and the poet François Villon's evocation of his mother's response to the murals in her parish church witnessed major changes in the representational practices associated with Christian buildings. The heavenly joys and hellish torments rendered so vividly in late medieval paintings and sculptures pointed forward in time, shaping viewers' hopes and fears about their own fates through such memorable material details and through the process of empathetic identification with the human subjects portrayed. Such images would have been utterly foreign to the early-seventh-century pope, who was interested in the ability of pictures—specifically, narrative images of biblical events and saints' lives—to propel the mind back in time, offering new converts the raw facts of Christian history as well as models of proper behavior and belief.[3]

Yet despite their different contexts, assumptions, and intentions, these two passages share one thing in common: faith in the ability of pictures to act as surrogate texts for persons untrained in Latin letters. This assumption formed the basis for the widespread notion, propounded by art historians like Émile Mâle and literary champions of Gothic architecture such as John Ruskin and Victor Hugo,[4] that the pictorial programs of medieval churches made those edifices legible as monumental "bibles in stone." The thirteenth-century cathedrals of northern France, with their rich arrays of figural sculpture, seem to exemplify this idea most clearly. Flanking the center portal of Reims Cathedral, for example, overlifesize statues enact three episodes from the life of the church's patron, the Virgin Mary. On the right-hand jamb, a youthful Mary receives the news of her imminent impregnation from a grinning angel before turning, in the form of a second figure, to greet her cousin Elizabeth at the Visitation (fig. 56). On the opposite jamb, a third figure of Mary extends the infant Christ toward the High Priest Simeon as Joseph and a female attendant observe from the sides. Although each episode corresponds with a biblical event, the

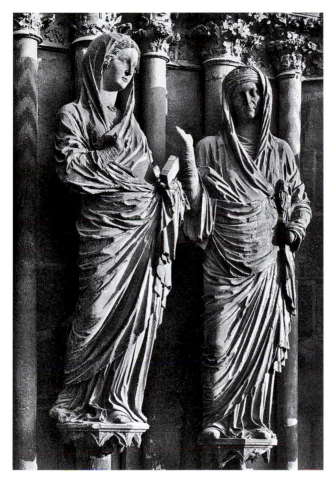

Fig. 56. *Visitation, west façade, Reims Cathedral (Marne), before 1233*

distinctive formal languages in which the narrative moments are couched lend them content beyond the scanty details of the textual sources. The classicizing style of the Visitation group gives the women a gravitas that contradicts the joyful aspect of their meeting in the scriptural account, while allowing the radiant smile of the Annunciate angel to glow all the more brightly (see fig. 13). In the Presentation scene, Joseph's jaunty pose and modish costume imbue him with a sense of character absent in his portrayal in the Gospels, injecting an air of courtly culture into the account of an otherwise solemn Jewish ritual in order to increase its accessibility and appeal for Christian beholders.

Although many of the heads in this section of the exhibition do not come from narrative ensembles such as that at Reims, they all played a similar role by simultaneously animating the stone walls of their respective churches and fleshing out the often minimalist language of the scriptural texts. The Early Gothic jamb figures from Saint-Denis (cat. nos. 28, 30) gave presence to the heroic kings of the Old Testament, employing large, heavy-lidded eyes—their gaze intensified by dark stones or lead set into the pupils—and soft but unsmiling lips to convey an impression of nobility, wisdom, and quiet, confident authority. Suppressing any trace of the swashbuckling military exploits attributed to many of those characters in the Hebrew Scriptures, the figures bring to view both the grandeur of Christ's royal heritage and the idealized qualities of contemporary Christian kings: a theme of utmost importance at this royal burial site. Like their well-preserved counterparts on the twelfth-century Royal Portal of Chartres Cathedral, the Saint-Denis heads graced tall, svelte, columnar bodies whose emphatic immobility underlined the changeless nature of the virtues the faces express.

Heads from narrative images, by contrast, often appear marked by transient muscular movements. The face of King Herod from Chartres (cat. no. 33) registers the malice attributed to him in the Gospels through its narrowed eyes, furrowed brows, and tensed forehead, features that pose a subtle but meaningful contrast with the placid, controlled demeanor of one of the Three Kings from the same monument (cat. no. 34). Both heads once belonged to the relief showing the Magi consulting with Herod during their journey to Bethlehem, part of an extensive narrative cycle devoted to the Infancy of Christ that embellished the cathedral's choir screen (now partly destroyed).[5] Like sculpture programs on other thirteenth-century screens, such as the magnificent surviving example at Naumburg Cathedral (fig. 57), this sequence offered beholders in the nave lively glimpses of biblical stories played out by modernized "actors" in emphatically contemporary settings.[6]

In addition to rendering visible the characters evoked in the scriptures, sculptures made for altars could engender scenes that were independent of textual support. The Pietà, which shows the dead Christ cradled by his grieving mother,

became one of the most widespread devotional images in the late Middle Ages despite the fact that it has no basis in the Gospels. As we see in a head of Christ likely from such a group (cat. no. 37), expressive features such as closed eyes, an open mouth, and creased flesh, all suggestive of Christ's final agonies, served above all to elicit emotional responses from beholders.[7] The figures were meant less to convey factual information about Christ's death than to help them feel its significance through empathetic *compassio* (cosuffering).

Whether in the form of iconic portrayals of saintly persons, narrative scenes drawn from sacred writings, or autonomous devotional images, the figural sculptures of medieval churches thus display a relationship with texts that is more complex and nuanced than the designation "stone bible" implies. Like the Last Judgment image that so moved Villon's mother, such figures worked less through a detached intellectual process of "reading" than through an immediacy of affect. Gazing outward from doorways, screens, or altars, these stone heads challenged viewers to assign them appropriate voices and stories; in return, they reinvigorated the texts of the Bible and satisfied the need for narrative embellishment and humanizing anecdote. In such figures, the unlettered and educated alike could indeed "read... what they [could] not read in books" precisely because they show what books do not, and cannot, tell. Rather than acting as a surrogate for sacred texts, the "stone bible" is best understood as a vibrant supplement to them, using artificial bodies to bridge the gap between ancient writings and contemporary human communities.

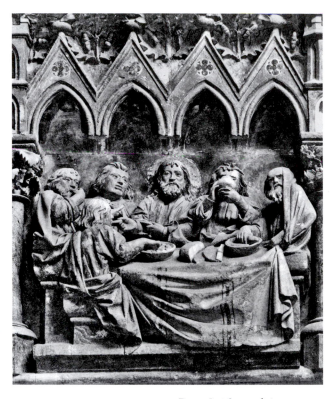

Fig. 57. Last Supper, choir screen, Naumburg Cathedral (Saxony-Anhalt), ca. 1245–60

NOTES

1. From "Letter to Serenus of Marseilles," in Davis-Weyer 1986, pp. 47–49 at 48.

2. From "The Testament," in Villon 1982, pp. 82–83, ll. 891–902. My thanks to Stephen K. Scher for pointing me to this passage.

3. The best historical analysis of the Gregorian dictum remains Chazelle 1990. On its continued resonance during the High Middle Ages, see Kessler 2006.

4. Ruskin 1884; Mâle 1984; Hugo 1993.

5. See Mallion 1964, pp. 135–47.

6. See Jung 2000.

7. The head may also come from a Lamentation; see discussion in cat. no. 37.

26. Head of a Bearded King

Gislebertus (active ca. 1120–40)
France, Burgundy, Autun (Soâne-et-Loire), 1125–35
Limestone, H. 5⅛ in. (13 cm)
Glencairn Museum, Academy of the New Church,
Bryn Athyn, Pennsylvania (09.SP.2)

Not all of the destruction that ravaged French art can be attributed to the often mindless, but also calculated and deliberate, fury of the French Revolution. During the seventeenth and eighteenth centuries, efforts by the clergy to embellish their churches in the current fashion did as much to disfigure and destroy the monuments of the Middle Ages as did the Protestant iconoclasm of the sixteenth century or the passionate ideology of the eighteenth century. Taking as their motto Psalm 25(26):8, "I have loved, O Lord, the beauty of thy house; and the place where thy glory dwelleth," the bishops and canons who controlled the decoration of their churches felt obliged to express the contempt they felt for medieval art by transforming, destroying, or masking the architecture, sculpture, and painting of that period with Baroque and Rococo forms in the first half of the eighteenth century and classical or pseudoclassical decor in the second half.[1]

The cathedral of Saint-Lazare at Autun was one of many churches to suffer such a fate. In 1766 the cathedral chapter set about correcting what they viewed as the horrors of

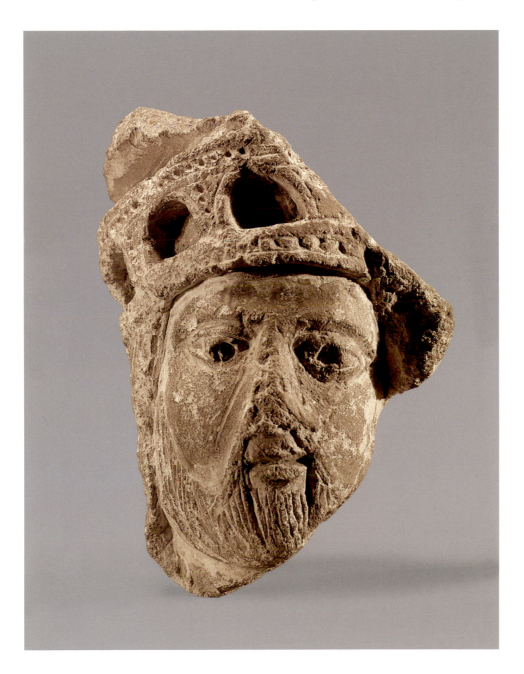

Every detail conveys the turbulence and emotional significance of this most dramatic of biblical moments, even in so small and heavily damaged an object as this head. Gislebertus was a master of the eloquent gesture that transmits the essence of a scene in the simplest possible way, creating an unmatched variety of forms from an imagination that, even in Romanesque terms, was remarkably fertile.

SKS

NOTES

1. For an exhaustive study of the transformation and/or destruction of French art, see Réau 1959.

2. Grivot and Zarnecki 1960, p. 28, pl. S.

EX COLLECTION

Raymond Pitcairn, Bryn Athyn, Pennsylvania

LITERATURE

New York 1968–69, pp. 22–23, no. 22; New York 1982, p. 79, no. 21; Cahn 1987, p. 70, no. 2; Cahn 1999, pp. 48–49, no. 4

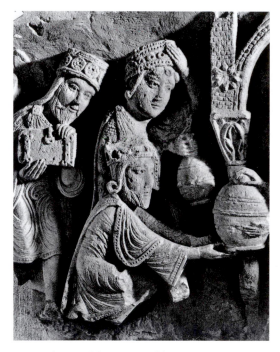

Fig. 58. *Adoration of the Magi, capital from nave, Cathedral of Saint-Lazare, Autun (Saône-et-Loire), ca. 1120–30*

medieval art by destroying the trumeaux of the portals and plastering over the great Last Judgment tympanum of the center portal of the west facade, one of the glories of Romanesque sculpture. At the same time, the innermost archivolt, which contained images of the Elders of the Apocalypse—who witness the Last Judgment (Apoc. 4:4)—was removed. A few pieces recovered from this location are preserved in the Musée Rolin, Autun, including two small crowned heads. It is quite possible that the present head belonged to that group and that it is from one of the twenty-four Elders.[3] It is also possible, however, that the head was part of a capital similar to those seen on the capitals at Saint-Lazare depicting the Magi before Herod, the Dream of the Magi, and the Adoration of the Magi (fig. 58). The first of these capitals had lost some of its heads by 1925, with further losses occurring later. As with the present example, lead pellets were used to fill the pupils of the eyes.

Beneath the feet of the huge, implacable figure of the Divine Judge who dominates the animated scenes of the Last Judgment in the west portal tympanum is carved the name of the artist who created this unforgettable work: "Gislebertus hoc fecit" (Gislebertus made this). The distinctive style of this great sculptor, who was allowed, exceptionally, to place his name in such a prominent location, had its roots in the abbey church of Cluny and can be found as well at Vézelay, but it is most evident in its maturity throughout the sculpture that adorns Autun. Gislebertus infused his work with swirling linear motion, grace, and a depth and variety of expression that is the epitome of Romanesque narrative.

27. Head of an Elder of the Apocalypse

France, Saint-Denis, ca. 1140
Abbey Church of Saint-Denis, center portal of west facade
Limestone, H. 9½ in. (24 cm)
Musée du Louvre, Paris (RF 516)

According to the vision revealed to John of Patmos, the Second Coming of Christ is witnessed by twenty-four Elders of the Apocalypse, who wear crowns and carry harps and golden vials (Apoc. 4:4, 5:8). This powerful head from Saint-Denis originally belonged to one of the Elders in the three outer archivolts of the center portal of the west facade, who accompany Christ of the Second Coming enthroned in the tympanum. But in the outermost archivolt, a vine representing the Tree of Jesse frames each figure, thereby making reference to the ancestors of Christ and to his royal lineage springing from the "root of Jesse" (Isaiah 11:1), thus conflating the imagery of the Elders with that of the kings and patriarchs of the Old Testament.

In about 1137, Abbot Suger (1081–1151) undertook to enlarge the Carolingian church of Saint-Denis, first by extending it to the west. The innovative triple portals of Suger's western extension, consecrated on June 9, 1140, initiated a series of Early Gothic *"portails royaux"* with entrances flanked by statue-columns. At Saint-Denis, the jambs, tympana, and archivolts of the portal contained a sculptural program of great sophistication and complexity, each part contributing to a unified statement. All of the heads in the portal were either mutilated or knocked off during the French Revolution,

and the figures were badly damaged. When the workshop at the abbey was disbanded in 1881, this head was one of three from the archivolts sent to the Musée du Louvre, Paris.[1] It belonged to the first Elder in the third archivolt on the right. Some reworking has modified the right eye, and most of the crown was cut away, yet vestiges of jewels and beading survive along the lower edge. The monumental, abstract style of the head looks back to stylizations of the Romanesque period. Adding to the stark power of the elongated face, flat bands representing eyelids or sockets emphasize the outsized, bulging eyeballs. Parallel striations define the straight, shoulder-length hair, the slightly drooping mustache, and the wavy beard, which is razor-cut along the cheeks. Below

the lower lip, overlapping the beard and centered on the chin, are two locks terminating in outward curls that provide an elegant embellishment.

The heads on a mid-twelfth-century Mosan baptismal font (cat. no. 39), possibly from the vicinity of Maastricht, provide close comparisons with this Elder.[2] Although somewhat more stark, the heads on the font (which is carved of an extremely hard, dark, calciferous stone) are equally powerful in conception. Like the Elder, they have low foreheads, curiously large, protruding eyes outlined with bands, and hair, mustaches, and beards articulated by deep, parallel, sometimes stiff striations. Of a facial type reminiscent of those seen in contemporary metalwork, the heads on the

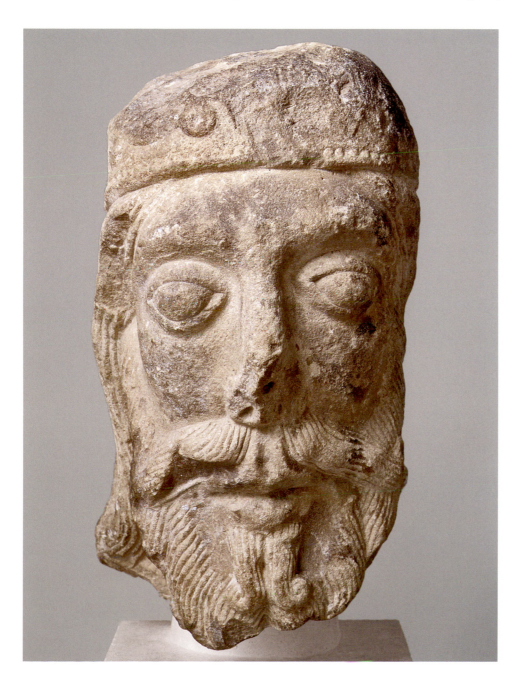

font, when compared with this head, reinforce the idea that metalwork influenced the sculptors working in stone at Saint-Denis. Since Abbot Suger specifically mentioned bringing in several goldsmiths from Lotharingia (modern Lorraine), it is possible he also summoned stone carvers from the Rhine-Meuse region.[3]

<div style="text-align: right;">PZB</div>

NOTES

1. Courajod 1878–87, vol. 3, pp. 400–403, fig. 401.

2. The Metropolitan Museum of Art, New York, 47.101.21; see Little 1987, pp. 164–65, no. 13 ("Baptismal Font").

3. Abbot Suger, *De Rebus in Administratione sua Gestis*, in Panofsky 1979, pp. 58–59.

EX COLLECTION

Magasins of Saint-Denis, until 1881

LITERATURE

Courajod 1878–87, vol. 3, pp. 400–403; Aubert and Beaulieu 1950, p. 60, nos. 52, 57; Blum and Crosby 1973, p. 254, pl. XXb–c; Little 1987, pp. 164–65, no. 13 ("Baptismal Font"); Blum 1992, pp. 98–99, fig. 30b–c; Baron 1996, p. 64; Châlons-en-Champagne 2005–6, pp. 60–61, no. 18

28. Head of an Old Testament King

France, Saint-Denis, ca. 1135–40
Abbey Church of Saint-Denis, center portal of
west facade (right jamb)
Limestone, H. 13¾ in. (34.9 cm)
The Walters Art Museum, Baltimore (27.22)

This head of an Old Testament king is one of two bought in 1911 by Henry Walters from the Parisian dealer Dikran Kelekian, who at the time described them as "thirteenth-century" works from the "Royal Cathedral of St.-Denis" (see also cat. no. 30). At first that provenance was regarded with suspicion, owing to heavy restorations in plaster. However, after careful study and "derestoration," which involved removing the plaster and repairing areas brutalized by restorers, the remaining original elements of an authentic head emerged, one that must be dated about 1135–40.[1]

The king's crown is battered and missing its projecting fleurons, but the original decorative pattern of jewels is fully understandable from the remaining portion on the right side of the head: large square-cut stones set on their points alternating with oval stones. In the spaces around the square-cut stones, small teardrop-shaped gems are readily visible, as is the top border of drilled "pearls." The upward sweep of the points of the crown and the bottom part of a fleuron are still

preserved. Details of hair and beard are also better preserved on the right side.

Long wavy locks that end in tight curls are pulled back across the forehead toward the back of the head and cover the upper part of the ear. The beard is composed of similar locks that turn away from the face. Most of the right eye is gone, but the left eye is largely intact. The large, almond-shaped eyes with drilled pupils are framed by shadows under the brow and smoothly modulated planes through the cheeks. The thin lips support a somewhat large mustache, the details of which are too damaged to read, and a little goatee covers the top of the chin. The planes of the face are smoothly modulated and, therefore, respond badly to harsh light. In natural light, the surface softens, as in the head of the Queen of Sheba, also from the center portal (fig. 59), and the head of a prophet from the south portal (cat. no. 29).

Marvin Ross investigated the claim that this head originated at Saint-Denis using drawings of the west facade statue-columns by Antoine Benoist (1725–28) previously published by Arthur Kingsley Porter (fig. 60).[2] Ross noted details in the drawing of the king identified as "Clothaire III" (from the right jamb of the center portal) that correspond closely to the Walters head, and he cautiously supported the attribution. In fact, the pattern of jewels on the crown and the treatment of hair and beard are so close, we can extrapolate from the drawing missing details such as the terminal

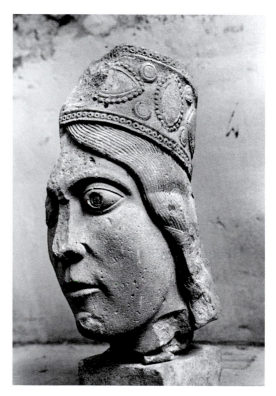

Fig. 59. Queen of Sheba, center portal, Abbey Church of Saint-Denis. Musée National du Moyen Âge, Thermes et Hôtel de Cluny, Paris (Cl. 23250))

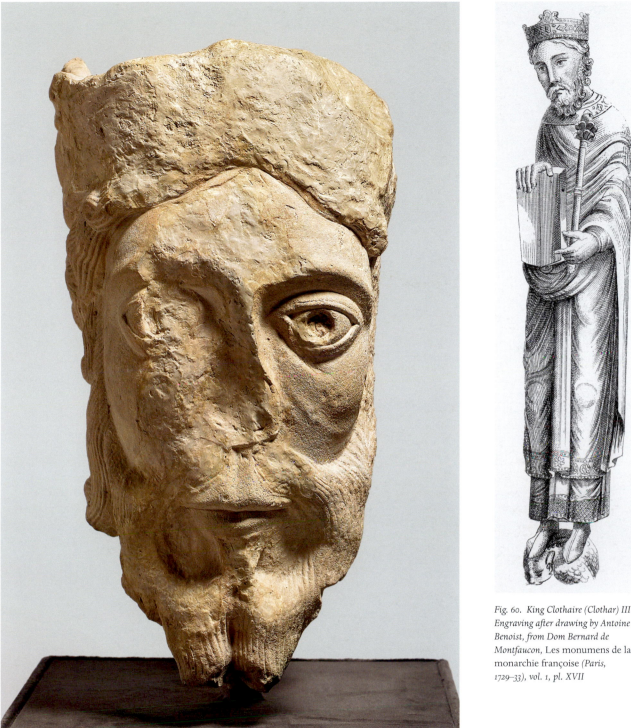

Fig. 60. King Clothaire (Clothar) III. Engraving after drawing by Antoine Benoist, from Dom Bernard de Montfaucon, Les monumens de la monarchie françoise (Paris, 1729–33), vol. 1, pl. XVII

curls of the beard and missing curls in the hair.[3] Final confirmation of that attribution has been provided by neutron activation analysis (NAA), which indicates that the limestone the king's head is carved of came from the same quarry or quarries that provided stone for four of the five other heads from statue-columns on the west facade of Saint-Denis.[4]

If we take the height of the Walters head (34.9 cm) and add it to the proportions of the figure represented in the Benoist drawing, we can estimate that the resulting statue-column would have been about 237 cm tall (an additional 3–5 cm would have been required to complete the carved socle, possibly a siren, on which the king stood). Thus, we can conclude that the statue-columns of the center portal

Fig. 61. *Photogrammetric view of center portal, west facade, Abbey Church of Saint-Denis*

occupied the entire height of the columns set in the door-jambs, and that the forward tilt of the nearly freestanding heads permitted a slight overlap (2–3 cm) with the lower zone of the capitals.

WWC

NOTES

1. The several stages of study and "derestoration" were documented by Marvin Ross; see M. Ross 1940.

2. Porter 1923, vol. 10, pls. 1445–57.

3. Thus, as demonstrated by Charles T. Little (see New York 1981, esp. p. 41), earlier disputes over the accuracy of the comparisons (see, for example, Providence 1969) can be dismissed.

4. Only the most recently identified head from the west facade (cat. no. 29) remains to be tested with NAA.

EX COLLECTIONS

[Dikran Kelekian, New York, until 1911]; Henry Walters, Baltimore

LITERATURE

M. Ross 1940; Charles T. Little, "Monumental Sculpture at Saint-Denis under the Patronage of Abbot Suger: The West Facade and the Cloister," in New York 1981, pp. 25–59, esp. p. 41

29. Head of a Prophet

France, Saint-Denis, 1137–40
Abbey Church of Saint-Denis, south portal of
west facade (left jamb)
Limestone, H. 16⅛ in. (41 cm)
Musée National du Moyen Âge, Thermes et Hôtel
de Cluny, Paris (Cl. 23415)

This is the most recently identified head from the statue-columns on the west facade of Saint-Denis, and only the second example from the south portal. Of the six heads now known from this pioneering ensemble, the present work is

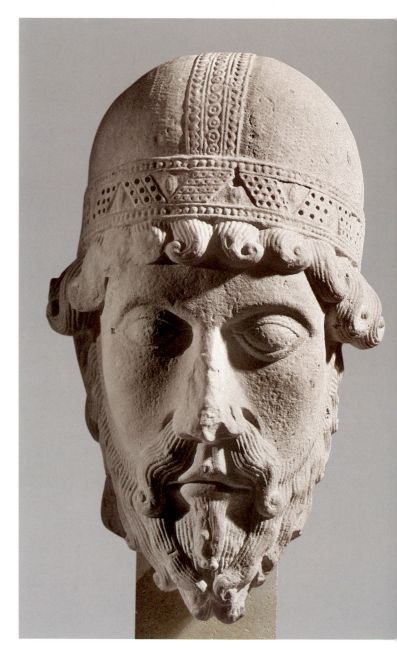

in the best condition and, except for some pitting and a missing nose, preserves much of its original surface.

The association of the head with a statue-column in the portal is based on comparison with the now-lost drawings by Antoine Benoist (1725–28) and the engravings after them made for Dom Bernard de Montfaucon (Paris, 1729–33). Xavier Dectot has traced the history of the use of the drawings and engravings to identify the heads originating from the west portals of Saint-Denis, noting that Marvin Ross (1940) was the first to apply the technique successfully, and that his results were generally accepted by French scholars, especially after Léon Pressouyre's identification of the Queen of Sheba's head in 1976 (see fig. 59).[1] One point that should be added to Dectot's discussion is that the drawings of the figures in the south portal, in addition to showing that one was already missing by 1729, are the only ones in which Benoist was careful to depict the eyes without pupils, even painted ones, suggesting that the paint was no longer visible in 1729. Both the upper and lower eyelids were carefully drawn, but the pupil area was left blank, almost as if the eyes were closed.[2]

The long, thin head is cylindrical in shape, especially when viewed from an angle, but it tapers to a fine point in the delicately carved beard, whose loose, wavy locks terminate in spiral curls. Instead of hanging, the locks of the beard pull in toward the chin to emphasize the taper. Below the straight, closed lips is a separate lock of facial hair, like a goatee, that enhances the axiality of the face. By beginning

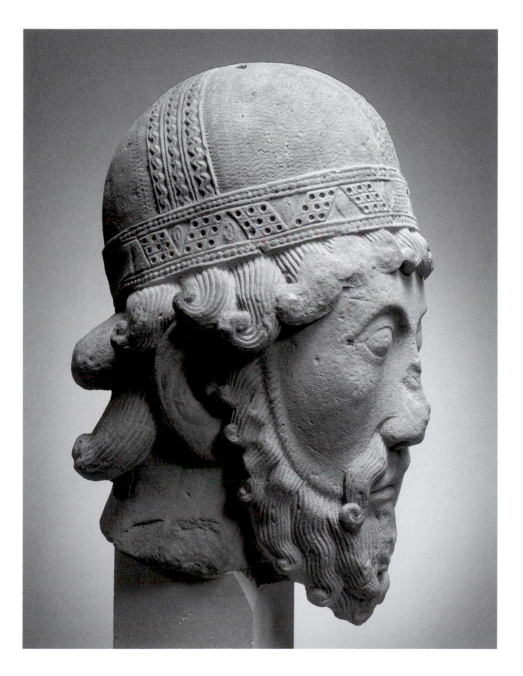

the beard in the sideburns, just below the curls of the hair, the sculptor effectively concealed the long straight ears set close to the head. The curls of the hair have the same form as the locks of the beard, but they are thicker and fuller and also end in tighter spirals.

Overall, the eyes and the crown are the head's most distinguishing features. Set under arched brows scooped out to create pockets of shadow, the slightly bulbous, almond-shaped eyes are highlighted by painted, rather than drilled, pupils. Traces of the darker pupils are still visible beneath the surface patina. The high cheekbones emphasize the abstract sense of surface modulation, which results in areas of smooth planes. The edge of the beard is marked by a line that separates beard from cheek, and by a groove in the beard itself that repeats the contour line with a band of shadow. As is true of all of the Saint-Denis heads, this one responds badly to harsh light, which makes the surface appear hard and shell-like; in natural light, the surface and features soften considerably. The rounded crown is decorated with a delicately carved band of drilled, finely detailed zigzag ornament with small almond-shaped jewels in the triangular interstices. Two additional carved bands run across the top of the crown, front-to-back and side-to-side. The patterns on the bands are so fine they resemble embroidery more than metalwork.

The form of the head gear, which is neither a royal crown nor a known ecclesiastical head covering, is one of two reasons why Dectot, following Alain Erlande-Brandenburg, identified the head as that of a prophet.[3] The second is that the figure of Moses, identified by the tablet of the Law he holds, is found in the south portal (it is the only identifiable figure in the three portals of the west facade). Moses is usually grouped with the leaders or patriarchs, however, not with the prophets, and his head gear differs to some extent from that of the present example. Nevertheless, given Abbot Suger's well-known idiosyncratic choices in iconography, it is certainly possible that this head represents a prophet.

WWC

NOTES

1. Pressouyre 1976. American scholars of the older generation (e.g., Crosby, Ludden, Rorimer, and Stoddard) had cautiously accepted those results, but there was a backlash and a questioning of the technique in the 1960s and 1970s, most notably by Stephen K. Scher (see Providence 1969, pp. 151–55); see also cat. no. 21.

2. This confirms André Rostand's declaration that Benoist was the best and most observant of the artists who worked for Montfaucon; see Rostand 1932.

3. Dectot 2005, p. 69, no. 63, and Erlande-Brandenburg 1992a, p. 69.

EX COLLECTION

Jean Rainaut, Paris, ca. 1923

LITERATURE

Erlande-Brandenburg 1992a; Erlande-Brandenburg 1992b; Laclotte 2003, p. 108; Dectot 2005, no. 63.

30. Head of an Old Testament King

France, Saint-Denis, 1137–40
Abbey Church of Saint-Denis, north portal of west facade (left jamb)
Limestone, H. 14¼ in. (36.2 cm)
The Walters Art Museum, Baltimore (27.21)

The ensemble of statue-columns in the three western portals of Saint-Denis, the first such groups erected on a Gothic facade, remained in place until 1771, when they were removed as part of an effort to enlarge the door openings to accommodate sedan-chairs. This head is the second of two heads bought by Henry Walters from Dikran Kelekian in 1911 that Marvin Ross identified as having originated on the west facade of Saint-Denis (dedicated 1140), in this case from the north portal (see also cat. nos. 28, 29).[1] Of the two, this one is the better preserved. Aside from general erosion in the beard on the right side of the face, damage is mostly limited to a missing section of the crown and forehead on the left side; the nose and the area around the eyes; and the back of the right side of the head. There is also some pitting in the cheeks and small pieces missing from the mustache and beard, but otherwise the distinguishing features of the head are intact. The unfinished area on the back of the left side is an indication that this area was not visible when the head was in situ.

The king's circular diadem is decorated with a broad center band containing a zigzagging pattern of inverse diamonds. The top and bottom bands are filled with continuous squares containing drilled holes. The hair is parted in the middle and rolled in long, wavy ropes that follow the contour of the forehead; they lift up and around the prominent ears before falling in curls to the nape of the neck. The mustache, twisted and rolled in a similar manner, falls gently around the mouth. The beard is created from small, somewhat short hanging locks similar to the tapering goatee below the lower lip. As with the head from the south portal (cat. no. 29), the edge between cheek and beard is outlined, and the curve is repeated through the beard by a shadowy groove. The wispy locks of the beard fall close to the jaw line and taper toward the chin; the center is missing its tips.

As Ross observed in 1940, Antoine Benoist's drawing of the figure identified as Childebert in the Montfaucon engravings (fig. 62) can be used to determine the missing parts of this head.[2] Clearly visible in the engraving (as with cat. no. 28) is a detailed representation of the crown, from the zigzag ornament to the upper and lower bands of jewels. Even more distinct is the way the roll of hair is pulled up and around the ears. Both eyes have sustained major damage, but it is evident that the pupils were originally drilled. When the head arrived at the Walters Art Museum the drilled pupils

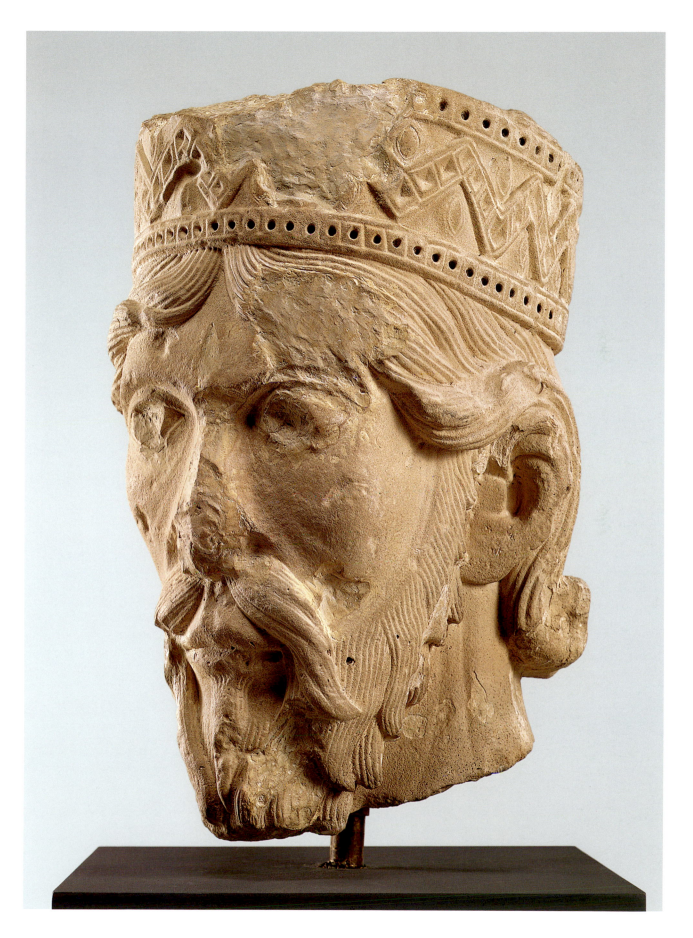

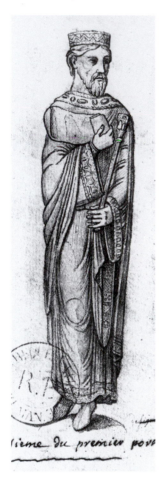

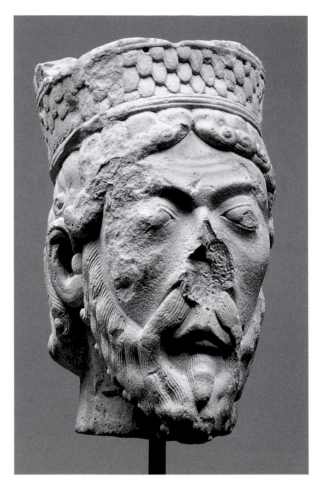

Fig. 62. King Childebert. Engraving after drawing by Antoine Benoist, from Dom Bernard de Montfaucon, Les monumens de la monarchie françoise (Paris, 1729–33), vol. 1, pl. XVI

Fig. 63. Head of a King, north portal of west facade, Abbey Church of Saint-Denis, ca. 1137–40. Fogg Art Museum, Harvard University, Cambridge; Harvey E. Wetzel Bequest Fund (1920.30.A)

had been filled in, a feature still visible in the other royal head from the north portal, now in the Fogg Art Museum, Harvard University (fig. 63).[3] (It should be noted that the pupils are more precisely defined in the drawing than in the head itself.) Both heads were tested using neutron activation analysis (NAA) and can be reliably attributed to Saint-Denis stone.

Although Montfaucon believed that the statue-columns on the west facade of Saint-Denis represented the kings and queens of France,[4] they were more likely monarchs, patriarchs, and prophets from the Old Testament, as Jean Mabillon argued.[5] More recently, Janet Snyder has convincingly demonstrated that the clothing worn by the figures was contemporary twelfth-century Parisian style, which might have facilitated the popular conception of them as both ancestral and contemporary French royalty.[6] Considering that they were installed on the royal abbey of Saint-Denis, there is every possibility that this dual meaning was intentional.

W W C

NOTES

1. M. Ross 1940, pp. 98–99.

2. Ibid.

3. Ross identified this head as being from Saint-Denis on the basis of the unusual petal or feather decoration on the crown.

4. Montfaucon 1729–33, vol. 1, pp. 193–94.

5. Cited in Vanuxem 1957, pp. 45–58.

6. Snyder 1996, pp. 467–502 (ch. 4, "Political Significance").

EX COLLECTIONS

[Dikran Kelekian, New York, until 1911]; Henry Walters, Baltimore

LITERATURE

Montfaucon 1729–33, vol. 1, pp. 193–94; M. Ross 1940, pp. 98–99; Vanuxem 1957; Charles T. Little, "Monumental Sculpture at Saint-Denis under the Patronage of Abbot Suger: The West Facade and the Cloister," in New York 1981, pp. 25–59; Cahn 1999, no. 5 (with earlier bibliography)

31. Head of a King

Southwest France, Aquitaine, Parthenay (?), ca. 1150–75
Limestone, H. 18⅛ in. (46 cm)
The Metropolitan Museum of Art, New York; Gift of Mr. and Mrs. Frederic B. Pratt, 1944 (44.85.1)

Secularization following the French Revolution placed many churches into the hands of private citizens, some of whom took the opportunity to demolish their new purchases in whole or in part, and even to sell off any items of value. One of the most celebrated of such dispersals involved Notre-Dame-de-la-Couldre in the Aquitainian town of Parthenay. A series of high-profile events in conjunction with the dispersal—spectacular sales, forgery, even suicide and possibly murder—made this church's sculptures among the most talked about of the 1910s and 1920s.[1] Works from Parthenay were particularly prized by collectors, who recognized them as exquisite examples of Early Gothic style and invoked them in the same breath as the portal sculpture of Chartres Cathedral.

A number of sculptures now in public and private collections trace their origins to Parthenay from these sales, including works now in the Isabella Stewart Gardner Museum, Boston; the Glencairn Museum, Bryn Athyn, Pennsylvania; and the Musée du Louvre, Paris. The Metropolitan Museum's crowned head does not benefit from so clear a provenance as those works, and its Parthenay origins have been questioned for more than half a century. It did, however, leave France in the same period as the others, for the head was already in the collection of Frederic B. Pratt by 1920, the year he loaned it to the Metropolitan for the Museum's fiftieth-anniversary exhi-

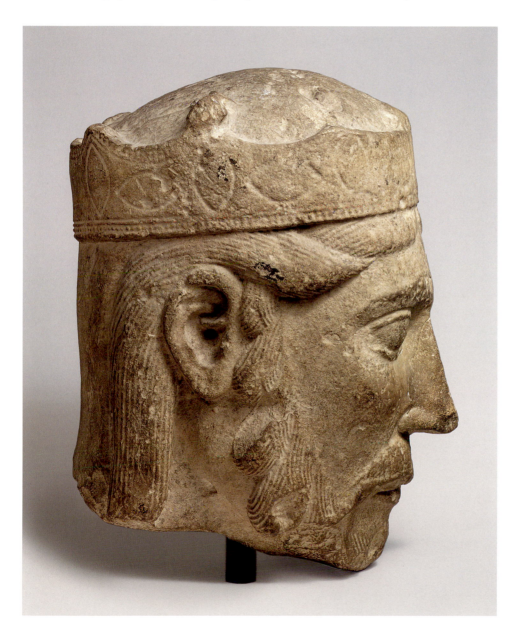

Fig. 64. Catalogue number 31 prior to restoration, ca. 1906–10. Photograph: Musée Turpin, Parthenay

bition.[2] The head formally entered the Museum's collection in 1944, and when curator James J. Rorimer published the piece a decade later, he described it as a "head of Christ" originating "probably from the facade of Notre-Dame-de-la-Couldre [Parthenay]." Rorimer had earlier published a study of Parthenay sculpture, and this no doubt fueled his speculations on the origins of the Pratt piece.[3]

A recently discovered photograph of the head appears to confirm Rorimer's hunch (fig. 64). This snapshot forms a pair with another photograph showing a related carved head; that head is identified by a tag on the sculpture itself and by a handwritten note on the verso of the print as originating at Notre-Dame-de-la-Couldre and as having been sold in 1910 to Victor Poulit of Nantes. Those indications for the one head cannot confirm with certainty the provenance of the other, but the photographs evidently place the two works concurrently in the studio of the antiquarian Valentin Guille, who sold a number of Parthenay sculptures (some that we can now identify, others that we cannot) to Poulit in 1910.

Apart from some retouches the head incurred while subsequently on the market—comparison with the old photograph reveals some reshaping, and notably the replacement of the nose and portions of hair—certain details, such as the striated hair falling back around the ears, the mustache over the pulpy upper lip, and the tussled beard, are all characteristic of Parthenay production. The crown's incised details, which evoke encrusted jewels and pearls, are likewise comparable to other local specimens. The relative lack of finesse, however, contrasts with the warm, naturalistic qualities of the bust figures in the Gardner, Louvre, and Glencairn museums, a discrepancy that would be partly explained if the head had originally been positioned high above the viewer and out of close view.

In fact, the figure's original placement and identification remain vexing questions. Although identified by Rorimer as a head of Christ, the sculpture may well belong to another type of figure. A large relief of a now-headless equestrian rider adorns the facade of Notre-Dame-de-la-Couldre, leading some scholars to connect the two. The Metropolitan's crowned head is only summarily carved toward the rear of one side, rendering plausible this placement (that is, turned slightly out toward the viewer). The head's dark, coarsely textured stone contrasts with that of the other works of the facade, however, and even with the remaining traces of the equestrian figure itself.[4] Moreover, neutron activation analysis (NAA), although inconclusive, has shown that the limestone of the head is somewhat inconsistent with that used for the facade's other sculptures.[5]

Some evidence suggests that other churches in Parthenay may have included monumental figures among their sculptures, leaving open the possibility that the head came from another local facade. Monumental riders adorn a number of Aquitainian churches, and although the archival evidence points to Parthenay, one cannot entirely exclude the possibility that the head originated from another, now-headless specimen, such as those in Civray and Benet. The evident popularity of these riders as an element of church sculpture in Aquitaine has not made their identity any less enigmatic. Constantine? Charlemagne? Local secular lords? Symbols of the Church Triumphant?[6] In the end, the figures may represent a subtle combination of these secular and religious models of contemporary rulership, eluding in the process any single named identity.

RAM

NOTES

1. See Maxwell et al. 2005.

2. In a letter to the Museum's director, H. E. Winlock (June 26, 1935), James J. Rorimer voiced concern over the head's authenticity and indicated closer examination was necessary before its acquisition.

3. Rorimer 1942.

4. The size of this head, too, places it on a scale far greater than that of the reliefs and the busts in the other collections, but it is difficult to determine if its proportions are appropriate to the equestrian figure in situ.

5. The ambiguous NAA results do not necessarily rule out the Parthenay provenance, since Parthenay's sculptors availed themselves of several different quarries for the monumental decoration of the town's ten churches. The Metropolitan head may therefore come from a still-unidentified quarry. See Maxwell et al. 2005.

6. Debate over their identity has animated scholarship for the past two hundred years. See L. Seidel 1981 and, most recently, Andrault-Schmitt 2001, both of which include extensive references to earlier bibliography.

EX COLLECTIONS

(?) Valentin Guille, Nantes, until 1910; (?) Victor Poulit, Nantes; Mr. and Mrs. Frederic B. Pratt, New York, by 1920

LITERATURE

Breck 1920, p. 182; Rorimer and Forsyth 1954, pp. 128, 130 (ill.); Franciscono 1962; Cahn 1969, pp. 53–68; Cahn and Seidel 1979, p. 78; Maxwell 2004; Maxwell et al. 2005

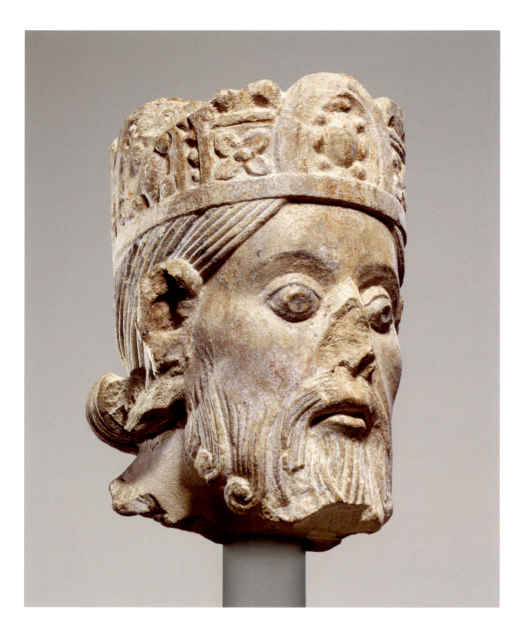

32. Head of a Magus

France, Strasbourg (Bas-Rhin), early 13th century
Strasbourg Cathedral, tympanum of north transept portal
Polychromed and gilded limestone (*grès blanc*),
H. 7 ½ in. (19 cm)
Private collection

This handsome head of a bearded king was found in a cellar on Strasbourg's rue des Frères, an indication that the sculpture is almost certainly from either the cathedral or one of the city's many other ecclesiastical monuments. Since its discovery about 1951 and its first publication by Robert Will, the head has been convincingly linked to the north transept portal of the cathedral, a small entrance leading onto the canons' cloisters. The tympanum of that portal once depicted the Epiphany along with the Adoration of the Magi and their return journey, but much of this area was eradicated when the cathedral was attacked first by Protestant iconoclasts from 1525 to 1530 and later during the French Revolution, when the choir screen was dismantled and the celebrated south transept portals lost major sculptures.

Enough of an outline of the Epiphany composition survives to show that the Three Magi approached the centrally enthroned Virgin and Child from the left. The present head certainly belonged to either the kneeling Magus or the next standing figure. The polychromy and gilding, likely original, remind us that the entire portal was once brilliantly colored, which, given the boldly articulated features of the head, must have made a strong impression when the ensemble was viewed from the pavement as one entered the church

from the cloister. This area was also protected from the elements, partly explaining the head's generally fine state of preservation, much like the mask from the cloister of Saint-Denis (see cat. no. 23).

In his 1966 study of Strasbourg Cathedral, Willibald Sauerländer articulated this head's important contribution to our understanding of the dramatic stylistic changes that took place in the cathedral's earliest sculpture and recognized the close affinities of that work to the late Romanesque sculptural decoration of the portal at the nearby parish church at Egisheim. In addition to similarities in overall facial form, these works share an approach to the rendering of the human head that is characterized by thick strands of hair and projecting eyeballs with slightly drilled pupils. These parallels are also key links in the evolution of the more famous and pioneering sculpture for Strasbourg's south transept portal by the Ecclesia Master (ca. 1230), which the present piece may predate by only a decade or two. What emerges is an apparent confrontation between the essentially Romanesque north portal and the radically different—and Gothic—south portal, one that yielded a seemingly rapid change of style.[1]

The present head has been directly connected by style and physiognomic type to the contemporary stained glass in the cathedral's north transept rose window, especially the scene of the Judgment of Solomon. The proportions and type of crown the king wears can be compared to that worn by a pharaoh in the famed codex *Hortus Deliciarum* created about 1185–90 for Herrad von Landsberg, abbess of the Alsatian abbey of Hohenbourg.[2] The head thus offers an important insight into the tendencies of the Gothic style in Strasbourg at a critical moment during its formation, when similar approaches to form and physiognomic expression were being explored in different media.

CTL

NOTES

1. See Haussherr 1968.

2. Sauerländer 1966, figs. 214, 215.

EX COLLECTIONS

M. J. Schwab, Strasbourg; [Charles Ratton and Guy Ladrière, Paris]

LITERATURE

Will 1951; Will 1955, p. 89, no. XL; Sauerländer 1966, pp. 127–34, figs. 213, 221

33. Head of King Herod

France, Chartres (Eure-et-Loir), 1210–30
Chartres Cathedral, choir screen
Limestone, H. 7 ⅜ in. (18.7 cm)
Private collection

The good are often made to look alike; villains, however, are individuated. This man—evidently so angry that his eyebrows undulate in double curves, and his nose, perhaps originally hawklike, descends without a break from his forehead—is Herod, chief antagonist of the Infancy of Christ, as depicted on the jubé (choir screen) of Chartres Cathedral. Whereas many church and cathedral choir screens represented the Passion, Chartres chose the Infancy to honor its relic of the tunic of the Virgin. Several reliefs from the Chartres jubé are preserved, among them the wonderful Nativity now in the cathedral's crypt—in which the Virgin turns in her bed with a gentle smile to touch the face of the Child lying in the manger—and the well-preserved and charming young Saint Matthew writing his gospel as dictated by an angel (Musée du Louvre, Paris).[1]

In 1972 Léon Pressouyre fit a cast of this head onto the body of the villainous king from a fragment of the choir screen, now in the crypt, showing the Magi before Herod (fig. 65).[2] He is seated cross-legged (a casual pose reserved for kings) beside the three now-headless Magi, and although his body faces forward, his head was evidently turned sharply to the right. Accordingly, the hair on that side of his head is only roughed out, and there the crown has none of the cabochons found on the other side. He raises his arm in a gesture of command, telling the Magi, as in Matthew (2:2–8), to find the newborn "king of the Jews" about whom he was hearing prophecies. Herod, of course, was disguising his fear of the usurper; only later were the Magi warned by an angel in a dream that they should not return to the king

Fig. 65. Magi before Herod, choir screen, Chartres Cathedral (Eure-et-Loir), ca. 1225–50

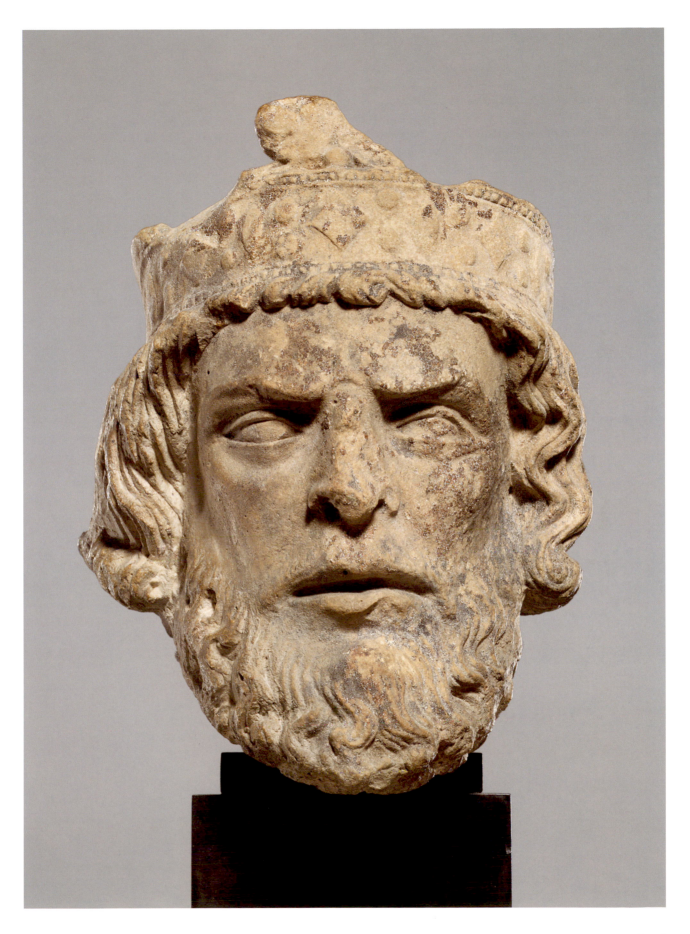

because he did not intend, as he had told them, "to come and adore" the infant. Nevertheless, the sculptor chose to represent the "true" face of Herod in this moment, capturing the monarch's anger and clearly conveying a threat that in the biblical narrative is only made apparent later.

The jubé reliefs at Chartres were arranged above an arcade on delicate columns spanning the opening to the east end of the cathedral. In the thirteenth century many cathedrals had acquired such screens, which supported platforms whence a priest would deliver a sermon. By the seventeenth century such screens had been deemed old-fashioned, and they also prevented the faithful from viewing the altar, which after the Counter-Reformation had become more desirable. Between 1648 and 1774 many choir screens were torn down, including those of Amiens and Bourges, some leaving no trace.[3]

The canons and bishop of Chartres worried about the stability of their own structure, fearing the reliefs might fall off. In 1783 they consulted an architect, who recommended tearing it down, and after much deliberation the screen was dismantled. A fire in 1836 led to some excavation in the crossing, where several of the jubé reliefs were discovered turned upside-down, serving as paving blocks. The rest of them, including the Magi before Herod, were excavated deliberately in 1849. Why so many heads from the reliefs had been carefully cut off and their noses smashed remains a mystery. Some of them turned up embedded in exterior walls in the town, while others showed up on the art market. This head of Herod is weathered on the proper left side as if it had been partially embedded for some time in an exterior wall.

GW

NOTES

1. For the choir screen at Chartres in general, see Mallion 1964.

2. The scene was accompanied by the Adoration and the Dream of the Magi. It is possible the Massacre of the Innocents was present as well.

3. Some, however, were extended around the choir; at Notre-Dame in Paris, for example, the older jubé was mostly lost, but the fourteenth-century enclosure around the other sides was retained.

EX COLLECTIONS

Private collection, Chartres; [Joseph Altounian, Mâcon]; John Simon, 1926; [Ernest Brummer, 1931]; Walter C. Baker, New York, 1932; [sale, Christie's, New York, June 13, 1985, lot 188]

LITERATURE

Pressouyre 1972b

34. Head of a King

France, Chartres (Eure-et-Loir), 1210–30
Chartres Cathedral, choir screen
Limestone, 6½ in. (16.5 cm)
Bowdoin College Museum of Art, Brunswick, Maine; Gift of Edward Perry Warren, Esq., Honorary Degree, 1926 (1915.100)

Like the head of King Herod (cat. no. 33), this charming yet powerful head of a king is from the jubé (choir screen) of Chartres Cathedral. The crown—which has beading along the top and bottom bands and, in the center band, alternating round and diamond-shaped cabochons framed by four small round jewels—is similar to that worn by Herod and another king in the fragment showing the Dream of the Magi still at the cathedral, suggesting that they were all carved after a workshop model. The manner in which the beard on this face emerges from the cheeks, and the thick, separated strands of hair are also comparable to the Herod figure, although here the younger monarch's short, fine-whiskered beard contrasts with the elaborate undulations of his hair.

Less weathered than the Herod head, the Bowdoin king also has a somewhat stonier countenance, particularly in the unnuanced modeling of the cheeks and the sharp definition of the crease near the nose. It is certainly not by the same sculptor who carved Herod, given that figure's bold suggestions of flesh. Indeed, the range of styles in the Chartres jubé indicates that sculptors of many ages, or from different ateliers, must have worked on it, perhaps over a period of several years. Like so many Gothic heads, particularly of kings, this one had its nose smashed, and another blow abraded the right eyebrow. Fortunately, most of the brow, the prominent lower lip, with its emphatic double line, and the heavy-lidded eyes were spared, so that the monarch's benign and untroubled expression remains strong.

Léon Pressouyre fit a cast of this head onto a fragment of the choir screen reliefs still at Chartres, as he did with Herod. The head fit onto the neck of a man who is wearing a cape, wound about his arms and upper torso, over a tunic with a brooch. The figure's missing right hand may have held the cape string. Both the costume and the gesture are associated with kings. The neck of the figure is bent so that the head, when fitted onto it, looks down, as if from a raised location. Pressouyre noted a narrow vertical trough in the back of the bust, which suggested to him that the statue had been cut away from a colonnette. He also thought that the rectangular hole on the top of the head might have received the end of a metal rod securing it to the colonnette. Neither attachments nor colonnettes were used in the narrative reliefs of the Chartres jubé, however, so the exact placement of this king is uncertain.

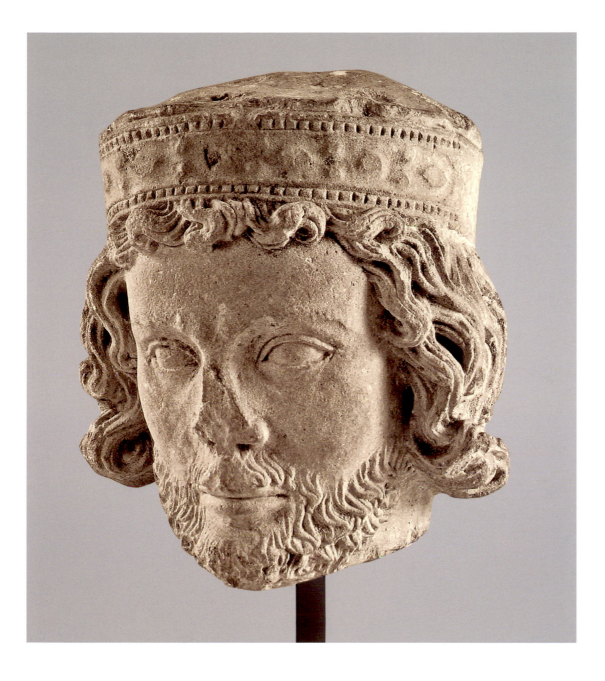

The oddly uneven destruction of the Chartres choir screen has left more than one mystery in its wake. Engravings of it—distant views with few details that often differ from one to another—do not show any figures against colonnettes, but they represent only the front of the structure, which projected before the crossing piers. This king, and presumably other figures as well, might have stood at the sides or even against the back wall under the walkway supported by columns and colonnettes. Although the limestone the head is carved of has not been tested using neutron activation analysis (NAA), the style of the sculpture seems appropriate for the site, and the size of the head and crown fit the fragmentary figure.

GW

EX COLLECTIONS

J. H. Fitzhenry, England; [Carfax and Co., London]; [sale, Christie's, London, November 19, 1913, lot 312]; Edward Perry Warren

LITERATURE

New York 1970, vol. 1, p. 19, no. 24; Pressouyre 1972a, 1972b; B. Stoddard 1975; Brooks W. Stoddard, "An Attribution for a Gothic Head of a King from the Bowdoin College Museum of Art," in Burke 1981, pp. 49–50, 63; Gillerman 1989, pp. 336–38, no. 248

35. Head of the Virgin

France, Île-de-France, ca. 1320–40
Marble with gilding on crown, H. 8 7/8 in. (22.5 cm)
Private collection

The percussive marks on the forehead tell us that this elegant marble sculpture of the Virgin was violently separated from its original context. It falls to the art historian to discover what that context was, and thereby to reclaim some of the history of the sculpture effectively erased by that fateful blow. One can see in the head why the beauty of marble, particularly the way the polished stone so closely imitates flesh, had long made it a desirable material. Here the smooth articulation of the face, the wavy hair, the natural proportions, and the type of crown—an impressive specimen that was originally enriched by glass or semiprecious stones and topped by projecting fleshy leaves—relate this head to a group of marble Virgins carved in the Île-de-France in the second quarter of the fourteenth century. Among the finest of these are the Virgin and Child from Pont-aux-Dames (Seine-et-Marne) now in the collection of the Metropolitan Museum (17.190.721); the Virgin in the parish church at Boulée (Loire-Atlantique); and the Virgin from the church of Saint-Savinien in Sens (now in the parish church at Bourbonne-les-Bains [Haute-Marne]).[1]

There is a similar treatment of forms, especially of the crown, in the large marble Virgin and Child known as Notre-

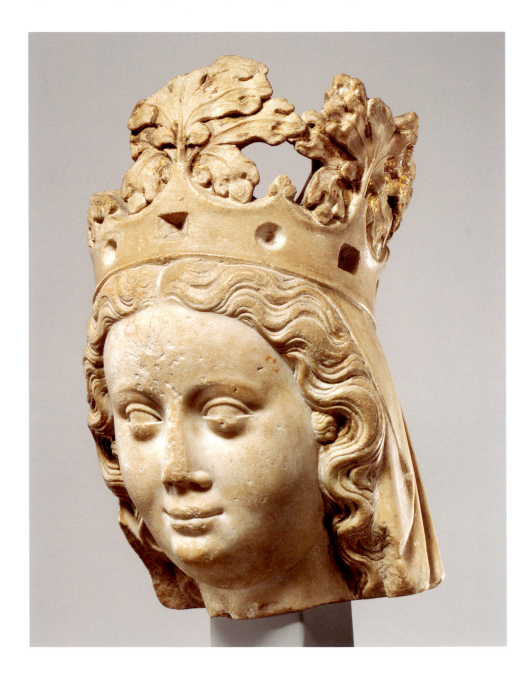

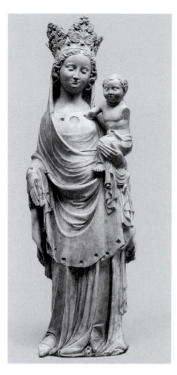

Fig. 66. Virgin and Child. France, ca. 1325–50. National Gallery of Art, Washington, D.C.; Samuel H. Kress Collection (1961.9.99)

Dame-la-Blanche in Saint-Germain-des-Prés,[2] a sculpture originally given to the abbey of Saint-Denis in 1340 by Jeanne d'Evreux, queen of France.[3] In addition, there are noticeable relationships between this head and several other marble statues, such as the Virgin at Neuillé-Pont-Pierre (Indres-et-Loire) near Tours, which in terms of technique and style is similar to the face of the Charles IV effigy at Saint-Denis (1327–29). This type of Virgin—with a round face framed by wavy locks and a high, floral crown studded with stones or glass—can also be seen in a number of examples in the Oise Valley, such as those in the parish churches at Boubiers, Catenoy, and Gouvieux.[4]

The present head exhibits particularly striking parallels to a complete marble statue of the Virgin and Child in the National Gallery of Art, Washington, D.C. (fig. 66), and it is possible that the two works, nearly the same size proportionally, were carved by the same sculptor. The Washington Virgin and Child, possibly from the chapel at Château de Sasangy (Saône-et-Loire), bears a few traces of gilding (as does this head) and polychromy, but it was aggressively cleaned in recent times.[5] Nevertheless, it shows us the classic form of the marble statues being produced in the Île-de-France during this period, as it also provides a more complete picture of the devotional images made for the burgeoning cult of the Virgin that were so ubiquitous in fourteenth-century France.

One key question is whether these marble sculptures, especially those of the Virgin and Child, were produced centrally (presumably in Paris) and then exported to other regions. Although the location and control of medieval marble quarries have not been systematically studied, the marble of this head and that of the Washington sculpture appear to have come from Carrara, but the Pyrenees cannot be ruled out.[6] The present head and its original figure were likely carved in Paris—the exceptional refinement of the work being typical of French courtly art during the reign of Charles V (r. 1364–80)—but a center in close touch artistically with the capital is also possible. The multiple examples of similar cult images in and around Paris and the Île-de-France would also suggest that Paris was most likely a center of production. And we can glean from documents that such works—many now lost—were indeed exported, such as two statues, described as alabaster but perhaps actually marble, sent from Paris to Artois in 1322.[7]

It should be noted that in the few surviving documented commissions for statues of the Virgin and Child in northern France during the High Middle Ages there is a persistent confusion between alabaster and marble. The 1329 commission of Netherlandish sculptor Jean Pépin de Huy for an "alabaster image of our Lady given to the Ladies of Gosnay" (the Carthusian nunnery of Mont-Sainte-Marie in Pas-de-Calais) seems straightforward, but in fact that work, now in the Musée des Beaux-Arts, Arras, is marble. The same confusion holds true for the Metropolitan Museum's marble Virgin and Child (24.215) ordered in 1345 by the Beguines at Saint-Diest, in the Meuse Valley.[8] Jean Pépin de Huy came from that region, as his name indicates, but he was active in Paris by about 1311–12 and was working on the royal tombs at Saint-Denis, notably that of Charles IV, from 1327 to 1329. The present head and the other devotional images in marble from this period may well be products of the same Parisian artistic context.

CTL

NOTES

1. See Paris 1981–82, nos. 36, 32, 27.

2. Suckale 1971, p. 195, fig. 32.

3. Alexandre Lenoir had tried to obtain this sculpture for his Musée des Antiquités et Monuments Français, but it was given to Saint-Germain-des-Prés in 1815. See Saunier 1899 (kindly brought to my attention by Mary Shepard); see also Huard 1938. The provenance is accepted with caution by Françoise Baron in Paris 1981–82, p. 134. See also Boehm 2000, pp. 35–87, esp. p. 47.

4. Baron 2001, figs. 354, 358, 360.

5. Middeldorf 1976, pp. 86–87, no. K 2161 (entry by Charles Avery), fig. 137.

6. See Blanc 1992, pp. 23–26.

7. Schmidt 1971, p. 168 n. 36, after Richard 1879, p. 296, no. 2.

8. Paris 1981–82, no. 8. See also Schmidt 1971; Beaulieu and Beyer 1992, p. 82. For the Diest figure (acc. no. 24.215), see Forsyth 1968, fig. 1, and Namur 1993, esp. pp. 40–44.

EX COLLECTION

Dorothy Blumenthal, New York; [William Doyle Galleries, New York, January 22, 1986, lot 642]

LITERATURE

Doyle 1986, lot 642; New York 1987a, no. 20

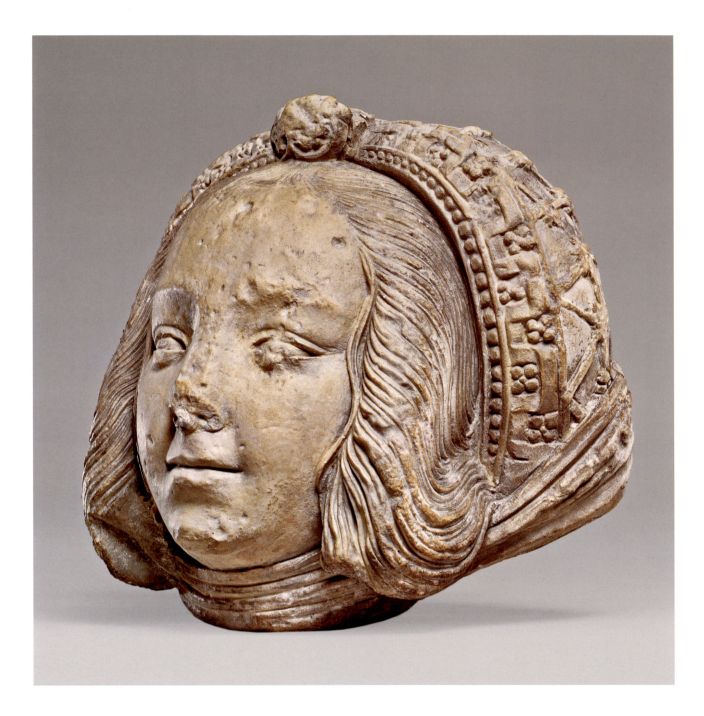

36. Head of a Woman

France, first quarter of the 16th century
Limestone, H. approx. 9 in. (22.9 cm)
Private collection

The destruction of a monument, always tragic, is some-
times also so thorough that associating the scattered frag-
ments with the original ultimately proves impossible. Such
is the case with this beautiful, richly carved head, which is
subtly animated by a faint smile. Probably not an actual por-

trait, it is more likely from a religious context, and therefore
a saint. Judging from the elaborate jeweled cap, which along
with the head's overall style support a date in the first quar-
ter of the sixteenth century, the head could be from a statue
of one of the popular female saints—Barbara, Catherine, or
Mary Magdalen—since they were often depicted in contem-
porary painting and sculpture wearing especially luxurious,
and at times somewhat fantastic, clothing.

The evolution of sculptural forms from the early
fifteenth century to this moment in the sixteenth century—
a period immediately preceding the deliberate importation
and subsequent domination of Italian Renaissance elements

in art and architecture—witnessed a mingling of French and Netherlandish sensibilities that moved sculpture toward a new realism. The most dramatic and influential of these developments emerged toward the end of the fourteenth century with the appearance of the work of Netherlandish sculptor Claus Sluter (ca. 1360–before 1406) and his immediate followers, who were active at the Burgundian court both in Burgundy and Flanders. Sluter's powerful, naturalistic style helped determine the course of sculptural development in western Europe for much of the next century, and it is the ultimate source for the careful expression of emotion and the meticulous detail seen in intriguing albeit fragmentary form in this head.

Closer in date and more specific in influence is the sculpture of Michel Colombe (active 1496–ca. 1515; see also cat. nos. 60, 61). Colombe's style, particularly as seen in the head of Prudence from the tomb of François II de Bretagne in Nantes (ca. 1500; see fig. 86), is an important example of sculptural developments in central France, especially in the Bourbonnais, during the second half of the fifteenth century.[1] Typical of the facial type from this region is the high forehead, small pointed chin, faint smile, and narrow, slightly slanted eyes, also found in the present head. Itinerant ateliers—such

as one possibly from Burgundy that carved the figures on the choir enclosure of Albi Cathedral (especially that of Judith) in about 1500—spread this facial type into other regions, where distinctive variations on a local style often appear to be related to, and influenced by, neighboring styles. Such variations can be seen in sculpture from this period made in Champagne, including a number of figures that have the same kinds of elaborate head gear but a range of facial types, a few of which show Bourbonnais characteristics, such as the Saint Martha in the church at Arrelle (ca. 1515).[2]

One of the few relatively close comparisons with the present head that can be made among the work of the Troyes ateliers that became especially active in the early sixteenth century is the head of the Virgin from the famous Visitation group in the church of Saint-Jean at Troyes (fig. 67), possibly from the hand of one of the Flemish sculptors working in Troyes at the time. The voluminous, heavily decorated drapery and the detailed accessory elements are all typical of late medieval sculpture as it developed from the latter half of the fifteenth into the early sixteenth century. Although some details, such as the handling of the scarf that secures the Virgin's hat or the carving of her hair, show distinct similarities, the specific modeling of the facial features of both Elizabeth and the Virgin are clearly different from that of the present head. Thus, except for the general observations already noted, it is not possible to determine the exact geographic origin of this beautiful and expressive head.

SKS

NOTES

1. See Gaborit 2001, p. 9.

2. Regarding costume, see, for example, the two Holy Women from the Entombment group from Moncheux (Moselle) from about 1510 (Staatliche Museen zu Berlin) or the Holy Woman in the church at Génicourt-sur-Meuse (Meuse) of about 1510. The Saint Martha is cited here as a comparison for facial type only.

EX COLLECTION

Baroness Marie Cassel van Dorn

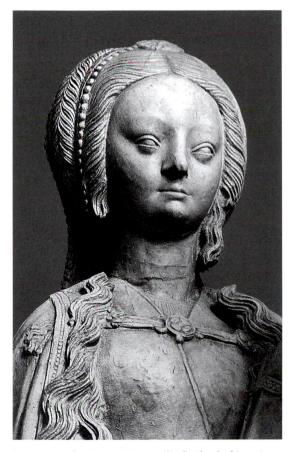

Fig. 67. *Virgin from a Visitation group (detail), Church of Saint-Jean, Troyes (Aube), ca. 1525*

37. Head of Christ

Netherlands, North Brabant, late 15th–early 16th century
Limestone with traces of wood, H. 9 9/16 in. (24.3 cm)
The Metropolitan Museum of Art, New York; Purchase,
Rogers Fund; Gifts of J. Pierpont Morgan, George Blumen-
thal and Messrs. Duveen Brothers, by exchange; Bequests of
George Blumenthal, Michael Dreicer, Theodore M. Davis
and Anne D. Thomson by exchange; and Mr. and Mrs.
Maxime L. Hermanos Gift, 1983 (1983.406)

By the late fourteenth century, religious expression, both lit-
erary and in the visual arts, had begun to include and even to
concentrate on the specific physical aspects of the Passion of
Christ and the Passion of the Virgin. This development gen-

erated new and often highly emotional subjects in the Pas-
sion, many of them based on mystery plays and the descrip-
tions of visions of such mystics as Saint Bridget of Sweden,
Saint Gertrude, Henry Suso, and Johannes Tauler.[1] The
ordeal of Christ in the events leading up to and including the
Crucifixion were expressed in horrifying detail in the repre-
sentation of the Mocking of Christ, the Flagellation, the
Ecce Homo, Christ Seated on Calvary, and the Man of Sor-
rows. The corresponding agony of the Virgin Mary was
described in her Seven Sorrows, which included not only
events from the Infancy of Christ and the Crucifixion but
also her participation in its aftermath, such as the Pietà and
the Entombment. Throughout the fifteenth and sixteenth
centuries images of these events, in painting and sculpture,
focused on their most pathetic aspects, often in highly exag-
gerated terms. One needs only to call to mind the striking

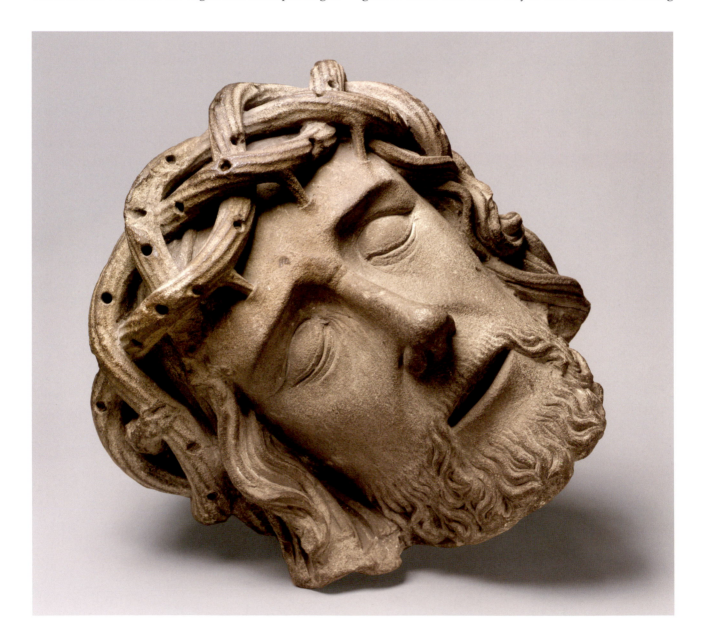

illuminations of the Hours of Rohan (ca. 1414–18), the work of Matthias Grünewald (Mathis Gothart Nithart, b. ca. 1475–80, d. 1528), or any number of representations of the body of Christ bound and covered in bleeding wounds to realize the intensity of feeling behind such works of art.

The head of Christ exhibited here has usually been associated with a Pietà group. There are, however, several factors that suggest the work's original source was an Entombment ensemble, in which Nicodemus and Joseph of Arimathea are placing the body of Christ in a sepulcher, accompanied by the Virgin Mary, Saint John, Mary Magdalen, and two additional Holy Women. The resolution of this ambiguity hangs on a question of provenance. In 1992 the Dutch art historian A. M. Koldeweij claimed emphatically that the present head was exhibited in 's-Hertogenbosch during World War II, at which time it was said to have come from the cathedral of Saint John in that city.[2] Koldeweij added that the family who owned the head prior to its possession by the Munich dealer Dr. Julius Böhler confirmed this provenance. In 2001 the head was illustrated in a corpus of the work of Hieronymus Bosch accompanying an exhibition in Rotterdam. There it is stated categorically, but without any supporting evidence, that the tomb of a neighbor of Bosch's, one Lodewijk Beys, was located before a representation of the Holy Sepulcher in the cathedral of Saint John and that the Metropolitan's head is the only survivor of this sculptural group, whose donor may have been Beys.[3]

In his extensive monograph on the cathedral, Cornelis Peeters makes no mention of any large Entombment or Pietà group, but his description of the sculpture in the church was limited to works in wood that were still present in 1985 and does not include works that may have been in existence at an earlier date, leaving open the possibility that there was indeed such a group.[4] The iconography of the head suggests that it could be from either a Pietà or an Entombment. The carving of the hair remains unfinished on the top of the head, where there is also a large hole and some losses to the surface. This detail might support the contention that the head comes from an Entombment, in which case it would have been resting against the shroud or one of the figures supporting the body.

Stylistically the head appears to be related to work made in the eastern Netherlands at the end of the fifteenth century. As pointed out by William D. Wixom, it bears a strong resemblance to a limestone Christ Seated on Calvary excavated in the yard of a church at Azewijn (ca. 1500).[5] The evolution of such increasingly detailed and naturalistic forms of representation begins in the fourteenth century and reaches an initial climax with the sculpture of Claus Sluter (ca. 1360–before 1406) from Haarlem, who worked primarily for the duke of Burgundy from the end of the fourteenth through the beginning of the fifteenth century. Sluter's influence was incalculable in France, the Netherlands, and the Rhineland, leading to a further culmination in the work of another innovative Netherlandish artist, Nikolaus Gerhaert von Leiden (active 1460–ca. 1473; see also cat. nos. 74–76). This head of Christ has its own originality and character, combining some degree of abstraction (in the simple planes of the forehead and cheeks; the sharp ridges of the eyebrows; the perfunctory carving of the mustache and beard; and the linear depiction of the closed eyes) with a particularly moving depth of expression (in the bulging, downward-sloping eyes; the partially open mouth; and the effective transformation of stone into flesh by the cadence of the thorns piercing the forehead). Despite having been separated from its original setting, the head still conveys, as do so many works from this period, the intense pain and suffering of the Passion.

SKS

NOTES

1. For an introduction to this subject that includes updated references, see Mâle 1986, ch. III, "Religious Art Expresses New Feelings: Pathos," pp. 81–135, esp. pp. 116–31.

2. Letter to William D. Wixom, February 2, 1992, in the files of the Department of Medieval Art and The Cloisters, The Metropolitan Museum of Art.

3. Rotterdam 2001, p. 39, fig. 31.

4. Peeters 1985, pp. 365–66. The cathedral and its contents were badly damaged during periods of iconoclasm in 1566 and 1629, presenting us with yet another example of how such fragments became separated from their original settings and were then set adrift in a sea of uncertainty.

5. Now in the Museum Catharijnconvent–Museum voor Religieuze Kunst, Utrecht, ABM bs692; see Bouvy 1962, pp. 110–11, no. 186, fig. 64. Cited by William D. Wixom in New York 1999, no. 246, where he acknowledges the proposal of this statue by Dr. Marieke van Vlierden in a letter of September 23, 1997.

EX COLLECTIONS

Private collection, Brabant; [Dr. Julius Böhler, Munich]

LITERATURE

Böhler 1982, no. 59, pl. 45; William D. Wixom in *Notable Acquisitions, 1983–1984: Selected by Philippe de Montebello, Director*, New York, The Metropolitan Museum of Art (1984), p. 16 (ill.); Worcester 1985, pp. 39–40, no. 1 (ill.); New York 1999, pp. 203–4, no. 246 (ill.) (entry by William D. Wixom); Rotterdam 2001, p. 39, fig. 31

What Are Marginalia?

Janetta Rebold Benton

I<small>N</small> the context of medieval art, the term *marginalia* refers to works that were literally created for the physical and iconographic peripheries, from architectural elements such as capitals, corbels, and bosses to church furnishings such as baptismal fonts and misericords. Consequently, most examples of sculptural marginalia in the Middle Ages were likely located in high or low rather than in prominent positions. These sculptures often served functional purposes. Capitals and corbels supported the church structure, while misericords, or "mercy seats," aided the clergy by enabling them to sit during long services while appearing to stand. Such elements would have functioned equally well without sculptural embellishment, but the medieval mind evidently considered such decoration, even at the borders and edges, mandatory. God's house, it was believed, should be honored by enrichment.

As many of the works in this exhibition demonstrate, medieval art is dominantly religious in message and didactic in purpose: for example, those figures located on the facades of churches and cathedrals that were designed to maximize the effectiveness of iconographic programs. Marginalia, in contrast, were not obligated to instruct. Thus freed, for the most part, from the strictures of tradition and the requirements of narrative, the medieval artists who created these works were permitted some latitude in subject and style and seem to have welcomed the opportunities for invention. The range of subjects found in marginal areas appears almost limitless, including all manner of flora and fauna, both real and imaginary, or a combination of the two. Although these subjects can often be identified, organized, and categorized by the art historian, two identical marginal images are unlikely to be found since precise duplication, free of the variations introduced by the human hand, is a modern goal that was unfamiliar in the Middle Ages. Working with hammer and chisel, the artists responsible for marginal works are comparable to contemporary manuscript illuminators working with pen and ink, especially in the latter's evident affection for the eccentric as they created the minute monsters and marvels that enliven folio edges. Wit and whimsy, then—as repeatedly seen in the ancillary areas of cathedrals and churches as well in manuscripts—coexisted with propriety and piety in the medieval world.

Like many of the other sculptures in this exhibition, most fragments of marginalia were long ago removed from their original contexts, the most telling sources of information about their identities. Some are presumed to be depictions of church notables or caricatures of local people known to the artists, including patrons, fellow workers, neighbors, friends, or even enemies, in which case what we are left with is

possibly a sculptor's gratitude, or revenge, immortalized in stone. Some may be self-portraits: a kind of signature for the illiterate. The heads with foliage issuing from their mouths can be counted among the many Green Men (or Leaf Men) created during the Middle Ages. These include a twelfth-century French double stone capital (cat. no. 40) and a fifteenth-century English wood boss (cat. no. 45), just a small sampling of the chronological, geographical, functional, and material diversity seen in this subject. Certain heads, such as that on the twelfth-century prior's portal at Ely Cathedral (fig. 68), may once have kept perpetual watch at doorways and entrances. And some of these, especially those with enlarged eyes, may reflect the medieval belief that everyone is always visible to God. Because physiognomy was studied during the Middle Ages, it is also possible that the nooks, crannies, and crevices of these carved facial terrains conveyed information about personality and character in ways unfamiliar to modern viewers.

Since fewer rules of religious and artistic convention applied in the margins, conformity was sometimes bypassed in favor of an artist's personal style, from significant distortion (cat. no. 38) to idealized perfection (cat. no. 43). Canonical physical beauty is not characteristic of marginal art, however; the exaggerated and the grotesque were clearly favored, and in many cases artists appear to have intentionally avoided the traditional proportions that characterize the faces of biblical and other religious figures. Using the human head as a point of departure, the sculptors

Fig. 68. Corbel Head, prior's portal, Ely Cathedral, 12th century

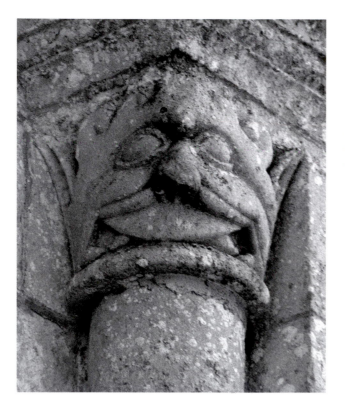

Fig. 69. Capital, north flank exterior, Church of Saint-Pierre-de-la-Tour, Aulnay-de-Saintonge (Charente-Maritime), 12th century

responsible for marginalia—ever inclined to the ornamental in their approach to anatomy—simplified, abstracted, and repeated elements for design purposes. At times anatomy was so malformed, the artist seems to have been exploring the extent to which a head can be distorted before it ceases to be identifiably human. This penchant for deformation occasionally produced amusing results, as seen on a twelfth-century column capital on the north side of the church of Saint-Pierre in Aulnay (fig. 69).

Given the range of physical types created by medieval artists, it is curious that these human heads do not express a fuller range of human emotions: happiness, sadness, fear, anger, and much more. The absence of any intentional indication of emotion through facial expression is characteristic of Romanesque art, perhaps with the exception of overtly fierce gargoyles and grotesques. In general, human facial expressions began to appear on sculpture during the Gothic era, with the first smile seen about 1200 (see "The Fate of the Face in Medieval Art" by Willibald Sauerländer, in this catalogue). The man on a fourteenth-century misericord from Wells Cathedral (cat. no. 43), for instance, knits his brow in worry. If this is in response to the weight of the clergyman sitting above him, then an element of humor was intended, and the frown on his face may have been intended to elicit a smile on the viewer's face. More frequently, however, it is the notable physical distortion of the marginalia heads that lends them their engaging expressiveness.

38. Fragment of a Voussoir

England, probably Herefordshire, ca. 1130–50
Sandstone, H. 6 in. (15.2 cm)
Lionel Goldfrank III

The carving on the front of this wedge-like block of red sandstone depicts the face of a goggle-eyed, bearded figure wearing a crown. The overall shape suggests the block was a voussoir, or part of an arch, in a decorated archivolt. The figure's prominent eyes are incised and outlined with a heavy ridge similar to the two parallel ridges of the furrowed brow, and the pupils are incised, recalling the well-known relief sculptures at the parish church of Saint Mary and Saint David at Kilpeck, Herefordshire, in the English West Country. The Kilpeck sculptures, generally dated to about 1130 to 1140, are the best known and best preserved of

the region's homogeneous Romanesque carvings,[1] and they are particularly profuse: including the interior sculpture on the chancel arch; an extensive corbel table on the exterior of the apse; and the richly decorated south doorway, with its tympanum and surrounding archivolts (fig. 70). The boldly carved fragment exhibited here has similarities with many of the heads at Kilpeck, but it compares most closely with the so-called beakheads and grotesques of the sixteen voussoirs surrounding the tympanum of the south doorway.

The figure's crown is surmounted by a cross carved in relief at the center. A bearded man wearing such a crown most likely represents one of the Elders of the Apocalypse, frequently seen surrounding images of the Last Judgment. The Elders are not found at Kilpeck, however, nor are they found elsewhere in the Romanesque sculpture of the region, but connections between the west of England and western France have long been noted.[2] The western French churches at Saint-Jouin-de-Marnes (Deux-Sèvres), Saintes,

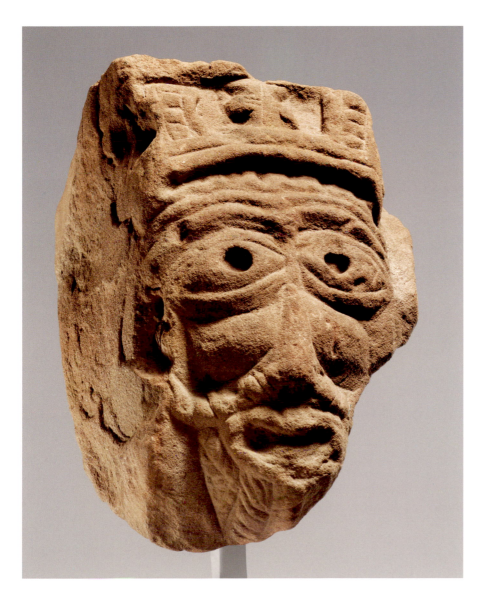

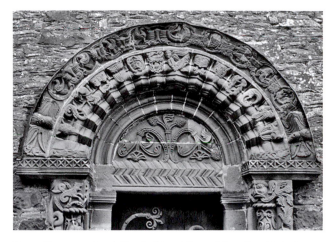

Fig. 70. *Tympanum, Parish Church of Saint Mary and Saint David, Kilpeck, Herefordshire, ca. 1130–40*

The font presents an interesting commentary on the theme of marginal sculpture in Romanesque art because not all of the heads found on it are marginal per se. The human heads at the cardinal points, for example, a frequent feature of fonts, relate to the baptismal liturgy,[2] specifically the rite of blessing the baptismal water in which the water is compared to the four rivers of paradise: the Phison, Gehon, Tigris, and Euphrates. The liturgy is taken from Genesis (2:10), and the Latin term used for the separate streams in the Vulgate, *capita* (heads), readily invites visual representation. Each of the heads on the font is slightly individuated, reinforcing the sense that they represent particular personifications of the biblical rivers.

The font's animal-headed corbels, in contrast, do not appear to have any specific iconographic reference beyond enlivening the piece and setting off its circular design. A third set of heads can be found on the bases of the arcade, most of them animal busts that include forepaws. Of these little beasts, the most lively and idiosyncratic acts like a true marginal grotesque, stretching out a paw to grab the adjacent colonnette.

The type of double arcade seen on the font, with an echoing set of arches (supported by corbels) superimposed on the main blind arcade, can be found in the architecture of the Mosan region of Belgium, such as at the cloister at Tongeren, where the corbels also have animal heads,[3] and at the gallery on the exterior of the apse at Saint-Trond.[4] The com-

and Aulnay (both Charente-Maritime), for example, all have historiated voussoirs including figures of the Elders of the Apocalypse.[3] This voussoir indicates that the theme was once found in Herefordshire as well.

PB

NOTES

1. For the most recent study of Kilpeck and related sculptures, see Thurlby 1999.

2. Zarnecki 1953, pp. 12–13.

3. On the Romanesque sculpture of western France, see L. Seidel 1981.

EX COLLECTIONS

[Maurice Braham, London]; [Michael Ward, New York]; [Daniel Katz, London]

LITERATURE

Katz 2000, no. 2

39. Baptismal Font

Valley of the Meuse, Maastricht region (?),
mid-12th century
Dark calciferous limestone, H. 14 ½ in. (36.8 cm);
Diam. 51 ¼ in. (130.2 cm)
The Metropolitan Museum of Art, New York; The Cloisters Collectionm 1947 (47.101.21)

This massive baptismal font is adorned with a highly finished arcade and four bearded male heads at the cardinal points. The carving of such fonts in dark stone was a Belgian industry in the twelfth century, and these large, heavy objects were widely exported not only within the region but also to parishes in England and France.[1] This example, featuring a wealth of animating detail, is more finely carved than most.

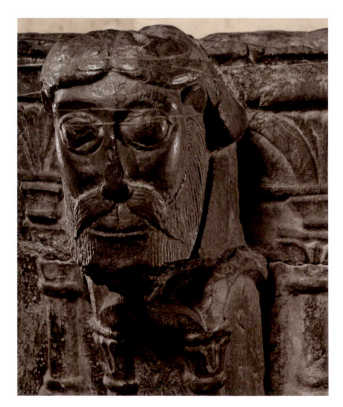

Detail of Baptismal Font (cat. no. 39)

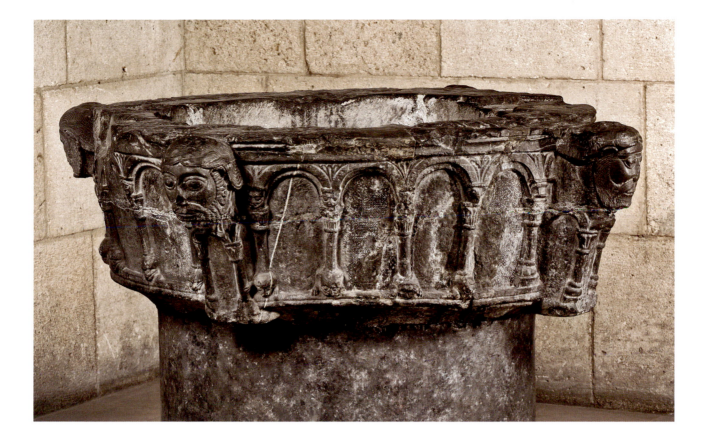

bination of heads and arcades can be found in many Mosan fonts, but the combination of a double arcade with bearded heads, with the arcade continuing below the heads, is very unusual. Only one other font, said to be in the cloister at Saint-Trond but known only from a rather poor-quality photograph, mirrors these features exactly.[5] Letters in the files of the Metropolitan Museum indicate that this font was not in the cloister as of 1963, however, and that it was unknown there at the time; the photographic negative could also not be located. Despite the inconclusive photography, it is clear that the supposed Saint-Trond font offers the closest parallel to this font, and the echo of the double arch at Saint-Trond provides additional evidence pointing to that Mosan parish.[6] Final confirmation of the font's Mosan origin comes from petrology. In 1961 a sample of the stone was sent to the Institut Royal du Patrimoine Artistique, Brussels, whose petrographic analysis indicated that it is a type of limestone from the Valley of the Meuse quarried between Huy and Dinant in the twelfth century.[7]

It should be noted that the style of the human heads on the font, with their bulging eyeballs, striated hair, and mustaches represented with parallel lines, shows a kinship with the carvings on the west facade of Saint-Denis, such as the head of an Elder of the Apocalypse from the archivolt (cat. no. 27). This similarity does not suggest a Saint-Denis origin for the font, but it is evidence of the influence that flowed from the Meuse Valley to the Île-de-France after

Abbot Suger imported craftsmen from that region (among other places).[8] Two carved fragments of Tournai stone found at Saint-Denis further demonstrate the connection between Belgium and the royal abbey.[9]

WAS

NOTES

1. Randall 1962, pp. 318–19; Drake 2002, p. 38.

2. Drake 2002, p. 45.

3. See Randall 1962, fig. 3, p. 319.

4. Courtens 1969, pl. xvii.

5. Tollenaere 1957, p. 306, pl. 32B.

6. The large heads on this font are also similar to those on a Mosan font from Ohey; see Tollenaere 1957, pl. lviiC. Another Mosan piece, a holy water basin from Flône, while not as finely carved as the Metropolitan's font, has a head that seems to have its ear on sideways, a rare and distinctive feature; see ibid., pl. lxvA.

7. Letter, files of the Department of Medieval Art and The Cloisters, The Metropolitan Museum of Art, New York.

8. Little 1987, p. 165.

9. Johnson and Wyss 1995, pp. 101–3.

EX COLLECTIONS

Lamart Collection, Belgium; [Joseph Brummer, Paris and New York]

LITERATURE

Randall 1962; Little 1987, pp. 165–66, figs. 13–15; Young 1988, p. 13; Wixom 1988–89, pp. 56–57

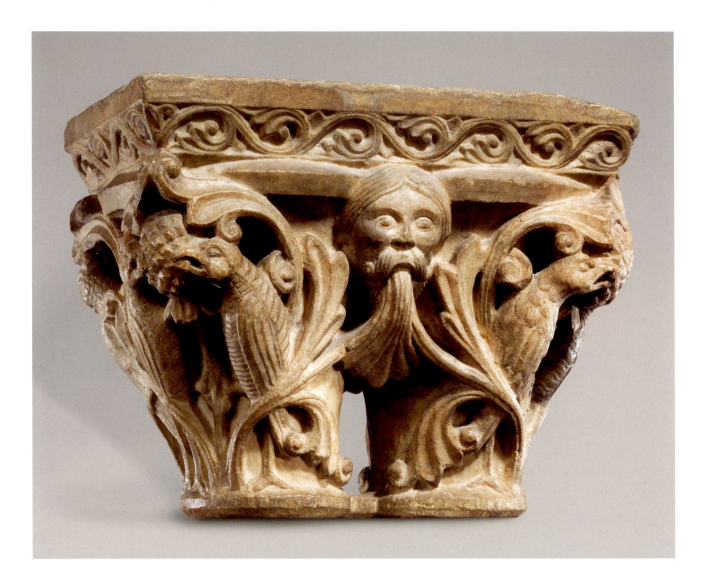

40. Double Capital

France, Toulouse region (?), mid-12th century
Marble, 15¼ x 19½ x 11¾ in. (38.7 x 49.5 x 29.8 cm)
The Metropolitan Museum of Art, New York; Rogers Fund,
1928 (28.81)

The delicacy and refinement of the finest Romanesque sculpture enliven this capital, a piece of marginal architecture. Although the general arrangement of the foliage, the birds at the corners, and the heads at the centers of the longer sides are relatively common elements, the artistic quality of the work is underscored by an obvious concern for detail. All four birds differ from one another in the shape of their feathers and other markings, and the masks—one a mustachioed man, the other a grinning, toothy ape—are well modeled, with swelling cheeks and bulging eyeballs.

Most often double capitals such as this one originated in a monastic cloister, a location that, during the Romanesque period, would not have been considered marginal at all since the cloister was the heart of monastic daily life and its capitals frequently incorporated figural and biblical subjects. Indeed, the Romanesque cloister is a milieu that tests the very notion of the marginal as well as the dichotomy between decorative and didactic schemes, as both often coexist within a single monument. Although this capital, with its animal and human forms interlocking with or replacing the traditional forms of a Corinthian capital, appears decorative, the equation of a human head with that of a monkey could indicate an admonitory message. Bernard of Clairvaux, in his famous tirade against the non-biblical elements of Romanesque sculpture, referred to apes as "lascivious,"[1] and Physiologus warned that the monkey "represents the very person of the devil."[2] Thomas Dale has analyzed the depiction of apes and monsters in the Romanesque cloister, noting that the ape was generally con-

sidered a spiritually deformed creature.[3] Several capitals from Saint-Michel-de-Cuxa juxtapose humans and apes, for example, which Dale interprets as warnings to the monks to avoid sinking to a bestial level. He also cites twelfth-century theological texts espousing the salutary and purgative effect of struggling against temptation, and he sees the cloister sculpture as "effecting a similar form of sublimation and conversion."[4]

The motif of the vine emerging from the mouth, seen here in the two masks, is a common decorative trope of classical origin that was deployed throughout the Middle Ages; it can be found in the Toulouse area at Saint-Étienne and at Saint-Sernin.[5] Other stylistic features that link the capital to the Toulouse region include the finely carved scrolling vine on the impost block and the entangling of the birds in the foliage, also seen at Saint-Sernin (ca. 1120–40).[6] The human head can likewise be compared generally to others of the region, such as a head of Christ on a capital from La Daurade or another from Saint-Gaudens.[7]

In terms of facial type, the closest comparison that can be made is to a capital known only from a photograph in the archives of the art dealer Lucien Demotte.[8] That work exhibits all of the structural idiosyncrasies of the Metropolitan's double capital: the way the top of the drum emerges just below the impost, displaying its carefully finished beveled edge; the treatment of the upper level as one unified field joined in a single decorative design; the gap separating the two capitals below the center heads, but with a small tag of stone joining the two astragals at the bottom; and the bottom moldings, which are chamfered, not rounded, a feature known in Toulousan capitals from the period.[9] Unfortunately, there is no record of where the Demotte capital was found, or where it is today.[10] That another such capital existed in a dealer's archive indicates only the likelihood that the monastery of origin for both works was in some state of ruin in the first decades of the twentieth century.

Without knowing the specific monastery from which this piece came, it is impossible to reconstruct the circumstances of its decapitation. The fact that it is carved in marble rather than limestone has led one scholar to speculate its origin might be closer to the Pyrenees than to Toulouse.[11] Generally speaking, the sixteenth-century Reformation was a key age for the destruction of monasteries, but it is also known that the cloister of Saint-Michel-de-Cuxa, to name just one from the Roussillon region, was dismantled and dispersed in the century following the French Revolution.[12]

WAS

NOTES

1. Saint Bernard of Clairvaux, *Apologia ad Guillelmum Abbatem*, in Rudolph 1990, p. 282.

2. *Physiologus*, trans. Michael J. Curley (Austin, 1979), p. 39.

3. Dale 2001.

4. Ibid., p. 430.

5. Saint-Étienne: Mesplé 1961, pp. 4, 16; Saint-Sernin: ibid., p. 244.

6. Mesplé 1961, p. 224.

7. La Daurade: Paris 2005, no. 219; Saint-Gaudens: Mesplé 1961, p. 276.

8. The Demotte archives are preserved at The Cloisters, New York. Demotte occasionally collaborated with the Paris dealers Seligmann and Rey.

9. Letter from Kathryn Horst to Charles T. Little, 1985, in the files of the Department of Medieval Art and The Cloisters, The Metropolitan Museum of Art, New York.

10. The photograph bears the number 3198.

11. Horst letter (see note 9).

12. Dale 2001, p. 405.

EX COLLECTION

[Seligmann and Rey, Paris, 1928]

LITERATURE

Rorimer 1931, p. 22, fig. 11; Little et al. 1987

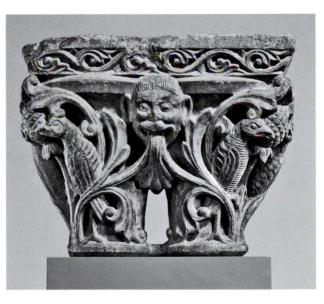

Reverse of Double Capital (cat. no. 40)

41. Head of a Grotesque

France, Champagne, Châlons-sur-Marne (Marne),
ca. 1200–1220
Church of Notre-Dame-en-Vaux (?)
Limestone, H. 14½ in. (36.8 cm)
The Metropolitan Museum of Art, New York; Rogers Fund,
1913 (13.152.2)

The variety of marginal imagery in medieval architecture is astonishing, ranging from the refined to the fantastic and grotesque. At the time this large grotesque head was acquired from the Parisian dealer Lucien Demotte, it was said to be from the abbey of Saint-Denis, near Paris, but it appears closer in type and carving technique to another grotesque, also with its tongue stuck out, originally from the church of Notre-Dame-en-Vaux at Châlons-sur-Marne (fig. 71). Around the choir chapels of that church, especially on the southeast side (fig. 72), there are a series of corbels supporting the roof cornice that are indeed not dissimilar to this grotesque,[1] particularly its boldly carved facial features such as the strongly projecting eye and the eyelids articulated with flat planes.

A date of about 1220 has been established for the construction of the apsidal chapels of Notre-Dame-en-Vaux,

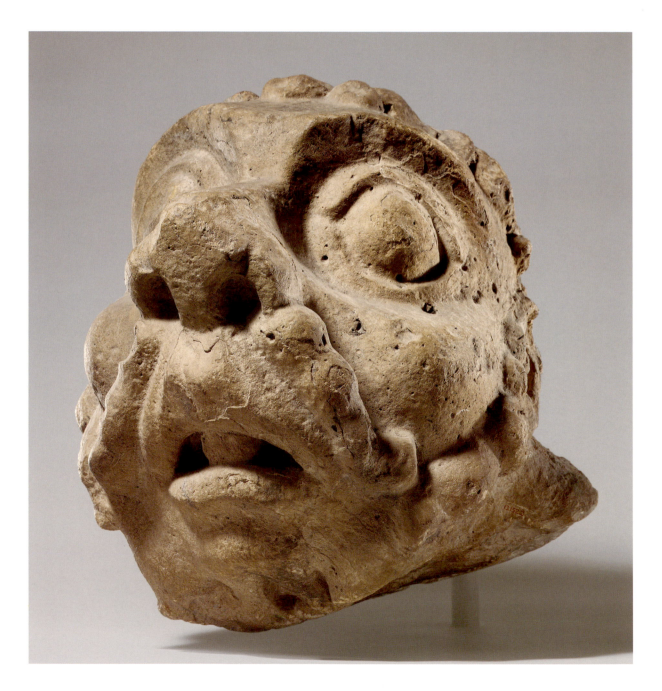

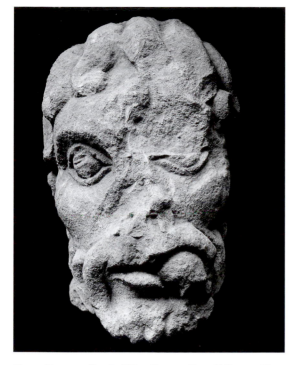

Fig. 71. Grotesque, Church of Notre-Dame-en-Vaux, Châlons-sur-Marne (Marne), ca. 1200–1220. Musée du Cloître de Notre-Dame-en-Vaux

NOTES

1. Corsepius 1997, fig. 261, pp. 117, 121, 128.

2. Ibid., p. 117.

3. See Gillerman 2001, no. 62 (entry by E. Pasten).

4. See, for example, the extensive study of Kenaan-Kedar 1995 and Camille 1992, p. 72.

EX COLLECTION

[Lucien Demotte, Paris and New York]

LITERATURE

Breck 1913

Fig. 72. Apsidal chapels, Church of Notre-Dame-en-Vaux, Châlons-sur-Marne (Marne), ca. 1220

based on dendrochronological dating of oak tie beams in the upper areas.[2] During the course of extensive restorations to the church in the nineteenth century, some corbels around the choir chapels were replaced, including the one in Châlons and possibly, by extension, this work. The head could also come from the cathedral at Châlons-sur-Marne, however, which was constructed about the same time as the church.

Despite some surface weathering, the distinguishing facial features of the head are still clear: exaggerated muttonchop whiskers; a long mustache; an open mouth revealing two teeth; a bulbous nose; and widely dilated eyes. Together they create a head that verges on the comical more than the truly grotesque. Another head of a bearded man, although unfinished, now at the Indiana University Art Museum, Bloomington, shares some features with the present head, and it too has been attributed to Notre-Dame-en-Vaux.[3] The bold features of these exotic or grotesque heads, part of a visual language specific to medieval buildings, are indicative of a type of decoration that was intended to be seen from a distance. In this marginal context, it is possible that the Metropolitan's head, presumably positioned on the apse of a church, served an apotropaic function.[4]

CTL

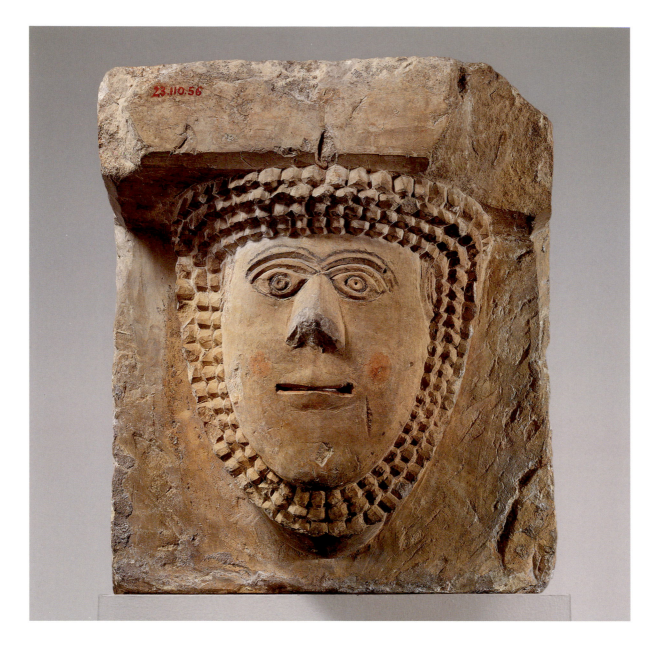

42. Corbel with Female Head

Spain, Castilla-León, Frías (near Burgos), early 13th century
Parish Church of San Vicente Martír
Stone with polychromy, 14⅞ x 13⅜ x 16⅛ in.
(37.8 x 34 x 41 cm)
The Metropolitan Museum of Art, New York; The Cloisters
Collection, 1923 (23.110.56)

In 1879 the bell tower of the parish church of San Vicente
Martír in Frías collapsed, bringing down the historiated portal
that had welcomed congregants since the first decade of the
thirteenth century. Many of the surviving remnants of
the sculpture program—reliefs with scenes from the Life

of Christ; animals and allegorical figures; and, on the out-
ermost archivolt, a series of lively, individuated heads of men
and women in contemporary hats and hairstyles—were
assembled and reinstalled at The Cloisters in 1938 (fig. 74).
This arresting head from Frías makes its debut in the present
exhibition. Unlike its counterparts on the archivolt, which
project freely from the stone ground to form a knobby
frame for the inner reliefs, this female head supports a thick
cornice that presses on it from above. That architectural fea-
ture, combined with the stark, simplified carving of the face,
suggests that the piece was originally situated high on the
church facade, probably near the roofline.

The transition from the architectural to the figural com-
ponents is masked by four curved rows of thin, horizontal
chevron strips. Three additional strips extend down from

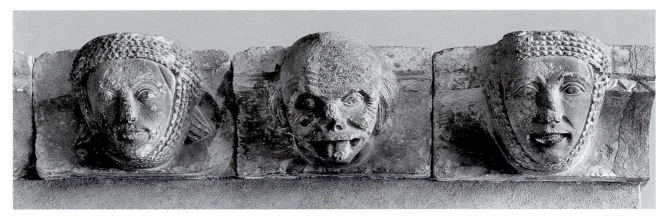

Fig. 73. Corbel Heads from the Parish Church of San Vicente Martír, Frías, prior to installation at The Cloisters

the outer edges, forming a recessed frame around the egg-shaped face. Although the sharp carving of the small, jagged triangles gives the strips a hard-edged appearance, they are meant to evoke the layers of the ruffled headdresses fashionable among married laywomen (fig. 73). The headdress and the tiny coils of hair barely visible at the joints between the circlet and chinstrap are the sole indicators of gender. Clearly the artist's aim was not to portray a specific person, but rather to suggest a certain type.

Stylistically, the face represents a departure from its cousins on the portal's archivolt program, with their bright, almond-shaped eyes, full lips, and softly modeled cheeks. The large nose, echoing in its geometrical simplicity the protruding triangles of the headdress, is the only plastically shaped feature of the face; consequently, it is the only part to have received extensive damage. The bridge of the nose is defined by the inner corners of wide open, close-set eyes, themselves delineated by pairs of deeply incised arcs that circumscribe circular pupils and, finally, dots denoting irises. Thicker lines running parallel to the upper curves of the eyes indicate eyebrows. Despite their stylized character, the eyes assume uncanny expressiveness through their subtle asymmetry and through the apparent softness of the stone as it bulges up between the incised lines. In the mouth, boldly rendered as a deep gash in the lower portion of the face, the severity of the carving is likewise softened by slight irregularities. A gentle expansion of the cut at both ends suggests the flicker of a smile, imbuing the face with an impression of character despite its unnatural appearance. The charm of the face was not lost on at least one post-medieval viewer, who took it upon himself or herself to enhance the figure's liveliness by adding rosy pigments to the cheeks and lips and lining the eyes with black graphite.

JEJ

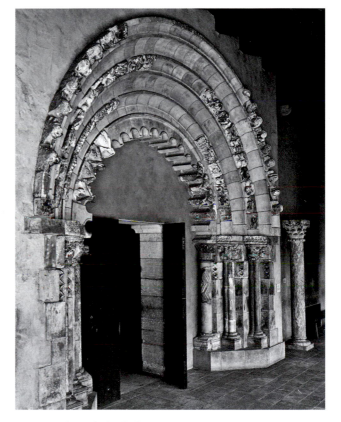

Fig. 74. Portal, Parish Church of San Vicente Martír, Frías, early 13th century (as installed at The Cloisters). The Metropolitan Museum of Art, New York; The Cloisters Collection, 1923 (23.110.56)

EX COLLECTION

[Joseph Brummer, Paris and New York]

LITERATURE

Breck 1924, p. 231; New York 1954–55, no. 39; Rorimer 1963, pp. 72–73

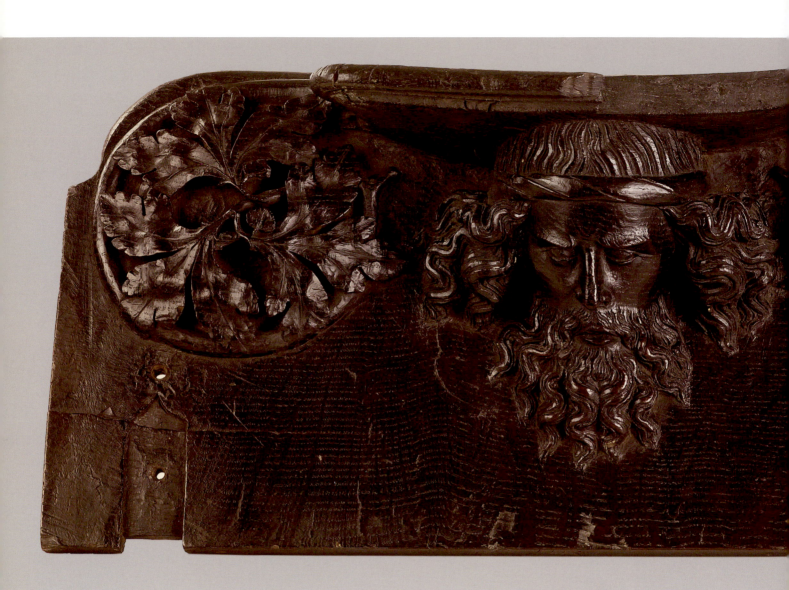

43. Misericord with Bearded Head

England, Wells, ca. 1335–40
Wells Cathedral
Oak with traces of gilding, 11⁷/₁₆ x 24⁷/₈ x 6⅛ in.
(29 x 63.2 x 15.6 cm)
Cooper-Hewitt, National Design Museum, Smithsonian
Institution, New York; Gift of Architectural League of
New York (1912-1-1B)

Misericords, or "mercy seats," are hinged platforms found
in the choirs of churches. The name derives from the fact
that the ledge carved into the underside of a misericord
offered the clergy the chance to sit during most of the Mass
even as they appeared to stand. This example is adorned
with a head that has beautifully defined features and luxuri-

ant coils of hair and beard. Its face bears a strong resem-
blance to that on two misericords at Wells Cathedral; one is
an animal-footed head, the other represents Alexander the
Great between two griffins (the Flight of Alexander).[1] It is
also strikingly similar to the face of a two-bodied hybrid
creature represented on a misericord from Hereford Cathe-
dral that is known to be closely related to, and dependent
on, the Wells group.[2]

That this piece comes from Wells rather than Hereford is
established by the leafy circles flanking the head: the so-
called supporters—subsidiary carvings flanking the central
carved area—typical of fourteenth-century English miseri-
cords. These richly carved areas of foliage, comprising three
deeply undercut leaves swirling into a tight circle, can be
compared with similar ones at Wells, such as those on the
Griffin Eating a Lamb misericord and another reproduced
by Charles Tracy.[3] When viewed in detail these supporters

Single carved heads look out from many misericords, some with grotesque, grimacing expressions, others with recognizable pagan Green Men, and still others that might be actual portraits. The head on the Cooper-Hewitt piece is expressively scowling, with drawn-together, overhanging eyebrows. He wears a fillet over his hair, which emerges below it in long curling locks. Those S-curved tendrils are echoed in his full beard. Apart from the fillet, the head has no attributes that might suggest a specific identity or meaning. A misericord still at Wells shows a woman's head with a decorated fillet.[8] Although she is not as scowling as the present example, they might have been meant as a pair.

The Wells choir stalls were carved from about 1335 to 1340 to replace an earlier set considered "ruinosi et deformes" in 1320.[9] Originally there were ninety of these new misericords, but an 1848–54 restoration disrupted the original arrangement, and today only sixty-four remain in the cathedral.[10] The master carpenter in Wells at the time was John Strode, and his assistant was Bartholomew Quarter,[11] but there is no evidence indicating whether they were in any way directly responsible for the misericords.

WAS

NOTES

1. Tracy 1987, pl. 106A; Christa Grössinger, "Misericords," in London 1987–88, p. 430, no. 530.

2. Tracy 1987, pl. 106B.

3. Ibid., pl. 102F.

4. Ibid., pl. 102.

5. Laird 1986, p. 10; Camille 1992, p. 93; Grössinger 1997, p. 13.

6. Kenaan-Kedar 1995, p. 143.

7. Camille 1992, p. 94.

8. J. Smith 1975, no. 47.

9. Church 1896, p. 326; Tracy 1987, p. 26.

10. J. Smith 1975; Remnant 1969, p. 136; Tracy 1987, pp. 25–27. Of the missing misericords, there is another in the Cooper-Hewitt, and one is in the Victoria and Albert Museum, London (w48-1912).

11. Grössinger 1997, p. 23; J. Smith 1975, p. 2. Strode is mentioned in charters in 1341 and 1344; Quarter is mentioned in 1343.

EX COLLECTION

Architectural League of New York

LITERATURE

Flushing 1959, no. 54, pp. 23, 48 (ill.)

also appear to resemble those at Hereford Cathedral,[4] but when the entire misericord is seen it becomes apparent that there is more space between the Hereford supporters and the center element. The Hereford supporters also curl away from the center, whereas the Wells supporters curl toward the center and closely abut the center element, as they do on this piece.

Misericords are considered marginal areas for church decoration because they were never seen by the laity and were unseen even by the clergy when in use. Most of them are carved with secular subjects, such as individual figures or small scenes, and they have been compared to the drolleries found in illuminated manuscripts.[5] They are also similar in some ways to the grotesques carved on corbels and gargoyles.[6] The inherent irony in this subject matter was expressed succinctly by Michael Camille: "Here in the very centre of the sacred space, the marginal world erupts."[7]

44. Head of a Bearded King

England, mid-14th–mid-15th century
Oak, H. 11¹³⁄₁₆ in. (30 cm)
Eric R. Kaufman

No clear facts have emerged about the origin of this impos-ing and impressive head, whose regal presence asserts both an artistic quality and physical strength. The violent icono-clasm of the Reformation and the English Civil War, which led to the widespread destruction of sculptures, especially those carved in wood, left little material for comparison. One scholar has estimated that "well over ninety percent of English medieval religious imagery" was demolished.[1]

The only known published reference on this crowned head describes it as "probably a corbel or a boss from a wooden roof."[2] Carved wood heads on roof bosses are known to exist, such as those from Exeter Cathedral now in the Victoria and Albert Museum, London.[3] According to one source, detached (or bodiless) heads are the second-most frequently depicted images on English bosses after

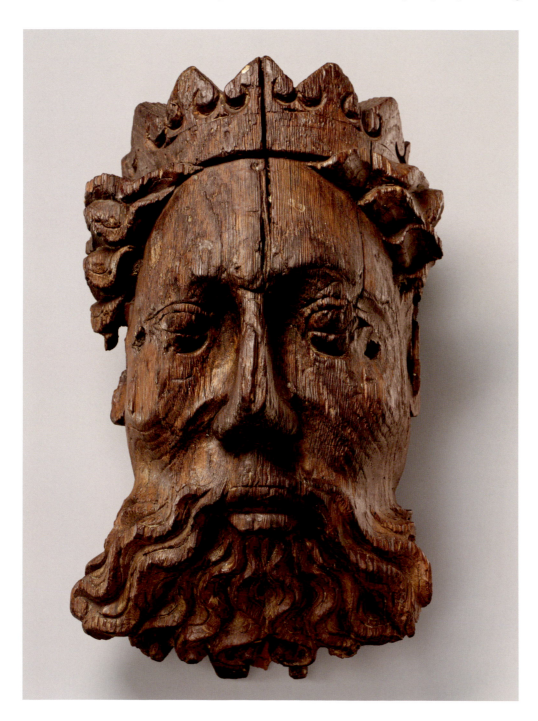

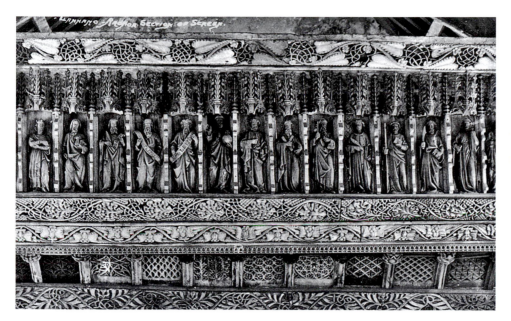

Fig. 75. Choir Screen, Church of Saint Anno, Llananno, Radnorshire (Wales), ca. 1490

foliage,[4] and some of these include crowned kings. One foliage-crowned bearded head from a boss in Arundel Cathedral bears some resemblance to this king,[5] but bosses tend to be more circular than the present work.

Stone corbels with detached heads can often be found high on church walls or exteriors in both England and France, but they rarely represent royalty.[6] Wood corbels also exist, but ones with detached heads are relatively rare. A number of churches in England and Wales have wood angel corbels supporting timber roofs, but not crowned figures.[7] Carved wood busts, including men with caps, serve as corbels or arch stops on the sixteenth-century hammer beam roof of the Great Hall at Hampton Court.[8] One of the distinguishing features of this head is the way the hair and beard are swept back, flowing almost horizontally away from the face, a treatment that tends to be found in corbels, such as the mid-fifteenth-century angel from York Cathedral.[9]

There is also the possibility that the head was originally attached to a full figure, and, as a standing statue of a king, it would have resembled the royal figures on the choir screens of the cathedrals at Canterbury (ca. 1450) or York (ca. 1480–1500).[10] The York kings have luxuriant beards somewhat similar to this one, and although both the Canterbury and York screens are carved in stone, there are examples in England of carved wood screens, such as at Manchester Cathedral (where there are no figures, however). If this head originated in such a context, then it would certainly not be considered marginal as it presumably depicts an ancestor of some English royal house or possibly an Old Testament king.

One example of a carved wood screen that includes such statues exists at Llananno, in Radnorshire, Wales (fig. 75). The small church there, although rebuilt in the nineteenth century, preserves its late-fifteenth-century screen or rood loft.[11] Adorning the west side of this extraordinary piece of wood carving are niches containing standing statues, one of which is crowned, suggesting a possible context for the origin of the present piece.

WAS

NOTES

1. Stone 1955, p. 2.

2. Richard Philp Gallery, sale cat., n.d., p. 12.

3. London 1987–88, nos. 590, 592; Tracy 1988, pls. 2, 12.

4. Cave 1948, p. 61.

5. Ibid., fig. 13.

6. Examples include one in Westminster Abbey (see Binski 2004, fig. 201); a choir vestibule in Lincoln Cathedral (see Givens 2005, p. 115); and one in Reims (see Camille 1992, p. 84, fig. 42). For a queen from Poitiers, see Kenaan-Kedar 1995, p. 114.

7. See, for example, the nave roof of Manchester Cathedral; Hudson 1924, pp. 141–74. Three angel corbels (ca. 1500) are in the collection of the Victoria and Albert Museum, London; see Tracy 1988, pl. 13.

8. Marks and Williamson 2003, pl. 114.

9. Ibid., no. 262.

10. Stone 1955, pl. 174. Phillip Lindley has commented on the appropriateness of representations of kings on *pulpita*, as it was from there that the genealogy of Christ was read; see Lindley 1997, p. 75.

11. Howard and Crossley 1917 (2d ed.), p. 42. The choir screen can also be seen at the website *www.genuki.org.uk/big/wal/RAD/Llananno*.

EX COLLECTION

[Richard Philp, London]

LITERATURE

Richard Philp Gallery, sale cat., n.d., pp. 12–13

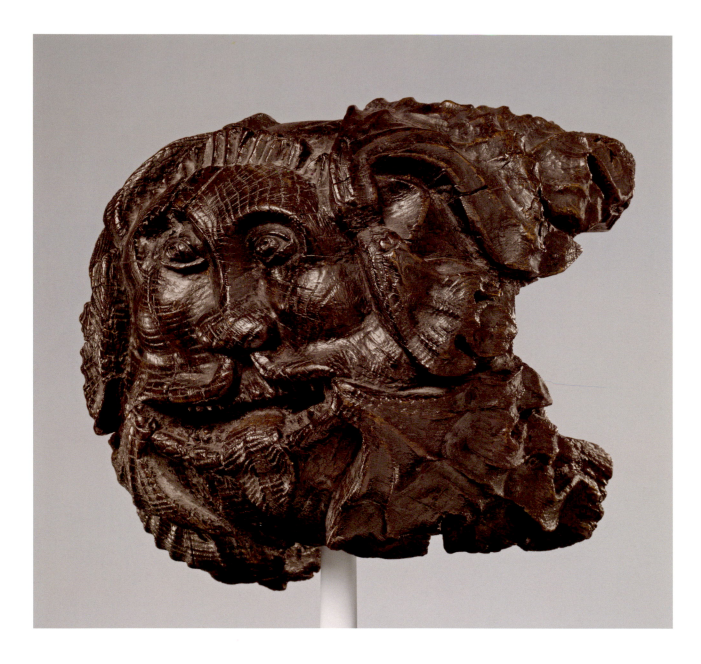

45. Ceiling Boss with Foliate Mask

England, 15th century
Oak, H. approx. 9 in. (23 cm)
Eric R. Kaufman

Grotesque heads in stone and wood embellished secular and ecclesiastical buildings and furnishings throughout the Romanesque and Gothic periods. In contrast to the official and didactic art of the church on portals, capitals, and walls, these hybrid images—which in their original architectural settings were often either hidden from view or at best hard to see—were expressive examples of the medieval artist's visions of secular life. They frequently incorporate anticleri-

cal satire, phallic representation, and scatological humor drawn from daily life or from ancient and pagan mythology, elements that lived on in folklore and that were incorporated into the Christian vocabulary of the Latin West.[1]

The size of this head and the form of the prongs suggest the piece was originally a ceiling boss. The grotesque face on the boss projects out from the four supporting prongs, which would have anchored the piece to the crossing of lap-jointed wood beams. By the fifteenth century, many similar and comparable wood examples were appearing in English parish churches, whereas in earlier Gothic churches such bosses were customarily carved in stone.[2]

The face is actually a hybrid mask: a human head that has been transformed into a leafy, organic visage partially animal in nature. The eyes and the hair, which is cut like that of

a tonsured monk, are human, but the bulbous nose is decorated with cross-hatchings that make it look like an acorn. Branches emanate out of the nostrils, grow off to the sides, and then bear oak leaves that flow into the lower prongs. Two other oak leaves, forming carefully decorated branches that curl up from below the ears, wind to the top of the head. The gaping mouth, full of menacing teeth, sticks out its tongue.

This representation combines several image types well known from classical antiquity and from the Germanic-Celtic pagan past. In Roman architectural sculpture, as seen on capitals and consoles, the somewhat naturalistic Foliate Man (or Green Man) was a popular representation of Silvanus, god of the forest, or Oceanus, a god of the sea and also a satyr.[3] In Italy, Germany, and France, these images were appropriated quite literally into the medieval Christian artistic repertoire of the twelfth and thirteenth centuries.[4] In Modena Cathedral, for example, a Roman capital that was reused as a holy water basin includes a Green Man figure (fig. 76), which was the source for a capital on the exterior by the twelfth-century sculptor Wiligelmo (active 1099–1120).

The leaves in these classically derived examples are most often acanthus, but at times they are transformed, as seen here, into the leaves of an oak, a more Nordic plant. The branches variously devoured, expelled, or grown from the mouth, nostrils, and ears of this mask follow a more Nordic or Hiberno / Saxon tradition that had been appropriated early on into Christian art, particularly in the inhabited scrolls of illuminated manuscripts and architectural decoration.[5] Such heads eventually took on a demonic expression, becoming associated with the Mouth of Hell and the devil.[6] The protruding tongue, recalling the head of Medusa, adds another grim dimension: namely, a menacing visage that was intended to ward off evil, although here that apotropaic function is combined with a carnivalesque playfulness and humor.[7]

The Green Man was particularly popular in the folklore and mythology of northern Europe, especially in England, where many surviving examples continue to be copied today and the persona lives on in numerous folk festivals.[8] Jack of the Green; the Bury Man; Green George; Robin Hood; Old Man in the Woods; the Wild Man; Sir Gawain and the Green Knight; May Day processions; and Morris Dancers: all of them share the Green Man as a mythological source. Along with the "Wilde Ma" in Basel and towns of the Valais,[9] these characters are based on ancient pagan festivals that sought to tame the forces of nature—and thus the fear of such forces—through humorous, playful folklore and carnivals.

cv

NOTES

1. Camille 1992; Kenaan-Kedar 1995; Benton 2004; Sheridan and Ross 1975.

2. Macek 1986–88; Cave 1948; Howard and Crossley 1917; Stone 1955; Tracy 1988; Christa Grössinger, "Misericords," in London 1987–88, p. 122 and passim.

3. Anderson 1990; Sheridan and Ross 1975; Basford 1978.

4. See Verzar 2005, figs. 20, 21.

5. Camille 1992; Kenaan-Kedar 1995. For Green Men, see Basford 1978, Doel 2001, Anderson 1990 and 1995.

6. Mellinkoff 2004; Strickland 2003.

7. Frazer 1935; Friedman 1981; Bakhtin 1984; Kenaan-Kedar 1995; Camille 1992, fig. 42; Basford 1978, pls. 86b, 87a–b.

8. Anderson 1990, 1995; Basford 1978; Doel 2001.

9. Bernheimer 1970; Bartra 1994; New York 1980–81; Verzar 2004.

EX COLLECTION

[Richard Philp, London]

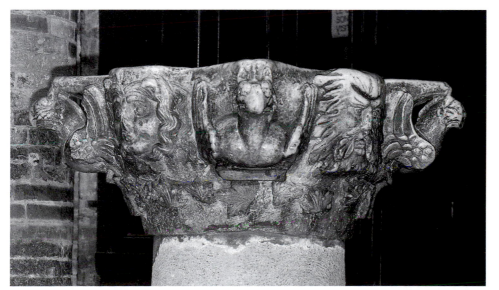

Fig. 76. Roman capital (3rd century A.D.) carved with a Green Man motif and now used as a water basin, Modena Cathedral (Emilia-Romagna)

46. Antlered Head

Upper Rhineland, Alsace, mid-12th–13th century or later
Red sandstone, H. 12¾ in. (32.4 cm)
Charles and Alexandra Van Horne Collection

This diamond-shaped, rough-edged block of sandstone was likely a corbel set at the springing point of a rib supporting a ceiling. The sharp edge of the rib is still visible between the antlers on the top of the head; apparently there was neither a torso nor a body attached. The head is thus a typical work of marginal sculpture, part of an unofficial program of decoration distinct from the religious art and the traditional narrative cycles that adorn medieval ecclesiastical monuments. It also belongs to the repertoire of secular images whose interpretations and functions have long been debated among scholars of medieval art.[1]

The face on the corbel is that of an old man who has sunken cheeks, a furrowed brow, and a short goatee. Large, bulging eyes lend the head a masklike appearance that is enhanced by the addition of animal features, specifically the

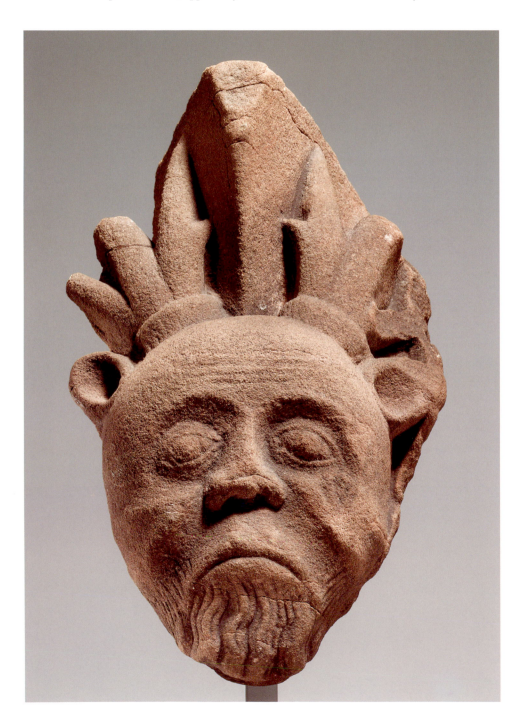

small, almost canine ears set at the outer edges of the brow and the two- to three-point antlers on top of the head. All but one of the antler tips have been broken off. The head stares out from beneath the antlers almost as if they were being worn as a crown or headdress.

Far from the fantasy of some medieval stone carver, this head actually follows a traditional iconography. The image of a bearded man with antlers is a medieval appropriation of the Greco-Roman deity Pan (or Faun), the god of woods, pastures, and other landscapes as well as the protector of animals and the tamer of beasts. Pan was a humanized goat in Roman art, in which he sometimes appears as an architectural supporting element rather like the classical and medieval atlantid figure. In the medieval world, he was also a conflation of the classical persona of Faun with the Celtic god Cernunnos, a version of the Green Man.[2] These mythological figures were often mixed together with human heads on corbels along the exteriors and interiors of medieval churches.

As Michael Camille and Nurith Kenaan-Kedar have noted, such marginal images were neither purely decorative elements nor were they negative representations of pagan gods and devilish monsters. Rather, they were part of the rich, imaginative everyday life of medieval culture, whose literature and folklore teemed with these kinds of mythological figures.[3] Although sometimes interpreted by medieval theologians in a moralizing, Christian context—as devils, Moses, Cain, or Jews in general[4]—they were also important components of the seasonal festivals and carnivals that still survive across Europe.[5] Pagan gods and other mythological characters related to the woods and nature, along with imaginative representations of peoples living in distant regions, took on fantastic hybrid forms in medieval illuminated encyclopedias,[6] but they were all nonetheless considered creatures of God. It is in this context that we should consider the original function and meaning of this antlered head.

The soft red sandstone and the figural style of the head place it in the Alsace region of the Upper Rhineland. Part of the dioceses of Basel and Strasbourg in the High Middle Ages, the Alsace enjoyed close political and cultural ties to the Holy Roman emperors, particularly during the late twelfth century, when the region flourished under the Hohenstaufen emperors as a main route along the Rhine. Numerous monastic and parish churches were built in the region at this time, and it seems likely that a single workshop using the local red sandstone was responsible for the rather distinctive sculptural and architectural embellishment of the portals and exteriors of many of these buildings. The figural style common to such monuments is characterized by a rather stylized and somewhat generalized head with large framed and bulging eyes, as seen in the churches of Murbach, Lautenbach, Alsbach, and Rouffach, among others.[7] It is possible that this style originated in the convent at Eschau (destroyed in 1529 during the iconoclastic fury of the Reformation[8]), some of whose sculptures are now in the Frauen Museum, Strasbourg. The same workshop seems to have been responsible for several of the exterior figures of Basel, including, possibly, this head.[9]

CV

NOTES

1. Mâle 1972 (1913), p. 48, nn. 2–3, p. 49, nn. 1–2; Schapiro 1977, pp. 28–101; Camille 1992; Kenaan-Kedar 1986, 1992, 1995; Bakhtin 1984, pp. 303–68; Gurevich 1988.

2. Anderson 1995, p. 11.

3. Camille 1992; Kenaan-Kedar 1995; Benton 2004.

4. Mellinkoff 1970; Mellinkoff 1981, pp. 107–8; Strickland 2003.

5. Verzar 2004; Doel 2001, fig. 61 et al.; New York 1980–81.

6. Friedman 1981.

7. Rumpler 1965, pls. 4, 38–43; Lemaître 1987.

8. Will and Haug 1982, pp. 55–100.

9. Meier and Schürmann 2002; Wandel 1995, p. 149.

EX COLLECTION

[Michael Dunn, New York]

Sculpting Identity

Stephen Perkinson

CENTURIES of warfare, religious upheaval, and changes in taste contributed to the destruction of many of Europe's greatest sculptural monuments. After each outburst of vandalism and violence, small bands of intrepid connoisseurs, collectors, and thieves clambered over the ruins of churches and palaces. They would have seen before them, scattered amid the dust and debris, countless fragments of stone bodies wrested from their original settings. But judging from the objects preserved in today's public and private collections, they must have searched with particular care for sculpted heads. Why?

The explanation lies in the fact that for centuries Western culture has tended to look to the head, especially the face, as the primary vehicle for the expression of an individual's identity.[1] But that predilection has created problems for the study of medieval art. When these dislocated heads are placed alongside ancient or Renaissance sculptures, many of them suffer by comparison. They can appear bland, undifferentiated. Indeed, they seem to prove a claim first advanced by scholars such as Jakob Burckhardt (1818–1897): that medieval people did not think of themselves as individuals so much as members of groups, or as examples of a type. Building on Burckhardt's claim, art historians have taken the advent of naturalistic portraiture as symptomatic of the shift from the Middle Ages to the modern era.[2]

But such an account fails to do justice either to these objects or to the broader artistic culture from which they were extracted. Medieval artists and their patrons were often acutely sensitive to the visual qualities of ancient art. Some medieval viewers were particularly aware of the verism of ancient images: the way they represented specific people through the precise, naturalistic rendering of their facial features. For example, the church chronicler Agnellus of Ravenna (active ca. 830–50) based his physical descriptions of his city's earliest archbishops on Late Antique mosaics. Imagining that his readers might doubt the accuracy of his descriptions, he sought to reassure them: "If by chance you should have some question about how I was able to know about their appearance, know that pictures taught me, since in those days they always made images in their likenesses."[3]

Medieval artists and patrons were thus aware of the possibility of producing images whose appearance resembled that of their human models, but they chose not to do so. This was partly a result of the belief that appearances were incapable of conveying a thing's essential nature, a widespread opinion in the early Middle Ages.[4] The antipathy toward verism, however, was also the result of anxieties concerning its representational capacities, anxieties that were, in retrospect, fairly sensible.

Saint Augustine (354–430) observed that "one thing can be similar to another in many ways," and that secure recognition depended on the viewer's familiarity with representational traditions; verism alone was never sufficient.[5] In certain respects, Augustine's insistence on the fundamentally conventional nature of all forms of representation foreshadows the writings of the twentieth-century philosopher of art Nelson Goodman, who demonstrated that even "realistic" images rely on culturally determined codes.[6] In a similar vein, the author of the *Libri Carolini* (ca. 793) worried that it would be impossible to tell the difference between an image of the Madonna and one of Venus without an inscription.[7] This is essentially the same quandary that today confronts scholars trying to identify the subject of the Ravello bust (cat. no. 66).

At the same time, we must be cautious when applying concepts such as "the individual" or "identity" to periods in the distant past. Recent scholarship has pointed to ways in which the modern notion of individuality functions as a comforting fiction, in that it posits a stable and continuous identity in order to mask a reality that is often fragmentary, contradictory, and disjunctive. Those studies have also stressed the degree to which present-day assumptions concerning individual identity are themselves the products of particular historical circumstances: the rise of absolutist monarchies or capitalist economies, for instance. Likewise, contemporary artists, literary historians, and philosophers strenuously challenge the notion that a stable "self" exists independent of its various representations.[8]

None of this is to say that medieval artists were incapable of considering specific people, in some senses at least, as individuals, or that they failed to develop artistic means of representing the identities of those individuals.[9] They worked out strategies that allowed an image to represent a particular person with multiple, conventionally established visual signs, each capable of denoting an aspect of the individual's identity. The result was often a massive sculptural complex that deployed an array of signs, including coats of arms denoting genealogy and territorial possessions, inscriptions identifying the name and ancestry of the person involved, and costume and implements connoting social standing and profession. A good example is the now-lost tomb of Jean de France (d. 1248), son of Louis IX (r. 1226–70), from Saint-Denis (fig. 78).[10] Heads such as those in this exhibition are, in many cases, only vestiges of much larger sculptural ensembles.

During the later Middle Ages, as artists and patrons began to imagine a link between a person's body and his or her essential nature, images began to represent individuals by referring to their actual physical forms. For much of the thirteenth century, corporeal likeness was conceived of primarily in terms of gesture, and patrons began to expect that the bodily comportment displayed by an image would correspond with the identity of the individual it represented.[11] Still, the language of gesture remained only part of a complex network of signs required to represent fully an individual's identity. Other, nonmimetic signs, most notably coats of arms and the inscription of names and

Fig. 78. Tomb of Jean de France, Abbey Church of Saint-Denis. Drawing, late 16th century, from collection of Roger de Gaignières (1642–1715). Cabinet des Estampes, Bibliothèque Nationale, Paris, (Est. Rés. Pe 1a, fol. 25)

Fig. 79. Probably Jean Le Noir and work-shop. Hours of Bonne of Luxembourg (detail), before 1349. Tempera, ink, and gold leaf on vellum. The Metropolitan Museum of Art, New York; The Cloisters Collection, 1969 (69.86)

other textual information, remained of crucial importance. Whether or not these signs were gestural or symbolic, they were, in any case, generally left behind in the rubble when these heads were removed from their original settings.

By the fourteenth century the traditional medieval system of signs of personal identity faced its own identity crisis. The same coats of arms had been used for generations to denote different members of the same family line, often leaving patrons yearning for a more effective means of conveying an identity that was distinctly their own. The result was what Michel Pastoureau has called an "efflorescence" of new signs of identity: mottos, devices, emblems, and the like. As Pastoureau suggested, the images that we today consider to be the earliest examples of modern portraiture must be understood within this context.[12] Images produced at this time included precise references to the embodied form of individuals, but this did not necessarily involve the naturalistic depiction of facial features. For example, an easy way of referencing a person's body is to duplicate its dimensions or mass, hence the vogue for devotional images replicating the length of Christ's side wound (fig. 79), or votive gifts of wax in the weight or height of patrons' bodies.[13]

In some cases, particularly talented and ambitious artists began to use verism as a means of referencing an individual's body. The reading habits of late medieval princes, princesses, and their retainers may have been partly responsible for driving the interest in verism. Readers at the aristocratic courts devoured treatises expounding theories of physiognomy in hopes of finding a way to judge the true characters of their fellow courtiers. In those treatises, various physical attributes were analyzed as signs of hidden traits: small ears indicated a dull and lecherous mind, a thin face revealed circumspection and a subtle intellect, and so on (see "The Fate of the Face

in Medieval Art" by Willibald Sauerländer, in this catalogue).[14] The enthusiasm for such texts may well have encouraged audiences to be particularly receptive to images that established likeness in facial terms. At the same time, court artists increasingly came to see facial mimesis as a means of demonstrating their memory of, and thus loyalty to, their lordly patrons, further increasing the taste for verism.[15]

This allows us to reach several broad conclusions. First, the Middle Ages was not a period without individuals, nor can veristic portraiture be taken as a simple byproduct of the modern concept of individual identity. It is entirely possible for an image to represent a particular individual without recourse to verism, and medieval artists were fully capable of representing specific people according to the terms in which they understood individual identity. Second, when verism entered the artistic vocabulary in the fourteenth century, it did so as a supplement to, rather than as a replacement for, established representational conventions. Even after artists began to employ verism as a means of representing identity, it was not required; thus it was entirely acceptable to execute a tomb sculpture, such as Jean de Liège's figure of Marie de France (cat. no. 58), decades after the death of the individual in question. And finally, both the veristic and nonveristic images brought together here have something in common: all are only fragments of much larger and more complex representations of individual identities.

NOTES

1. For a discussion of the artistic implications of this cultural tendency, see Brilliant 1991; West 2004; and Ernst H. Gombrich, "The Mask and the Face: The Perception of Physiognomic Likeness in Life and in Art," in Gombrich 1982, pp. 105–36.

2. For a classic application of Burckhardt's ideas to the study of portraiture, see Pope-Hennessy 1966. I have offered a critique of such scholarship in Perkinson 2005.

3. Agnellus of Ravenna, *Liber pontificalis ecclesiae ravennatis*, edited by Oswald Holder-Egger (Hannover, 1878), p. 297; the translation appears in Deliyannis 2004, p. 135. On Agnellus's thoughts about images, see Deliyannis 1996.

4. For an early and thoughtful treatment of this issue, see Ladner 1965; more recently, see Wirth 1989, esp. pp. 53–107.

5. Augustine, *De doctrina christiana*, edited and translated by R. P. H. Green (Oxford, 1995), II, 98–99, pp. 102–3.

6. Goodman 1972, pp. 437–46; Goodman 1968, pp. 6–10.

7. [Theodulf of Orléans], *Opus Caroli regis contra synodum* (*Libri Carolini*), edited by Ann Freeman (Hannover, 1998), chap. IV.16, p. 529. On this issue, see Chazelle 1986, esp. p. 174.

8. For example: the images of Cindy Sherman (see Krauss 1993); the literary scholarship of Stephen Greenblatt (see Greenblatt 1980); and the theoretical writings of Gilles Deleuze and Félix Guattari ("Year Zero: Faciality," in Deleuze and Guattari 1987, pp. 167–91).

9. For a recent collection of studies on the medieval concept of the individual, see Bedos-Rezak and Iogna-Prat 2005.

10. See, for instance, Dale 2002.

11. On the role of gesture in later medieval art, see J. Schmitt 1990; Bonne 1993; Binski 1997.

12. Pastoureau 1985.

13. On the side wound, see Lewis 1997. For examples of the use of weight to represent an individual, see Picard 1910–13, pp. 34–36. An example of the use of the donor's height is described in Vallet de Viriville 1858, pp. 344–45. For a recent discussion of the introduction of verism into votive imagery, see Velden 2000, esp. pp. 223–46.

14. For the Latin version of one of the most popular physiognomic treatises, see Roger Bacon, *Opera hactenus inedita Rogeri Baconi*, pt. 5, *Secretum secretorum*, edited by Roger Steele (Oxford, 1920), pp. 164–72. For the text's courtly audience, see Williams 2003.

15. See Perkinson forthcoming.

47–48

47–48. Portrait Busts of a Man and a Woman

Eastern Mediterranean (Asia Minor), ca. 270–90
Marble, H. 13¼ in. (33.7 cm); 13⅛ in. (33.3 cm)
The Cleveland Museum of Art; John L. Severance Fund
(1965.242, .243)

49–50. Portrait Busts of a Woman and a Man

Eastern Mediterranean (Asia Minor), ca. 270–90
Marble, H. 12¼ in. (31.1 cm); 13¼ in. (33.8 cm)
The Cleveland Museum of Art; John L. Severance Fund
(1965.244, .247)

51–52. Portrait Busts of a Woman and a Man

Eastern Mediterranean (Asia Minor), ca. 270–90
Marble, H. 13 in. (33 cm); 13⅞ in. (35.2 cm)
The Cleveland Museum of Art; John L. Severance Fund
(1965.246, .245)

These three pairs of underlifesize portrait busts were acquired by the Cleveland Museum of Art in 1965 along with a group of five statuettes: four depicting episodes from the Old Testament story of Jonah, and one of the Good Shepherd. Reports that the busts and the statuettes were found together in the same undisclosed location are supported by the fact that all of the works are carved from the same fine-grained marble, share certain stylistic features, and show a similar yellowish brown patina with traces of incrustation. Scientific analysis of the highly crystalline white marble has confirmed that the stone for the busts and the statuettes is likely to have come from the same source: the quarries at Dokimeion (near the modern Turkish city of Afyon) in Asia Minor.[1]

Each of the six busts is carved from a single block of marble and has a circular base with a blank index tablet. On the back, the busts are hollowed out on either side of the supporting center stem and the base moldings have been left unfinished, indicating that the portraits were originally meant to be placed either in niches or against a wall. Given the close physiognomic similarities among the male and female portraits, it seems highly likely that the three pairs represent the same individuals, presumably a husband and wife.

Although the Cleveland busts are unique in that they represent three pairs of small-scale portraits of the same aristocratic couple, multiple representations of single individuals

49–50

are known from both imperial and private portraiture of the High and Late Roman Empire.[2] Shortly after the death of Caracalla (Marcus Aurelius Antoninus, r. 211–17), his successor, Macrinus, commissioned a series of six statues of the emperor: two showing him on horseback; two on foot, clad in military attire; and two seated and dressed in civilian garb.[3] Furthermore, a series of five painted portraits of Emperor Tacitus (r. 275–76) is known to have existed in the palace of the Quintilii, showing him "once in a toga, once in a military cloak, once in armor, once in a Greek mantle, and once in the garb of a hunter."[4] Multiples of statues representing private individuals are also known from the second and third centuries through epigraphic evidence. At Ephesus, Gaius Iulius Celsus Polemaeanus (governor of the province of Asia, A.D. 105–6) was depicted five times in the sculptural program of his library, twice on horseback and three times as a standing figure.[5] Marcus Plotius Faustus Sertius and his wife, Cornelia Valentina Tucciana Sertia, were represented three times in the market (*macellum*) he founded at Thamugadi (Timgad): once in front of the market's entrance and twice inside.[6] Noteworthy among the preserved examples of statues representing the same individual are two third-century busts of a bearded man in the Glyptothek, Munich,[7] and three lifesize statues of a middle-aged man with short hair and cropped beard in the Doria Pamphilj collection, Rome,

which show him once dressed in a toga, once with a sword, and once with a dog in the guise of a hunter.[8] Multiple representations of the same individual can also be found on a number of second- and third-century Roman sarcophagi that show the deceased in various guises stressing his *pietas* and *virtus* in public and private life.[9]

What distinguishes the Cleveland busts from other multiples is the fact that the variations in dress and accessories appear too insignificant to characterize different aspects of the couple's public or private persona. Consequently, their original display context and intended function remain a puzzle. While a separate presentation of each pair in the same overall setting seems more plausible than a joint display in a private portrait gallery, it is possible they were not meant to be displayed together at all, but rather were intended for distribution among members of the same family. The alleged discovery of the portrait busts with the Jonah figures and the Good Shepherd further complicates matters, as it raises the question of whether the statuettes and portraits formed part of the same funereal or domestic context, or if their survival together implies other reasons. It has been suggested that the busts and statuettes survived as an ensemble because they were stored together by a workshop or patron before they could be distributed; likely scenarios for a joint display include their use in a family mausoleum or in the

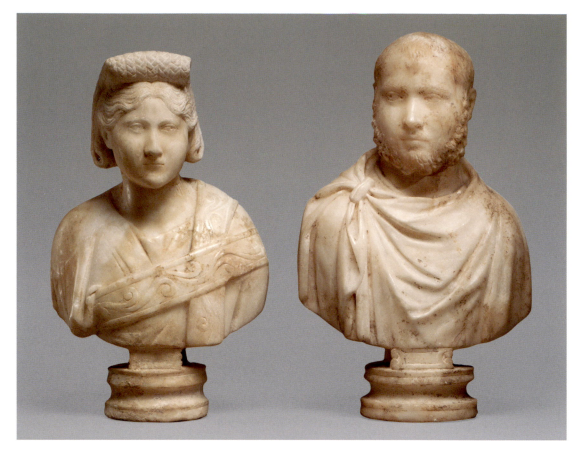

51–52

villa of a Christian Roman family of aristocratic rank.[10] Despite the fact that the busts themselves hold no definite clues as to their original grouping, there can be little doubt that they were conceived as pairs. The current arrangement, which differs slightly from previously published pairings, is based in equal part on the overall proportions of the figures, the direction of their gazes, and characteristics of their dress and accessories.

In the first pair of busts (cat. nos. 47, 48), the male figure is represented in a tunic and mantle, the latter held together over his right shoulder by a bar-shaped fibula. The folds of the mantle form a heavy band of drapery around the neck. A fringed border or fur lining is visible at the hemline, which is draped over the sitter's left shoulder and frames a cascade of V-shaped folds over his chest. His head, turned to his left, is fixed in a calm, contemplative gaze. The eyes are also turned toward the left, and the pupils are placed directly below the lid. The shortly cropped hair, indicated by repeated strokes with a fine chisel, recedes above the eyes and leaves a triangle of hair jutting out onto the smoothly polished forehead. On the sides, full sideburns develop into a curly beard, characterized by the delicate use of the drill. With the exception of the eyebrows and a thin mustache, which were cut into the

marble with a chisel, the face is highly polished and shows no sign of wrinkles.

The accompanying female bust (cat. no. 48) is likewise dressed in a tunic and mantle, the latter draped all around, creating a prominent array of folds over the chest. The woman's head looks out straight toward the viewer, but her eyes are turned to her left. Her round, softly modeled face has a prominent chin, fleshy cheeks, and a relaxed expression. Her lips are thin, and her mouth is tightly closed. The hair, like the eyebrows, is worked with a chisel; parted in the center, it flows down the sides behind the ears and into the nape of the neck, where it is plaited into eight braids, taken up again, and then folded under at the forehead. This coiffure, commonly referred to as a *Scheitelzopf* (from the German words for "top of the head" and "braid"), closely compares to the hairstyle of Ulpia Severina, wife of Emperor Aurelianus (r. 270–75), and Magnia Urbica, wife of Emperor Carinus (r. 282–85), thus indicating a date for the manufacture of the Cleveland busts between about 270 and 290.[11]

The female figure in the second pair (cat. no. 49) is nearly identical to the female figure in the first pair and is dressed in the same manner. Differences become apparent only in the drapery of the mantle, which in catalogue number 49 falls flatter around the shoulders and neck, and in the pronounced left turn of the head, which follows the direction of

the figure's gaze more prominently than in the previous example. Furthermore, the bust shows a slightly smaller section of the sitter's upper body, which may explain the difference in height between this example and the other portraits in the group. The male bust that has been chosen as a complement (cat. no. 50) matches the reduced size of the female bust better than the male figure traditionally paired with it (cat. no. 52). Although the sitter is dressed in the same manner as the man in the previous pair, the fibula here is circular, not rectangular, and the drapery, which falls flatter around the neck, is less animated. The most notable differences, however, are the arresting right turn of the man's head and his gaze, which contrasts sharply with the former bust. Otherwise, the middle-aged sitter is characterized in much the same manner, including his closely cropped hair and full sideburns that develop into a curly beard. These features compare best to the portrait type of Emperor Carinus and other busts associated with it, confirming a likely date for the group between 270 and 290.[12]

The figures represented in the third pair differ from the previous two in details of dress. The man, once again portrayed with his head and gaze emphatically turned to his right, is wearing a tunic and mantle, but the mantle lacks a fringed border or fur lining. The head and eyes of the woman are more prominently turned toward her left, establishing a strong visual bond with the male bust; her *Scheitelzopf* is also more elaborate than the others and, uniquely, extends slightly over her forehead. The most distinctive difference, however, is the broad stole or border on her garment, which is decorated with a rinceaux pattern. This elaborate dress is reminiscent of a trabeated toga and may be identified as a *cyclas* or *ricinium*: a woman's equivalent of a man's toga commonly decorated with a rich border of gold embroidery. Although this type of garment is most often associated with empresses, related examples can also be found in funerary portraits representing high-ranking private individuals.[13] The closest parallel can be found on the lid of a sarcophagus from Sidamara (Archaeological Museum, Istanbul), where a similar garment is worn by a woman represented reclining with her husband.[14] Based on the evidence of dress and the funerary context in which such a garment frequently appears, it has been suggested that the Cleveland busts are likely to have derived from a similar context.[15] There is only circumstantial evidence to support such claims, however, which are based partly on considerations of the Jonah and Good Shepherd statuettes found with the busts (both stories were often depicted in Roman catacombs as symbols of hope and salvation).[16] So while the busts may well have been commemorative in nature, the possibility that they were once in a private home cannot be ruled out.[17]

HAK

NOTES

1. Isotopic analysis was performed in 1988 by Dr. Norman Herz at the Center for Archaeological Sciences at the University of Georgia, Athens.

2. For multiple representations in imperial and private statuary, see Fittschen 1977.

3. SHA: Macrinus VI.8, II, 62–63; Wiggers and Wegner 1972, p. 42 and n. 98.

4. SHA: Tacitus XVI.2–4, III, 324–325.

5. Wilberg et al. 1953, nos. 2–5, 62–67.

6. Courtois 1951, pp. 78–79; CIL: VIII, 2394–2399.

7. Furtwängler 1910, nos. 382, 383, 372.

8. Calza et al. 1977, nos. 372–374, 299–303; Wixom 1967, p. 75.

9. Zanker and Ewald 2004, pp. 168–78, fig. 169, pp. 192–93, fig. 175, pp. 226–29, figs. 204–206.

10. Hannestad forthcoming.

11. For the hairstyle, see Wessel 1946–47, pp. 66–70; Bergmann 1977, pp. 189–200.

12. Compare especially the colossal head now generally accepted as that of Emperor Carinus in the Museo del Palazzo dei Conservatori, Rome, Sala dei Magistrati 9 (inv. no. 850). Fittschen and Zanker 1985, nos. 117, 141, 142; see most recently Hannestad forthcoming. For other closely related busts, see İnan and Rosenbaum 1966, nos. 268, 269, 195, 196.

13. For the type of dress, see Alföldi 1935, pp. 27–28; Alföldi-Rosenbaum 1996, pp. 105ff.; Dahmen 2001, p. 89.

14. Inv. no. 1179; İnan and Alföldi-Rosenbaum 1979, p. 325.

15. İnan and Alföldi-Rosenbaum 1979, p. 325; Alföldi-Rosenbaum 1996, pp. 105ff.; Hannestad forthcoming.

16. See Provoost 1994; Hannestad forthcoming.

17. Dahmen 2001, p. 95.

EX COLLECTION

[J. J. Klejman, New York]

LITERATURE

Wixom 1967; Bergmann 1977, pp. 188–90; New York 1977–78, nos. 362–368, 406–411 (entries by William D. Wixom); Kitzinger 1978 (1993 rpt.); İnan and Alföldi-Rosenbaum 1979, nos. 320–325, 323–327; Provoost 1994; Dahmen 2001, nos. 148–153, 69, 89, 93, 95, 183, 184; Hannestad forthcoming

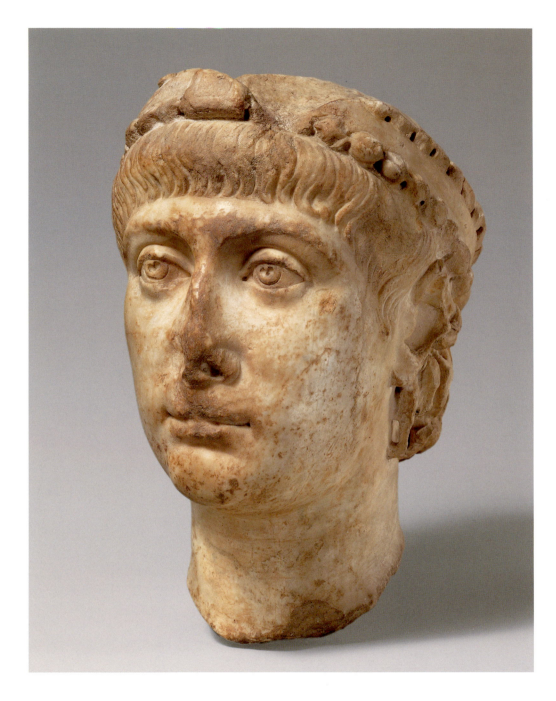

53. Head of Constans

Early Byzantine (Eastern Roman Empire), ca. 337–40
Marble, H. 10 ⅝ in. (27 cm)
The Metropolitan Museum of Art, New York; Rogers Fund,
1967 (67.107)

The static pose of the head and the figure's calm gaze, which is focused into the distance, make it clear even at first glance that this image was intended to evoke power and authority. The subtle carving of the smooth, rounded cheeks and

mouth suggests that the head depicts a youth, while the rounded base indicates that this bust, like many Roman images, was meant to be inserted into a now-lost separately carved body, perhaps a standing figure. The evenly curving locks over the youth's forehead and the longer, more freely curling ringlets at the back are held in place by a richly jeweled imperial diadem, which is bordered by rows of pearls (with a large gemstone set over the forehead) and tied in the back by pelmets. There are losses to the diadem, nose, lips, ears, and portions of the hair. There are also chips on the base of the neck and traces of polychromy on the face, hair, and diadem.

The diadem and the curly hair offer the initial keys to the identification of the figure. The Roman Emperor Constantine the Great (r. 306–37) introduced the diadem and the hairstyle about 325, after he had officially recognized Christianity as a legal religion within the empire and established his New Rome on the Bosphoros, popularly called Constantinople (city of Constantine), now the city of Istanbul, Turkey. Much scholarly research in the first part of the twentieth century sought to identify imperial busts, often on the basis of portraits on coins. The difficulty in determining the identification of this figure is related to the concept of imperial portraiture in the fourth century. Constantine's four sons were seen as reflections of his greatness, and thus it was considered appropriate to portray them as appearing similar to their father. In an oration given in honor of the thirtieth anniversary of Constantine's reign, in 336, Eusebius of Caesarea stated, "Just as the light of the sun shines upon settlers in very distant lands through its rays reflected far into the distance, so too does he [Constantine] assign his son[s] . . . to be beacons and reflectors of the brilliance emanating from himself. Accordingly, after yoking the four most noble caesars [junior emperors] like spirited colts, under the single yoke of his own imperial chariot, he directs their course by the reins of sacred harmony and concord."[1] The emperor was also meant to inspire awe, and so he appeared in processions seated rigidly and looking into the distance to demonstrate his authority.[2] Thus imperial portraits, as political images meant to encourage the belief of citizens in the power of the state, began to be carved with formalized, abstracted features.

This head was in a private collection in Istanbul in 1933 when Richard Delbrueck identified it as the head of the emperor's youngest son, Constans (b. ca. 323, caesar 333–37, augustus 337–50), a devout Christian who was assassinated in 350.[3] Other scholars have preferred to associate the bust with another of Constantine's sons, Constantine II (b. 317, caesar 317–37, augustus 337–40); the later fourth-century emperors Arcadius (r. 395–405) or Honorius (r. 393–423); or simply with an unidentified fourth-century ruler.[4] Jutta Meischner recently supported the identification of the image as Constans,[5] and while no identification can be confirmed beyond question, the head is indeed most similar to the depictions of Constans identified by Delbrueck and others. Moreover, as James D. Breckenridge has noted, the youthfulness of the head encourages an identification of the figure as Constans, who was about seventeen when he became co-emperor in 337.[6]

HCE

NOTES

1. From Eusebius Pamphili, *Oratio de laudibus Constantini*, edited by Ivar Heikel (Leipzig, 1902), pp. 198–202, in Geanakoplos 1984, pp. 17–18.

2. Ammianus Marcellinus, *Res Gestae* XVI: 10, 6–10, in Mathews 1993, pp. 25–27; and Portland 2002, p. 29 (entry by Elizabeth Marlowe).

3. Delbrueck 1933, pp. 154–55, pl. 59.

4. L'Orange 1984, p. 133, for a summary of the specific attributions; Bruns 1932, pp. 135–36, pls. 5, 6, for an attribution to Constantius II; Calza 1972, p. 327, no. 233, for an attribution to Arcadius; Portland 2002, p. 29, for a generic attribution.

5. Meischner 2001, pp. 98–99, 102.

6. New York 1977–78, p. 22, no. 15 (entry by James D. Breckenridge).

7. Bruns 1932, pp. 135–36, pls. 5, 6; Delbrueck 1933, pp. 154–55, pl. 59; correspondence in the files of the Department of Medieval Art and The Cloisters, The Metropolitan Museum of Art.

EX COLLECTIONS

Private collection, Istanbul, 1932; Dr. Wilhelm Fabricus, Bonn and Istanbul, from ca. 1932; his son, Wilhelm Fabricus, Bonn, 1967[7]

LITERATURE

Bruns 1932, pp. 135–36, pls. 5, 6; Delbrueck 1933, pp. 154–55, pl. 59; New York 1977–78, p. 22, no. 15 (entry by James D. Breckenridge); L'Orange 1984, p. 133; Meischner 2001, pp. 98–99 (with earlier bibl.); Portland 2002, p. 29 (entry by Elizabeth Marlowe)

54. Head of Empress Flaccilla (?)

Early Byzantine (Eastern Roman Empire), ca. 380–90
Marble, H. 10 11/16 in. (27.2 cm)
The Metropolitan Museum of Art, New York; Fletcher Fund, 1947 (47.100.51)

Slightly underlifesize, this head stares forward with the distant gaze typical of fourth-century imperial Byzantine images. The formal pose of the face is dominated by the elaborate "round plait" coiffure, in which the hair is pulled across the face in marceled waves, swept to the rear, brought up over the back of the head in a plait, and then arranged in a braided coronet around the top of the head. The nose is broken, probably as a result of the head's having fallen forward, and there are other limited losses to the face and base. The sheen of the highly polished face survives, as does the matte finish of the hair. The image is more highly worked on the face than the rear, suggesting that it was not meant to be seen in the round, as does the hole (now filled) drilled on the back of the head. The tongue on the base was used to insert the head into a larger form, probably a standing figure or bust.

Identification of women of the Early Byzantine era is often based on different hairstyles, some of which were worn for decades by a series of imperial figures. This image of a mature woman has the elaborate coiffure that Richard Delbrueck has associated with the Empress Aelia Flaccilla, first wife of Theodosius I (r. 379–95), on the basis of comparisons to coins and other works. Delbrueck suggested that the lack of a crown meant that the image was carved before her coronation in 383.[1] Other scholars, while recognizing the stylistic links to depictions of the empress, have considered the lack of a diadem evidence that the figure

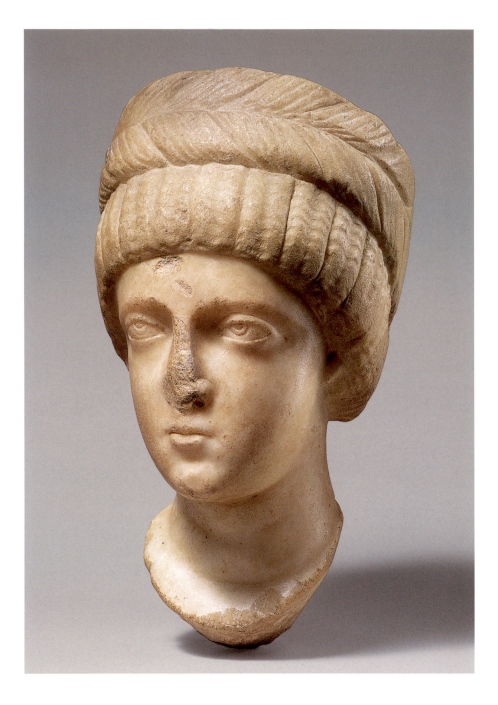

depicts an aristocrat, possibly of the Theodosian court, who was imitating the hairstyle of the empress.[2] Interestingly, in some ways the plaits of the hair imitate the effect of a crown.

Flaccilla was the first woman to be crowned empress since the mother and wife of Constantine the Great early in the fourth century, and she became a model for later empresses, who often imitated her coiffure. A devout Christian, she was described by Gregory of Nyssa at her death (ca. 386–87) as "this ornament of the empire, this zeal for the faith, this pillar of the church."[3] As the head is without its base, there is no way to know whether the complete work—if it does depict Flaccilla—originally made any reference to her faith.

Damage to imperial sculptures occurred for several reasons, but in many cases it was because the carved image was understood throughout the empire as a representation of imperial authority. The Byzantine historian Zosimos recorded that in 387, during the so-called Riot of the Statues in Antioch, images of Theodosius and the recently deceased Flaccilla were dragged through the streets by mobs as an expression of the populace's opposition to tax increases.[4]

HCE

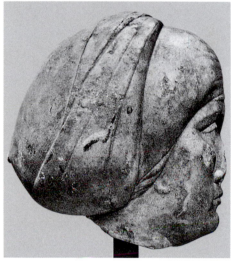

NOTES

1. Delbrueck 1933, pp. 202–3, pls. 99–101.

2. New York 1977–78, pp. 290–91, no. 269 (entry by James D. Brecken-ridge); Holum 1982, pp. 41–42; Kiilerich 1993, pp. 118–19; Cambridge 2002–3, pp. 81–82, no. 26 (entry by Elizabeth A. Gittings). Jutta Meischner and Kathrin Schade also consider the head a private portrait of the Theodosian era; see Meischner 2001, pp. 115, 181–82; Schade 2003, pp. 190–91, pls. 41, 3–4.

3. Holum 1982, pp. 23–24.

4. McClanan 2002, p. 143.

5. Helbing 1930, pls. 4, XII; Delbrueck 1933, pp. 202–3, pls. 99–101; files of the Department of Medieval Art and The Cloisters, The Metropolitan Museum of Art.

EX COLLECTIONS

Baron Max von Heyl, Darmstadt, until 1930; [H. N. Calman, London, 1933–38]; [Joseph Brummer, Paris and New York, 1938–47][5]

LITERATURE

Helbing 1930, pls. 4, XII; Delbrueck 1933, pp. 202–3, pls. 99–101; New York 1977–78, pp. 290–91, no. 269 (entry by James D. Breckenridge); Kiilerich 1993, pp. 118–19; Cambridge 2002–3, pp. 81–82, no. 26 (entry by Elizabeth A. Gittings, with bibl.); Schade 2003, pp. 190–91, pls. 41, 3–4 (with earlier bibl.)

55. Portrait Bust of a Woman with a Scroll

Early Byzantine (Eastern Roman Empire), late 4th–early 5th century A.D.
Marble, H. 20⅞ in. (53 cm)
The Metropolitan Museum of Art, New York; The Cloisters Collection, 1966 (66.25)

Fig. 80. Female Head, Villa at Chiragan, Martres-Tolosane (Haute-Garonne), late 4th century A.D. Musée Saint-Raymond, Toulouse (MSR 30139)

This exceptional portrait, arresting in its sensitive presentation and accomplished carving, is one of the masterpieces of Early Byzantine sculpture.[1] Recent research places the bust, formerly known as a "Lady of Rank," in the late fourth or early fifth century,[2] revising an earlier dating (end of the fifth or beginning of the sixth century) that associated it with the courtly circles of Empress Theodora, wife of Justinian I (r. 527–65).[3]

Over the past two decades, portraiture specialists, including Bente Kiilerich, R. R. R. Smith, Jutta Meischner, and Kathrin Schade, have explored the complexity of Late Antique culture and the continuing development of ancient portraiture traditions into the Late Antique era. The result of their research is an assembled body of male and female portraits, comparable in style to this bust, that are datable to the late fourth or early fifth century.[4] Among the hallmarks of the predominant style of these decades is the blending of classicizing elements with more formal ones in the rendering of physiognomy.

A close parallel for this portrait is found in the female head now preserved in the Musée Saint-Raymond, Toulouse (fig. 80), which Lea M. Stirling recently identified as part of the Late Antique decoration of the villa at Chiragan, in southwest Gaul. The facial features and head covering of that figure are strikingly similar to the Metropolitan Museum's bust, suggesting some sort of stylistic connection between them, perhaps a shared but as yet unlocated atelier, possibly in Asia Minor. The head covering, sometimes referred to as a snood or, using the German term, a *Haube*, is first seen in fourth-century female portraiture.[5]

The precise meaning and function of the Metropolitan's portrait are topics of considerable debate. Damage to the sculpture's right side—where a portion of the bust, including the right shoulder and forearm, was cut down—has prompted speculation about its original form. Elisabeth

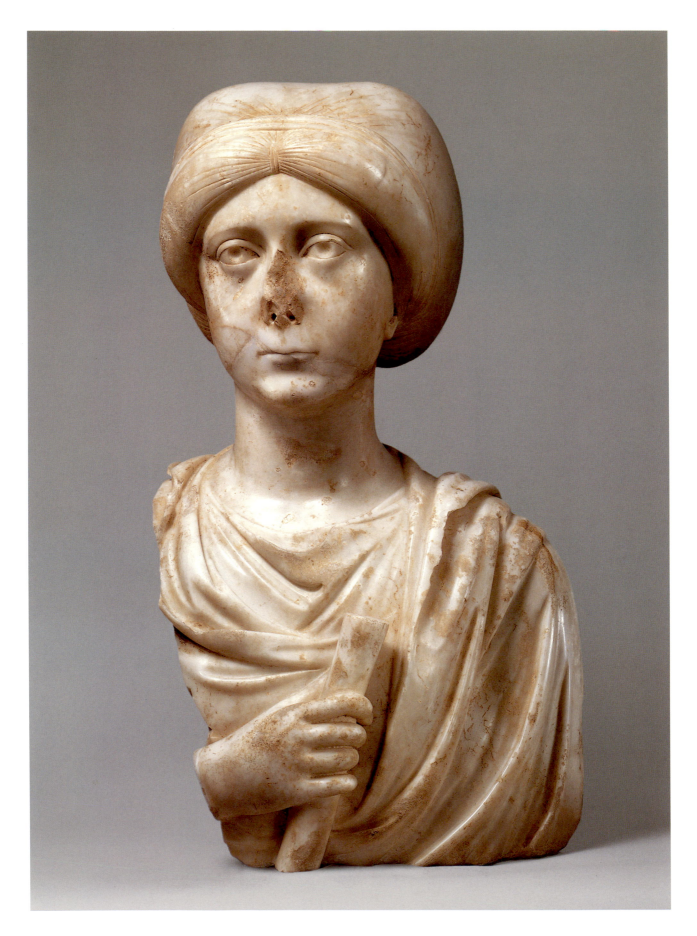

Fig. 81. Fresco of Aelia Arisuth, necropolis at Gargaresh, Tripolitania (Libya), second half of the 4th century A.D.

Alföldi-Rosenbaum first proposed that a male figure may have been joined to it, forming an image of husband and wife. However, despite many examples of married couples depicted in relief carving on sarcophagi, in gold glass medallions, and in silver—most famously the portrait of Projecta and Secundus on the so-called Projecta Casket (British Museum, London)[6]—no parallel in bust portraiture survives, possibly because single portrait busts could be placed side by side in order to represent husband and wife (see, for example, cat. nos. 47–52).[7] Another reasonable explanation for the damage has been proposed by Schade, who raises the possibility that the cutting down of the piece was part of an effort to repair the broken shoulder.[8]

The most striking iconographic parallel for the woman, who is shown holding a scroll, is the bust image of Aelia Arisuth in a fresco, dated to the second half of the fourth century, decorating the walls of her funerary chapel at Gargaresh, Tripolitania, in modern Libya (fig. 81).[9] The garments worn by both women—tunic, palla (mantle), and head covering—reflect their maturity as well as their modesty and Christian piety. The scroll symbolizes an appreciation for classical education and learning (paidea), which in turn reflects the subjects' noble status.[10] Although freestanding sculpted portraits and busts regularly decorated earlier Roman tombs of the first century B.C. to the second century A.D., they are uncommon in funerary decoration of the Late Antique period.[11] The present bust, therefore, seems more likely to have been part of a civic sculptural display—in commemoration of a public donation or church foundation, for example[12]—or shown in a domestic context.[13]

STB

NOTES

1. Alföldi-Rosenbaum 1968, p. 19 n. 2, compared the marble's fine-grained texture to that quarried in the region of Dokimeion, in Phrygia.

2. Kiilerich 1993, pp. 121–23, fig. 68; Meischner 2001, pp. 113–16, figs. 323, 324; Schade 2003, pp. 208–10, no. I 49, pl. 56.

3. For authors supporting this range of dates, see Forsyth 1967, pp. 304,

306; Alföldi-Rosenbaum 1968, 1972; New York 1977–78, pp. 293–95, no. 272 (entry by James D. Breckenridge); Harrison 1989, p. 36. It is of historiographic interest that sixth-century attributions for the bust, acquired by the Metropolitan Museum in 1966, coincided with the 1960 discovery and subsequent excavation of one of the great Constantinopolitan churches founded by an imperial princess, the church of Hagios Polyeuktos, built in 524–27 by Anicia Juliana. The dating proposed here precludes the identification of this bust as Anicia Juliana. On the church, see Harrison 1986–92 and 1989. Helga von Heintze's challenge of the work's authenticity has been dismissed by subsequent authors; see Heintze 1970, esp. p. 55 n. 19.

4. Kiilerich 1993; Meischner 2001, pp. 113–16; Schade 2003, pp. 45–166. On Late Antique portraiture in civic contexts, see R. Smith 1999.

5. See Alföldi-Rosenbaum 1968, pp. 35–40; Kiilerich 1993, pp. 123–24; Meischner 2001, fig. 322; Schade 2003, pp. 199–200, no. I 40, pl. 49, 1.2; and Stirling 2005, p. 60.

6. I am grateful to Professor Marice Rose of Fairfield University, Connecticut, for discussing the evidence for double portraits in these varied media, especially those representing a husband or wife holding a scroll. See Rose 2000, pp. 187–90; on the Projecta Casket, see also Elsner 2003.

7. Schade 2003, p. 209.

8. A confirmed restoration was completed before the work entered the Museum's collection: a horizontal break through the head—seen, for example, passing through the mouth. The two parts were joined with an adhesive and marble fill. Schade 2003, p. 209.

9. Kiilerich 1993, p. 123; Schade 2003, pp. 209–10, 244–45, no. III 7, pl. 14, 1.

10. Marrou 1956, chap. 9; Elsner 1998, pp. 106–13.

11. Portraits that appear on third- to fifth-century tombs are more often on relief-carved sarcophagi or executed in fresco. I greatly appreciate the discussions of these traditions and the Museum's bust that I had with Professor Ann Marie Yasin of the University of Southern California, Los Angeles. For her recent work on the period, see Yasin 2005.

12. R. Smith 1999.

13. See, for example, Stirling 2005, pp. 60–61, 168–69.

LITERATURE

Alföldi-Rosenbaum 1968; New York 1977–78, pp. 293–95, no. 272 (entry by James D. Breckenridge); Kiilerich 1993, pp. 121–23, fig. 68; Schade 2003, pp. 208–10, no. I 49, pl. 56 (with complete bibl.)

56. Head of a Woman

Early Byzantine (Eastern Roman Empire), ca. late 400s
Marble, H. 11¼ in. (28.6 cm)
The Metropolitan Museum of Art, New York; Fletcher
Fund, 1947 (47.100.52)

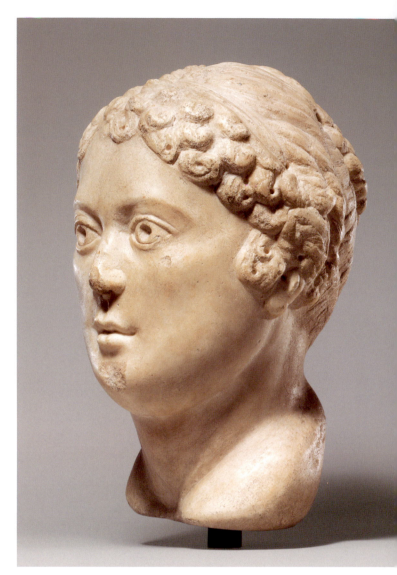

With its small curving mouth and large staring eyes, this face projects an air of almost complacent authority. High cheekbones rise above fleshy cheeks on a thick, strong neck. Delicate ringlets, held in place by a ribbon, frame the highly polished marble of the calm face; the rest of the hair is swept up in the back to the top of the head in carefully arranged braids that end in a pair of small, tightly curled knots. The eyes have large holes for pupils that were possibly meant to be filled with lead or stone. On the top of the head, around the ends of the braids, are drill holes that suggest the head was once adorned with an ornament or net. Additional drill holes at the ends of the hair ribbon indicate that its ends may have had metal decorations, and similar holes in the ears imply that they were originally adorned with earrings. All of this jeweled ornamentation would have made the statue a far more elaborate, elegant image. Now the nose is abraded, there is a deep gash on the chin, and there are smaller chips on the face, the right side of the neck, and in the hair. The flat base suggests that the head was meant to be inserted into a separately carved body or bust.

When first published in 1931 by Arthur Sambon, the head was identified as an Italo-Byzantine representation of Helena, mother of Constantine the Great (r. 306–37), and was dated to the fourth or fifth century.[1] Subsequent scholarship placed the head within a more generalized fifth-century context.[2] More recently, Jutta Meischner and Kathrin Schade have identified the head as an important work from the end of the fifth to the early sixth century by comparing the fleshy articulation of the face and the large, staring eyes to crowned portraits of the Empress Ariadne, who was born into the imperial family in Constantinople prior to 457.[3] Ariadne, who eventually made two men emperor through marriage, wielded great power at court for many years before dying in 515.[4] As the head reflects the style of imperial portraiture in Constantinople about 500, it was probably carved there. However, the arrangement of the hair is not typical of surviving sculpture of that period and may, therefore, be a deliberate evocation of the age of Constantine the Great. Another head, perhaps that of Fausta, wife of Constantine, has similar ringlets on the face and swept-back braids.[5] It is possible that the woman depicted here wished to evoke both the style of the powerful empress of her own time and the memory of the equally powerful, devout Christian empresses of the age of Constantine.

HCE

NOTES

1. Sambon 1931, pl. XXX. Piero Tozzi claimed it was possibly from Ravello.

2. Baltimore 1947, p. 25, pl. VII.

3. Meischner 2001, pp. 133–35; Schade 2003, pp. 224–25, pls. 65, 2–4.

4. T. E. Gregory and A. Cutler, "Ariadne," in *The Oxford Dictionary of Byzantium*, edited by Alexander Kashdan, vol. 1, pp. 166–67 (New York, 1991).

5. Schade 2003, pp. 167–68, pl. 22, figs. 1–3.

EX COLLECTIONS

[Piero Tozzi, Rome, 1920s]; [Arthur Sambon, Paris, after 1931]; [Joseph Brummer, Paris and New York, 1947]

LITERATURE

Sambon 1931, pl. XXX (with identifying caption); Baltimore 1947, p. 25, pl. VII; Meischner 2001, pp. 133–35; Schade 2003, pp. 224–25, pls. 65, 2–4 (with earlier bibl.)

57. Capital with Angels Holding the Veil of Saint Veronica, with column

North Italy, Veneto (?), ca. 1325–75
Limestone with traces of polychromy, H. 73⅞ in. (187.5 cm) overall; capital: 15⅜ x 15⅜ x 20¼ in. (39.1 x 39.1 x 51.4 cm)
The Metropolitan Museum of Art, New York; Purchase, Gifts of Irwin Untermyer, J. Pierpont Morgan and Marcus T. Reynolds, by exchange; Bequests of George D. Pratt, Susan Dwight Bliss and Henry Victor Burgy, by exchange; and Rogers and Frederick C. Hewitt Funds, 1981 (1981.9a-c)

The legend of the veil of Saint Veronica is the basis for one of the most popular images in the Latin West during the High Middle Ages.[1] Different versions of the story exist, but they all relate the same essential narrative of how Roman Emperor Tiberius (r. A.D. 14–37), having fallen ill, heard of Jesus' miraculous cures and sent an emissary, Volusian, to Jerusalem to bring Jesus to Rome. Pilate had already put Jesus to death, however, so Volusian met with Veronica, who possessed a cloth onto which an image of Jesus had been miraculously imprinted after she had wiped his face with it as he was led to Calvary. (The name Veronica is derived from the phrase Vera Icon, or "true image.") Veronica and Volusian brought the cloth to Rome, and Tiberius regained his health after gazing upon the image of Christ's face.

The linen cloth with the image, which was kept at Saint Peter's and survived until at least 1527, was one of the most venerated relics of the Middle Ages. In 1216 Pope Innocent III (r. 1198–1216) composed a prayer in its honor that carried indulgences of ten years when said before it. The practice was reinforced in 1300, the first jubilee year for the remission of sin, as established by Pope Boniface VIII (r. 1294–1303), and is even referred to in Dante's *Paradiso* (31:103–108). Prayers, hymns, and indulgences became the main agencies through which the popularity of the Veronica relic was perpetuated, but the cloth itself was also seen by hordes of pilgrims, who either purchased token pilgrim badges or were given them: one of the main reasons why knowledge and dissemination of the image were so widespread.

On this capital—which is included here because in the Middle Ages the face on the cloth was considered to be an actual portrait—the strongly three-dimensional image of Christ's face is carved in high relief, and he is shown as if he were still alive, without the crown of thorns of the Passion

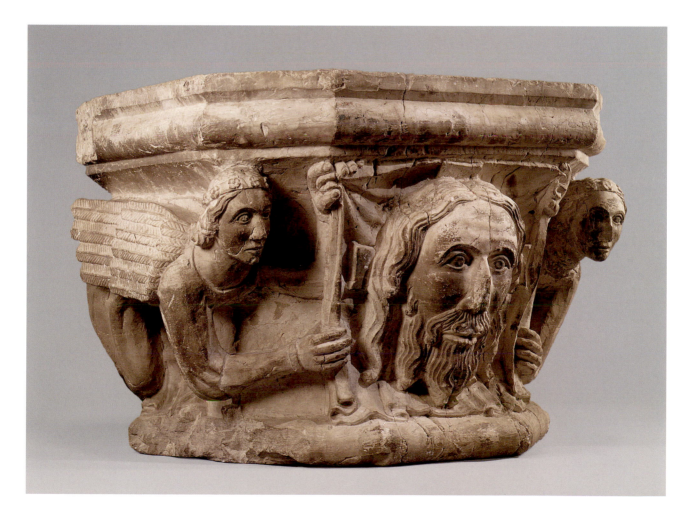

Fig. 82. Capital with Lamb of God
(reverse, cat. no. 57) on current
column and base

Fig. 83. Left: Catalogue number 57 in the
gallery of Antonio Carrer, Venice, ca. 1910,
before the loss of the abacus and the cutting
down of the column. Right: Column and
capital with Samson and the Lion (?) in the
same gallery (current whereabouts
unknown). Photographs: Department of
Medieval Art and The Cloisters, The
Metropolitan Museum of Art, New York

but with the arms of the Cross behind his head. The cloth is held by two kneeling angels carved partially in the round; they wear long tunics and have wings that run parallel to the abacus (now lost). The angel on the left bears a decorated girdle, while the one on the right is wrapped in a cord terminating in tassels, possibly an indication that the column originated in a mendicant context.

On the other side of the capital is the Lamb of God (fig. 82), an appropriate counterpoint to the face given the sacrificial connotations. In her *Spiritual Exercises*, the Benedictine nun and visionary Gertrude of Helfta (1256–1302) used the Lamb imagery from the Apocalypse (19:7–9) to elucidate the association for the nuns under her rule: "To obtain entrance for me into the nuptials of the Lamb, just as each one of you has entered to see the face of God."[2] Another prayer written in honor of the Veronica image (*Salve sancta facies*, or "Hail, Holy Face"), attributed to Pope John XXII (r. 1316–34), says: "Hail, Sudarium [a napkin for wiping the face], excellent jewel, be our solace and reminder. No human hand depicted, carved or polished you, as the heavenly Artist knows who made you as you are."[3] Like the earlier prayer, recitation of this one before an image of the veil granted indulgences of ten years, guaranteeing that such images—whether in stone, paint, or other media—would become immensely popular.

Images like this one were intended to inspire meditation through a visual identification of Christ's likeness. The earliest sculptural representation of the cloth is generally believed to be the standing figure of Saint Veronica in the church of Notre-Dame at Ecouis (1308–13), in which the face of Christ, carved in low relief, is represented as if he were still alive, with his eyes open, and not suffering. When the Metropolitan Museum acquired the capital and column in 1981, information from the dealer suggested that it came from the crypt of a church in Aubeterre (Charente-Maritime), based, in part, on the story that Veronica, following the Crucifixion, was believed to have established a hermitage in the nearby town of Soulac (Médoc). Although this provenance was never confirmed on either historical or stylistic grounds, the question was rendered moot by the discovery of photographs of this work and a related sculpture being offered to the Museum about 1910 by the Venetian dealer Antonio Carrer (fig. 83), increasing the likelihood of a Venetian origin. At the time, the column was evidently twice its present height and had an abacus; there was also a companion capital (with abacus, shaft, and base) showing Samson or David Battling a Lion. Both columns show limited signs of weathering in the photographs, indicating that they probably came from an interior ecclesiastical setting, perhaps supporting a canopy over a side altar dedicated to Veronica or a canopy over a funerary monument.

The stone of the capital was analyzed to determine its geological origin, a useful gauge for determining possible provenances for the carving. The limestone proved to be globigerina-biomicrites, a type found in the Veneto, Lombardy, and the Apennines.[4] Given the North Italian source and a likely later provenance in the Veneto, a more careful study of this unusual work is now required.

CTL

NOTES

1. See Jacobus da Varagine 1993, vol. 1, p. 212.

2. Hamburger 1998, p. 379.

3. London 2000, p. 86.

4. For this information we are grateful to Prof. Lorenzo Lazzarini, Direttore, Laboratorio di Analisi dei Materiali Antichi, Università IUAV di Venezia, and George Wheeler, Research Scientist, Department of Scientific Research, The Metropolitan Museum of Art.

EX COLLECTIONS

[Antonio Carrer, Venice, ca. 1910]; [Charles van der Heyden, Rotterdam]

LITERATURE

New York 1999, no. 146

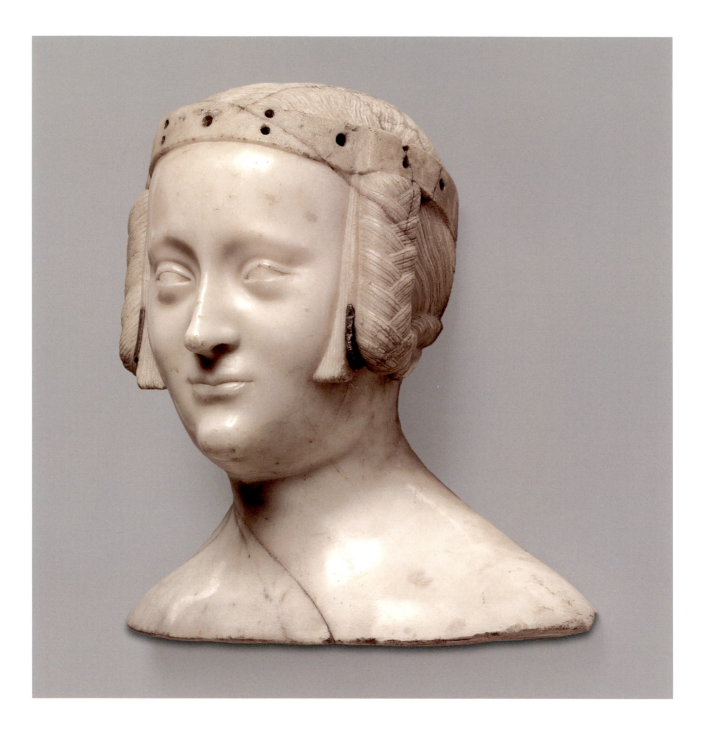

58. Bust of Marie de France

Jean de Liège (Franco-Netherlandish, active ca. 1361–81)
France, Saint-Denis, ca. 1381
Abbey Church of Saint-Denis, chapel of
Notre-Dame-la-Blanche
Marble with lead insets and traces of polychromy,
H. 12¼ in. (31.1 cm)
The Metropolitan Museum of Art, New York; Gift of
George Blumenthal, 1941 (41.100.132)

The unchecked destructive fury of the mob during the French Revolution—whether spontaneous or, more often than not, mandated by the government—was directed not only against the living representatives of the hated privileged classes (the monarchy, aristocracy, and clergy) but also against the monuments that perpetuated their history, in particular the sculptural decoration of churches and the innumerable funerary effigies found within them. The abbey church of Saint-Denis, on the northern outskirts of Paris, was a special target since it was the royal necropolis, housing an unbroken succession of sculpted tombs.

The story of the secularization of Saint-Denis and the destruction and removal of its tombs has been told often and well.[1] At first the greatest care was taken to ensure the preservation of the vast riches contained within the church, augmented in the spring of 1791 when Saint-Denis became the recipient of objects and tombs from churches that were being converted to other uses. In August of the following year, however, free rein was given to the passions of the mob by the National Assembly, which ordered that all monuments, or "restes de la féodalité" (remains of feudalism), be removed and destroyed because they offended the sensibilities of a people newly released from bondage and because the bronze and lead of which many of the monuments and most of the coffins were composed were sorely needed for the casting of cannon and *balles patriotes* (patriotic bullets). One year later, in August 1793, the National Convention passed a decree ordering the elimination of all objects that seemed still to represent the pride and arrogance of a privileged class, specifying that the tombs in Saint-Denis should be destroyed and their contents removed. Throughout the autumn the work of demolition was methodically carried out; the tombs were smashed and emptied of their contents, and whatever sculpture survived was either gathered together haphazardly or scattered. What remains there today is largely original, but restored.

The bust of Marie de France (1327–1341) is a sad reminder of these events. Having passed through a succession of owners, the bust was given to The Metropolitan Museum of Art in 1941. It remained unidentified until 1945, when William Forsyth, a curator in the Department of Medieval Art, was able to match it to a drawing made for Roger de Gaignières of the tomb of Marie de France and her sister, Blanche de France (1328–1392), daughters of King Charles IV, le Bel (r. 1322–28), and his queen, Jeanne d'Evreux (1310–1371) (fig. 84).[2] Traveling about with an artist, Gaignières had drawings made of all the tombs he saw and recorded their emplacement and inscriptions, in this case locating the tomb in the chapel of Notre-Dame-la-Blanche in the abbey church of Saint-Denis.

Once these essential facts had been established, it was possible to identify the tomb's sculptor as Jean de Liège (active ca. 1361–81). The inventory of the contents of Jean's atelier, made shortly after his death, lists a number of tombs, among them that of Blanche de France (fig. 85) and her sister, Marie, who had died some forty years earlier, at the age of fourteen. The tomb was apparently completed by the

Fig. 84. *Tombs of Marie de France and Blanche de France, Abbey Church of Saint-Denis. Drawing, late 16th century, from collection of Roger de Gaignières (1642–1715). Cabinet des Estampes, Bibliothèque Nationale, Paris (Est. Rés. Pe 1a, fol. 39)*

Fig. 85. *Jean de Liège (Franco-Netherlandish, active ca. 1361–81). Tomb of Blanche de France, Abbey Church of Saint-Denis*

time of Jean's death, ten years before Blanche's own demise. Since Blanche elected to include her sister's effigy with her own so long after the latter's death, the question of the portrait's accuracy is raised. Either the sculptor used a funerary mask taken at the time of Marie's death, or the young woman's visage is a product of his imagination, perhaps partly based on Blanche's features. In either case, the bust gives the impression of a highly successful attempt at individualization, for Jean de Liège was a member of a group of North French and Netherlandish sculptors and painters active in the fourteenth and fifteenth centuries who contributed an important element of realism to late medieval art that seems to be particularly associated with artists from that region.

The head was originally adorned with a metal coronet probably decorated with real or imitation precious stones and attached to the sculpted band across Marie's forehead.[3] She is depicted as a fashionable court lady with a hairstyle that was in vogue (with some variations) during the last quarter of the fourteenth century and into the first years of the fifteenth century. Her sister, in contrast, wears the close wimple of a widow. The small pieces of lead inserted between the braids and the straight locks of hair that fall along the temples and cheeks would have supported small pieces of jewelry that, on a living person, would have held the braids in place, the latter being pulled to the back of the head.[4]

Regardless of whether or not the bust is a portrait, the quality of the work is ample testimony to the high standing of Jean de Liège as a favored sculptor to Charles V, le Sage (r. 1364–80). About 1365 Jean was working on portraits of the king and his queen, Jeanne de Bourbon, for the great staircase of the old palace of the Louvre, and in 1367 he had completed the tomb of Philippa of Hainaut (d. 1369), queen of England and wife of Edward III (r. 1327–77), a monument that still exists in Westminster Abbey. As a *tombier* Jean enjoyed a distinguished career, and the bust of Marie de France, along with the full effigy of her sister, Blanche, have been used as the basis for the attribution to him of several other female effigies.[5] Both heads show an extraordinary sensitivity of portraiture, with extremely delicate surface modeling that accentuates the subtle expression of the face, especially in the case of Marie, whose faint smile activates the mouth beneath the plump cheeks of youth and a small, pointed nose (which has miraculously escaped damage). The smooth curve of the forehead ends in the slight protrusion of the fashionably plucked eyebrows, which frame a series of volumes that define the eyes above deeper depressions, characteristic of the artist's style.

Except for his brief sojourn in London, Jean appears to have remained in Paris for most of his career. He would thus have been drawn inevitably into the artistic climate fostered by Charles V, epitomized by the tombs of Jean's great fellow sculptor and countryman André Beauneveu (active 1363–ca. 1397), whose works represent a culmination of the trend toward a sober and more realistic representation of natural forms.

SKS

NOTES

1. See Guilhermy 1848; Despois 1868; Courajod 1878–87; Billard 1907; Vitry and Brière 1925.

2. The drawings gathered by Gaignières are divided between Paris and Oxford. In Paris, 4,273 drawings are in the Cabinet des Estampes, Bibliothèque Nationale; another 678 are in the Département des Manuscrits. In Oxford, 1,844 drawings are in the Bodleian Library. Tracings of the Oxford drawings may be found in the Cabinet des Estampes of the Bibliothèque Nationale. See Bouchot 1891; Guibert 1911–14; Adhémar and Dordor 1974–77; Brown 1988 (with further bibl.). The drawing of the tomb of Blanche de France and Marie de France is catalogued as Pe 1a, fol. 39, in the Cabinet des Estampes, Bibliothèque Nationale, Paris.

3. As a royal princess Marie would not have worn a crown. For a good example of a queen and her entourage, the latter including royal princesses with the same hairstyle and coronet worn by Marie de France, see Piponnier 1970, p. 345, pl. VII. The illustration is from the *Grandes chroniques de France*, Paris, Bibliothèque Nationale, ms. fr. 2813 (Piponnier does not give a fol. number). The scene shows Jeanne de Bourbon greeting Holy Roman Emperor Charles IV and his son, Wenceslas.

4. In addition to the Piponnier book cited in note 3, as a source of information regarding costume see, for example, Beaulieu and Baylé 1956, esp. pp. 83–84.

5. These are all in Saint-Denis and include Marie d'Espagne (d. 1379), originally in the church of the Jacobins, Paris; Marguerite de Flandre (d. 1382); and Blanche d'Evreux (d. 1398) and her daughter, Jeanne de France (d. 1371). The entire group of six figures, including the two documented to Jean de Liège, is quite unified in terms of style, approach, and level of quality, the only possible exception being the effigies of Blanche d'Evreux and her daughter. These two were possibly by a follower of Jean de Liège and probably date slightly later than the others, which were executed about 1380–82. For Jean de Liège, see Devigne 1932, pp. 78–96; Scher 1966, pp. 56–58, 61–67; Gerhard Schmidt, "Beiträge zu Stil und Oeuvre des Jean de Liège," in Schmidt 1992, pp. 77–101; Heinrichs-Schreiber 1997, pp. 89–93; Carqué 2004, pp. 282–321. See also the entry in *The Dictionary of Art*, edited by Jane Turner, vol. 17, pp. 458–59 (London, 2002).

EX COLLECTIONS

Dufay Collection, Paris, 1900; George and Florence Blumenthal, New York, 1920–41

LITERATURE

Forsyth 1945; Los Angeles–Chicago 1970, no. 76; Paris 1981–82, no. 78 (with earlier bibl.); Laclotte 2003, p. 210; Paris 2004, no. 16; Wixom 2005, p. 39

59. Head of a Cleric

East France, ca. 1450–60
Red sandstone, H. 9 in. (22.9 cm)
The Metropolitan Museum of Art, New York; Rogers Fund,
1947 (47.42)

The files of the Metropolitan Museum contain a note regarding the provenance of this eloquently and sensitively carved head in which the vendor, a Paris dealer, states that the former owner (another Paris dealer) maintained the head was from "a statue from the porch of the chapel of the Abbey of Moyenmoustiers [*sic*] (Vosges)." The monastery of Moyenmoutiers has ancient roots, having been founded in the seventh century by Saint Hidulph. Over the course of many centuries, the monastic buildings, including at least two churches, Saint-Pierre and Sainte-Marie, were demol-

ished and rebuilt; the current church dates to the eighteenth century. Extensive research into the history of this monastery has revealed no evidence whatsoever of any monument from which this head could have been taken. Only the red sandstone it is carved of establishes any sort of physical link with eastern France.[1]

If, as seems possible, the head belonged to a funerary monument, an examination of the extensive collection of drawings of such monuments done for Roger de Gaignières in the mid-eighteenth century—before most of them were destroyed in the French Revolution—has nevertheless yielded no match for its source.[2] We are thus faced with yet another homeless fragment, albeit one of extraordinary quality, that was "untimely ripped" from its original location and set adrift, like so many works in this exhibition, into a mute, historical amnesia. Whether from a tomb effigy or not, the face, portrayed with the distinct individualism of a portrait and in an attitude of deep and contented medita-

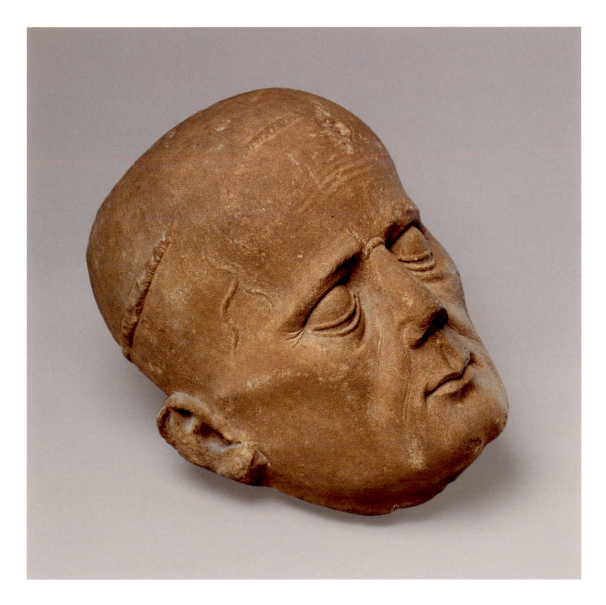

tion, is that of a living being rather than a lifeless corpse. There is, however, a certain ambiguity about the head depending on how it is viewed. Since we do not know its original positioning—that is, vertical or horizontal, both of which are possible positions for a tomb effigy—and since the eyes are not completely closed, the subject, if viewed from directly in front, appears to be merely in an attitude of deep introspection. If seen from almost any other angle, however—from above or below, or from the side in a horizontal position—it has the appearance of a corpse.

Whatever the ultimate resolution of this question, if there is any, the artist has combined with great skill and extreme subtlety the modeling of facial features—prominent cheekbones over sunken cheeks, the soft flesh around the nose and mouth, the dimpled chin, and, in particular, the slight smile that plays over the mouth—with perfunctory indications of surface details, such as the wrinkled brow, the incised age lines around the eyes and mouth, and the prominent veins on the temples. The smooth dome of the shaved head, delineated by a thin tonsure, is echoed in the stylized volumes of the downcast, not fully closed eyes. The artist has succeeded in conveying the serenity of spirit of the cloistered monk tinged with the slightly bemused expression of a worldly cleric.

The research into this sculpture's chronological and art historical context is both limited and unconvincing. The head of a man with a soft cap and downcast eyes from an Entombment group, originally in the church of Notre-Dame-en-Vaux in Châlons-sur-Marne and now in the Musée du Louvre, Paris, has been compared to the Metropolitan Museum's head, but beyond a certain general correspondence in date and the presence of downcast eyes, this association is of little use.[3] Closer in appearance, and with many similar characteristics, is the head of Bishop Hartmann Münch, originally from his tomb, that was found under the floor of the Niklauskapelle in the Basler Münster.[4] Both heads are certainly not by the same hand, however, and may share only a chronological correspondence, namely the late fifteenth century.

Of greater relevance is the inclusion of this head by Theodor Müller in his presentation of the work of Nikolaus Gerhaert von Leiden (active 1460–ca. 1473).[5] Although Müller wisely refrains from attributing too close an association with Gerhaert, there is no question that the head occupies an important position in the development of strongly naturalistic representation in both painting and sculpture, as seen in the works of Netherlandish artists beginning in the late fourteenth century. In sculpture, the most dramatic innovations occur in the work of Claus Sluter (ca. 1360–1406), who is an undeniable source for the even more impressive originality of Gerhaert. The unforgettable individualization produced by the latter, especially in the fragments of sculpture, also in red sandstone, preserved from the Chancellery portal

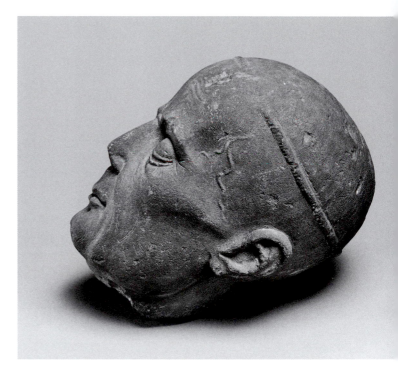

of Strasbourg (1464), presents us with a roughly contemporary conceptual, stylistic, and even geographical context for this head of a cleric, which can surely claim nearly the same high level of quality.[6]

SKS

NOTES

1. The exact composition of the stone, previously misidentified as limestone, was established through X-ray fluorescence in the Object Conservation Laboratory of The Metropolitan Museum of Art in November 2005. Detailed analysis is on file in the Department of Medieval Art. My thanks to George Wheeler, Research Scientist, Department of Scientific Research, for conducting these tests.

2. Most of these drawings were published in a series of articles by Jean Adhémar in the *Gazette des Beaux-Arts*, continued by Jean-Bernard de Vaivre. For a complete listing as well as additional material, see Brown 1988, pp. 1–2, nn. 1, 2.

3. Aubert and Beaulieu 1950, p. 202, no. 298; Baron 1996, p. 179, no. RF1100.

4. Correspondence and photograph in the files of the Metropolitan Museum; the head is in the Stadt- und Münstermuseum, Kleines Klingenthal, Basel.

5. Müller 1966, pp. 79–87, esp. p. 85. Müller also mentions the Louvre head from Châlons-sur-Marne in this context.

6. The works in question are in the Musée de l'Oeuvre Notre-Dame, Strasbourg (inv. nos. 162, 165) and the Liebieghaus, Museum Alter Plastik, Frankfurt am Main (inv. no. St.P. 353).

EX COLLECTIONS

[M. Tedeschi, Paris]; [Raphael Stora, New York, until 1947]

LITERATURE

Müller 1966, pp. 85–86, nn. 31–32, pl. 97B; New York 1980, p. 10 (ill.)

60. Head of a Man

Central France, first quarter of the 16th century
Marble, H. 5½ in. (14 cm)
The Cleveland Museum of Art; Gift of William G. Mather
(1921.1004)

61. Head of a Young Woman

Central France, first quarter of the 16th century
Marble, H. 5¾ in. (14.6 cm)
The Cleveland Museum of Art; Gift of William G. Mather
(1921.1003)

If the sculptures in this exhibition stimulate feelings of appreciation for their beauty or expressiveness or for the skill with which they were fashioned, such emotions must, at the same time, be accompanied by a deep regret for the often severe trials these works have undergone. Nowhere is this more apparent than with these two heads. Judging from their size, style, and material, they were both undoubtedly part of the same dramatic narrative relief and were forcibly removed from that monument, which, unfortunately, no longer exists, making an exact identification almost impossible and thus intensifying our sense of loss.

The male head appears to be that of a tonsured cleric, who gazes to his left with an anguished expression, achieved with extraordinary subtlety through the partly open mouth, the high, prominent cheekbones above the concavity of the visible cheek, and the deep eye sockets beneath bony, protuberant brows that are slightly compressed above the nose. The female head is treated no less naturalistically and is given a distinct individuality. Her expression is calmer, her youthfulness conveyed through the fuller volumes and smoother surfaces of the face. Her hair is drawn back behind the head and is covered with a folded cloth that is secured over the

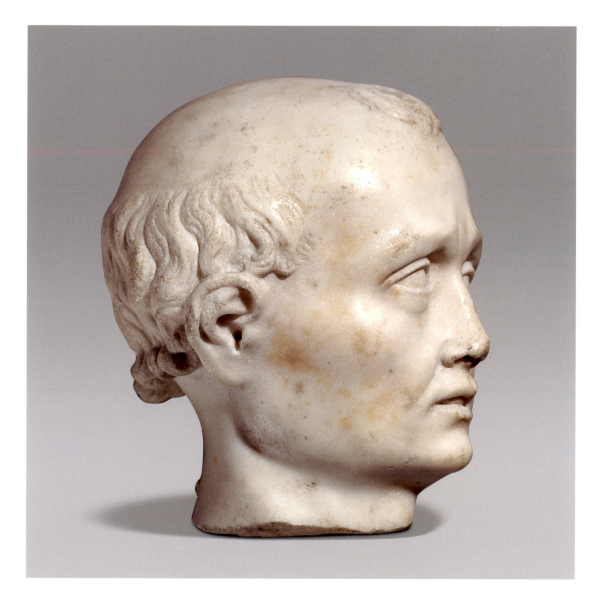

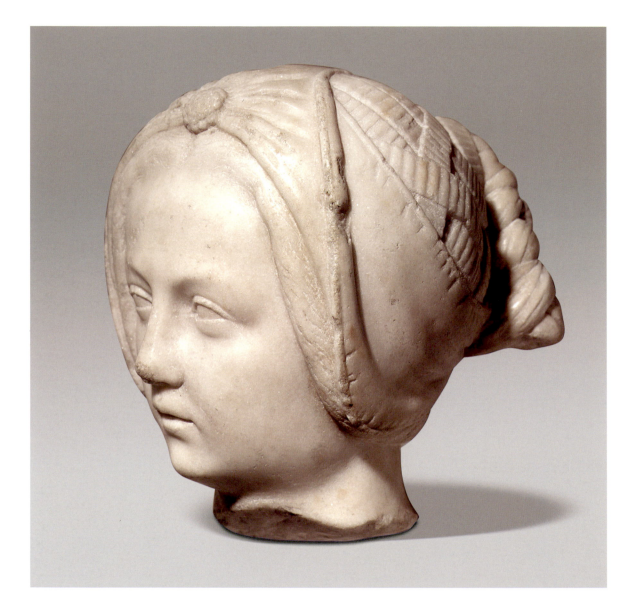

forehead with a simple jeweled clasp. Her mouth, too, is barely parted, but her emotions are expressed with greater ambiguity and restraint than those of her companion.

The female head's high forehead, slightly squinting eyes, and oval face with tiny chin are typical of the sculptures produced in central France, particularly the Bourbonnais, in the early part of the sixteenth century that are associated with the work of Michel Colombe (active 1496–ca. 1515). Such works represent a significant moment in the history of French Gothic sculpture as it came into contact with and absorbed elements of the Italian Renaissance.[1] Although Colombe received many important commissions, which we know of through existing documents, much of his work is now untraceable or was later destroyed, especially during the French Revolution. The most significant and influential surviving monument by Colombe is the tomb of François II of Brittany and Marguerite de Foix in Nantes Cathedral,

which was commissioned by their daughter, Anne de Bretagne, in 1499 and completed in 1509. The ensemble—composed of the funerary effigies, attendant angels, reliefs of mourners and saints, and, at the corners, four large female statues representing the cardinal Virtues (fig. 86)—is an important example of the integration of Late Gothic and Italian Renaissance forms.

Although a direct attribution of the Cleveland heads to Colombe is not possible on stylistic grounds, there is no doubt that they were executed by a sculptor of great skill working in the region whose style can generally be associated with Colombe and his followers. Only the broadest comparisons, to establish regional and chronological links, can be made with such sculptures as a Saint Madeleine in Bourbon-l'Archambault;[2] another Saint Madeleine in Limeray (Indre-et-Loire);[3] a more typically Bourbonnais head of a woman in the Musée du Louvre, Paris;[4] or, from the same

region, the head of the Virgin in an Education of Christ sculpture, also in the Louvre.[5] Scholars have also mentioned the Virgin of Olivet (Musée du Louvre)[6] and the Virgins from Mesland (Loir-et-Cher)[7] and Écouen (Musée du Louvre).[8] All of these examples date between the end of the fifteenth and the end of the first quarter of the sixteenth century, but they can establish only a basic, not a specific, context for the Cleveland female head, which is, in some cases, more expressive and more delicately modeled.

Dorothy Gillerman has noted a large retable in marble that was meant to accompany the Nantes tomb—and which was left unfinished at Colombe's death—as a possible setting for these two heads.[9] The retable contained a crucifix flanked by figures of Saints Francis and Margaret. The Cleveland heads could be associated iconographically with these two saints, but because nothing remains of the monument, and since stylistically the heads do not correspond very closely to the tomb sculptures, this connection must remain tantalizingly unlikely.

<div style="text-align:center">SKS</div>

NOTES

1. For Michel Colombe, see Pradel 1953; Philippe Rouillard in *The Dictionary of Art*, edited by Jane Turner, vol. 7, pp. 595–96 (London, 2002).

2. Pradel 1953, pl. XVII, 3.

3. Ibid., pl. XVIII, 2.

4. Baron 1996, p. 185, RF2203.

5. Ibid., p. 194, RF2763.

6. Pradel 1953, pp. 84–85, pls. XXI, XXII, 2.

7. Ibid., pl. XXXI, 1.

8. Ibid., pl. XXXI, 2; Gaborit 1998, p. 656, MR Sup 447 (dated ca. 1530).

9. Gillerman 2001, pp. 324–26; Pradel 1953, pp. 53–54.

EX COLLECTIONS

Comte de Rochebrune; [Seligman, Rey and Co., New York]; William G. Mather, Cleveland

LITERATURE

Milliken 1922; Cleveland 1966–67, pp. 332–33, no. VII, 20; Gillerman 2001, pp. 324–26

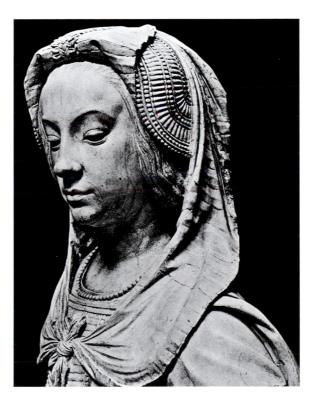

Fig. 86. Michel Colombe (active 1496–ca. 1515). Prudence, from tomb of François II of Brittany, Nantes Cathedral (Loire-Atlantique), ca. 1500

Gothic Italy: Reflections of Antiquity

Christine Verzar and Charles T. Little

UNLIKE in northern Europe, where iconoclasm and revolution accounted for much of the damage to medieval works of art, in Italy there was no such history of violence or systematic destruction for religious or political purposes. Exterior sculptural ensembles from Italian monuments were removed and replaced at different times, but more often in the interests of modernization or restoration or as a result of changes in artistic tastes or liturgical practices.[1] (An important exception is the Angevin succession of the Hohenstaufen dynasty in the thirteenth century, discussed below.) Today, many medieval Italian sculptures from both church exteriors and interiors have been extracted from their original contexts to the safety of local museums. Many others have been sold and are now in private and public collections. The Italian sculptures in this exhibition, most of which date from the thirteenth and fourteenth centuries, represent two areas of medieval Italy: the realm ruled first by the Hohenstaufen dynasty and then by the Angevins, in the south, and Tuscany, in the north.

The preservation and collection of sculptures of heads was especially popular in Italy, as it was in northern Europe. The keen interest in the human face derived from the fact that both likeness and idealization played significant roles in the classical as well as the medieval artistic languages of representation. The relationship between medieval and Antique art provides an especially important subtext for Italian sculpted heads, particularly in terms of the reuse or appropriation of ancient heads (and their medieval variants) in later periods. Artists and patrons had been rediscovering classical art and architecture since at least the eleventh century, when the passion for representing the human visage on the architectural consoles of church and castle exteriors in northern and southern Italy resulted in Roman heads often being reused as *spolia* and mixed in among medieval heads. And not only did medieval artists emulate Antique forms and subjects in their works; after the Renaissance, patrons consciously began to collect classical fragments as well as classicizing sculptures they believed were Roman but were, at least in some cases, actually medieval. When Cosimo I de' Medici (1519–1574) was acquiring heads for his *studiolo*, for example, he ordered his courtiers to remove thirteenth-century examples by Nicola Pisano from the Pisa Baptistery (fig. 87), which he thought were Roman, as well as truly ancient ones from the Arch of Constantine.[2]

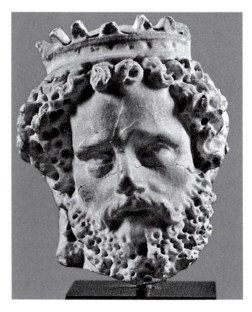

Fig. 87. Follower of Nicola Pisano. Crowned Head, Apulia, late 13th century. Museum of Fine Arts, Boston; Charles Amos Cummings Fund (47.1446)

The role of antiquity in the visual arts of western Europe during the thirteenth and fourteenth centuries was neither universal nor systematic, yet it percolated just beneath the surface and was to some degree a regional phenomenon. In Italy, the evidence of antiquity resonated continuously throughout the Middle Ages, as reflected in modern terms such as proto-Renaissance, Gothic humanism, and *style antiquisant* for specific moments and periods of classical revivals. The most conspicuous attempts to fashion an Antique style were promulgated at the court of the Hohenstaufen Emperor Frederick II (r. as emperor 1212–50),[3] whose "renaissance," although neither widespread nor sustained, was in many respects similar to the Italian Renaissance two hundred years later.

Frederick II was crowned Holy Roman emperor in Aachen, but he spent most of his life in Italy, and much of his reign consolidating his position between his southern Italian kingdom and Germany.[4] A remarkable ruler, statesman, and intellectual, Frederick looked to classical antiquity as a precedent for his support of poetry, the visual arts, architecture, and science, and his political aspirations helped shape his self-image and determine the tenor of his artistic patronage. Much has been written on Frederick's role in developing a political, cultural, and artistic agenda based on an ancient Roman model, an ambition predicated on an imperial system of justice as articulated in the famed Constitutions of Melfi (1231), the first comprehensive legal code in Europe.[5] His notion of equality before the law incorporated an element of religious freedom that was remarkably progressive for the period. The culture of Frederick's court, moreover, was surprisingly cosmopolitan; it included Jews and Muslims as well as the polymath astrologer Michael Scot (d. 1235). His abiding interest in the beauty of all sciences can be gleaned from a dialogue with Scot, in which Frederick is recorded as saying: "I praise the mechanical arts and I want to glorify their craftsmen, just as I have done for the authors of books, for both of them are

Fig. 88. City Gate over Volturno River, Capua, reconstruction plan from Shearer 1935 (fig. 58, p. 118)

useful and necessary."[6] Considered a threat to the papacy because of his moderniz-ing tendencies, Frederick was excommunicated from the church. Nevertheless, he led the Sixth Crusade (1228–29) and captured Jerusalem, installing himself as its king.

Frederick was also adept at using art as propaganda, recognizing its potential as an effective political tool. One monument that stands out as a glimpse of this aspect of Frederick's campaign is the city gate built in 1234 over the Volturno River at Capua, in Campania, which was probably the first site a traveler from papal Rome would have encountered upon entering Frederick's realm (fig. 88).[7] Now largely ruined, the gate had as its centerpiece an enthroned sculpture of the emperor that is generally considered to have been the first lifesize image of a living ruler carved since antiquity. Using the vocabulary of Roman gates as well as elements of tri-

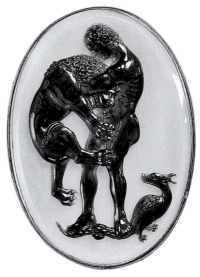

Fig. 89. *Augustale of Frederick II (obverse). Brindisi (Apulia), minted ca. 1230–40. Private collection*

Fig. 90. *Augustale of Frederick II (reverse)*

Fig. 91. *Sardonyx Cameo with Hercules and the Nemean Lion, South Italy, ca. 1220–50. Dum-barton Oaks Research Library and Collection, Washington, D.C. (62.38)*

umphal arches, Frederick's gate was filled with portrait busts of his court and alle-gories of his realm, many of which survive, at least in part, in the Museo Provinciale Campano di Capua.

Frederick's identity was also glorified in a new gold coinage known as the augustales, issued from mints in Messina and Brindisi, which included imagery and meaning dependent upon Roman prototypes (see fig. 95).[8] On the obverse, with the laureate image (fig. 89), is the inscription "C[A]ESAR AUG(*ustus*) IMP(*erator*) ROM(*anorum*)" (Caesar Augustus, Emperor of the Romans); on the reverse (fig. 90) is an imperial eagle with the inscription "FRIDERICUS," the name divided into segments to emphasize its meanings in German: *friede* (peace) and *ricus*, or *reich* (rule). The likeness on the coin is suggestively individualized to resemble that of Augustus on the latter's portrait busts, but otherwise Frederick's features are idealized. The emperor is known to have collected ancient works of art, and he fostered the production of cameos with mythological and biblical scenes (fig. 91). These ancient images of power were incor-porated into magical charms for their royal owners and were perhaps worn for protec-tion. He also oversaw the contruction of dramatic structures throughout the Hohen-staufen realm. The most magnificent and best-preserved of Frederick's many castles, Castel del Monte, in Apulia, is an exceptional, even unique architectural masterpiece that perfectly unites principles of Arab, Greek, Roman, Norman, French, and German

Fig. 92. Castel del Monte, Apulia, begun 1240

Gothic forms (fig. 92).[9] The sculptures still in situ, especially the console heads and the atlantid figures that support the rib vaults in some of the towers, are pervaded by an innovative sensitivity, liveliness, and naturalism.

Frederick's death in 1250 brought the Hohenstaufen dynasty to a quick demise. His sons were imprisoned and then murdered by the Angevins (after Charles of Anjou, r. 1265–85), the new French rulers of southern Italy, who intentionally destroyed or modified many of Frederick's castles, gateways, and other structures in order to suppress or even obliterate his legacy. In a reversal of political fortunes, however, some Hohenstaufen sculptures were later appropriated by the Spanish Aragonese, who succeeded the Angevins as rulers of southern Italy in the fifteenth century and who modeled themselves on Frederick's example. A case in point is the likely updating of the inscription on the bust of Julius Caesar (cat. no. 63) by Frederick IV of Naples (r. 1496–1501), the last of the Aragonese rulers, who was said to admire and emulate his namesake.[10]

After 1250 the classical style in sculpture, with its new Gothic naturalism, was brought from southern Italy to Tuscany and Umbria by Nicola Pisano (also known as Nicola d'Apulia, active 1257–84) and his son, Giovanni (ca. 1240–before 1320), who together developed Frederick II's self-conscious revival of Roman imperial sentiment through the many portraitlike heads they made for the exteriors of the Pisa Baptistery and the cathedrals of Siena and Lucca. In Rome, Florence, and Perugia, the style was disseminated by Arnolfo di Cambio (active 1265–1302/10).[11] The new style was employed in these city-states for both civic and ecclesiastic commissions, the latter exemplified by two works in this exhibition. One is a head of a prophet (cat. no. 68) that must have been part of a large typological program not unlike those of the great Gothic cathedrals of France and Germany. It was probably made for the exterior of one of the Tuscan cathedral churches, most likely Siena, where

Nicola and Giovanni worked between 1260 and 1295. The other example—a small allegorical figure of Prudence, or the Ages of Man (cat. no. 69)—was likely intended for a sepulchral monument, a relatively new sculptural form at the time that commemorated an individual with an effigy surrounded by allegorical figures pertaining to his life. Both works were probably removed from their original settings some time after the sixteenth century, when many sepulchral monuments and liturgical furnishings were destroyed for the reasons discussed above.[12]

That such works were preserved for us today attests to the lasting appeal after the Renaissance for the collection of fragments of the human face. Italian medieval and Renaissance art proved an especially popular pursuit for study and collection in the mid-nineteenth century, when travelers, critics, and scholars such as John Ruskin, Charles Eliot Norton, and Wilhelm von Bode cultivated an interest in Italian works, leading to numerous acquisitions for English, American, and German institutions.[13] Many fragments became available after the unification of Italy in 1861 as a result of the dissolution and sale of Italy's private aristocratic collections, which gave scholars the opportunity to study these works and, if possible, to determine their original artistic contexts.

NOTES

1. Nearly all of the original medieval architectural sculptures on the cathedrals of Siena and Florence and on the Pisa Baptistery have been replaced by modern copies and are now in their respective cathedral museums. For earlier replacements for reasons of changes in taste or restoration, see, for example, the sixteenth-century replacement of the fourteenth-century sculptural groups by Tino di Camaino (ca. 1285–1337) above the doors of the Florentine Baptistery; Levin 2005.

2. For documentation of Cosimo's collection of antiquities, see Max Seidel, "A Sculpture by Nicola Pisano in the Studiolo of Cosimo I de' Medici" (1973), in M. Seidel 2005, pp. 289–92. Some of the heads on the Last Judgment panel of Nicola Pisano's pulpit in the Pisa Baptistery are missing; while they have not turned up in collections, the small head of a king now in the Museum of Fine Arts, Boston (fig. 87), is the same size and style of the body of a now-headless king on the lintel by Nicola Pisano at the cathedral of Lucca, and it is possible the Boston head was taken in the sixteenth century from its original context to the Medici collection. Frederick II's collection of antiquities is also well documented. See Settis 1984–86 and Verzar 1999, n. 1 (with bibl.), for the reuse of *spolia* for civic public monuments in Italy; Verzar 2005, for the reuse of Roman sarcophagi for the tombs of the Canossa family.

3. For biographies of Frederick II, see Kantorowicz 1931b; Van Cleve 1972; Abulafia 1988 (1992 rpt., with further bibl.); Tronzo 1994; Cardini 1994; Bari 1995; Stuttgart 1977; Wolf 1966.

4. Van Cleve 1972; Abulafia 1988 (1992 rpt.); Romanini 1980; Tronzo 1994. See also the important exhibitions on this period, Stuttgart 1977, Bari 1995, and Rome 1995–96, where many of these Frederican heads and busts were brought together.

5. Abulafia 1988 (1992 rpt.), pp. 202–25.

6. Morpurgo 1983.

7. Jill Meredith, "The Arch at Capua: The Strategic Use of *Spolia* and References to the Antique," in Tronzo 1994, pp. 109–26.

8. For the augustales and cameos, see Stuttgart 1977; Bari 1995; Tronzo 1994; Rome 1995–96.

9. Losito 2003; Tronzo 1994; Maria Stella Calò Mariani, "Castel del Monte: La veste ornamentale," in Bari 1995, pp. 305–12; Calò Mariani 1997, 1998; Cardini 1994.

10. Hersey 1973; Bologna 1996.

11. For the vast bibliography on Tuscan sculptors, see cat. nos. 67 and 68.

12. Ames-Lewis 1997, pp. 46–66, discusses the dismantling and removal of sculptural ensembles in and from Tuscan churches.

13. See De Benedictis et al. 1984–86. See also Kathryn McClintock, "The Classroom and the Courtyard: Medievalism in American Highbrow Culture" and "The Earliest Public Collections and the Role of Reproductions (Boston)," in University Park 1996, pp. 41–53, 55–60; and Elizabeth Bradford Smith, "George Grey Barnard: Artist/Collector/Dealer/Curator," in ibid., pp. 133–42.

62. Head of a Bearded Man with a Garland Crown (Jupiter?)

South Italy, ca. 1230–50
Limestone, H. 16¾ in. (42.5 cm)
Isabelle Golovin (Willard Golovin Collection)

This monumental classicizing head offers a rare glimpse of medieval art that is apparently devoid of Christian symbolism. It was recently identified as a work made in southern Italy during the reign of the Hohenstaufen emperor Freder-ick II (r. as emperor 1212–50). The head's physical characteristics suggest it was intended to evoke a Roman image of Jupiter, while its formal aspects, including the overall conception and carving technique, confirm that it is medieval, not Roman or provincial Roman.

The morphology of the head—for example, the rigorous, regularly geometric treatment of hair and beard and the emphatic articulation about the eyes—constitutes a complete transformation of the Roman model. The swelling of the eyelid and the shape of the eye, with the pupil defined as a raised disc, are unknown in Roman sculpture and clearly distinguish this head from Antique examples. That feature is

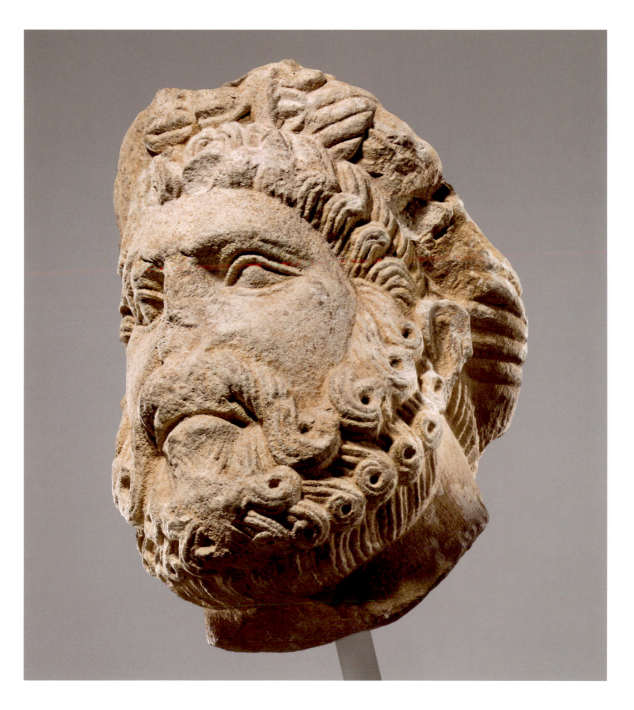

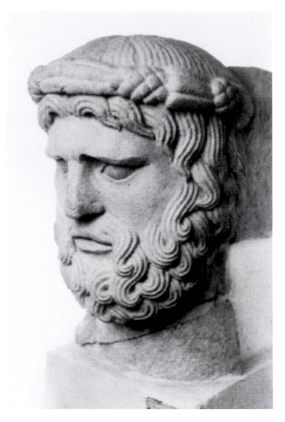

Fig. 93. *Taddeo di Bartolo (Italian, ca. 1362–1422). Jupiter, Sala del Consiglio, Palazzo Pubblico, Siena (Tuscany), 1406–7*

Fig. 94. *Head of Jupiter, probably from City Gate over Volturno River, Capua, ca. 1234–9. Museo Provinciale Campano di Capua*

also a trademark technique of early-thirteenth-century Italian sculpture, as seen, for example, in the work of the Emilian artist Benedetto Antelami (active 1178–1233?), particularly the figure of January from the cycle of the months at Parma Cathedral.

That the figure represents Jupiter is clear not only from the distinctive physiognomy but also from the use of an attaching element on the left side of the head, which must have originally supported the god's torch. The transformation of images of Jupiter from antiquity into the Middle Ages can be seen in a number of Italian Gothic monuments, such as the wall paintings in the vestibule of the Palazzo Pubblico in Siena (fig. 93). There the allegorical images of the planets include Jupiter holding his torch aloft in a manner that was perhaps similar to the original positions of this figure with its torch. An eagle, the god's attribute, can be seen below guiding him on his celestial journey.[1]

This colossal Jupiter head is just one of many efforts by Apulian sculptors to create images that were meant to be understood as genuine relics of ancient Rome. Majestic and serene, this colossal head is actually more daring than the truly gigantic limestone head of what is presumed to be a figure of Jupiter thought to come from the bridge head gate on the Volturno River in Capua erected about 1234–39

(fig. 94).[2] The Capua head has a coarser treatment of hair and is crowned with a rope-like garland of wheat sheaves and pinecones, an older style that sought to minimize classical idealism.[3] Although the Capua head is not clearly documented as being from the gate and does not appear in any Renaissance drawings of it, some have suggested that it was the keystone for one of the principal chambers, since there is a mass of stone behind it.

Like the Capua head, the present piece was likely connected to the imperial ambitions of Frederick II. As a manifestation of court culture, such a sculpture would have represented the planetary protection of Jupiter and his attendant imperial eagle, which is certainly plausible given Frederick's wide-ranging political agenda and his obsession with astrology. As the top of the head is unfinished, we can assume the sculpture was installed in a high position; the power of the features is also enhanced when the head is viewed from an oblique angle. Whether the head was part of a bust or a larger composition is uncertain, however, since most of the decoration of Frederick's palaces—where one presumes such a work might have originated—has been eradicated.

In Apulia and Sicily, many of the castles and palaces built at Frederick's instigation incorporate either works of antiq-

uity or imitations thereof that were intended to deceive his contemporaries. We know that he ordered Hellenistic and Roman *spolia* from Naples moved to his castle at Lucera as well as Roman bronze rams for Castel Maniace in Syracuse (now in the Museo Nazionale, Palermo). Frederick's Palatium at Foggia, begun in 1221, also contained extensive decoration; even though it was completely destroyed in an earthquake in 1731, at the time it was said to be "rich in marble, statues, and columns."[4] The most celebrated of Frederick's buildings is Castel del Monte in Apulia, built beginning about 1240, which incorporates several classicizing elements in the inner courtyard. A wonderfully expressive albeit fragmentary head of a man with a garland found nearby the castle offers a close comparison to this head, especially in the swelling of the eyelid, the garland, and the cut of the hair.[5]

Frederick II's interest in planetary astrology was probably driven by a number of factors. The court astrologer to Frederick was the versatile Michael Scot (d. 1235), whose influential *Liber introductorius* on the power of the planets enumerates the characteristics of Jupiter: "Jupiter produces a man who naturally delights to be a judge, advocate, master *in cathedra*, potent of earth, captain of a castle and ruler of many; he also likes to listen to laws and deeds of the ancients." We also learn that a man born under Jupiter is of "natural stature, of sanguine complexion, white skin, and jaws reasonably colored. It makes the head large, hair blond, and long, face round, broad and pleasant and hairy, nose agreeable enough. Its man naturally delights in some easy, honorable, pleasant, celebrated and quite profitable art such as teaching, the science of letters, namely grammar, philosophy, law, astronomy."[6]

Whether Frederick II had a specific fascination with Jupiter is uncertain. In his poem on the city of Rome, the court poet Gregorius of Gallipoli, in Calabria, extolled the emperor's mythic status: "He is powerful, a three time saint, 'flash of fire,' wonder of the world, his bow is made of bronze and his arrow is like a thunderbolt which burns his enemy, he is all powerful over earth, sea and sky and he brings back to 'me' [Rome] power and posterity. In the whole universe one can hear Frederick's voice and the loud noise of his army."[7] In addition, Gregorius wrote an "enthusiastic encomium on Frederick II in which the Emperor figures as Zeus, the Thunder God and Lightning-Wielder of Greek mythology."[8] To his court, then, Frederick would have seemed to be poetically endowed with many of the attributes of Jupiter. No doubt the present head contributed to that impression, displaying the emperor's Roman character for all to admire.

CTL

NOTES

1. See Seznec 1961, p. 128, fig. 42.

2. Rome 1995–96, no. IV.9 (entry by Silvia Silvestro, with earlier bibl.).

3. Bologna 1989; Rome 1995–96, no. IV.9.

4. Luisa Derosa in Fonseca 1997, p. 38.

5. Rome 1995–96, no. V.1 (entry by Paola Mathis).

6. Thorndike 1965, p. 101 (after Munich, Bayerischen Staatsbibliothek, Clm 10268, *Liber introductorius*, fol. 101r.).

7. Giorgio di Gallipoli, Versi XIII, in Gigante 1979, pp. 64 n. 17 and 187V.

8. Kantorowicz 1931a, p. 306; Kantorowicz 1931b (1963 ed.), p. 133.

63. Bust of Julius Caesar

South Italy, Apulia, 1225–50
Limestone, H. approx. 36 in. (91.4 cm)
Inscribed on titulus: DIVI IVLI(*us*) CAE(*saris*)
Private collection, United States

First introduced to the scholarly community in the mid-1990s, this overlifesize bust of Julius Caesar is thought to belong to a group of images associated with the patronage of Hohenstaufen emperor Frederick II (r. as emperor 1212–50).[1] When the bust is viewed in profile, the laurel wreath headdress and the arrangement of the hair in ringlets clearly echo the image of Julius Caesar found on a Roman silver denarius minted in 40 B.C. (fig. 95), four years after his assassination.[2] The titulus on the bust also bears the same abbreviated inscription found on the coin. The strongly articulated and realistic features of the bust's physiognomy, which includes musculature, veins, an expressive, open mouth, and eyes with carved pupils, likewise correspond to the image on Roman coinage. Other aspects, however, especially the

Fig. 95. Silver denarius of Julius Caesar (obverse). Rome, minted 40 B.C. Private collection

elaborate folds of the mantle, are much closer to a northern Gothic sculptural style found at imperial centers in Germany, particularly Bamberg.[3]

Although somewhat smaller in size, the bust is similar to another bust, now in the Museo Civico, Barletta (fig. 97), recently proposed to be originally from an equestrian image of Frederick II made about 1237 and later cut down.[4] The Julius Caesar bust is known to have been displayed with the Barletta bust and a bust of Marcus Aurelius (location unknown) in Apulia in the nineteenth century, when the inscriptions on all three works were recorded.[5] At that time they were apparently part of a display set on top of the entrance arch to the Masseria Fasoli, an estate—not far from the ancient site of Cannae—founded by the Aragonese, the Spanish

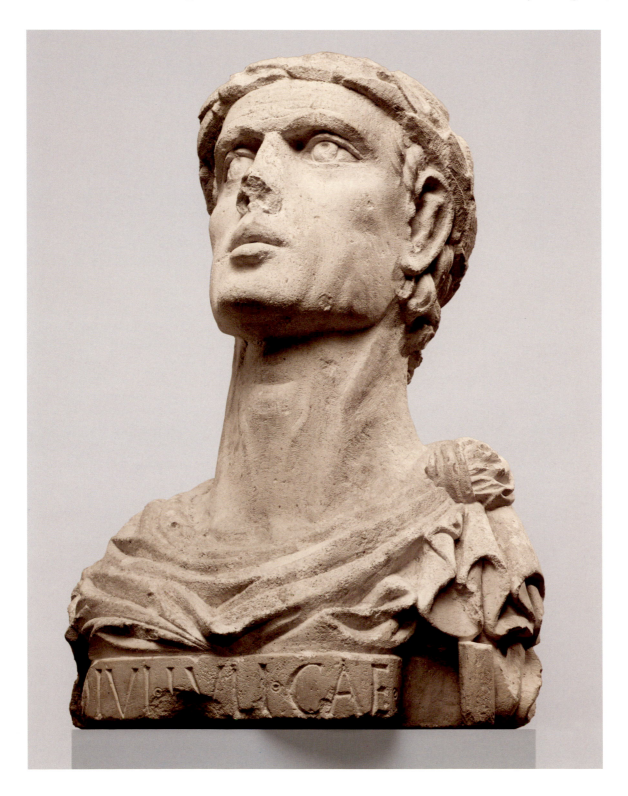

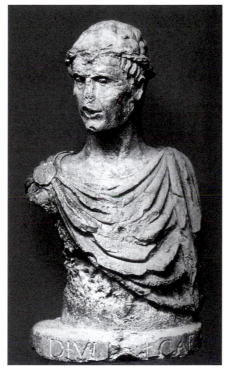

Fig. 97. Bust of Frederick II, ca. 1237. Museo Civico, Barletta

Fig. 98. Seated Figure, Trani Castle (Apulia), ca. 1233

dynasty that succeeded the Hohenstaufens and Angevins as rulers of southern Italy in the mid-fifteenth century.[6]

The stylistic correspondences among this bust, the Barletta bust, and other Frederican works as well as thirteenth-century northern European sculpture provide much evidence that the present piece is indeed from the thirteenth century.[7] The corrugated drapery forms that hang down from this example, which were obviously meant to be viewed from beneath the figure as it projected from a wall, is a feature also found on an engaged seated figure in Trani Castle, built for Frederick II in 1233 (fig. 98).[8] Intended for a niche or balustrade high above eye level in one of Frederick's public monuments, such busts exude a strong, vibrant authority that was subsequently taken up by Tuscan sculptors of the Trecento.[9]

Interestingly, the undulating form of the titulus is unlike others of the thirteenth century, and the epigraphy of the inscriptions is more characteristic of the fifteenth- or sixteenth-century Renaissance than of the Hohenstaufen period.[10] The designations of the figures as DIVI IVLI(*us*) CAE (*saris*) (Julius, the Deified Caesar) on this bust; as DIVE FRI (*derici*) CAE(*saris*) (Frederick, the Deified Caesar) on the Barletta bust; and as DIV(*us*) AUG(*ustus*) PAT(*er*) (The Deified Father Augustus) on yet another bust (private collection, Italy) copy Roman coinage, but this type of inscription is otherwise unprecedented in works made under the patronage of Frederick II and argues for a fifteenth-century date. Moreover, the style and cutting of the letters seems to

match the epigraphy found on Aragonese medals (fig. 99), the arch from Castel Nuovo, Naples (ca. 1442), and fifteenth-century Apulian sculptures by Stefano da Putignano (ca. 1450–1540) and other local artists.[11]

In each of the three examples, the text on the preserved titulus may copy or reflect a titulus that was originally

Fig. 99. Medal of King Alphonso of Aragon and Naples, 1499. Private collection

painted or carved and that was later planed down and recarved in a Renaissance style. The appropriation of sculpture for ideological purposes is certainly not unprecedented in Italy.[12] In particular, Frederick IV of Naples (r. 1496–1501), the last of the Aragonese rulers, sought to emulate his namesake by erecting triumphal arches with portrait busts in the heroicizing ancient Roman tradition, similar to Frederick II's architectural and sculptural programs at Capua, Foggia, Barletta, and Castel del Monte.[13]

CV

NOTES

1. Mellini 1996; Bologna 1996; Todisco 1997, 1998.

2. For the denarius, see Sydenham 1952, no. 1132; Crawford 1974, no. 526/2. Compare these with the so-called augustales of Frederick II (see fig. 89). For the emulation of Roman emperors by medieval rulers, see Hausmann 1990.

3. For convincing comparisons with Mosan metalwork, drawings by Villard de Honnecourt (active ca. 1220–40), and sculptures at Bamberg, especially the statue of Saint Elizabeth dated to the 1230s, see Bologna 1996, figs. 42–62.

4. Bologna 1996, fig. 4, compares the hairstyles, the rendering of curls, and the laurel wreaths; for a detailed analysis of the Barletta bust, see also Peter Eichhorn, "Zur Büste von Barletta: Versuch einer Ergänzung," in Stuttgart 1977, vol. 5, pp. 419–30; Tronzo 1994; Peter Cornelius Claussen, "Creazione e distruzione nell'immagine di Federico II nella storia dell'arte: Che cosa rimane?" in Bari 1995, pp. 68–81; Valentino Pace, "Il 'ritratto' e i 'ritratti' di Federico II," in Rome 1995–96, pp. 5–10; Quirini-Poplawski 2002; Russo 2001.

5. Recorded by George Kaibel and then Theodor Mommsen; see Mommsen 1883, p. 5; Bologna 1996, p. 25 n. 11. The same Salento limestone was used for the Barletta bust and a head of Marcus Aurelius (private collection) thought to be from the circle of Frederick II; see Todisco 1998, fig. 1. It is unknown if the latter is the third head seen by Mommsen at the Masseria Fasoli in the mid-nineteenth century.

6. Bologna 1996, pp. 18–19.

7. Some scholars have voiced doubts about the Hohenstaufen date of the Julius Caesar bust, but many Frederican sculpted heads still in situ in the Apulian region display a wide variety of rather eclectic styles, some similar to this one, and appear to be examples of different contemporary workshops.

8. See Fonseca 1997, pp. 93–97, fig. p. 97.

9. See the large heads placed by Nicola Pisano on the exterior galleries of the Pisa Baptistery; M. Seidel 2005, p. 23, pl. CI.

10. For a discussion of the epigraphy, see Bologna 1996, pp. 4–20; Todisco 1992, 1997, 1998. For the differences between epigraphies of inscriptions on works from the Aragonese period and from the patronage of Frederick II, see, for example, the caroccio in Rome (Rome 1995–96, no. X.1) or inscriptions on Foggia Cathedral (Calò Mariani 1997) and at Castel del Monte (Losito 2003).

11. For the Aragonese arch in Naples, see Hersey 1973; for fifteenth-century Apulian busts with inscriptions, see Gelao 1990, p. 35, pls. I, II; Gelao 2004, p. 17 (ill.); Bari 1994.

12. For the reuse of ancient *spolia* and works of art in medieval Italy, see Settis 1984–86. For the reuse of ancient works as civic monuments in Italian city squares, see Verzar 1999. For the reuse of ancient sarcophagi for the Canossa dynastic tomb program at the castle of Canossa and Beatrice's tomb in Pisa, see Verzar 2005, p. 443.

13. Bologna 1996, pp. 18–19; Jill Meredith, "The Arch at Capua: The Strategic Use of *Spolia* and References to the Antique," in Tronzo 1994, pp. 109–26; Willibald Sauerländer, "The Presence and Absence of Frederick II in the Art of the Empire," in ibid., pp. 189–209; Stuttgart 1977; Romanini 1980; Claussen in Bari 1995, pp. 61–80; Rome 1995–96; Brenk 1991; Losito 2003.

EX COLLECTION

Villa Masseria Fasoli, near Canosa di Puglia

LITERATURE

Mellini 1996; Bologna 1996; Todisco 1997, 1998

64. Capital with Four Heads

South Italy, Apulia, probably Troia, ca. 1230
Limestone, H. 14¼ in. (36.2 cm); max. W. and D. at abacus: 13 x 13 in. (33 x 33 cm)
The Metropolitan Museum of Art, New York;
Gift of James Hazen Hyde, 1955 (55.66)

Fleshy acanthus leaves arranged in bunches of three ascend from the astragal base of this capital, which is shaped like an inverted bell. At the four corners, human heads emerge from the foliage. Although the facial features of the heads are similar—all four have closely set eyes, convex eyeballs, full lips, and hair that covers only the upper portion of the ears—they represent different iconographic types. One is an elderly man, presumably a Muslim, wearing a turban; another is a youth whose hair is arranged in loose waves parted at the center; the third is a Moor with prominent cheekbones and deep-set, bulging eyes; and the fourth is another youth, crowned by curls. At the top rests a square, chamfered abacus.

In 1965 Vera Ostoia related this work to a very similar capital (Museo Diocesano, Troia) discovered in the 1920s during the restoration of Troia Cathedral.[1] At about the same time, in 1928, the present work had appeared in Paris at an exhibition organized by its owner, the dealer Arthur Sambon.[2] It was subsequently purchased by an American collector, who gave it to the Metropolitan Museum in 1955, and both capitals were shown together in 1977 at the monumental exhibition *Die Zeit der Staufer* in Stuttgart.[3] Differences of style and in the surfaces of the two capitals led some to question the authenticity of the Metropolitan's capital, and it was removed from exhibition in New York even though many scholars continued to accept the piece.[4]

The motif of heads emerging from foliage, found in both capitals, reflects an Antique tradition, examples of which still exist in Apulia.[5] This particular configuration of heads rising up out of richly patterned foliage is also found on a Tuscan capital that has been dated to the mid-thirteenth century and attributed to Nicola Pisano (Museo dell'Opera del Duomo, Pisa).[6] Differences in the type of limestone as

well as in style suggest that these two works, although contemporary, may have had a slightly different origin. In varying ways, each offers evidence for the penetration of French and Rhenish Gothic artistic concepts into Apulian culture, most likely through the presence of Northern artists working at the court of Frederick II. The heads on the Troia capital are closer to more typically Gothic sculptures in France and Germany,[7] while the rougher but more dramatic and immediate portraits on the Museum's capital are closer to examples by local sculptors working for Frederick's court, such as the so-called Molajoli head, found at Castel del Monte (Museo e Pinacoteca Provinciale, Bari),[8] or the work known as the Barletta bust, considered to be the remains of an equestrian statue of Frederick himself (see fig. 97).[9]

LCT

NOTES

1. Ostoia 1965. See also De Santis 1957, pp. 353–54.

2. Paris 1928, p. 30.

3. Stuttgart 1977, vol. 1, no. 841.

4. These views are summarized in Bari 1995, pp. 394–97 (entry by Lisbeth Castelnuovo-Tedesco), including the possibility, suggested by Charles T. Little, that the work is an early copy of the Troia capital intended to replace it in the original setting.

5. Bari 1995, pp. 392–93 (entry by Maria Stella Calò Mariani), pp. 393, 474 (ill.).

6. Testi Cristiani 1987, p. 42, fig. 66.

7. Wentzel 1954, pp. 187–88.

8. Claussen in Rome 1995–96, p. 99, fig. 2.

9. Claussen in Bari 1995, p. 68 (ill.).

EX COLLECTIONS

[Arthur Sambon, Paris]; James Hazen Hyde, Paris, after 1931

LITERATURE

Paris 1928, p. 30; De Santis 1957, pp. 353–54; Ostoia 1965; Stuttgart 1977, vol. 1, no. 841; Testi Cristiani 1987, pp. 12–13, 305; Bari 1995, pp. 393 (entry by Maria Stella Calò Mariani) and 394–97 (entry by Lisbeth Castelnuovo-Tedesco); Peter Cornelius Claussen, "Creazione e distruzione nell'immagine di Federico II nella storia dell'arte: Che cosa rimane?" in Bari 1995, p. 79; Peter Cornelius Claussen, "Scultura figurativa federiciana," in Rome 1995–96, p. 102

65. Head of a Woman

South Italy, probably Campania, ca. 1270
Carrara marble with added lead and lapis lazuli,
H. 13¾ in. (34.9 cm)
The Metropolitan Museum of Art, New York; Fletcher
Fund, 1947 (47.100.53a)

Carved in the round from a single piece of marble, this head portrays a young woman whose hair is arranged in elaborate plaits under a crownlike ornament called a coronal, a decorative circlet designed to hold in place a garland of leaves or flowers.[1] The work is severely eroded, the face barely legible. When acquired in 1947 by The Metropolitan Museum of Art, the head was awkwardly affixed to a later bust from which it has since been separated.[2] The poor condition of the piece

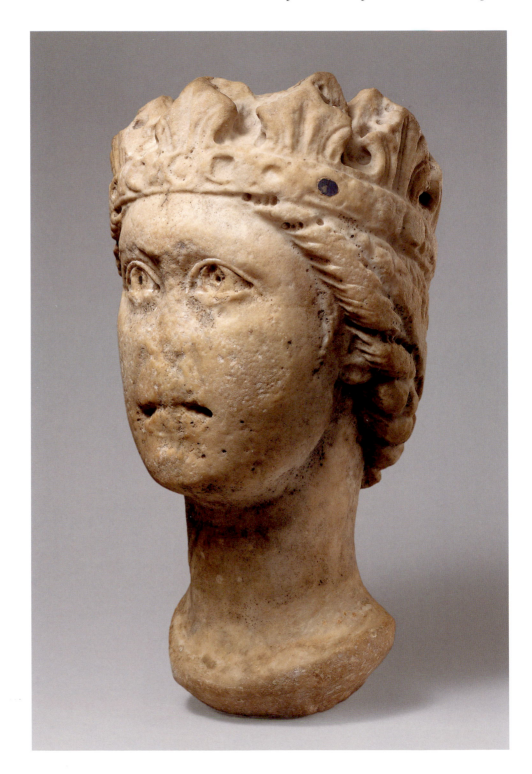

and the addition of the bust both served to obscure a correct identification of this work's subject and origin.

Initially, the coronal was believed to be a crown, and accordingly the earliest references identify the head as a southern Italian portrait bust of a queen or princess.[3] Some scholars, unable to interpret the obscured facial features, believed it to represent a young man, even a prince.[4] Others associated the portrait bust with the revival of interest in classical sculpture during the reign of Frederick II and thought it could have been made in Apulia about 1240 at a workshop associated with Frederick's court.[5] Stylistically, however, the head is more closely related to two works from another part of southern Italy, Campania.[6] One is the magnificent bust of a woman by Nicola di Bartolomeo da Foggia (active ca. 1230–72), dated by inscription 1272 and now in the Museo del Duomo di Ravello (cat. no. 66).[7] The other is a female bust from Scala that was once in Berlin (Kaiser Friedrich Museum), now known only from a cast.[8] Ronald Lightbown concluded that these three works were domestic portraits of wealthy women,[9] but it is more likely that the elaborately bejeweled Ravello head is an allegorical representation. Lightbown surmised that at some point the Berlin bust was installed in a niche over the front door of a dwelling.[10] The severe weathering found on the face of the New York head would reflect such an installation, even though the detailed hairstyle and headdress might argue for a more protected setting. Although these works are less directly influenced by Antique sources than were sculptures from the time of Frederick II, the concept of domestic portraiture is derived from Roman, and thus Antique, tradition.

LCT

NOTES

1. Lightbown 1988, p. 111, suggests that the Angevin court introduced this head ornament, fashionable in France, into southern Italy after 1266. Unlike a crown, it does not signify rank, although coronals, as in this case, were often set with precious or semiprecious stones.

2. The head is shown still attached to the questionable bust (47.100.53b) in Mellini 1998, figs. 18, 19. The ex-Berlin bust from Scala appears to have been made of one piece of stone, as does the Ravello piece (see below, notes 6 and 7).

3. Taylor 1931, p. 470; Worcester 1937, p. 30.

4. Hoving 1965, p. 347; Lavin 1970, p. 221; Schuyler 1976, pp. 71–72.

5. Boston 1940, p. 49; Deér 1952, p. 42; Hoving 1965, p. 347; Stuttgart 1977, vol. 1, p. 671, no. 854 (entry by Hermann Fillitz); Paola Puglisi, "Componenti federiciane in San Galgano," in Romanini 1980, vol. 1, p. 386; Jill Meredith, "The Bifrons Relief of Janus," in Bruzelius and Meredith 1991, p. 119; Mellini 1998, p. 31 n. 86.

6. See Bari 1995, p. 478 (entry by Lisbeth Castelnuovo-Tedesco).

7. See Ravello 1984, pp. 37–38; Leone de Castris 1986, figs. 11, 12. The latter scholar, p. 123, actually attributes it to Nicola di Bartolomeo da Foggia. Calò Mariani 1997, p. 145, reviews the pertinent comparisons.

8. Volbach 1930, pp. 61–62; the cast is illustrated in Mellini 1998, figs. 15, 16.

9. Lightbown 1988, pp. 111–12.

10. Ibid., p. 112.

EX COLLECTION

[Joseph Brummer, Paris and New York]

LITERATURE

Taylor 1931, p. 470; Worcester 1937, p. 30; Boston 1940, p. 49; Deér 1952, p. 42; Hoving 1965, p. 347; Lavin 1970, p. 221; Schuyler 1976, pp. 71–72; Stuttgart 1977, vol. 1, p. 671, no. 854 (entry by Hermann Fillitz); Paola Puglisi, "Componenti federiciane in San Galgano," in Romanini 1980, vol. 1, p. 386; Leone de Castris 1986, p. 123, figs. 13, 14; Lightbown 1988; Jill Meredith, "The Bifrons Relief of Janus," in Bruzelius and Meredith 1991, p. 119; Bari 1995, p. 478 (entry by Lisbeth Castelnuovo-Tedesco); Mellini 1998, pp. 28, 30, 31, figs. 18, 19

66. Crowned Bust of a Woman

Nicola di Bartolomeo da Foggia (Italian, active ca. 1230–72)
South Italy, Campania, Ravello, 1272
Marble with traces of polychromy, H. 18¾ in. (47.5 cm)
Duomo di Santa Maria Assunta, Collocazione Museo del Duomo, Ravello

This lifesize crowned bust comes from the beautiful hill town of Ravello, situated high above Italy's rocky Amalfi Coast, whose cosmopolitan noble and merchant families were closely allied to the Normans, Byzantines, Hohenstaufens, Angevins, and Aragonese.[1] The bust has a classical appearance, with a low brow surrounded by drilled rolls of hair, deeply carved features, and slightly parted lips revealing teeth (see also cat. no. 56). Although the figure was probably conceived as a separate bust, from the Aragonese period in the sixteenth century to the 1970s it was located in the cathedral of Ravello on the back rim of the pulpit, above the entrance door.[2]

Signed and dated by inscription 1272, the bust has generated much interest among scholars of Italian medieval art. It was carved in the period immediately following the Hohenstaufen rule of Frederick II (d. 1250), when Nicola Rufolo and his sons, the treasurers and bankers for Charles of Anjou (r. 1265–85), had cleverly transferred allegiance to the new French rulers of southern Italy after the defeat of the Hohenstaufen dynasty.[3] Given the bust's naturalism and contemporary style of dress and jewelry, the piece is thought by some to be a portrait of Nicola's wife, Sigilgaita.[4] That identification has been based in part on the lengthy Latin inscription on the pulpit where it was long installed, which gives the date, 1272, and the names of the patrons, Nicola and Sigilgaita Rufolo. It might also seem plausible that this bust would have been paired with a now-lost representation of Nicola. That is unlikely, however, since the husband-wife patrons named in the inscription have been connected with smaller reliefs on the pulpit, namely the heads in profile on the squinches of the back door's cusped archway.[5]

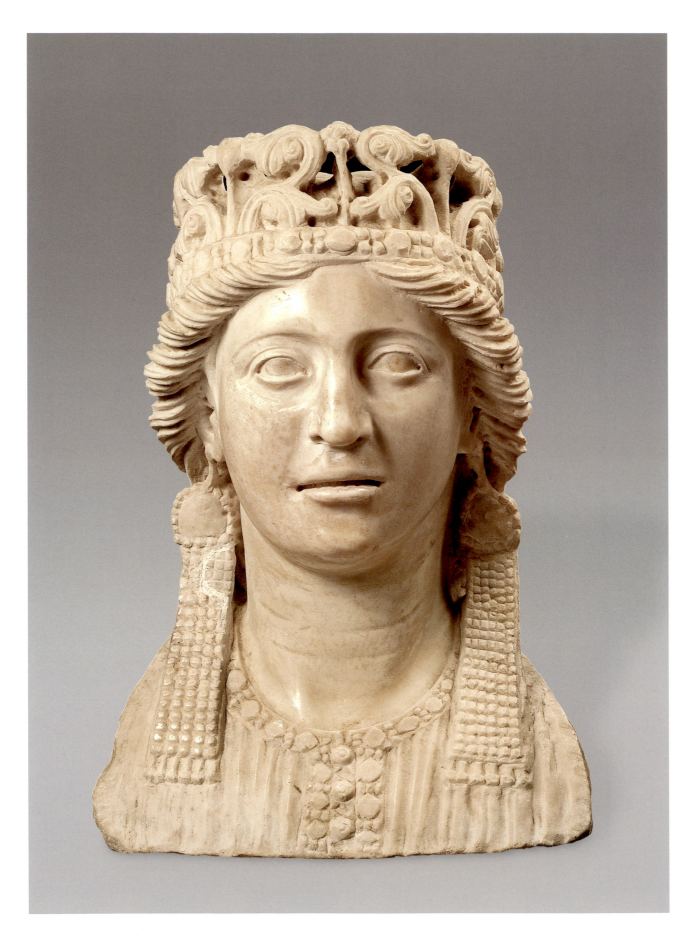

The bust's richly jeweled appearance and its strictly frontal, formal stance suggest a second, more generic identification with an allegorical meaning: the Mater Ecclesia, as she appears in southern Italian Exultet rolls.[6] If so, such an allegory or personification of the church would have been intended for a niche on top of the cathedral portal. The crown exhibits some features typical of French royal design. The upper portion, with its interwoven leaves, most closely resembles the crown worn by the thirteenth-century Ecclesia on the north transept portal of Strasbourg Cathedral, where the figure is a companion to Synagogue.[7] The back of the headdress is gathered in two braids that hang down below the neck diagonally and meet on the shoulders, a common style for medieval women. The front of the hair does not conform to northern French figures of the time,

however; it reaches down into the brow, forming a twisted band with diagonally drilled streaks in the manner of a Roman or Byzantine matron, a feature enhanced by the long earrings (see cat. no. 67). Ronald Lightbown has identified the earrings as typical of Angevin Naples, which had appropriated Byzantine and Islamic motifs into its jewelry designs.[8] The richly trimmed border of the dress is also Italian, and it can be compared to contemporary as well as earlier royal garments.

The third possible identification of the head is that it represents a personification of the town of Ravello, following the Roman tradition of using crowned female statues in the form of the goddess Tyche or Fortuna to embody a city's prosperity. If that is the case, it would likely have been placed on the town gate.[9] We know of two very similar con-

temporary female portrait heads from this region: a head of a woman now in the Metropolitan Museum (cat. no. 65),[10] and a now-lost head from Scala, a town adjacent to Ravello (Kaiser Friedrich Museum, Berlin, until World War II). Neither of these sculptures has the expressive sharpness or the rich detailing of the Ravello head, though, which seems to exude authority.

Nicola di Bartolomeo da Foggia was the son of the sculptor Bartolomeo da Foggia, who had been employed by Frederick II in Apulia. The characterization of the facial features on the bust is closest to that seen in other heads from southern Italy known to have been commissioned for Frederick, especially those on a console in the castle at Lagopesole (1240).[11] It is well documented that Nicola Rufolo spent much time in Apulia, where he could have engaged local sculptors previously in Frederick's employ. Another head, originally made for a niche on the triumphal gateway Frederick erected at Capua (1234–39),[12] is thought to be either a personification of Justice (*Iustitia Imperialis*) or the city itself, perhaps bolstering the argument that the Ravello head was also a personification of a city. The heads on the corbels on the exterior of Siena Cathedral and the Pisa Baptistery (1270) by Nicola Pisano (active 1257–84) are stylistically quite similar and are indicative of the classicizing revival spearheaded by Frederick's workshops.[13] The realism evident in all of these heads is part of the development toward portraiture that began in this period, as seen in tomb effigies and political statues such as that of Charles of Anjou (ca. 1275) made for the Roman senate by Arnolfo di Cambio (active 1265–1302/10).[14]

CV

NOTES

1. Caskey 2004; Bari 1995, pp. 399–401 (entry by Maria Stella Calò Mariani); Fontevraud 2001, pp. 74–79.

2. Reid 1897 (1997 ed.), p. 22; Lightbown 1988.

3. Caskey 2004; Leone de Castris 1986; Angevin 1998. Colorful stories about them appear in Boccaccio's *Decameron* (II.4); Reid 1897 (1997 ed.).

4. Bertaux 1904, p. 784, with summary of earlier scholarship in Caskey 2004, p. 182 n. 142; Bari 1995, pp. 394–97 (entry by Lisbeth Castelnuovo-Tedesco).

5. When viewed in profile, the heads have the same caps and hairstyles found in the Frederican treatise on falconry and on cameos of the period; see Braca 2003, fig. 199.

6. Avery 1936, vol. 2, pp. 18–19, pl. XLI, fig. 9; Cavallo et al. 1994, p. 242.

7. Sauerländer 1972, figs. 132, 134; Lightbown 1988; Shearer 1935, p. 167; Kalinowski 1999, p. 235.

8. Lightbown 1988.

9. For Early Byzantine statuettes with the figure of Tyche / Fortuna, see Cambridge 2002–3, fig. 1; for Early Byzantine weights with female empresses, see Cambridge 2002–3, figs. 12–14, and New York 1999, no. 31. For a discussion of the Ravello head as the personification of a city, see Reid 1897 (1997 ed.) and Caskey 2004.

10. Braca 2003, figs. 220–222.

11. Marina Righetti Tosti-Croce, "La scultura del castello di Lagopesole,"

in Romanini 1980, vol. 1, pp. 237–64; Heinrich Thelen, "Ancora una volta per il rilievo del pulpito di Bitonto," in ibid., vol. 1, pp. 217–25; Calò Mariani 1997, p. 145, fig. 21.

12. Caskey 2004, pp. 182–83; for the head of Justice from the Capua gate, see Moskowitz 2001, p. 15, figs. 13, 16; Brenk 1991, fig. 7; Jill Meredith, "The Arch at Capua: The Strategic Use of *Spolia* and References to the Antique," in Tronzo 1994, pp. 109–26, figs. 7, 13.

13. M. Seidel 2005, p. 210, figs. 11, 17, 20, 22, 30, 57, 112–115.

14. Moskowitz 2001, p. 45 n. 3.

LITERATURE

Reid 1897 (1997 ed.), p. 22; Bertaux 1904, p. 784; Lightbown 1988; Bari 1995, pp. 399–402 (entry by Maria Stella Calò Mariani); Gandolfo 1995; Gandolfo 1999; Moskowitz 2001, p. 15, fig. 16; Braca 2003, fig. 199; Caskey 2004, pp. 182–83

67. Steelyard Weight with a Bust of a Byzantine Empress and a Hook

Early Byzantine (Eastern Roman Empire), 400–450
Copper-alloy weight filled with lead, with brass hook,
H. 9⅛ in. (23.2 cm)
The Metropolitan Museum of Art, New York; Gifts of J. Pierpont Morgan, Mrs. Robert J. Levy, Mr. and Mrs. Frederic B. Pratt, George Blumenthal, Coudert Brothers and Mrs. Lucy W. Drexel, by exchange; Bequest of George Blumenthal and Theodore M. Davis Collection, Bequest of Theodore M. Davis, by exchange; and Rogers Fund, 1980 (1980.416a, b)

Byzantine weights often include busts of empresses, who are usually imbued with a calm symmetry, as seen here. This unusually elaborate example shows the empress holding a scroll in her left hand and raising her right hand in a traditional speaking gesture. Her intricately arranged hair has tight curls framing the face and braids drawn up from the nape of the neck to the top of the head in a style popular with empresses of the Theodosian dynasty (379–457).[1] Her diadem of pearls and gemstones has prependoulia, or pearls hanging to the sides of the head, as seen on imperial crowns of the Early Byzantine court (see cat. no. 66). Around her neck are large jewels, most likely a necklace comprising several strands, including a band of large pearls at the top and four large pendant jewels at the base. There is no damage to the weight other than limited areas of corrosion. The long hook used to attach the weight terminates in the head of a bird with a large beak.

Earlier scholarship sought to identify weights like this one with specific Theodosian empresses, especially Pulcheria (r. 414–53), Licinia Eudoxia (r. 439–55), and Galla Placidia (r. ca. 421–50). More recently, the weights have been understood as generic representations of empresses of the

Theodosian dynasty.[2] Anne McClanan has argued that the weights are so generic they should not be associated solely with the Theodosian era,[3] but the Theodosian hairstyles seen on many examples suggest that, even if they are not all products of the era, the standard for the form was established at that time.

The Theodosian tradition of presenting the imperial figures of the dynasty in similar poses probably made the specific identification of the figure unnecessary, as the image would have been intended to represent the authority of the state, not of an individual. The serenity of the pose may also have served as a reminder to the public of the government's duty to maintain *taxis*, or order and harmony, in the universe. One aspect of this order was the assurance of proper weights, and thus the legitimacy of commercial contracts involving the buying and selling of goods.[4] The elaborate jewels on the figure could be understood as a reflection of the prosperity of the state. McClanan and Diliana Angelova have connected the popularity of empress weights in Early Byzantium with the contemporary use of weights in the shape of another woman: the classical goddess Athena.[5] Angelova has argued that both types represent wisdom per-

sonified, since empresses and Athena were admired for their learning.[6] Such an interpretation may have been quite appealing to a people whose great church in their capital, Constantinople, was dedicated to Hagia Sophia (Holy Wisdom).

<div style="text-align: right;">HCE</div>

NOTES

1. Kiilerich 1993, pp. 95–96.

2. New York 1999, pp. 26–27, no. 31 (entry by Helen C. Evans).

3. McClanan 2002, pp. 47–48.

4. Evans et al. 2001, p. 16, no. 4 (entry by Helen C. Evans); Franken 1994, pp. 104–5.

5. McClanan 2002, pp. 55–60; Cambridge 2002–3, pp. 53–56, no. 11 (entry by Diliana N. Angelova).

6. Cambridge 2002–3, pp. 54–56.

EX COLLECTION

George Zacos, Basel, 1980

LITERATURE

Franken 1994, p. 179, no. CA58, pl. 97; New York 1999, pp. 26–27, no. 31 (entry by Helen C. Evans, with earlier bibl.); Evans et al. 2001, p. 16, no. 4 (entry by Helen C. Evans); McClanan 2002, pp. 41–45; Cambridge 2002–3, pp. 53–56, no. 11 (entry by Diliana N. Angelova, with earlier bibl.)

68. Head of a Prophet

Workshop of Giovanni Pisano
Italy, Siena, first quarter of the 14th century
Marble, H. 12½ in. (31.8 cm)
The Cleveland Museum of Art; Leonard C. Hanna, Jr. Fund (1977.181)

This head exhibits many characteristics of the workshop associated with Giovanni Pisano (ca. 1240–before 1320), especially the sculpture made while he was master of works at Siena Cathedral (1285–97). Instead of preserving the more idealized, generic features of ancient heads as his father, Nicola, had done, Giovanni was adept at combining classical techniques, such as drilling marble, with an individualized characterization of facial features, an ability he had acquired from his knowledge of northern Gothic sculpture. In this head, the deeply set eyes shadowed by heavy brows, the sunken cheeks, the drill work in the beard and hair, and the open mouth convey an energy comparable to other examples associated with Giovanni's oeuvre.[1]

The head was sheared off at the back so that it now resembles a mask, a distinctive feature that has suggested to Dorothy Gillerman the head was originally located on a flat surface. Accordingly, she has proposed that the head may have been made for a location such as Siena's Baptistery, where there is a series of masked heads set in roundels along the lower

facade.[2] This piece is not the same size as the heads still in situ, though; stylistically and proportionally, it is more akin to the busts of prophets and the seated Four Evangelists surrounding the rose window on the facade, or to the full-length standing prophets on the exterior roof along the southern aisle. Like most of the facade sculptures, the originals of these have long been replaced by copies and are now in the Museo del Duomo and other protected locations.[3] On one of the evangelists, now displayed in the cathedral's souvenir shop, a modern head has been set onto the original body, and judging from the angle of the torso's neck, the original head must have been detached with a flat cut (fig. 100). Yet even though the size of the Cleveland head matches that modern copy exactly, it cannot represent an evangelist since it is veiled, and is thus apparently a prophet.[4] Moreover, the Cleveland head is quite similar stylistically to recently published prophets and apostles attributed to Giovanni Pisano's workshop that are now at Castello Gallico, near Siena, suggesting that it could very well have belonged to one of the prophets on the exterior of Siena Cathedral.

<div style="text-align: right;">CV</div>

NOTES

1. See Gillerman 2001, pp. 341–42, no. 249. The head had previously been associated with the work of minor masters of the Pisan school, such as Lupo di Francesco (active 1315–36) and the Master of San Michele in Borgo, whose work was inspired by Giovanni Pisano's later sculptures (1302–10).

2. Middeldorf Kosegarten 1984, p. 355, no. 23, figs. 241–249.

3. For the exterior sculptures, see Middeldorf Kosegarten 1984, figs. 164–188. Although most of Siena's sculptures have been preserved in their entirety, some are missing heads. For a discussion of nineteenth-century copies, see Keller 1937, pp. 163–201, esp. fig. 121, which shows

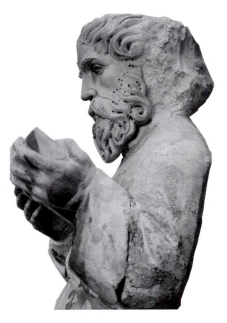

Fig. 100. *Workshop of Giovanni Pisano. Figure of an Evangelist (with modern face), Siena Cathedral (Tuscany), ca. 1300*

the Evangelist Matthew without a modern head, while Middeldorf Kosegarten 1984, p. 349, fig. 187, shows the same figure with a modern head.

4. The veiled figure is misidentified as an evangelist in Kreytenberg 2003; it is correctly described as a prophet in Bartalini 2000, figs. 7, 9.

EX COLLECTIONS

Royal Württemberg Collections; Württembergisches Landesmuseum, Stuttgart; Merz Bank, Hamburg, by 1947; Dr. Salb, Hamburg; private collection; [Heim Gallery, London]

LITERATURE

Gillerman 2001, pp. 341–42, no. 249

69. Prudence and the Ages of Man

Circle of Giovanni di Balduccio
Central or North Italy, ca. 1325–30
Carrara marble, H. 9¼ in. (23.5 cm)
The Metropolitan Museum of Art, New York;
Robert Lehman Collection, 1975 (1975.1.1491)

The three faces on this small bust, a fragment from a larger monument, together represent the cardinal Virtue Prudence, whose tripartite nature (*memoria*, *intelligentia*, and *providentia*) is represented here by three crowned visages shown at different stages of life. Unlike the personification of Prudence seen frequently in Italian sepulchral monuments,[1] which shows a woman holding a serpent and mirror, this representation conflates Prudence with the concept of the Ages of Man and the *vultus trifrons* (three-headed Being). All of the faces seem to depict the same person, but each age is distinctive, and the face thus grows more drawn as it gets older: the first (the future) is youthful, the second (the present) is mature, and the third (the past) is elderly. A triangular diadem is set atop each visage, but as a single bust they share a neckline with a collar, which is decorated with an interlace pattern.

Combinations of double- and triple-headed figures had been common in sculpture since Roman times, but before the fourteenth century combinations of such imagery with Prudence were rare (fig. 101). The only other representation of Prudence from that period with the same iconography appears in a miniature (ca. 1340) representing the Neapolitan king Robert the Wise of Anjou (1309–1343), who is enthroned and surrounded by the eight Virtues.[2] By the late thirteenth century, several Tuscan moral and medical treatises as well as Dante's *Convivio* (I.5–13) (1304–7) discuss the Ages of Man in conjunction with specific qualities associated with the Virtue Prudence,[3] and by the Renaissance, as Erwin Panofsky has shown, the Ages of Man were being represented by three-headed figures.[4] Of those, Titian's is the most famous (ca. 1565–70, National Gallery, London), but several others appear in Tuscany in different media. On the fourteenth-century floor mosaic of Siena Cathedral, for example, an enthroned Prudence with a serpent and mirror displays the three heads.[5] A Trecento sculpture of a veiled woman, now in the Museo Nazionale del Bargello, Florence, likewise holds a serpent, and there is a second face on the back of the main head,[6] as there is in another example formerly in the Liechtenstein collection.[7] The merger of medieval moral concepts of virtue with those of the human life cycle coincided with a more nuanced and subtler understanding of human nature as well as a focus on the individual apparent from that time onward.

The style of this work can be related to that of Giovanni

Fig. 101. *Master of the Armature. Prudence, campanile, Florence Cathedral, 1336–41. Museo dell'Opera del Duomo, Florence*

di Balduccio (active 1318–49), a sculptor of Pisan origin.[8] The softness of the carving contrasts with the more angular, firmer hand seen in Giovanni's later Milanese works dating from the 1330s, however, suggesting that this piece was made during an earlier period, when the artist was active in Tuscany. Although Giovanni used personifications of the Virtues as supports for the tomb of Saint Peter Martyr in Sant'Eustorgio, Milan (1339), this personification is probably from an earlier Tuscan[9] or Genoese[10] monument, or even from a capital.[11]

CV *and* LCT

NOTES

1. New York 1987b, p. 109.

2. Max Seidel, "Una nuova opera di Nicola Pisano," in M. Seidel 2005, pp. 271–88, esp. p. 285, fig. 17.

3. See Sears 1986, pp. 99–107.

4. Erwin Panofsky, "Titian's Allegory of Prudence: A Postscript," in Panofsky 1955, pp. 146–68; Oklahoma City 1985, pp. 106–7, no. 21 (entry by George Szabo).

5. Caciorgna and Guerrini 2004, fig. 116.

6. Inv. no. 191 S.

7. Liechtenstein 1954, p. 10, pls. 3–5.

8. Oklahoma City 1985, pp. 106–7.

9. See, for example, tombs in the Baroncelli Chapel, Santa Croce, and San Casciano Val di Pesa, Florence; illustrated in Moskowitz 2001, figs. 190, 193, respectively.

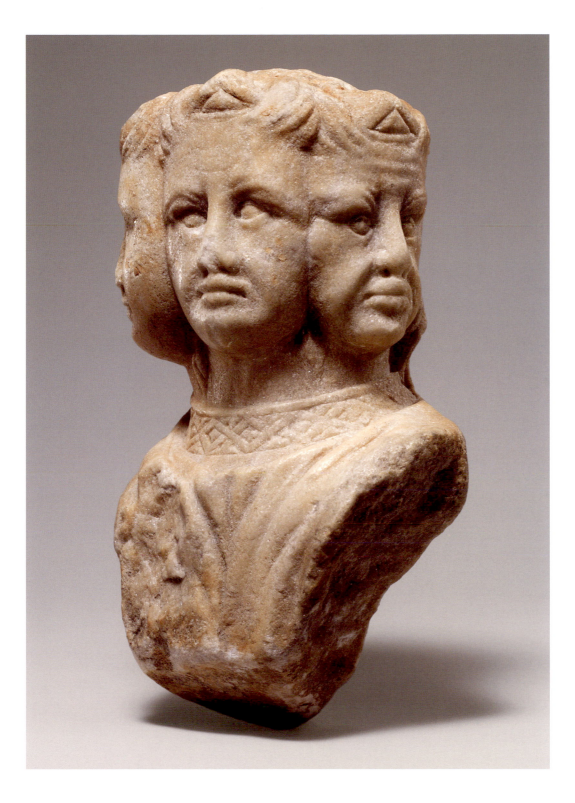

10. See New York 1987b, nos. 13, 14, for an example of two angels holding back tomb curtains.

11. See the capitals from Santa Caterina, Pisa (Max Seidel, "Le [*sic*] sculptures of Giovanni di Balduccio from Santa Caterina a Pisa: An Attribution for the Capital of the Evangelists in the Liebighaus," in M. Seidel 2005, pp. 645–62, figs. 1–14).

EX COLLECTION

Robert Lehman, New York

LITERATURE

Oklahoma City 1985, pp. 106–7, no. 21 (entry by George Szabo)

Reliquary Busts: "A Certain Aristocratic Eminence"

Barbara Drake Boehm

In 1354, Saint Vitus's Cathedral in Prague possessed twenty-six skulls of saints. Within a year, twelve more are listed, and of the total number, twenty-eight are described as being enshrined in bust-shaped reliquaries made of precious metal encrusted with gems. Grouped according to a descending hierarchy of the saints, the bust-shaped examples are the first objects recorded in the 1355 inventory, taking precedence over reliquaries in the form of arms, statuettes, crosses, sacred vessels, and vestments. Within a century, however, all of the reliquary busts from Saint Vitus's had been dispersed.[1] Some were later enshrined in new busts donated by Władysław II Jagiełło (r. 1440–57), but never again would they appear together in such an imposing array.[2]

The example of the lost reliquary busts from Saint Vitus's is dramatic, but it is also, unfortunately, emblematic. The ravages of war, reformation, and revolution have left us with an impoverished picture of medieval sculpture, both in the variety of its forms and the range of its materials. In the case of reliquary busts, our view is particularly impaired. Where once precious metal glistened in church interiors, all too often only the sobriety of stone remains. The mere mention of Notre-Dame in Paris or the royal abbey of Saint-Denis conjures up images of stained glass and portal sculpture, but not of the once-renowned bust of Saint Philip at Notre-Dame,[3] or of the bust of Saint Denis at his titular abbey.[4] Those busts that survive have remained largely outside the accepted canon of medieval sculpture. Treated today as isolated curiosities, or more often ignored, these works, created across Europe from the late ninth century until well into the Renaissance, were often the defining sculptural images of their communities.[5]

The first documented reliquary bust, made to hold the skull of Saint Maurice, patron of the cathedral of Vienne (Isère), was commissioned by Boson, king of Burgundy (r. 879–87), a powerful vassal and the brother-in-law of Charles the Bald (r. 840–77).[6] The king's epitaph proclaimed that he was the sponsor of the reliquary, lost centuries ago, which was apparently made of gold and decorated with precious stones and a jeweled gold crown.[7] An early example of ecclesiastical patronage is Abbot Stephen of Tournus, who in January 979 exhumed the body of Saint Valerian, the abbey's patron, and had an image reliquary created to house the saint's skull.

The Massif Central region of south-central France conceived and still preserves a remarkable number of precious reliquary busts from its affluent Romanesque monasteries, a rich heritage also reflected in the area's contemporary churches,

monumental wall painting, and illuminated manuscripts.[8] In the thirteenth century, reliquary busts began to proliferate across northern France and in urban centers elsewhere, paralleling Gothic building campaigns. Even the Cistercian community at Clairvaux, which one might expect to have been philosophically reticent about such lavish works, commissioned reliquary busts, including an enameled, gilded-silver example studded with sapphires to hold the skull of Saint Bernard.[9] A reliquary bust once at the abbey of Saint-Germain-des-Prés in Paris speaks to the perceived importance of these precious Gothic sculptures. Alexander, a mid-thirteenth-century sacristan or treasurer at the abbey, was memorialized on his tomb (at the entrance to the abbey's famous Lady Chapel) as the patron of a reliquary bust. On the tomb, Alexander held the head of Saint Amand, and a laudatory inscription proclaimed his role as patron:

> Here lies Alexander, monk of this church, who had the chin of Saint Vincent put in silver, and the head of Saint Amand, and the foot of an Innocent, who always during his lifetime was a [prudent] man and valiant. Pray to God for his soul. Amen.[10]

The early example of Boson's commission for the cathedral of Vienne notwithstanding, documentation suggests that Europe's secular rulers did not become major patrons of important reliquary busts until the thirteenth century, but soon afterward a plethora of examples appeared. Philip the Fair's commissioning of the gold head reliquary of Saint Louis in 1299 exemplifies the importance of such precious sculpture in the context of royal patronage (fig. 102). The reliquary's role within Sainte-Chapelle was as vital to the Crown as the creation of the chapel, with its celebrated program of sculpture and glazing, had been under Saint Louis. In a letter to the pope, Philip defended the translation of the saintly king's skull from Saint-Denis on the grounds that Sainte-Chapelle was itself the "head of the entire realm of France."[11]

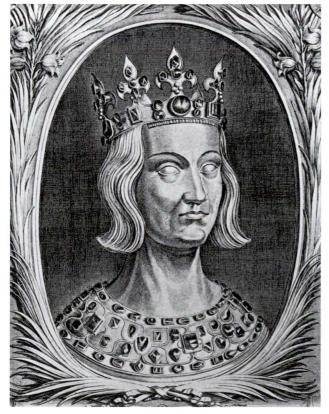

Fig. 102. Reliquary Bust of Saint Louis. Engraving, frontispiece to Jean, sire de Joinville, Histoire de S. Louys, *ed. Charles Du Fresne Du Cange (Paris, 1668). Bibliothèque Mazarine, Paris (5863 2nd Ex.)*

The eleventh-century chronicle of Tournus, despite its early date, contains several key details about reliquary busts that resonate across the Middle Ages. It states that "the true head [of Valerian] was set up separately near the memorial place in a comely image of gold and most precious gems in the likeness, to a certain point, of the martyr."[12] This is important for several reasons, but first in its unequivocal assertion that the reliquary contained the "true head." In the early eleventh century, Bernard of Angers had similarly proclaimed that the gold image of Saint Foy "has long been distinguished by a more precious treasure than the ark of the Covenant once held, since it encloses the completely intact head of a great martyr, who is without doubt one of the outstanding pearls of the heavenly Jerusalem."[13] The preponderance of reliquaries in bust form were created expressly to hold the skull of a saint, or a fragment thereof, and documentation makes this explicit.[14] It is significant, then, that Bernard knew the enthroned, full-length image of Saint Foy contained the saint's skull, for in this reliquary, as in most preserved

busts before the thirteenth century, the relics are not visible. He must have been informed of the presence of the skull, a clear indication that its presence there was far from incidental. Nor was this interest a function of an isolated moment in time. As late as 1482, in an inquiry ordered by Louis XI (r. 1461–83), the image of Saint Lazarus once at Avallon in Burgundy was identified as the one containing the "caput vero" (true head).[15]

The second important point to be gleaned from the Tournus chronicle is that the creation of the bust of Saint Valerian was part of a larger campaign to embellish the church and honor its patron. Abbot Stephen oversaw the rebuilding of the abbey, which included a new stone altar over the saint's tomb in the crypt. While he placed the skull in the reliquary image, other important relics were set in a gilded-silver chasse; lesser ones remained in the sarcophagus.[16] At Saint-Pourçain, a dependency of Tournus, the same Abbot Stephen translated the body of the patron, dividing the relics between a lost imagine (image) and a loculo (coffin) just before the complete rebuilding of the abbey. Accordingly, the skull relic became part of the active veneration of and engagement with the saint, while the coffin was designated for quieter commemoration. The golden head reliquary of Saint Hugh once at Lincoln was conceived as the focal point of the cathedral's famous Angel Choir.[17] These quite typical examples, plucked from distinct locations and times, bear witness to the importance of these reliquaries in the larger history of medieval sculpture.

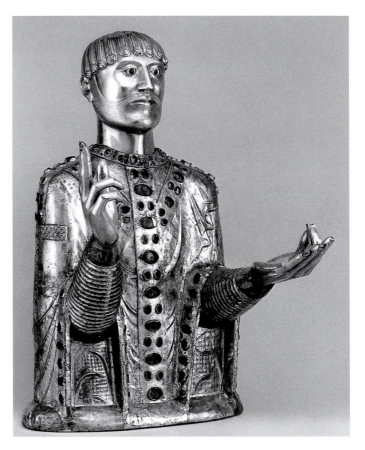

Fig. 103. Reliquary Bust of Saint Baudime, ca. 1125–50. Copper gilt over wood with cabochons and horn. Church of Saint-Nectaire (Puy-de-Dôme)

The third point is that the image of Saint Valerian is called "comely," apparently by virtue of its precious materials.[18] Moreover, it is described as being in "the likeness, to a certain point, of the martyr." Other sources similarly attest to the resemblance between image and saint. The equation between the image of Saint Foy and her reliquary was so strong that she appeared to people in dreams as her golden image, as did the reliquary head of Saint Privatus of Mende.[19] Such convictions raise a question: What elements contributed to a medieval Christian's perception of the veracity of a reliquary image like that of Saint Valerian, who had been martyred a millennium earlier?

The precious materials of reliquary busts suggested to many Christians the expected luminosity of a heavenly being,[20] an aspect that was enhanced by the placid gazes of the saints. Medieval reliquary busts are also remarkable for their frontal presentation and regular features. With rare exceptions, such as the late-fifteenth-century reliquary bust of Saint Just, none of the images suggests the suffering or decay brought on by self-denial or martyrdom.[21] In addition, the peaceful countenances of medieval reliquary busts seem consistent with contemporary discussions of both the form and meaning of the human head, adapted from Plato's Timaeus.

Plato had described the smoothness and spherical form of the head, seeing in it "a certain aristocratic eminence." This text was amplified by the fourth-century commentary of Chalcidius, which remained current during the Middle Ages:

> He [Plato] begins from the head and this part of the body he says is of a certain chief eminence and on account of this it is fitting that it is placed on high and in a prominent place as if it were the citadel of the whole body....[22]

Although images such as the reliquary bust of Saint Yrieix (cat. no. 72) may seem icy or remote today in comparison with either late Roman or Renaissance portrait traditions, Bernard of Angers insisted that the eyes on the reliquary of Saint Géraud at Aurillac (now lost) enlivened the work:

> It was an image made with such precision to the face of the human form that it seemed to see with its attentive, observant gaze the great many peasants seeing it and to gently grant with its reflecting eyes the prayers of those praying before it.[23]

Indeed, colored eyes made of a distinct material frequently lend a more human aspect to otherwise shimmering, awesome sculptures such as the one of Saint Baudime (fig. 103).[24]

Other artistic choices likewise softened the somewhat imposing aspect of these images, indicative of the saints' status as intercessors: inhabitants of heaven, yet still recognizably human. The goldsmith who created the bust of Saint Yrieix punctuated the silver sheet of the saint's face to suggest the stubble of his beard and also incised and gilded the beard and brows. The entire face of the reliquary bust of Saint Juliana (cat. no. 73) is painted to simulate flesh tones.[25] On the eve of the Renaissance, the telling marks of worldly cares regularly begin to appear on the foreheads of reliquary busts, first as wrinkle lines,[26] and then as faces contorted by suffering.[27]

The association of reliquary busts and the saints they represent was often facilitated by the artist's use of gesture and attribute.[28] Miters identified bishops, and their headdresses were hinged to allow the skull to be revealed.[29] In an illumination of the translation of the skull of Saint Martin, a cleric raises the miter from the reliquary bust to allow the skull, just removed from the larger chasse and cradled in the bishop's hands, to be set into the sculpture (fig. 104).[30] A bust of Saint Vincent from Saint Vitus's Cathedral was described succinctly in an inventory as being in the manner of a deacon's head.[31] Saint Baudime, as an apostle of the Auvergne, extends his right hand in blessing, and he once clasped a now-lost object between his thumb and index finger.[32] The lost tenth-century bust of Saint Martial from Limoges was posed in blessing, holding the Gospel,[33] emphasizing his legendary role in evangelizing pagan Gaul. Saint Yrieix appears as a tonsured monk: silver denotes his shaved pate, while gilding distinguishes his wavy fringe of hair.

In the Gothic period, reliquaries were increasingly clothed in the emblems of their secular patrons. The arms of Jean de France, duc de Berry (1340–1416), once decorated the base of the bust of Saint Philip at Notre-Dame Cathedral as well as the reliquary busts of Saint James and Saint Ursin at the duke's Sainte-Chapelle in Bourges.[34] In an age when European royalty were particularly interested in their own privileged relationship to royal saints,[35] the lines between the royal patron and the canonized ruler represented in a reliquary bust were intentionally blurred. Thus the coronation crown of the kings of Bohemia, created for Charles IV (r. 1355–78), graced the reliquary bust of Saint Wenceslas in Prague.[36] A bust for another

Fig. 104. Initial S with the translation of the skull of Saint Martin (above) and the royal family in prayer (below), ca. 1328–50. Bibliothèque Municipale, Tours (Ms. 1023, fol. 101)

fragment of the skull of Saint Louis, presented to the royal convent of Poissy in 1351, bore a gold crown that Philip VI's widow, Jeanne de Bourgogne (d. 1348), had worn at her coronation.[37]

Reliquary busts often share an aesthetic vocabulary with sculpture in other media. The golden face and hair of Saint Baudime, for example, resemble the heads carved into the stone capitals of the church of Saint-Nectaire (Puy-de-Dôme). Late-thirteenth-century gilded copper reliquary heads from Limoges likewise parallel the funerary masks made there for ecclesiastical, aristocratic, and royal patrons from England to Spain.[38] The bust of Saint Juliana (cat. no. 73) resembles a Sienese painted wood image of the Virgin Annunciate.[39] Reliquary busts thus belong to both the history of devotion and to the history of sculpture, and they ought, increasingly, to figure prominently in their study.

NOTES

1. Seven relics were taken to Karlštejn Castle in 1420, and nine to the monastery of Olywin in 1421 to remove them from immediate danger during the Hussite Revolution. In 1454, seven were returned to Prague, none protected by more than a simple container or wrapping. See Podlaha and Šittler 1903, pp. LXII–LXIV.

2. Ibid., p. 21; Braun 1940, p. 420. Today, no reliquary bust is exhibited at Prague's cathedral. Even the precious skull of Saint Wenceslas, once enshrined in a gold bust, is now presented on a gilded rectangular tablet, a gift from the Czech-American citizens of Chicago and New York at the beginning of the twentieth century.

3. Delaborde 1884, pp. 300–303. The bust is included in the 1416 inventory; it was melted down, except for the collar and gems, following an order in 1562. It weighed 46 marcs (nearly 25 pounds).

4. Described in the abbey's inventories and illustrated—before its destruction in the French Revolution—in the engraving of Dom M. Félibien of 1706; reproduced in Paris 1991, fig. 9.

5. They were especially favored in France, where the earliest examples are recorded, and in the lands of the Holy Roman Empire, in England, and, in the Gothic period, in Italy. See Braun 1940 and Falk 1991–93. Simplified images of lost reliquary busts appear as emblems on lead pilgrims' badges, signifying that the wearer had visited the celebrated shrine, much like a T-shirt or snow dome of the Eiffel Tower today signifies a visit to Paris. Pilgrims' badges sometimes offer the only visual record of reliquary busts lost from Arras Cathedral or Canterbury. Compelling cases for this are inherent in the articles published by Souchal 1966 and Moskowitz 1981.

6. He was also patron of Magdeburg Cathedral. See "The Fate of the Face in Medieval Art" by Willibald Sauerländer, in this catalogue (fig. 25).

7. See Kovács 1964a.

8. See Langmead 2003; Paris 2005.

9. Lalore 1875, p. 106. It was commissioned by Jean d'Aizanville, a mid-fourteenth-century abbot.

10. "Ci gist Alixandre moyne de cette église qui fist mettre en argent le menton seint Vincent, & le chef seint Amand, & le pié des Innocens, qui toûjours en son vivant fu preudhomme & vayllant. Priez Dieu pour l'ame de lui. Amen." Bouillart 1724, Book III, p. 135. I am grateful to Mary B. Shepard for bringing this to my attention.

11. Brown 1980, p. 176.

12. "Caput vero juxta memoratum loculum in imagine quadam velut ad similitudinem martyris ex auro et gemmis pretiosissimis decenter efigiata separatim erigitur"; transcribed in Poupardin 1905. The terms adopted in medieval inventories do not always make clear the form of the reliquary. For example, the word *caput* (head) is used in a tenth-century inventory from Clermont-Ferrand, where the full description makes clear that the reliquary was in the form of a bust with arms. See Douët-d'Arcq 1853, p. 172.

13. Sheingorn 1995, p. 79.

14. Among exceptions are early examples from Germanic lands. There was a proliferation of reliquary busts of Saint John the Baptist. Many claimed to contain at least a fragment of the skull of the famously decapitated saint. The bust of the Baptist from Aachen-Burtscheid prominently displays a humerus bone (New York–Prague 2005–6, p. 153, no. 24), anticipating a type that came to the abbey of Saint-Denis in the early fifteenth century, through the patronage of Jean de Berry, in which the bust of the saint presents his own arm reliquary. See Paris 1991, fig. 8.

15. See Charmasse 1865.

16. Boehm 1990, pp. 345–46.

17. See Farmer 1987 and Stocker 1987.

18. On the relationship between the value of materials and the perception of beauty, with special attention to Abbot Suger, see Eco 1986, pp. 13–15.

19. Sheingorn 1995, p. 83; Brunel 1912, p. 106.

20. See Dahl 1978 and Remensnyder 1990.

21. In that case, the headless torso of the saint presents his head for veneration, following the convention of ostension and veneration of the relic. See Montgomery 1997.

22. Chalcidius, commentary on Plato's *Timaeus*.

23. Sheingorn 1995, p. 77.

24. The eyes of Saint Foy are made of blue and white glass; those of the twelfth-century image of Saint Baudime at Saint-Nectaire are horn and ivory. The fourteenth-century gilded bust of Saint Ludmila has eyes with silver "whites" and black pupils. See New York–Prague 2005–6, p. 137, no. 6.

25. Outside the medieval tradition, the sixteenth-century reliquary bust of Saint Erasmus from the saint's titular abbey in Halle furthers this trend by representing the saint with a black face and conventionalized African features. See Halm and Berliner 1931, p. 46, no. 175, pl. 98.

26. See, for example, the bust from Passignano, in Braun 1940, pl. 131, fig. 499. In France, the mid-fifteenth-century example of the bust of Saint Dumine at Gimel may be cited; see Souchal 1966, p. 212, fig. 11.

27. See, for example, the reliquary bust of Saint Gregory of Spoleto in the treasury of Cologne Cathedral; reproduced in Amsterdam–Utrecht 2000–2001, pp. 77–78, fig. 76.

28. For the importance of the busts' appearance in relation to their function, see Boehm 1990, pp. 74–112.

29. The reliquary of Saint Ferreolus preserved in Nexon and the lost image of Saint Aurelien of Limoges are notable examples. See Paris–New York 1995–96, pp. 430–32, no. 157, and Bonaventure de Saint-Amable 1676–85, vol. 2, p. 589, respectively.

30. See Otavsky 1992, fig. 36.

31. Podlaha and Šittler 1903, p. IX, no. 293.

32. Although the tightly closed fingers suggest that this object was a martyr's palm frond, Saint Baudime was not martyred.

33. Duplès-Agier 1874, p. 43.

34. "'Trésor" 1850, p. 143, nos. 7, 9.

35. See Klaniczay 1990, 2002.

36. First recorded in the 1354 inventory. See Podlaha and Šittler 1903, p. III, and Otavsky 1992.

37. Parguez 1914, p. 25.

38. See Paris–New York 1995–96.

39. The link to a piece in the Thyssen collection was first noted by Anthony Radcliffe in Williamson 1987, no. 18, pp. 98–102.

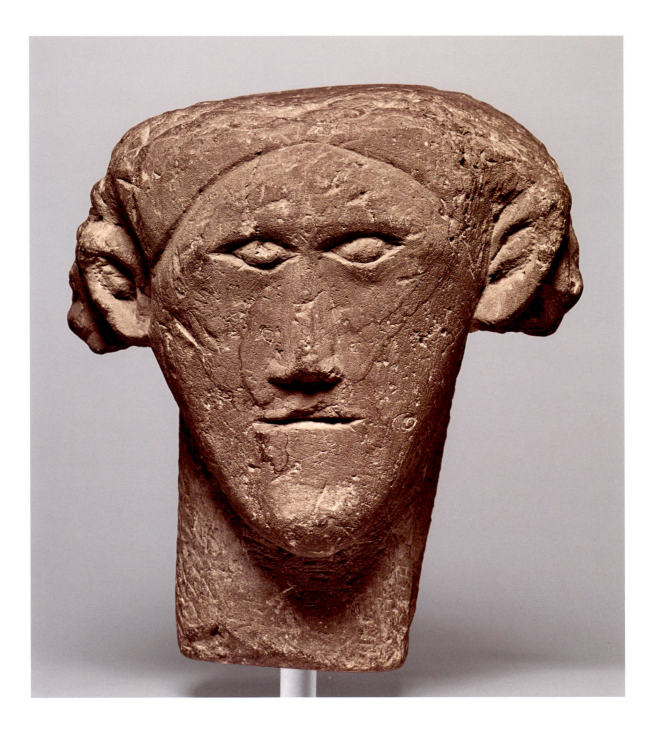

70. Head of a Man

England (Celtic tradition), probably 2nd–3rd century A.D.
Arkosic sandstone with traces of paint, H. 13 in. (33 cm)
The Cleveland Museum of Art; Gift of Dr. and Mrs. Jacob
Hirsch (1955.555)

Although the minimal approach taken to the carving makes
this head appear almost as if it were unfinished, the sculp-
ture possesses an undeniable force and mystery. Intended to
be seen primarily from the front, the head is severely angular
in shape, and the face is almost concave in profile. The
figure's essentially anticlassical features have been reduced
to geometric forms: the lentoid eyes are expressionless; the
ears are virtually nonexistent; the mouth is but a line; and
the hair is only schematically suggested. Any impulse to con-
vey dimensionality and completeness has been suppressed.

We know little about the head's early history, and its pre-
cise date is uncertain. The articulation of the hair with
rough, cross-hatched patterns and the curving scalp line
across the front is not unlike some Romano-Celtic heads.

Indeed, despite the abbreviation of natural proportion and physiognomic form, the head does echo the Romano-British-Celtic world. To support a British attribution, Stephen Fliegel and others have cautiously compared this head to one excavated at Winterslow, between Salisbury and Winchester, that can be dated to the second or third century A.D. That head also possesses lentoid eyes and schematic hair on a geometrically reduced face, and it may well represent a local deity. Many similar heads of varying degrees of quality have appeared in private collections and on the art market, all without provenance or a documented archaeological context, leading to speculation that some were actually carved later: the reason many are placed simply "in the Celtic tradition."

Because this head has a long neck with a beveled terminus and there is no evidence it was attached to a body, Fliegel has suggested it was meant to be inserted into a larger votive setting. The head appears to be an independent carving, however. It was possibly intended for ritualistic purposes as part of the Celtic cult of the head, known principally from stone heads like this one and from written sources—including such classical authors as Diodorus Siculus, Strabo, and Livy[1]—who recorded how Celtic chiefs prized the trophy heads of their enemies and displayed them in a temple within their camps.[2] As emblems of conquest, such heads were essential to the Celtic worldview and to their concept of the value of human life. The veneration of the human head was rooted in the Celtic religious system, which regarded the head both as the seat of the soul (the same idea expressed in Plato's *Timaeus*) and as capable of independent being. The Celts also believed that powers inherent in the human head could protect against evil. A number of surviving stone heads have been found near natural springs, which were particularly valued by the Celts, and their presence in these contexts suggests they had a magical or apotropaic function.

As cult objects, some Celtic stone heads possibly functioned as surrogates for actual decapitated human heads taken in battle, although nothing about the present example suggests this intention. Like the Winterslow head, it may have been intended as a votive object or a representation of a deity. The Celtic reverence for the head helped lay the foundation for the Christian view of the head as the locus of the soul, an important reason why the heads of saints were often preserved as relics. Indeed, such heads (see also cat. no. 71) are included in this exhibition in recognition of the fact that from ancient times—from Plato to Beowulf—the head has been deemed both precious and holy and has been equated with the soul or even, in a sense, the person.[3]

CTL

NOTES

1. Diodorus Siculus V29.XTH; Strabo IV.V.4,5; Livy X.26, xxiii.24 (as in London 1989–90, no. 27).

2. The Roman view of these practices was probably colored, at least in part, by propagandistic motives as they sought to portray the Celts as savages and drive them from the Empire. For example, on Trajan's column in Rome there is a depiction of a Celtic display of severed heads around a Dacian camp. Richmond 1935 (1982 rpt.), p. 39.

3. See especially Onians 1988, pp. 93–104.

EX COLLECTIONS

French art market, by 1904; Walter Carl, Frankfurt am Main, before 1919; [sale, F.A.C. Prestel, Frankfurt am Main, July 19, 1919, lot 6]; (?) Rothschild Collection; Dr. Jacob Hirsch, New York, 1945–55

LITERATURE

Fliegel 1990 (with earlier bibl.)

71. Head of a Man Wearing a Cap or Helmet

Probably British Isles (Celtic), possibly 2nd–3rd century A.D.
Fossiliferous limestone, H. 9 in. (22.9 cm)
The Metropolitan Museum of Art, New York; Gift of Torkom Demirjian, in honor of Mary and Michael Jaharis, 2000 (2000.525.1)

Like catalogue number 70, this pear-shaped head, which is carved from a coarse, fossiliferous limestone (possibly a gritstone of glacial origin), has minimally articulated facial features. The eyes are blank, the mouth is a slit, and the ears are mere outlines. Despite the lack of facial expression, the head's austere, abstract aesthetic is powerful, and the countenance is nonetheless disconcerting. Instead of hair, there is a tight-fitting cap with a cheek guard, a standard component of head protection for the Celtic military in some regions of Europe.[1]

We know from classical written sources that the Celts considered the trophy head of an enemy an emblem of conquest and often a source of magical power and good fortune (see cat. no. 70). The Greek historian Diodorus Siculus (1st century B.C.) wrote that the Celts "embalm in cedar-oil the heads of the most distinguished of their enemies and keep them carefully in a chest; they display them with pride to strangers. They refuse to accept for them a large sum of money even the weight of the head in gold."[2]

It appears that this head was originally carved as an independent object; the holes on the base, made for mounting, are modern additions. Nothing is known of the head's provenance. Along with the headgear, the facial features are characteristic of other Celtic sculptures, especially those from the British Isles, where this type of stone is found and where a wide range of stone heads have been recovered,[3]

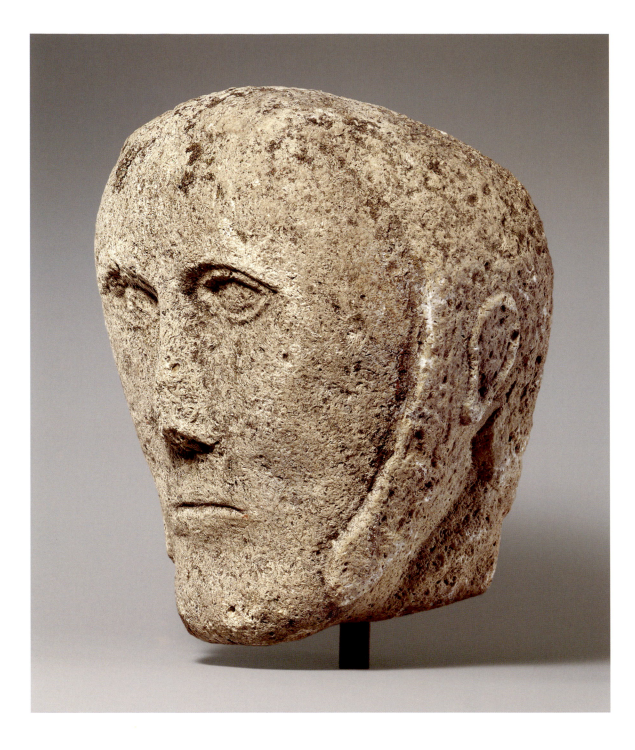

including as many as four hundred in Yorkshire. Although many of these are labeled "Celtic," a good number of them were likely made later in the Celtic tradition. Few of these have the headgear seen in this example, however, making it more likely that this piece is an actual Celtic carving and not a later evocation of the tradition. The headgear is strikingly similar to that of a bronze Celtic tricephalos from Himmerland, in Denmark.[4] Although such images were made in both stone and wood, their purpose was the same, as illustrated by an episode reported by the poet Lucan (A.D. 39–65)

in which Julius Caesar's army encountered Celtic heads in a sacred grove near Marseilles:

> The images were stark, gloomy blocks or unworked timber, rotten with age, whose ghastly pallor terrified their devotees.[5]

At the source of the Seine in Burgundy—known since the Romano-Celtic and Gallo-Roman periods as the Fontes Sequanae—some seven hundred sculptures in wood and stone have been found that must have been linked to Celtic

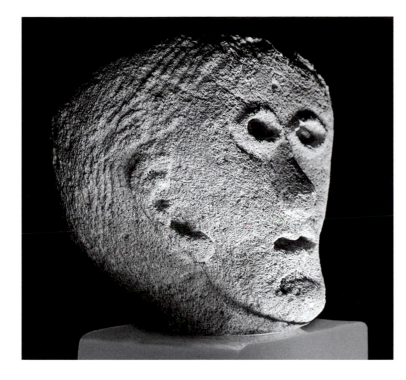

Fig. 105. Votive Head, Dijon, 2nd–3rd century A.D. Found at the Gallo-Roman Sanctuary, Sequanae (Côte-d'Or). Musée Archéologique, Dijon

votive offerings and to the nourishing role of spring water, which the Celts believed could cure a variety of diseases. Many of these sculptures are of heads (fig. 105), some of them articulated to show the effects of a particular affliction, such as Paget's disease, which can lead to abnormal bone growth. Representations of limbs, fetuses, and hands, some with abstract and simplified features not unlike the present head, were also found.[6] Destined for the healing shrine, these objects likely had a specific ritual function, such as to aid in healing or to give thanks for a cure. By the sixth century A.D. the goddess Sequanae (from which we get the name Seine) had become the local Saint Sequanus, a demonstration of continuity between pagan and Christian traditions.

CTL

NOTES

1. J. N. G. Ritchie and W. F. Ritchie, "The Army, Weapons and Fighting," in Green 1995, pp. 43–44.

2. *History*, V.29.4–5.

3. See, for example, a sandstone bust illustrated in London 1989–90, fig. 3.

4. A. Ross 1986, fig. 13.

5. *Pharsalia* III.412–17, as cited by Miranda J. Green, "The Gods and the Supernatural," in Green 1995, p. 470.

6. See esp. Aldhouse-Green 1999.

EX COLLECTION

[Torkom Demirjian, New York]

72. Reliquary Bust of Saint Yrieix

France, Limousin, Saint-Yrieix-la-Perche (Haute-Vienne), second quarter of the 13th century
Church of Saint-Yrieix-la-Perche
Gilded silver, rock crystal, gems, and glass, originally over walnut core with silver leaf and gesso on the interior, H. 14¾ in. (37.5 cm)
The Metropolitan Museum of Art, New York; Gift of J. Pierpont Morgan, 1917 (17.190.352)

As precious in material as it is commanding in aspect, this bust of Saint Yrieix is a quintessential example of a medieval reliquary bust. Created for the monastery of Saint-Yrieix, about thirty kilometers south of Limoges, this gilded-silver image once housed the skull of the founder and eponymous patron saint of the community.

The life of Saint Yrieix (Aredius) is documented by Gregory of Tours.[1] Born to a landed family in the Limousin in the sixth century, Yrieix became a Christian under the influence of the bishop of Trier. He lived as a hermit on his property at Attanum, eventually founding a monastery there, now the site of the town named after him. Yrieix died a natural death in about 591. Renowned for miracles both during his lifetime and at his tomb, Yrieix's legend is well developed in the writings of Gregory. Documentation concerning the saint's relics, however, is neither plentiful nor precise enough to allow the history of the reliquary to be reconstructed.[2]

As a sculptural image, the reliquary bust of Saint Yrieix is a rarity in the Limousin, which preserves only isolated

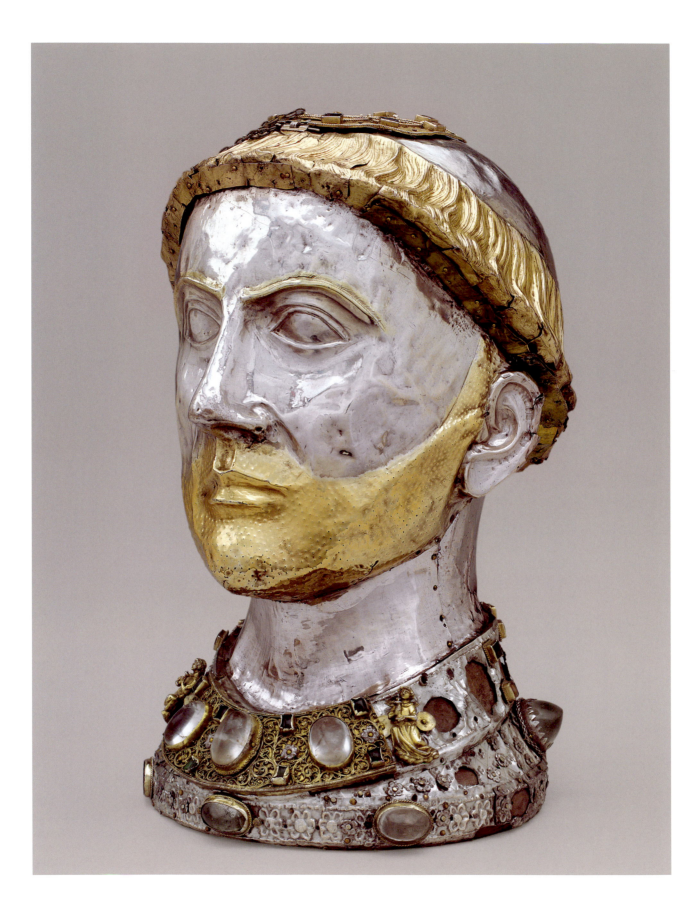

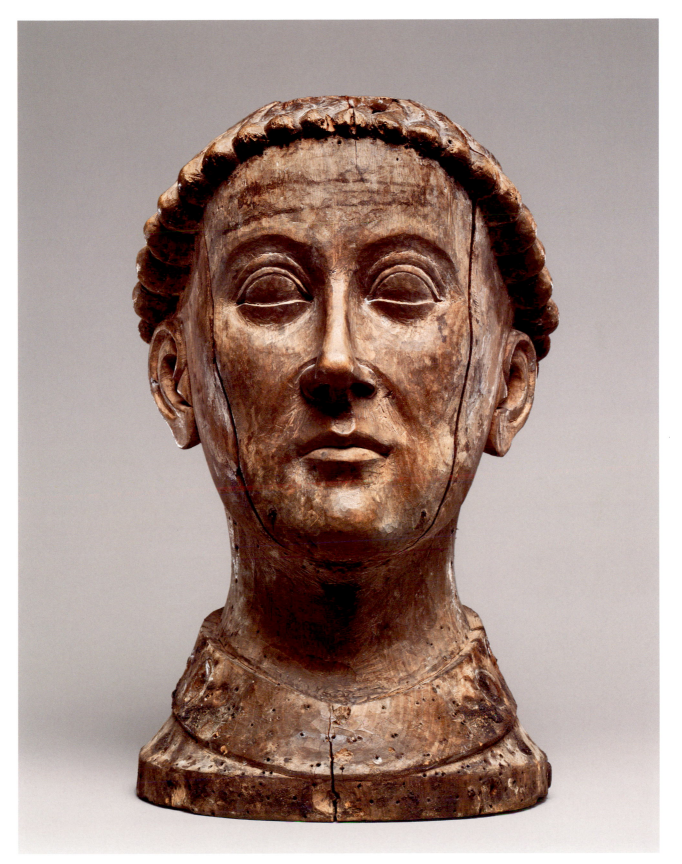

Walnut core of Reliquary Bust of Saint Yrieix (cat. no. 72, opposite)

monuments of figural sculpture in stone or wood. A point of departure for relative dating may be suggested by the trumeau figure of Saint Stephen on the west portal of Sens Cathedral, dated to about 1200.[3] Common to both are the almond-shaped eyes, long nose, small mouth, hollow cheeks, and rigidly frontal posture and gaze. The goldsmiths' work is demonstrably Limousin: the filigree of the orphrey at the neckline is typical of the region[4] and can be compared to that on the reliquary at Arnac-la-Poste,[5] from the early thirteenth century, and on the reliquary of Saint Amand at Saint-Sylvestre,[6] which was presented to the abbey of Grandmont in 1255.

Two events from the first half of the thirteenth century focused attention on the town of Saint-Yrieix and may have provided impetus for the creation of the reliquary. First, in 1226, the doyen of Saint-Yrieix (also archdeacon of Limoges) was elevated to bishop of Limoges. Second, in 1247, arbitration to resolve a dispute between the new doyen of Saint-Yrieix and the viscount of Limoges upheld the rights of the church over certain lands and its jurisdiction in both civil and criminal cases, except homicide.[7] The reliquary might have been created at the behest of the new bishop or the chapter at this important moment, when the community's ecclesiastical privileges were confirmed.

The sculpted wood core, which was not originally intended to be seen, is currently separated from the silver image, now supported by a modern mold. The hinged plate at the top of the reliquary fits awkwardly and appears to be a later replacement. An early-twentieth-century copy of the bust, housing the skull, is preserved at the parish church of Saint-Yrieix-la-Perche.

BDB

NOTES

1. Gregory of Tours, *Glory of the Confessors*, translated by Raymond Van Dam (Liverpool, 1988).

2. The bust is first referred to in a diary of a priest of the town in the seventeenth century. It was inventoried during the French Revolution in 1791 but somehow escaped being melted down.

3. This was suggested as a general comparison by Charles T. Little, oral communication.

4. See Taburet-Delahaye 1990.

5. Paris 1965, no. 355.

6. Ibid., no. 376.

7. See Tenant de La Tour 1993, pp. 30–36. The link to the arbitration of 1247 was suggested by Emlyn Patterson in an M.A. thesis for Columbia University.

EX COLLECTIONS

[Duveen, London, 1905]; J. Pierpont Morgan, London and New York, by 1907

LITERATURE

Texier 1856, col. 292; Rupin 1890, pp. 452–53, fig. 504; Barbier de Montault 1892, pp. 100–102; Kovács 1964b, pp. 69–70, no. 28; Boehm 1990, pp. 231–53; Boehm 1997; Amsterdam—Utrecht 2000–2001, pp. 98–101.

73. Reliquary Bust of Saint Juliana

Circle of Giovanni di Bartolo
Italy, ca. 1376
Gilded copper, gesso, and tempera paint,
H. 11¾ in. (29.8 cm)
Inscribed on band along lower edge: [C]APUD SANTE IULIANE; on back: ROMA. A. D[OMINO]. GUILLE[LMO]
The Metropolitan Museum of Art, New York;
The Cloisters Collection, 1961 (61.266)

In 1376 the Dominican brothers of Perugia separated a piece of the skull of Saint Juliana, whose body they had preserved, and presented it to Gabriella Bontempi, abbess of the convent dedicated to Juliana in the same town. The abbess had a reliquary created to enshrine the skull, an elaborate ensemble comprising this painted bust-length image of the saint set within a gilded-copper tabernacle (fig. 107). The base of the tabernacle, which is decorated with twelve enamel medallions of saints, including one of Juliana, bears a Latin inscription commemorating the gift.[1] The ensemble was restored in the mid-nineteenth century[2] and the bust was removed from the tabernacle; it was subsequently acquired by the Galleria Nazionale dell'Umbria in 1910.[3]

The bust and the tabernacle are testaments to the accomplished goldsmiths whose work and influence radiated out from Siena. The bust especially resembles the head of Saint Agatha of 1376 preserved at the cathedral of Catania, Sicily (fig. 106), made by the Sienese-born goldsmith Andrea di Bartolo (active 1389–1428). The parallels between the two

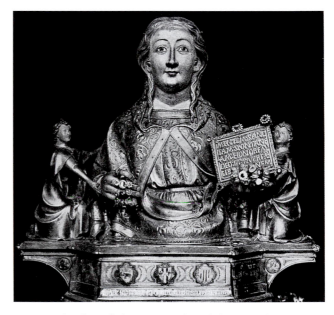

Fig. 106. Andrea di Bartolo (active 1389–1428). Head of Saint Agatha, Catania Cathedral (Sicily), ca. 1376

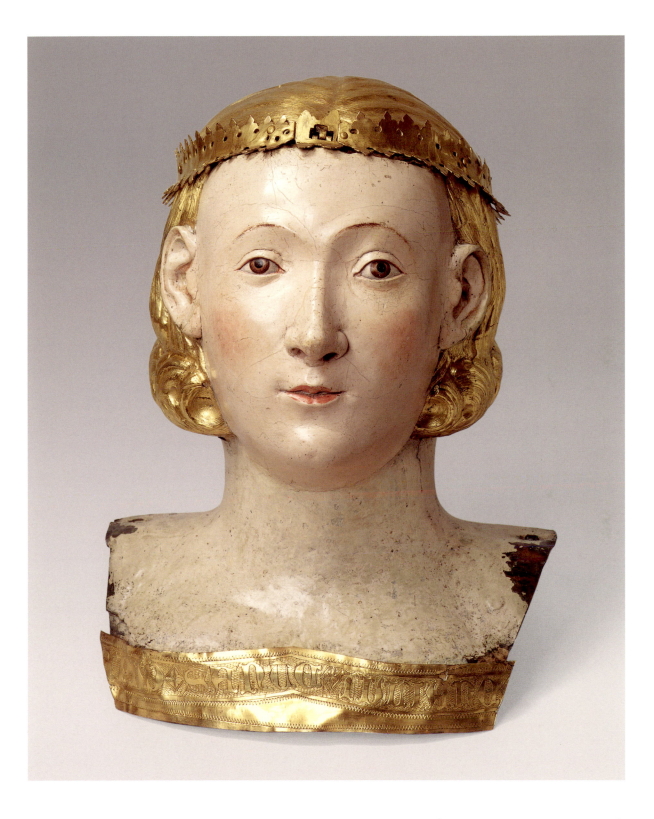

works exceed their common technique; both have similarly wide foreheads with raised, arched brows; long noses ending in full nostrils; full upper lips with a defined philtrum; prominent rounded ears; and full necks. Both are also sister images to Giovanni di Bartolo's (active 1364–1404) lost reliquary busts of Saints Peter and Paul created for Old Saint Peter's in 1369.[4] All employ gesso and paint on the saints' faces to simulate flesh, creating a built-up surface that Thomas Hoving mistakenly attributed to an effort to reshape an earlier, underlying reliquary of distinct provenance. The partial inscriptions at the front and back of the bust naming Juliana, the city of Rome, and the partial name

Fig. 107. Circle of Giovanni di Bartolo. Tabernacle, Convent of Saint Juliana, Perugia, ca. 1376. Copper gilt with translucent enamel. Galleria Nazionale dell'Umbria, Perugia

GUILLE (apparently that of the artist) are characterized by rather crude engraving, but they were described in the mid-nineteenth-century and are thus likely authentic. They are, moreover, similar to the inscription on the mid-fourteenth-century bust of San Nicandro in Venafro.[5] Although the workmanship of the saint's crown is similarly rather unrefined, the girlish beauty of the face and the gilding of the hair create an appealing image of youth.

BDB

NOTES

1. "Hic collocatur capud Giuliane virginis gloriose quod predicators fraters de P[er]us[io] Reverende Matri Ghabrielle Abatisse Mon[asterii] eiusdem virginis et suo cap[itu]lo gratis honoriffice donaveru[n]t cure[n]tibus A[n]nis D. . ." (Herein is contained the head of Saint Juliana, glorious virgin, that the Dominican brothers of Perugia gave, of their own free will and with honor, to the Reverend Mother Gabriella, abbess of the convent, and to her chapter in the year 1376 during the month of August).

2. Ricci 1913.

3. See Santi 1985, p. 172, where, however, he compares the pieces only for technique, not for style.

4. Churchill 1906–7.

5. Cagnola 1915, pp. 43–44.

EX COLLECTION

[Brimo de Laroussilhe, Paris]

LITERATURE

Gnoli 1908, pp. 59–61; Hoving 1963; Santi 1985, pp. 171–73; Boehm 1997

74. Reliquary Bust of Saint Margaret of Antioch

Attributed to Nikolaus Gerhaert von Leiden
(active 1460–ca. 1473)
Franco-Netherlandish, ca. 1465–67
Abbey Church of Saints Peter and Paul, Wissembourg
Walnut with traces of polychromy, H. 20 in. (50.8 cm)
The Art Institute of Chicago; Robert Alexander Waller
Memorial Fund (1943.1001)

75. Reliquary Bust of Saint Catherine of Alexandria

Circle of Nikolaus Gerhaert von Leiden
Franco-Netherlandish, ca. 1465–67
Abbey Church of Saints Peter and Paul, Wissembourg
Polychromed basswood, H. 18 ⅝ in. (47.3 cm)
The Metropolitan Museum of Art, New York; Gift of
J. Pierpont Morgan, 1917 (17.190.1734)

76. Reliquary Bust of Saint Barbara

Circle of Nikolaus Gerhaert von Leiden
Franco-Netherlandish, ca. 1465–67
Abbey Church of Saints Peter and Paul, Wissembourg
Polychromed ash, H. 19⅞ in. (50.5 cm)
The Metropolitan Museum of Art, New York; Gift of
J. Pierpont Morgan, 1917 (17.190.1735)

As an ensemble, these three reliquary busts are a rare example of art historians being able to reunite the scattered elements of a composite work of art. In 1943 Guido Schönberger recognized a bust in the William Randolph Hearst collection, previously described as sixteenth-century Spanish, as one of four such works known from plaster casts in the Musée de l'Oeuvre Notre-Dame, Strasbourg. The four casts—representing Saints Agnes of Rome, Barbara, Catherine of Alexandria, and Margaret of Antioch—were probably made about 1870 and appear in an 1880 inventory of the museum, in which they are identified as having been taken from busts in the Benedictine abbey church of Saints Peter and Paul at Wissembourg (Bas-Rhin), near Strasbourg. Hearst had acquired his bust (Saint Margaret) in 1910 in Paris, but the work had dropped out of sight among his vast holdings and until then no one had connected it to its original location; it was purchased by the Art Institute of Chicago in 1943. Of the three remaining busts, two (Barbara and Catherine) were acquired by J. Pierpont Morgan in 1910 and were given to the Metropolitan Museum in 1917.[1] The Saint Agnes bust has been lost and is known only through the plaster cast.

Aside from the 1880 Strasbourg inventory there is nothing to support the Wissembourg provenance, but it has always been accepted.[2] Nor is it known when the busts were removed from the church of Saints Peter and Paul, although the bust of Saint Margaret was on the market in Paris by 1894.[3] Given the apparent destruction of their original context, it can only be surmised that the four saints were once placed on the high altar of the church, perhaps in niches around a central composition, to form either part of a predella or the main body of the altarpiece itself. A similar arrangement—no doubt influenced by the Wissembourg altar and by other contemporary examples from the 1460s through the 1480s—can be seen in the high altar of the church of Saint Kilian at Heilbronn, which was carved by Hans Syfer (active 1480s, d. 1509) and his workshop in 1498, and in the high altar of the cathedral parish church of Lorch,

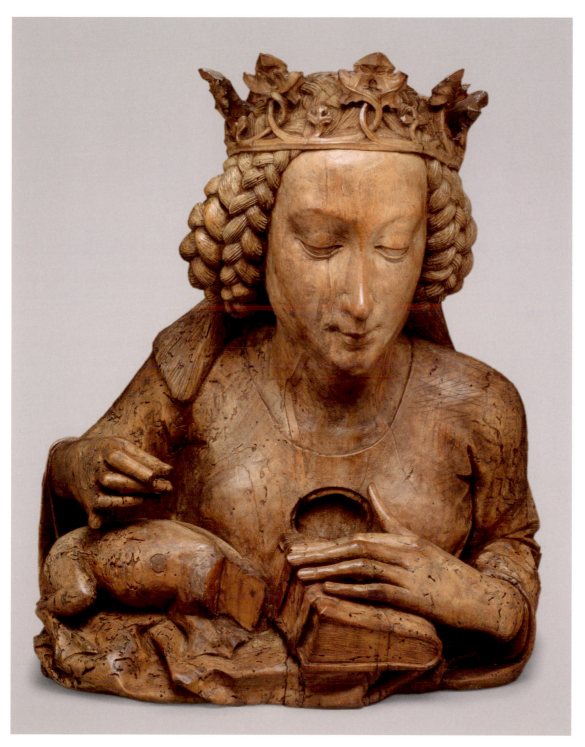

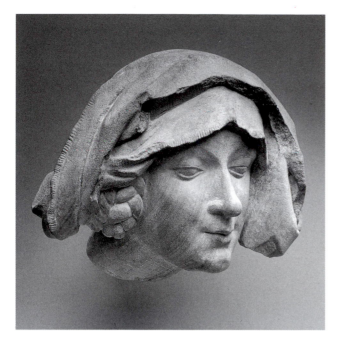

Fig. 108. Nikolaus Gerhaert von Leiden (active 1460–ca. 1473). Head of a Sibyl, portal of New Chancellery (destroyed), Strasbourg, 1462–63. Liebieghaus, Frankfurt am Main

executed in 1483.[4] In the former, there are four busts of male saints in the predella and two busts of female saints in the upper register.[5] In neither of these altarpieces were the busts used as reliquaries, however, whereas all four Wissembourg figures have recesses in the chest that presumably held relics. Considering the placement of the Heilbronn busts, it is perhaps significant that Saints Barbara and Catherine are clearly meant to be seen at eye level, while the other two saints were composed to be viewed from below.

As reliquary busts, the four examples from Wissembourg represent something of an innovation: a departure from the conventional hieratic, frontal pose toward a more active, naturalistic manner that utilizes the *bust accoudé* form already established in the famous sculptures of the palace of Jacques Coeur in Bourges (1443–51).[6] This morphological lineage also includes the portal of the New Chancellery in Strasbourg (1462–63). Although the portal no longer exists, its appearance is known, and several fragments of its sculptural decoration survive, notably, for our purposes, the head of a sibyl now in the Liebieghaus, Museum Alter Plastik, Frankfurt am Main (fig. 108).[7] Indeed, the resemblance between this head and the bust of Saint Margaret is so close, one must seriously consider the possibility that they are by the same artist. In the case of the sibyl, we know from documents related to the Strasbourg portal that this was Nikolaus Gerhaert von Leiden (active 1460–ca. 1473), one of the most significant and original sculptors of his day.

Little is known about Nikolaus Gerhaert, and much of his most important sculpture is lost, but those works that still exist situate him squarely in the tradition of the great Netherlandish sculptor Claus Sluter (ca. 1360–before 1406) and, more generally, Franco-Netherlandish sculpture from the first half of the fifteenth century. His birth date is unknown, but we presume from his signature that he had a close connection with the town of Leiden. He is first documented in 1462 by his signature on the tomb of Archbishop Jakob von Sierck in Trier; in 1463 he was in Strasbourg and was invited to Vienna by Emperor Frederick III; in 1464 he was granted citizenship in Strasbourg, where he carved the New Chancellery portal; and from 1465 to 1467 he worked at the cathedral of Constance, where he carved the wood high altar. The loss of that altar has deprived us of a key monument in the reconstruction of Gerhaert's development, since none of his surviving documented work is in wood. From 1467 until his death in Wiener Neustadt in 1473, Gerhaert carved a crucifix in the Stiftskirche Baden-Baden (1467), worked on a tomb for Frederick III in either Vienna or Wiener Neustadt (1469), and bought a vineyard in the latter town (1472). In addition to the documented works, he signed and dated (1464) an epitaph for a priest, probably Conrad von Busnang, that is now in the Musée de l'Oeuvre Notre-Dame, Strasbourg. Several other works in wood and stone are attributed to him or to his immediate workshop.[8]

With its extraordinary individuality and subtlety, the Strasbourg head of a sibyl establishes Gerhaert's commanding position in the development of sculpture in the second half of the fifteenth century, and it serves as a stylistic touchstone for the attribution of similar works. To varying degrees, the reliquary busts from Wissembourg share a number of facial characteristics with the Strasbourg head, whose most distinctive features include its long, oval shape that ends in a round, prominent chin with a dimple; heavy lidded eyes; a thin, sharply pointed nose; and a small, pinched mouth animated by a faint, mysterious smile. Among the four Wissembourg busts, that of Saint Margaret is clearly the closest in terms of style and quality to the Strasbourg sibyl, and it possesses almost all of the same physical characteristics. The very slight differences in the handling of such details as the modeling of the eyes, nose, and mouth have caused some scholars to assign the Saint Margaret to the hand of a close follower of Gerhaert, but it bears remembering that the master did not limit himself to one facial type. In the Madonna from the epitaph for Canon Busnang, the mourning Virgin from the high altar of the church of Saint George in Nördlingen, and the so-called Dangolsheim Madonna and Child (Bodemuseum, Staatliche Museen zu Berlin)—which may be by either Gerhaert or an immediate follower—a recognizable type is established, but with variations that underscore Gerhaert's inventiveness. Similar variations are certainly found in the Wissembourg busts, but the regrettable loss of comparative material makes it difficult to attribute to Gerhaert the busts of Saints Barbara, Catherine, and Agnes, despite their undoubted quality. In

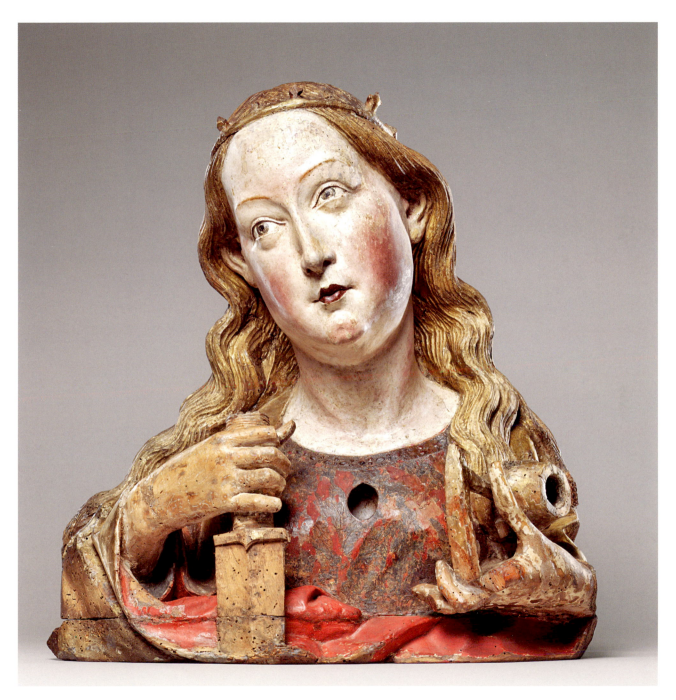

75

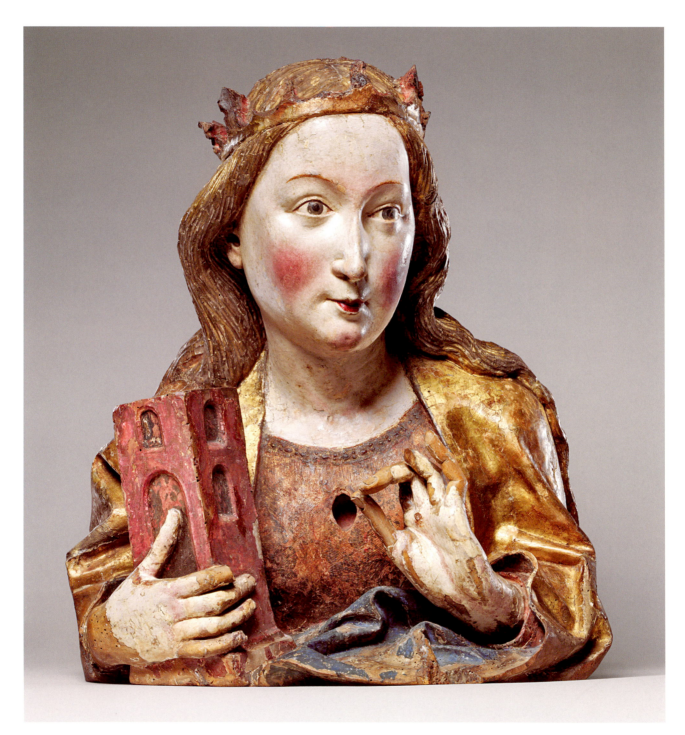

76

the final analysis, it is probable that there are different hands at work.

Although there is no historical evidence to prove the existence of any of these four saints, their legends and identities grew to become among the most venerated of the Middle Ages, largely because of their inclusion in the thirteenth-century *Golden Legend* of Jacobus da Varagine.[9] In Germany, three of them (Margaret, Barbara, and Catherine) number among the Fourteen Helpers in Need and the Four Chief Virgins.

The legend of Saint Margaret relates how she was converted to Christianity at the age of fifteen and was subsequently imprisoned, where she underwent a series of tortures and temptations, including combat against Satan in the form of a dragon. In some versions of the story the beast swallows her, but upon making the sign of the cross she bursts from its belly. She is ultimately decapitated, but in her last prayer she beseeches the Lord to allow pregnant women to call upon her help in their delivery. This power is the chief source of her popularity, but she was also invoked against tempests. The Chicago bust shows her with her attribute, a small dragon, whose head was stolen in 1951.

Saint Catherine is shown holding a sword and a broken wheel, both of them instruments of her martyrdom, which occurred when she refused to marry the emperor Maxentius by claiming she was a bride of Christ. Catherine was endowed with extraordinary intelligence; at one point she defeated in debate fifty learned doctors. In the Middle Ages, she was called upon as an intercessor with Christ and as a protector of the dying and those in danger. Her many virtues and talents made her the object of widespread devotion.

Saint Barbara, having been converted to Christianity, was imprisoned by her protesting father in a tower, from which she eventually escaped only to be recaptured, tortured, and finally beheaded. An Eastern saint, Barbara's popularity in the West began to grow only in the fifteenth century. She provided protection against lightning and sudden death (her father was killed by a bolt immediately following her execution) and was the patron saint of many corporations and professions, especially those concerned with artillery, mining, bell ringers, prisoners, and architects and masons. Here she is shown with her attribute, the tower in which she was originally imprisoned.

The fourth, and missing, member of this holy quartet, Saint Agnes, was venerated for her purity and chastity. Having refused to worship the ancient gods, she survived various attempts at execution before having her throat cut. She was the patron saint of the betrothed and gardeners, the latter because of her virginity, as often represented by the *hortus conclusus*. In the plaster cast of the lost bust she is depicted holding a lamb, which is not only a symbol of Christ, the Lamb of God (*agnus dei*), but also a play on her name and a reference to her purity.

SKS

NOTES

1. The Art Institute files do not indicate from whom Hearst acquired the bust, whereas the files for the Metropolitan Museum busts indicate that Morgan purchased his busts from Cyrus Picard, Paris, May 6, 1910.

2. The most complete study of the busts, with a full review of past scholarship and a complete bibliography to 1986, may be found in Rosenfeld 1986. Subsequent bibliography may be found in the Literature section of this entry.

3. Molinier 1894, probably no. 71.

4. Tiemann 1930, pls. 12, 15; Rosenfeld 1986, figs. 197, 198.

5. Schnellbach 1931, figs. 1, 12, 13; Rosenfeld 1986, figs. 185–190.

6. Favière 1992, pp. 70–71, figs. 36, 37.

7. I.N.St.P. 353; Beck 1980, pp. 206–10, fig. 143. See also Recht 1987, pls. I.1, I.3, I.6, I.9. It should be noted that this head and its companion, the head of a prophet in the Musée de l'Oeuvre Notre-Dame, Strasbourg, are all that remain of a more complete ensemble that survived the destruction by fire of the chancellery in 1686. The busts were transported to the local library, which was destroyed in 1870, at which time the busts were lost. The bust of the prophet was rediscovered in 1915, when it was given to the Frauenhaus-Museum, Strasbourg. The bust of the sibyl was found in 1933 and eventually arrived at the Liebieghaus in 1935 in its present fragmented form. The original pieces in bust form survive in plaster casts made before 1870 and are now preserved in the Musée de l'Oeuvre Notre-Dame, Strasbourg.

8. For a complete and up-to-date bibliography on Nikolaus Gerhaert, see Schreiber 2004. I am indebted to Charles T. Little for this reference.

9. Jacobus da Varagine 1993.

EX COLLECTIONS

Cat. no. 74: Gavet Collection, Paris, 1894; Doistau Collection, Paris, 1909; William Randolph Hearst, 1910; [Gimbel Brothers, New York, 1943].
Cat. nos. 75 and 76: [Cyrus Picard, Paris, until 1910]; J. Pierpont Morgan, London and New York

LITERATURE

Rosenfeld 1986; Recht 1987, pp. 149–50, 344, figs. 32, 34; Rosenfeld 1995, fig. 1; Gillerman 2001, pp. 28–31 (entry by Stephen K. Scher); Chicago 2004–5, pp. 64 (ill.), 81–82

77. Reliquary Bust of Saint Balbina

South Lowlands, Brussels (?), ca. 1520–30
Painted and gilded oak, H. 17 ½ in. (44.5 cm)
The Metropolitan Museum of Art, New York; Bequest of
Susan Vanderpoel Clark, 1967 (67.155.23)

78. Reliquary Bust of a Companion of Saint Ursula

South Lowlands, Brussels (?), ca. 1520–30
Painted and gilded oak, H. 17 ⅞ in. (45.4 cm)
The Metropolitan Museum of Art, New York; Gift of
J. Pierpont Morgan, 1917 (17.190.728)

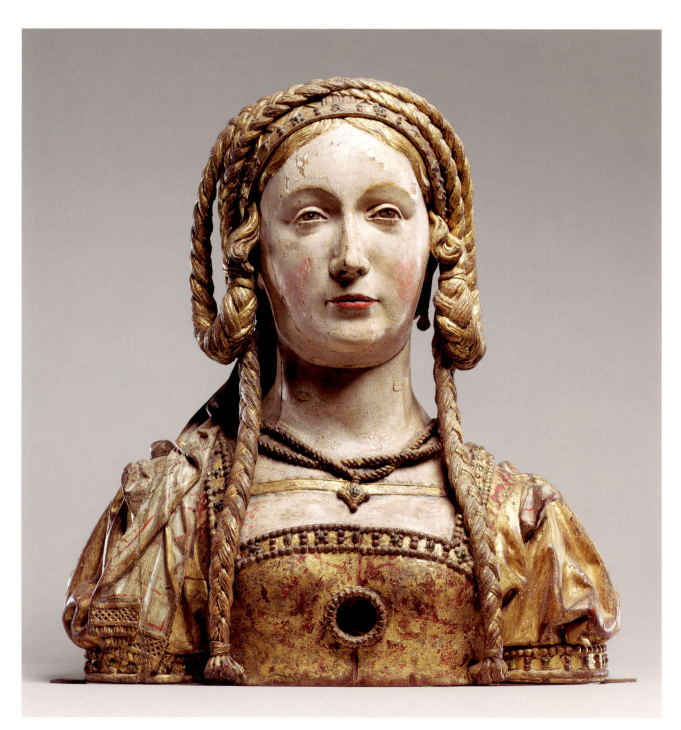

The legend of Saint Ursula, elaborated over the course of several centuries, found its final form by about A.D. 1000. The narrative tells how Ursula, a Christian British princess, was promised in marriage to a pagan prince. As a precondition to the nuptials, she required her fiancé to study Christianity over a period of three years and, in the meantime, to provide her with ships so that she could go on a pilgrimage with her companions. The maidens traveled up the Rhine as far as Basel, then overland to Rome, but on their return voyage they were murdered at Cologne by the Huns. Ursula and her companions later appeared to the Huns in a ghostly vision as armed warriors, causing them to flee in terror.

In 1106 a large cemetery believed to contain the relics of the famous virgins was discovered in Cologne, and their veneration subsequently became a pan-European phenomenon. Given the number of relics unearthed, reliquary busts of the companions of Saint Ursula are, understandably, among the most ubiquitous of the genre. In addition to the extraordinary concentration of painted wood busts in the Golden Room of the church of Saint Ursula in Cologne,

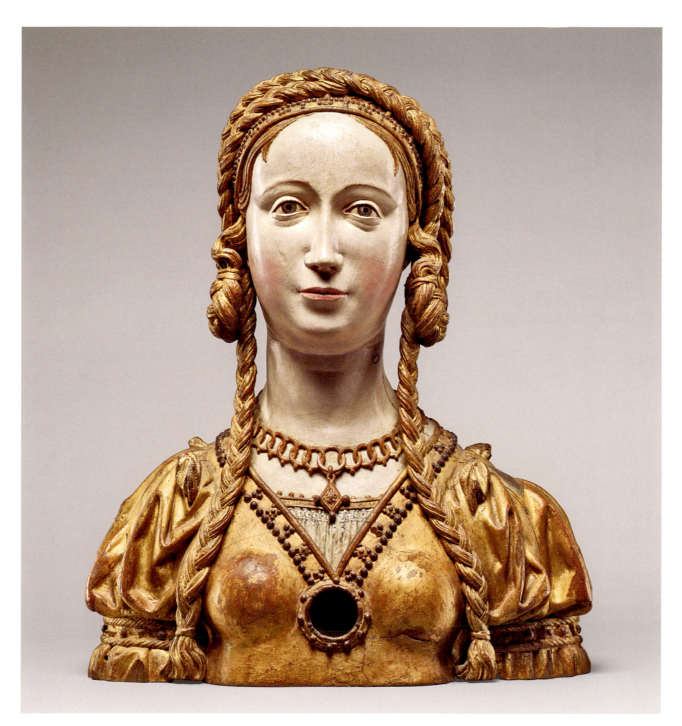

Fig. 109. *High Altar, Church of Our Savior, Ubeda (Jaén), ca. 1531*

Fig. 110. *Reliquary Bust of Saint Balbina (cat. no. 77) showing hinged door at crown of head used to expose relic*

Additional examples of Ursuline reliquary busts are preserved in the Los Angeles County Museum; Hearst Castle, San Simeon, California; and the Isabella Stewart Gardner Museum, Boston. Closely related examples are inserted into niches of the high altar of the Andalusian church of the Savior in Ubeda (Jaén) (fig. 109).[2] Those busts are linked to the patronage of Francisco de los Cobos, secretary of state under Emperor Charles V, whose palace in Ubeda dates to 1531.[3] Examples from another ensemble are preserved in the Museo Diocesano, Vitoria (Alava); the Museo de los Caminos, Astorga (León); and in the cathedral of Avila.[4] All are said to reflect a tradition among members of Charles V's court to acquire such busts in the Netherlandish territories.[5] Comparisons to full-scale figures, such as the Saint Barbara in the church of the Rich Clares in Brussels,[6] attest to the Netherlandish style of the busts.

BDB

NOTES

1. Holladay 1997.

2. See Molina Hipólito 1962, pp. 18–21. Brussels 1985, vol. 2, C36–40, asserts that two of the New York examples come from Ubeda, but there does not appear to be a place for them in the niches of the altar.

3. See the UNESCO report on Ubeda: *http://whc.unesco.org/archive/advisory_body_evaluation/522rev.pdf.*

4. Brussels 1985, vol. 2, pp. 518–20.

5. Ibid.

6. Borchgrave d'Altena 1944, pl. LXXXVIII; Krohm 1976.

EX COLLECTIONS

Cat. no. 77: Louis Mohl, Paris, sold 1912; Susan Vanderpoel Clark, New York. *Cat. no. 78:* [Bourgeois Frères, Cologne]; Baron Albert Oppenheim, Cologne, sold 1904; [Jacques Seligmann, Paris]; J. Pierpont Morgan, London and New York

LITERATURE

Metropolitan Museum, *Notable Acquisitions 1975–1979*, p. 26; Krohm 1976, pp. 32–33; Brussels 1985, vol. 2, C36–40; Wixom 1988–89, pp. 40–41

Ursuline reliquaries survive in an exceptionally wide variety of materials, dates, and provenances. While those produced for Cologne itself may have been intended to encourage the vocation of nuns drawn from affluent local families,[1] many Ursuline reliquary busts were often specifically associated with political gifts, a tradition that proved to be long lived.

The Metropolitan Museum owns four of these reliquary busts, all apparently from the same original context; two are included here. They are constructed from two wood halves joined along a vertical seam to form a tight shell around the saint's skull. The lavish gowns, simulated jewels, and elaborate coiffures mimic aristocratic high fashion of the early sixteenth century and, in so doing, evoke the social status of the legendary eleven thousand maidens martyred with the saint. A hinged door at the crown of the head of catalogue number 77 can still be opened to expose the relic (fig. 110), along with a tag identifying it, unexpectedly, as the skull of Saint Balbina, an early virgin martyr of Rome, not a companion of Saint Ursula.

79. Head of Saint John the Baptist on a Charger

Germany, Munich, ca. 1330
Polychromed sandstone, Diam. 18⅛ in. (46 cm)
Bayerisches Nationalmuseum, Munich; Gift of the Munich Master Stonemason Georg Westermeier in 1869 (MA976)

In terms of visual power and visceral presence, few sculptures from the Middle Ages can compare to this astonishingly naturalistic, beautifully conceived and carved head of Saint John the Baptist. Although the origin of the work is unknown, stylistically related sculptures in Munich's Frauenkirche—such as the potent image of the Man of Sorrows (fig. 111)—suggest the head came from that vicinity. The Baptist's face is handsome and youthful, with alert, open eyes and a remarkable flair of beard and hair. The strands of hair are formed into long elastic locks that radiate out from the head and attach to the edge of the charger; some of these are now broken off. The severed neck is not depicted in a gruesome manner, contributing to the image's overall aesthetic appeal.[1]

The original placement of this curious work is an open question. As a devotional object, it could have been intended

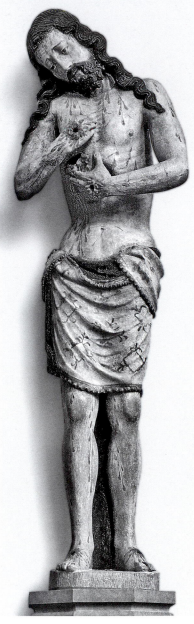

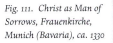
Fig. 111. Christ as Man of Sorrows, Frauenkirche, Munich (Bavaria), ca. 1330

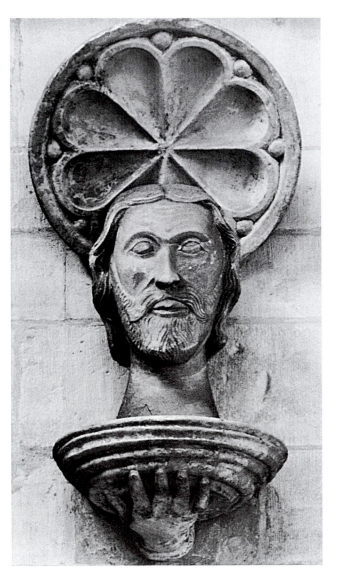

Fig. 112. Head of Saint John the Baptist on a Charger, Münster Cathedral (Westphalia), late 13th century

to be placed on an altar, as seen in a 1511 painted altar in Gutenstetten (Mittelfranken) by Erhard Altdorfer (1511), which depicts the Veneration of Saint John's Head.[2] Yet its size and weight suggest it might also have been integrated within an architectural setting, as seen, for example, in the thirteenth-century cathedral in Münster (Westphalia), where, over an arch by the north transept, there is an over-lifesize, upright stone head of the Baptist on a charger held by a hand emerging from the wall (fig. 112).[3]

The biblical story of Salome asking King Herod for the head of John the Baptist to be brought to her "in a dish" is told within the broader Gospel narrative of John's life (Matthew 14:1–12). The head of the Baptist became an object

of devotion, and the reputed charger upon which it was placed became one of the principal relics in the treasury of Genoa Cathedral.[4] The cult of the head of John the Baptist seems to have been already established in France by about 1120, when Guibert, abbot of Nogent, stated that the head was claimed by the church at Saint-Jean-d'Angély (Charente-Maritime), Constantinople, and San Silvestro in Capite, Rome.[5] But it was the arrival in Amiens (Picardy) of what was thought to be the genuine relic of the head of John the Baptist in 1206, following the Fourth Crusade, that truly launched the cult in the West.[6] It gained widespread devotion throughout Europe, and more than a dozen relic heads of the saint were recorded. The curative and protective pow-

ers of the head and its developing cult were partly linked to the head's reputed ability to cure epilepsy, known as "le mal de Saint-Jean." Other maladies supposedly eased by the various heads include melancholy and headaches. Sufferers of the latter would simply place their hat on the saint's head to invoke his intercession and healing power.[7]

The devotion to the head of John the Baptist became especially widespread by the fourteenth century, when numerous examples were carved in wood, stone, and precious metals (see cat. no. 80). In Germany, especially in Westphalia and Bavaria, there are many intriguing examples in situ and in local museums, some of which are characterized by an extreme realism. In those pieces, the severed neck is sometimes revealed, the eyes are open, and the mouth is agape, as if the head were about to speak (fig. 113).[8]

The head of the Baptist also had Eucharistic significance, since he foretold the Crucifixion, and his sacrificial nature was often represented theologically and visually with the evocative image of a Lamb resting on a Eucharistic plate. This meaning was explicit in liturgy by the fifteenth century, as expressed in the Mass for the Decollation of Saint John (August 29): "Saint John on the dish signifies the body of Christ which feeds us on the holy altar."[9]

CTL

NOTES

1. The traces of polychromy are of an uncertain date.

2. Stuebe 1968–69, fig. 3.

3. Arndt and Kroos 1969, pp. 287–89, 271, fig. 36.

4. See Cherry 1999; Di Fabio 1991, pp. 254–61.

5. Cherry 1999, p. 143.

6. See Brooks 1990, pp. 96V.

7. Andree 1904, p. 146; Witte 1912, pl. 52, no. 4; Stuebe 1968–69, p. 3.

8. See the comprehensive study in Arndt and Kroos 1969.

9. Lawley 1880–83, vol. 2, col. 517; see also Stuebe 1968–69, esp. pp. 6–7.

EX COLLECTION

Georg Westermeier, Munich, by 1869

LITERATURE

Halm and Lill 1924, no. 274; Arndt and Kroos 1969, pp. 287–89; Eikelmann 2000, p. 34 (ill.)

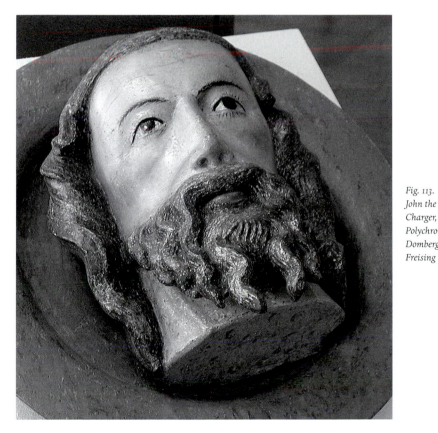

Fig. 113. Head of Saint John the Baptist on a Charger, 14th century. Polychromed wood. Dombergmuseum, Freising

80. Plaque with the Head of Saint John the Baptist on a Charger

England, Nottingham (?), 15th century
Alabaster with original polychromy, H. 8¼ in. (21 cm)
Inscribed around nimbus: CAPUT...IOHANNIS BAPTISTE
The Metropolitan Museum of Art, New York; Rogers Fund,
1913 (13.124)

Alabaster panels carved with the image of John the Baptist's head were especially widespread in England, where they functioned primarily as domestic devotional objects. The numerous household inventories that mention such images indicate that many were placed in the parlor and were draped, to be unveiled only at the proper moment for contemplation and veneration. The relatively small size and shallow carving of this relief suggest that it was placed in a shrine, which would explain the relatively fine condition of the polychromy. No doubt it was also kept in a frame with folding shutters, similar to a complete mid-fifteenth-century example in the Burrell collection, Glasgow (fig. 114).[1] Such plaques were the special domain of alabaster workers in the Nottingham area, and many of them were produced by a single workshop in Nottingham that continued operations until the early sixteenth century. First documented in England in 1432, when Isabella

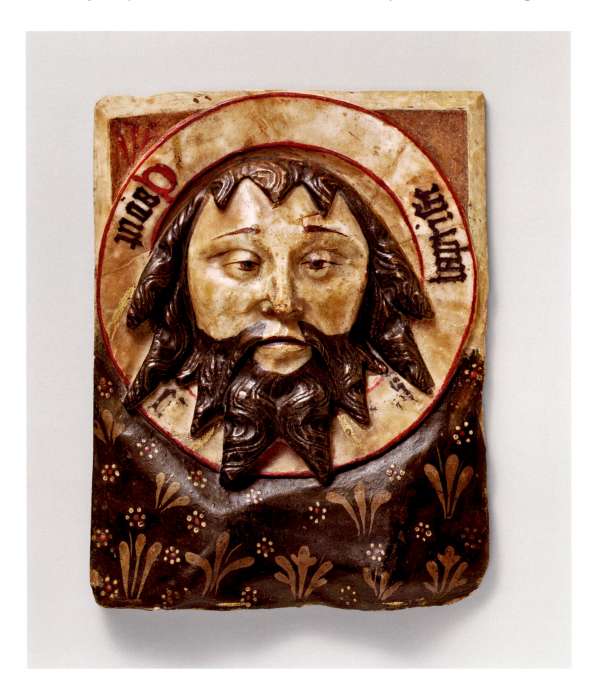

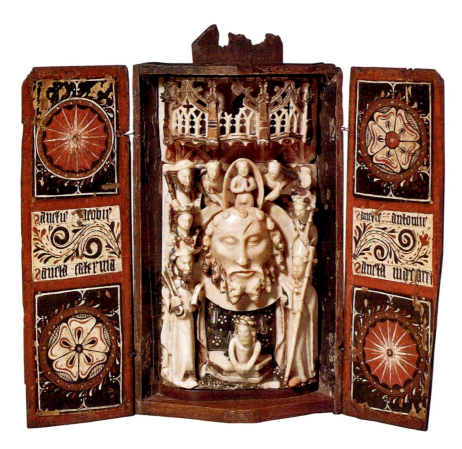

Hamerton of York left one in her will, they were ascribed curative and protective powers against epilepsy, convulsions, and other similar disorders (see cat. no. 79).[2]

As the precursor of Christ, John the Baptist was often linked to him in the liturgy and in the Eucharist. Heads such as this one were the subject of special veneration during the celebration of the Decollation of John the Baptist, on August 29, when they were displayed with wounds on the face recalling the wounds of Christ. The lost "true" relic of the head of John the Baptist at Amiens Cathedral, which came to France in the wake of the Fourth Crusade (1202–4), is richly described in several church inventories and in early engravings. A curious detail found on that celebrated relic and on the present head is the cut above the saint's left eye, a direct visual reference to the apocryphal story (based on Matthew 14 and Mark 6) in which Herodias, Herod's brother's wife, strikes John with a knife.

CTL

NOTES

1. See Leeds 2002–3, p. 36, fig. 9.

2. Hope 1890; Cheetham 1984, p. 322, no. 246. See also Réau 1955–59, vol. 2, pt. 1, p. 437.

EX COLLECTION

[Partridge, London]

LITERATURE

Hildburgh 1928, pp. 62–63, pl. XVII, fig. 2; Hildburgh 1933, p. 143 n. 63; Tavender 1946, pp. 126, 137, fig. 1; Cheetham 1984, p. 317

81. Saint Firmin Holding His Head

France, Amiens (Somme), second or third quarter
of the 13th century
Limestone with polychromy, H. 43½ in. (110.5 cm)
The Metropolitan Museum of Art, New York; Gift of
Mr. and Mrs. Frederic B. Pratt, 1936 (36.81)

This three-quarter-lifesize statue of a martyred bishop holding his own decapitated head—dead but seemingly alive—may strike some as either macabre or morbid. The martyr in this case is Saint Firmin, patron saint of Amiens and its first bishop, and the statue can almost certainly be assigned to that center. Martyred in the fourth century, the bishop was probably a missionary. Over his tomb, a later bishop of Amiens named Saint Firmin the Confessor built a church for his namesake, whose feast day is September 25. The image of Saint Firmin bearing his own head pays homage to Saint Denis—who was martyred in a similar manner and who is also represented holding his own head—enriching the meaning of both the local patron saint and the patron saint of France.

The surface of the statue is covered with multiple layers of polychromy and gilding, both of uncertain date. The bishop's vestments include a pallium (the cloth representing his episcopal authority) worn over a dalmatic, not the more typical chasuble with amice, and an alb showing the ends of the stole beneath it. A maniple hangs from his left forearm, and in the crux of his right arm he holds a crozier, now damaged. The saint's miter is of a type worn in the thirteenth and fourteenth centuries. The cylindrical forms of the vestment drapery, the thin folds across the front, and the articulation of the head with soft, tight curls of hair together suggest a date in the second or third quarter of the thirteenth century. The style of the figure also bears some resemblance to the sculpture on the south transept portal of Amiens Cathedral dedicated to Saint Honoratus, which might imply a close affiliation with the cathedral.

The Parisian dealer Henri Daguerre, who sold the work to the American collector Frederic B. Pratt in 1910, claimed the statue was "said to have come from the destroyed bishop's palace in Amiens." Little is known of this medieval structure, which was mostly demolished in 1755. According to a ground plan made about the time of the palace's destruction, the chapel, which was rebuilt, could be dated to the thirteenth century, but in the early nineteenth century it, too, was destroyed. The chapel was originally dedicated to Saint Vincent; it is not known whether it was decorated with sculpture.[1]

The image of Saint Firmin is ubiquitous in Amiens, and many medieval sculptures of the saint are known to have existed in the cathedral. A chapel beneath the choir screen was dedicated to the saint and contained a sculpted image of him. Additional sculptures of Saint Firmin (now lost) were found in the cathedral cloister and in other local churches dedicated to him,[2] including several in the vicinity of the cathedral: Saint-Firmin-en-Castillon (demolished 1805), Saint-Firmin-à-la-Porte, Saint-Firmin-à-la-Pierre, and Saint-Firmin-au-Val (destroyed during the French Revolution), any one of which could have been the statue's original location.[3]

Immediately adjacent to the bishop's palace was a church dedicated to Saint Firmin the Confessor: a "little sister" to the cathedral that was under construction in 1247, the same period when the cathedral's facade was erected. Louis Duthoit's eighteenth-century drawings of the elegant structure reveal nothing of the church's decoration,[4] but apparently in the early nineteenth century there was a sculpture of the bishop holding his head still extant on the trumeau of the portal.[5] Whether this refers to the present figure is unclear, but the possibility that the image of the patron saint was saved at the time of the church's destruction and then found its way to the new bishop's palace, built in the nineteenth century, cannot be excluded.

The Amiens provenance of the statue is supported by neutron activation analysis (NAA) of the limestone, whose composition corresponds to that of the stone source used for the cathedral's west facade (see also cat. no. 24). In fact, the sculptural decoration of Amiens Cathedral is quite homogeneous in terms of stone source,[6] virtually assuring that this work originated in Amiens.

CTL

NOTES

1. Foucart 1980, pp. 301–10 and plan p. 309 (reference courtesy of Thierry Crépin-Leblond).

2. See, for example, Corblet 1868–75, vol. 2, pp. 184–85. For an account of images of Saint Firmin in Amiens, see Salmon 1861, pp. 363–81.

3. Calland and Dubois 1884, p. 138; Nodier et al. 1835.

4. See Murray 1996, p. 141.

5. Gilbert 1833, p. 80.

6. See Little 1999, fig. 3.

EX COLLECTIONS

[Brauer, Paris]; [Henri Daguerre, Paris]; Frederic B. Pratt, New York, 1910

LITERATURE

Rorimer 1936, pp. 198–200; Little 1999

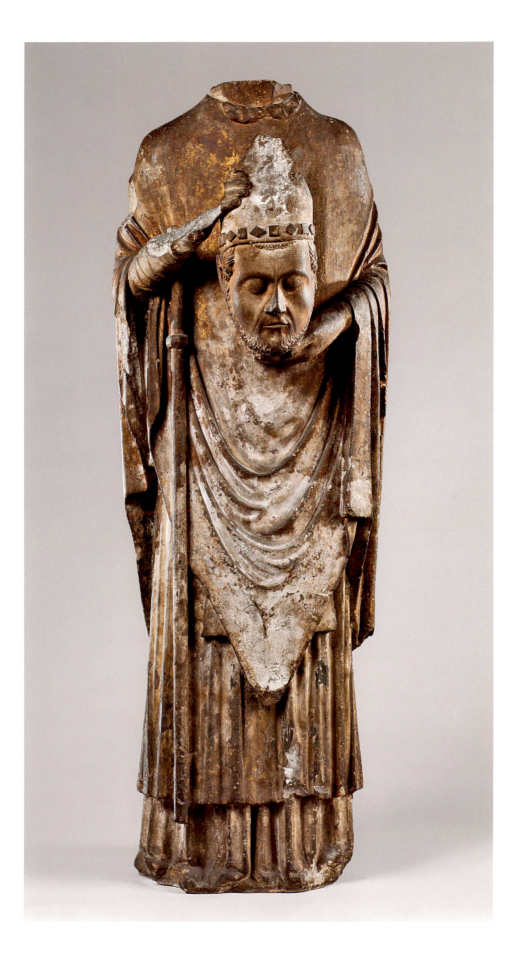

Bibliography

Abulafia 1988. David Abulafia. *Frederick II: A Medieval Emperor.* Oxford, 1988. Reprint, London, 1992.

Adams 1913. Henry Adams. *Mont-Saint-Michel and Chartres.* London, 1913. Reprint, Princeton, 1981.

Adhémar and Dordor 1974–77. Jean Adhémar and Gertrude Dordor. "Les tombeaux de la collection Gaignières: Dessins d'archéologie du XVIIe siècle." *Gazette des Beaux-Arts* 84 (1974), pp. 1–192; 88 (1976), pp. 1–128; 90 (1977), pp. 1–76.

Aldhouse-Green 1999. Miranda J. Aldhouse-Green. *Pilgrims in Stone: Stone Images from the Gallo-Roman Sanctuary of Fontes Sequanae.* Oxford, 1999.

Alföldi 1935. Andreas Alföldi. *Insignien und Tracht der Römischen Kaiser.* Munich, 1935.

Alföldi-Rosenbaum 1968. Elisabeth Alföldi-Rosenbaum. "Portrait Bust of a Young Lady of the Time of Justinian." *Metropolitan Museum Journal* 1 (1968), pp. 19–40.

Alföldi-Rosenbaum 1972. Elisabeth Alföldi-Rosenbaum. "Bemerkungen zur Porträtbüste einer jungen Dame justinianischer Zeit im Metropolitan Museum." *Jahrbuch für Antike und Christentum* 15 (1972), pp. 174–78.

Alföldi-Rosenbaum 1996. Elisabeth Alföldi-Rosenbaum. "Women's Mantles with Decorated Borders." In *Festschrift für Jenö Fitz*, edited by Gyula Fülöp, pp. 105–16. Székesfehérvár, 1996.

Ames-Lewis 1997. Francis Ames-Lewis. *Tuscan Marble Carving, 1250–1350: Sculpture and Civic Pride.* Aldershot, 1997.

Amsterdam–Utrecht 2000–2001. *The Way to Heaven: Relic Veneration in the Middle Ages.* Exh. cat. by Henk van Os et al. Amsterdam, Nieuwe Kerk, and Utrecht, Museum Catharijneconvent, December 16, 2000–April 22, 2001. Baarn, 2000.

Anderson 1990. William Anderson. *Green Man: The Archetype of Our Oneness with the Earth.* London, 1990.

Anderson 1995. William Anderson. "The Green Man and the Goddess: Exploration of a Living Myth." *Orion* (Summer 1995), pp. 7–15.

Andrault-Schmitt 2001. Claude Andrault-Schmitt. "Le 'cavalier Constantin': Une image polysémique de Rome dans l'Aquitaine du XIIe siècle." *Méditerranées: Revue de l'Association Méditerranées* 28 (2001), pp. 129–53.

Andree 1904. Richard Andree. *Votive und Weihegaben des katholischen Volks in Süddeutschland.* Braunschweig, 1904.

Angevin 1998. *L'État Angevin: Pouvoir, culture et société entre XIIIe et XIVe siècle.* Rome, 1998.

Arndt and Kroos 1969. Hella Arndt and Renate Kroos. "Zur Ikonographie der Johannesschüssel." *Aachener Kunstblätter* 38 (1969), pp. 243–328.

Aubert 1932–33. Marcel Aubert. Entry in *Bulletin Archéologique du Comité des Travaux Historiques et Scientifiques* (1932–33), p. 290.

Aubert and Beaulieu 1950. Marcel Aubert and Michèle Beaulieu. *Description raisonnée des sculptures du Moyen Âge, de la Renaissance et des temps modernes,* vol. 1, *Moyen Âge.* Paris, 1950.

Avery 1936. Myrtilla Avery. *The Exultet Rolls of South Italy.* 2 vols. Princeton, 1936.

Bailly 1960. Jean Bailly. "Le Collège apostolique de l'abbaye de Jumièges." *Revue des Sociétés Savantes de Haute-Normandie* 18 (1960), pp. 29–42.

Baker 1929. C. H. Collins Baker. *Catalogue of the Pictures at Hampton Court.* Glasgow, 1929.

Bakhtin 1984. Mikhael Bakhtin. *Rabelais and His World.* Bloomington, 1984.

Baltimore 1947. *Early Christian and Byzantine Art.* Exh. cat. Edited by Dorothy Miner. Baltimore Museum of Art, April 25–June 22, 1947. Baltimore, 1947.

Barbier de Montault 1892. Xavier Barbier de Montault. "Le trésor de l'église paroissiale de Saint-Yrieix (Haute-Vienne)." *Bulletin de la Société Scientifique, Historique et Archéologique de la Corrèze* 14 (1892), pp. 99–138.

Bari 1994. *Confraternite, arte e devozione in Puglia dal Quattrocento al Settecento.* Exh. cat. Edited by Clara Gelao. Bari, Pinacoteca Provinciale, October 9–November 27, 1994. Naples, 1994.

Bari 1995. *Federico II: Immagine e potere.* Exh. cat. Edited by Maria Stella Calò Mariani and Raffaela Cassano. Bari, Castello Svevo, February 4–April 17, 1995. Venice, 1995.

Barnet 1999. Peter Barnet. "Recent Acquisitions: A Selection: 1998–1999." *Metropolitan Museum of Art Bulletin* 57 (Fall 1999), p. 16.

Barnet 2005. Peter Barnet. "Head." *Metropolitan Museum of Art Bulletin* 63 (Fall 2005), p. 12.

Baron 1975. Françoise Baron. "Le décor sculpté et peint de l'hôpital Saint-Jacques-aux-Pèlerins." *Bulletin Monumental* 133, no. 1 (1975), pp. 29–72.

Baron 1996. Françoise Baron. *Sculpture française. I, Moyen Âge / Musée du Louvre, Département des Sculptures du Moyen Âge, de la Renaissance et des Temps Modernes.* Paris, 1996.

Baron 2001. Françoise Baron. "La statuaire mariale dans le Département de l'Oise à la fin du XIIe au XIVe siècle." In *L'art gothique dans l'Oise et ses environs (Actes du Colloque organisé à Beauvais par le GEMOB les 10 et 11 octobre 1998)*, pp. 191–206. Beauvais, 2001.

Bartalini 2000. Roberto Bartalini. "Una nuova opera di Giovanni Pisano: Il 'San Pietro' di Gallico." *Prospettiva* 100 (2000), pp. 19–26.

Bartra 1994. Roger Bartra. *Wild Men in the Looking Glass: The Mythic Origins of European Otherness.* Ann Arbor, 1994.

Basford 1978. Kathleen Basford. *The Green Man.* Ipswich, 1978.

Beaulieu and Baylé 1956. Michèle Beaulieu and Jeanne Baylé. *Le costume en Bourgogne: De Philippe le Hardi à la mort de Charles le Téméraire, 1364–1477.* Paris, 1956.

Beaulieu and Beyer 1992. Michèle Beaulieu and Victor Beyer. *Diction-naire des sculpteurs français du Moyen Âge.* Paris, 1992.

Beck 1980. Herbert Beck. *Liebieghaus, Museum Alter Plastik: Guide to the Collection. Mediaeval Sculpture I.* Frankfurt am Main, 1980.

Bedos-Rezak and Iogna-Prat 2005. Brigitte Bedos-Rezak and Dominique Iogna-Prat, eds. *L'individu au Moyen Âge: Individuation et individualisation avant la modernité.* Paris, 2005.

Benton 2004. Janetta Rebold Benton. *Medieval Mischief: Wit and Humour in the Art of the Middle Ages.* Stroud, Gloucestershire, 2004.

Bergmann 1977. Marianne Bergmann. *Studien zum römischen Porträt des 3. Jahrhunderts n. Chr.* Bonn, 1977.

Bern–Strasbourg 2000–2001. *Iconoclasme: Vie et mort de l'image médiévale.* Exh. cat. Edited by Cécile Dupeux et al. Bern, Musée d'Histoire, November 2, 2000–April 16, 2001; Strasbourg, Musée de l'Oeuvre Notre-Dame, May 12–August 26, 2001. Paris, 2001.

Bernard 1975. Honoré Bernard. "Thérouanne: Ville morte." *Archéologia* 81 (April 1975), pp. 41–63.

Bernard 1983. Honoré Bernard. "Les cathédrales de Thérouanne: Les découvertes de 1980 et la cathédrale gothique (état des fouilles en octobre–novembre 1980)." *Archéologie Médiévale* 13 (1983), pp. 7–45.

Bernheimer 1970. Richard Bernheimer. *Wild Men in the Middle Ages: A Study in Art, Sentiment, and Demonology.* New York, 1970 (1952).

Bertaux 1904. Émile Bertaux. *L'art dans l'Italie méridionale.* Paris, 1904.

Beyer 1955. Victor Beyer. *La sculpture strasbourgeoise au quatorzième siècle.* Strasbourg, 1955.

Billard 1907. Max Billard. *Les tombeaux des rois sous la Terreur.* Paris, 1907.

Binski 1997. Paul Binski. "The Angel Choir at Lincoln and the Poetics of the Gothic Smile." *Art History* 20, no. 3 (1997), pp. 350–74.

Binski 2004. Paul Binski. *Becket's Crown: Art and Imagination in Gothic England, 1170–1300.* New Haven, 2004.

Blanc 1992. Annie Blanc. "Les marbres et les roches ornementales dans les monuments français." In *La conservation de la pierre monumentale en France*, edited by Jacques Philippon, Daniel Jeannette, and Roger-Alexandre Lefèvre, pp. 23–26.Paris, 1992.

Bled 1904. O. Bled. *Regestes des evêques de Thérouanne 500–1533*, vol. 1, pt. 3, *1252–1414.* Saint-Omer, 1904.

Blum 1992. Pamela Z. Blum. *Early Gothic Saint-Denis: Restorations and Survivals.* Berkeley, 1992.

Blum 1998. Pamela Z. Blum. "La Porte des Valois de Saint-Denis: À quelle époque son édification a-t-elle commencé?" *Bulletin de la Société des Fouilles Archéologiques et Monuments Historiques de l'Yonne* 15 (1998), pp. 21–25.

Blum and Crosby 1973. Pamela Z. Blum and Sumner McK. Crosby. "Le portail central de la façade occidentale de Saint-Denis." *Bulletin Monumental* 131 (1973), pp. 209–66.

Blum et al. 1994. Pamela Z. Blum, with Annie Blanc, Lore L. Holmes, and Danielle Johnson. "Fingerprinting the Stone at Saint-Denis: A Pilot Study." *Gesta* 33, no. 1 (1994), pp. 19–28.

Blum et al. 2006. Pamela Z. Blum, William W. Clark, and Grover A. Zinn, eds. *Re-Visions: New Studies of the Royal Abbey of Saint-Denis.* Forthcoming, 2006.

Boehm 1990. Barbara Drake Boehm. "Medieval Head Reliquaries of the Massif Central." Ph.D. diss., New York University, Institute of Fine Arts, 1990.

Boehm 1997. Barbara Boehm. "Body-part Reliquaries: The State of Research." *Gesta* 36, no. 1 (1997), pp. 8–19.

Boehm 2000. Barbara Drake Boehm. *The Hours of Jeanne d'Évreux: Commentary Volume.* Luzerne, 2000.

Böhler 1982. *Gemälde, Handzeichnungen, Plastiken.* Sale cat. Munich, Julius Böhler, 1982. Munich, 1982.

Bologna 1989. Ferdinando Bologna. "'Cesaris imperio regni custodia': La porta di Capua e la 'interpretazione imperialis' del classicismo." In *Nel segno di Federico II: Unità politica e pluralità culturale del Mezzogiorno*, pp. 159–92. Naples, 1989.

Bologna 1996. Ferdinando Bologna. "DIVI IVLI CAEsaris: Un nuovo busto federiciano e gli interessi dei circoli umanistici del Regno per Federico II." *Dialoghi di Storia dell'Arte*, no. 2 (1996), pp. 4–31.

Bonaventure de Saint-Amable 1676–85. Le P. Bonaventure de Saint-Amable. *Histoire de S. Martial, apôtre des Gaules et principalement de l'Aquitaine et du Limosin, ou la Défense de son apostolat contre les critiques du temps.* 3 vols. Paris, 1676–85.

Bonne 1993. Jean-Claude Bonne. "L'image de soi au Moyen Âge (IXe–XIIe siècles): Raban Maur et Godefroy de Saint-Victor." In *Il ritratto e la memoria (Materiali 2)*, edited by Augusto Gentili et al., pp. 37–60. Rome, 1993.

Borchgrave d'Altena 1944. Joseph de Borchgrave d'Altena. *Oeuvres de nos imagiers romans et gothiques, sculpteurs, ivoiriers, orfèvres, fondeurs: 1025 à 1550.* Brussels, 1944.

Bossche 2002. Benoît Van den Bossche. "L'authenticité iconographique des portails occidentaux de la cathédrale de Strasbourg." *Bulletin de la Cathédrale de Strasbourg* 25 (2002), pp. 21–48.

Bossche 2005. Benoît Van den Bossche. "Les prophètes strasbourgeois." In *Realität und Projektion: Wirklichkeitsnahe Darstellung in Antike und Mittelalter*, edited by Martin Büchsel and Peter Schmidt, pp. 117–45. Berlin, 2005.

Boston 1940. *Arts of the Middle Ages.* Exh. cat. Boston, Museum of Fine Arts, February 17–March 24, 1940. Boston, 1940.

Bouchot 1891. Henri Bouchot. *Inventaire des dessins exécutés pour Roger de Gaignières.* 2 vols. Paris, 1891.

Bouillart 1724. Jacques Bouillart. *Histoire de l'abbaye royale de Saint-Germain-des-Prez.* Paris, 1724.

Bouvy 1962. D. Bouvy. *Beeldhouwkunst van de middeleeuwen tot heden uit het Aartsbisschoppelijk Museum te Utrecht.* Amsterdam, 1962.

Braca 2003. Antonio Braca. *Le culture artistiche del Medioevo in Costa d'Amalfi.* Salerno, 2003.

Braun 1940. Joseph Braun. *Die Reliquiare des christlichen Kultes und ihre Entwicklung.* Freiburg im Breisgau, 1940.

Breck 1913. Joseph Breck. "Recent Accessions: Twelfth Century Sculpture." *Metropolitan Museum of Art Bulletin* (November 1913), pp. 249–50.

Breck 1920. Joseph Breck. "Medieval and Renaissance Decorative Arts and Sculpture." *Metropolitan Museum of Art Bulletin* 15, no. 8 (1920), pp. 180–83.

Breck 1924. Joseph Breck. "The New Galleries of Medieval and Renaissance Art." *Metropolitan Museum of Art Bulletin* 19 (October 1924), pp. 231–35.

Brenk 1991. Beat Brenk. "Antikenverständnis und weltliches Rechtsdenken im Skulpturenprogramm Friedrichs II. in Capua." In *MUSAGETES: Festschrift für Wolfram Prinz zu seinem 60. Geburtstag am 5. Februar 1989*, edited by Ronald G. Kecks, pp. 93–103. Berlin, 1991.

Brilliant 1991. Richard Brilliant. *Portraiture.* Cambridge, Mass.: Harvard University Press, 1991.

Brooks 1990. L. C. Brooks. "La translation de la relique de saint Jean-Baptiste à la cathédral d'Amiens, récits latins et français." *Neuphilologische Mitteilungen* 91 (1990), pp. 93–106.

Brouillette 1981. Diane C. Brouillette. "The Early Gothic Sculpture of Senlis Cathedral." Ph.D. diss., University of California, Berkeley, 1981.

Brown 1980. Elizabeth A. R. Brown. "Philippe le Bel and the Remains of Saint Louis." *Gazette des Beaux-Arts* 95 (May–June 1980), pp. 175–82. Reprinted in Elizabeth A. R. Brown, *The Monarchy of Capetian France and Royal Ceremonial.* Aldershot, 1991.

Brown 1988. Elizabeth A. R. Brown. *The Oxford Collection of the Drawings of Roger de Gaignières and the Royal Tombs of Saint-Denis.* Philadelphia, 1988.

Brunel 1912. Clovis Brunel, ed. *Les miracles de saint Privat: Suivis des opuscules d'Aldebert III, évêque de Mende.* Paris, 1912.

Bruns 1932. Gerda Bruns. "Zwei Bildnisse eines Spätrömischen Kaisers." *Jahrbuch des Deutschen Archäologischen Instituts* 47, no. 3–4 (1932), pp. 135–38.

Brussels 1985. *Splendeurs d'Espagne et les villes belges, 1500–1700.* Exh. cat. 2 vols. Edited by Jean-Marie Duvosquel and Ignace Vandevivere. Brussels, Palais des Beaux-Arts, September 25–December 22, 1985. Brussels, 1985.

Bruzelius 1985. Caroline A. Bruzelius. *The 13th-Century Church at St-Denis.* New Haven, 1985.

Bruzelius and Meredith 1991. Caroline Bruzelius with Jill Meredith. *The Brummer Collection of Medieval Art: The Duke University Museum of Art.* Durham, N.C., 1991.

Burke 1981. Margaret R. Burke, ed. *Bowdoin College Museum of Art: Handbook of the Collections.* Brunswick, 1981.

Caciorgna and Guerrini 2004. Marilena Caciorgna and Roberto Guerrini. *Il pavimento del Duomo di Siena: L'arte della tarsia marmorea dal XIV al XIX secolo: Fonti e simbologia.* Milan, 2004.

Cagnola 1915. Guido Cagnola. "L'oreficeria medievale a Venafro e Isernia." *Rassegna d'Arte* 15 (1915), pp. 43–48.

Cahn 1969. Walter Cahn. "Romanesque Sculpture in American Collections. IV. The Isabella Stewart Gardner Museum, Boston." *Gesta* 8, no. 2 (1969), pp. 53–68.

Cahn 1977. Walter Cahn. "Romanesque Sculpture in American Collections. XIV. The Academy of the New Church, Bryn Athyn." *Gesta* 16, no. 2 (1977), pp. 69–79.

Cahn 1999. Walter Cahn, ed. *Romanesque Sculpture in American Collections,* vol. 2, *New York and New Jersey, Middle and South Atlantic States, the Midwest, Western and Pacific States.* Turnhout, 1999.

Cahn and Seidel 1979. Walter Cahn and Linda Seidel. *Romanesque Sculpture in American Collections,* vol. 1, *New England Museums.* New York, 1979.

Calland and Dubois 1884. Henri Calland and Alexis-Auguste Dubois. *Guide de l'étranger à Amiens.* New ed. Amiens, 1884.

Calò Mariani 1997. Maria Stella Calò Mariani, ed. *Foggia medievale.* Foggia, 1997.

Calò Mariani 1998. Maria Stella Calò Mariani, ed. *Capitanata medievale.* Foggia, 1998.

Calza 1972. Raissa Calza, ed. *Iconografia romana imperiale da Carausio a Giuliano (287–363 d. C.).* Rome, 1972.

Calza et al. 1977. Raissa Calza et al., eds. *Antichità di Villa Doria Pamphilj.* Rome, 1977.

Cambridge 2002–3. *Byzantine Women and Their World.* Exh. cat. by Ioli Kalavrezou et al. Cambridge, Mass., Arthur M. Sackler Museum, Harvard University Art Museums, October 25, 2002–April 28, 2003. Cambridge, Mass., 2003.

Camille 1992. Michael Camille. *Image on the Edge: The Margins of Medieval Art.* London, 1992.

Cardini 1994. Franco Cardini, ed. *Federico II di Svevia: Stupor mundi.* Rome, 1994.

Carqué 2004. Bernd Carqué. *Stil und Erinnerung: Französische Hofkunst im Jahrhundert Karls V. und im Zeitalter ihrer Deutung.* Göttingen, 2004.

Caskey 2004. Jill Caskey. *Art and Patronage in the Medieval Mediterranean: Merchant Culture in the Region of Amalfi.* Cambridge, 2004.

Cavallo et al. 1994. Guglielmo Cavallo, Giulia Orofino, and Oronzo Pecere, eds. *Exultet: Rotoli liturgici del medioevo meridionale.* Rome, 1994.

Cave 1948. C. J. P. Cave. *Roof Bosses in Medieval Churches: An Aspect of Gothic Sculpture.* Cambridge, 1948.

Caviness 2003. Madeline H. Caviness. "Iconoclasm and Iconophobia: Four Historical Case Studies." *Diogenes* 50 (2003), pp. 99–114.

Châlons-en-Champagne 2005–6. *Regards sur l'art médiéval.* Exh. cat. by Jean-René Gaborit et al. Châlons-en-Champagne, Musée des Beaux-Arts et d'Archéologie, July 1, 2005–January 15, 2006. Paris, 2005.

Charles-Roux 1911. Jules Charles-Roux. *Saint-Gilles: Sa légende, son abbaye, ses coutumes.* Paris, 1911.

Charmasse 1865. Anatole de Charmasse. "Enquête faite en 1482 touchant le chef de saint Lazare conservé à Avallon." *Bulletin de la Société d'Études d'Avallon* (1865), pp. 1–87.

Chazelle 1986. Celia Chazelle. "Matter, Spirit, and Image in the *Libri Carolini.*" *Recherches Augustiniennes* 21 (1986), pp. 163–84.

Chazelle 1990. Celia Chazelle. "Pictures, Books, and the Illiterate: Pope Gregory I's Letters to Serenus of Marseilles." *Word & Image* 6, no. 2 (April–June 1990), pp. 138–53.

Cheetham 1984. Francis Cheetham. *English Medieval Alabasters: With a Catalogue of the Collection in the Victoria and Albert Museum.* Oxford, 1984.

Cherry 1999. John F. Cherry. "The Dish of the Head of St. John the Baptist in Genoa." In *Tessuti, oreficerie, miniature in Liguria: XIII–XV secolo: Atti del convegno internazionale di studi, Genova-Bordighera, 22–25 maggio 1997,* edited by A. R. Calderoni Masetti et al., pp. 135–48. Bordighera, 1999.

Chicago 2004–5. *Devotion & Splendor: Medieval Art of the Art Institute of Chicago.* Exh. cat. by Christina M. Nielson et al. Chicago, Art Institute, September 25, 2004–January 2, 2005. Chicago, 2004.

Church 1896. Rev. C. M. Church. "The Prebendal Stalls and Misericords in the Cathedral Church of Wells." *Archaeologia* 55 (1896), pp. 319–42.

Churchill 1906–7. Sydney J. A. Churchill. "Giovanni Bartolo, of Siena, Goldsmith and Enameller, 1364–1385. *Burlington Magazine* 10 (October 1906–March 1907), pp. 120–25.

CIL. *Corpus Inscriptionum Latinarum.* 18 vols. Berlin, 1862–1989.

Cleveland 1966–67. *Treasures from Medieval France.* Exh. cat. by William D. Wixom. Cleveland Museum of Art, November 16, 1966–January 29, 1967. Cleveland, 1966.

Coolen 1962. Georges Coolen. "Les remparts de Thérouanne." *Bulletin Trimestriel de la Société Académique des Antiquaires de la Morinie* 19 (1962), pp. 546–65.

Coolen 1969. Georges Coolen. "Le jugement dernier de Thérouanne." *Bulletin Trimestriel de la Société Académique des Antiquaires de la Morinie* 21 (1969), pp. 194–203.

Corblet 1868–75. Jules Corblet. *Hagiographie du diocèse d'Amiens.* 5 vols. Paris, 1868–75.

Corsepius 1997. Katharina Corsepius. *Notre-Dame-en-Vaux: Studien zur Baugeschichte des 12. Jahrhunderts in Châlons-sur-Marne.* Stuttgart, 1997.

Courajod 1878–87. Louis Courajod. *Alexandre Lenoir: Son journal et le Musée des Monuments Français.* 3 vols. Paris, 1878–87.

Courtens 1969. André Courtens. *Romanesque Art in Belgium.* Brussels, 1969.

Courtois 1951. Christian Courtois. *Timgad: Antique Thamugadi.* Algier, 1951.

Crawford 1974. Michael H. Crawford. *Roman Republican Coinage.* London, 1974.

Crépin-Leblond 1996. Thierry Crépin-Leblond. "L'architecture et le décor de l'abbaye de Sainte-Geneviève au moyen âge et à la renaissance." In *Le lycée Henri-IV, Paris,* edited by Jacques Bouillon et al., pp. 32–41. Thionville, 1996.

Crosby 1972. Sumner McKnight Crosby. *The Apostle Bas-Relief at Saint-Denis.* New Haven, 1972.

Crosby 1987. Sumner McKnight Crosby. *The Royal Abbey of Saint-Denis: From Its Beginnings to the Death of Suger, 475–1151.* Edited and completed by Pamela Z. Blum. New Haven, 1987.

Dahl 1978. Ellert Dahl. "Heavenly Images: The Statue of Sainte Foy of Conques and the Signification of the Medieval 'Cult-Image' in the West." *Acta ad Archaeologiam et Artium Historiam Pertinentia* 8 (1978), pp. 175–91.

Dahmen 2001. Karsten Dahmen. *Untersuchungen zu Form und Funktion kleinformatiger Porträts der römischen Kaiserzeit.* Münster, 2001.

Dale 2001. Thomas E. A. Dale. "Monsters, Corporeal Deformities, and Phantasms in the Cloister of St-Michel-de-Cuxa." *Art Bulletin* 83 (September 2001), pp. 402–36.

Dale 2002. Thomas E. A. Dale. "The Individual, the Resurrected Body, and Romanesque Portraiture: The Tomb of Rudolf von Schwaben in Merseburg." *Speculum* 77, no. 3 (2002), pp. 707–43.

Davezac 1983. Bertrand Davezac. "Monumental Head from Thérouanne Cathedral." *Bulletin, The Museum of Fine Arts, Houston* 8, no. 2 (1983), pp. 11–23.

Davis-Weyer 1986. Caecilia Davis-Weyer, comp. *Early Medieval Art, 300–1150: Sources and Documents.* Toronto, 1986.

De Benedictis et al. 1984–86. Cristina De Benedictis, Enrica Neri Lusanna, and Lucia Faedo, eds. *Il Museo Bardini a Firenze.* 2 vols. Milan, 1984–86.

De Santis 1957. Msg. Don Mario De Santis. *L'anima eroica della cattedrale di Troia.* Foggia, 1957.

Dectot 2005. Xavier Dectot, ed. *Sculptures des XIe–XIIe siècles: Roman et premier art gothique: catalogue / Musée National du Moyen Âge–Thermes de Cluny (Paris).* Paris, 2005.

Deér 1952. József Deér. *Der Kaiserornat Friedrichs II.* Bern, 1952.

Delaborde 1884. Henri-François Delaborde. "Le Procès du chef de saint Denis en 1410." *Mémoires de la Société de l'Histoire de Paris et de l'Île-de-France* 11 (1884), pp. 297–409.

Delbrueck 1933. Richard Delbrueck. *Spätantike Kaiserporträts von Constantinus Magnus bis zum Ende des Westreichs.* Berlin, 1933.

Deleuze and Guattari 1987. Gilles Deleuze and Félix Guattari. *A Thousand Plateaus: Capitalism and Schizophrenia.* Minneapolis, 1987.

Deliyannis 1996. Deborah Mauskopf Deliyannis. "Agnellus of Ravenna and Iconoclasm: Theology and Politics in a Ninth-Century Historical Text." *Speculum* 71, no. 3 (1996), pp. 559–76.

Deliyannis 2004. Deborah Mauskopf Deliyannis, trans. *The Book of Pontiffs of the Church of Ravenna / Agnellus of Ravenna.* Washington, D.C., 2004.

"Demotte" 1930. "Demotte Holds Fine Showing of Sculptured Portraits from Egyptian to Despian." *Art News* (November 8, 1930), pp. 3–4.

Despois 1868. Eugène Despois. *Le vandalisme révolutionaire.* Paris, 1868.

Devigne 1932. Marguerite Devigne. *La sculpture mosane du XIIe au XVIe siècle.* Paris, 1932.

Di Fabio 1991. Clario Di Fabio. "Oreficerie e smalti in Liguria fra XIV e XV secolo." *Annali della Scuola Normale Superiore di Pisa, Classe di Lettere e Filosofia* 21, no. 1 (1991), pp. 233–74.

Diemer 1978. Dorothea Diemer. *Untersuchungen zu Architektur und Skulptur der Abteikirche von Saint-Gilles.* Stuttgart, 1978.

Doel 2001. Fran Doel and Geoff Doel. *The Green Man in Britain.* Stroud, Gloucestershire, 2001.

Douët-d'Arcq 1853. Louis Douët-d'Arcq. "Inventaire du trésor de la cathédrale de Clermont-Ferrand, document de la fin du Xe siècle." *Revue Archéologique* 10 (1853), pp. 160–74.

Doyle 1986. *Estate of Dorothy Blumenthal.* Sale cat. New York, William Doyle Galleries, January 22, 1986. New York, 1986.

Drake 2002. C. S. Drake. *The Romanesque Fonts of Northern Europe and Scandinavia.* Rochester, N.Y., 2002.

Duplès-Agier 1874. Henri Duplès-Agier, ed. *Chroniques de Saint-Martial de Limoges.* Paris, 1874.

Durand and Grave 1884. Alphonse Durand and Eugène Grave. "Inventaire du mobilier de l'église de Mantes." *Bulletin de la Commission des Antiquités et des Arts* (1884), pp. 116–29.

Durand and Grave 1886. Alphonse Durand and Eugène Grave. "Église de Notre-Dame à Mantes." In *Inventaire général des richesses d'art de la France: Province: Monuments religieux I*, pp. 181–94. Paris, 1886.

Durliat 1965. Marcel Durliat. "Mélanges et documents: Le portail occidentale du Midi." *Annales du Midi* 67 (1965), pp. 215–23.

Durliat 1990. Marcel Durliat. *La sculpture romane de toute de Saint-Jacques: De Conques à Compostelle.* Mont-de-Marsan, 1990.

Echalier 2005. Catherine Echalier. *L'abbaye royale Sainte-Geneviève au Mont de Paris.* Paris, 2005.

Eco 1986. Umberto Eco. *Art and Beauty in the Middle Ages.* New Haven, 1986.

Eikelmann 2000. Renate Eikelmann, ed. *Bayerisches Nationalmuseum: Handbuch der kunst- und kulturgeschichtlichen Sammlungen.* Munich, 2000.

Elsner 1998. Jaś Elsner. *Imperial Rome and Christian Triumph: The Art of the Roman Empire, AD 100–450.* New York, 1998.

Elsner 2003. Jaś Elsner. "Visualising Women in Late Antique Rome: The Projecta Casket." In *Through a Glass Brightly: Studies in Byzantine and Medieval Art and Archaeology Presented to David Buckton*, edited by Chris Entwistle, pp. 22–36. Oxford, 2003.

Enlart 1920. Camille Enlart. *Villes mortes du Moyen Âge.* Paris, 1920.

Enlart and Héliot 1950. Camille Enlart and Pierre Héliot. "Le chevet de la cathédrale de Thérouanne." *Bulletin Monumental* 118 (1950), pp. 103–16.

Erlande-Brandenburg 1975. Alain Erlande-Brandenburg. "L'Adam du Musée de Cluny." *Revue du Louvre* 25 (1975), pp. 81–90.

Erlande-Brandenburg 1982a. Alain Erlande-Brandenburg. *Les sculptures de Notre-Dame de Paris au Musée de Cluny.* Paris, 1982.

Erlande-Brandenburg 1982b. Alain Erlande-Brandenburg. "Une tête inédite provenant du bras nord de Notre-Dame de Paris." In *Mélanges d'archéologie et d'histoire médiévales: En l'honneur du doyen Michel de Boüard*, pp. 137–41. Geneva: Droz, 1982.

Erlande-Brandenburg 1992a. Alain Erlande-Brandenburg. "Tête de prophète." *Revue du Louvre* 3 (1992), p. 69.

Erlande-Brandenburg 1992b. Alain Erlande-Brandenburg. "Une tête de prophète provenant de l'abbatiale de Saint-Denis (portail de droite de la façade occidentale)." *Académie des Inscriptions et Belles-Lettres, Comptes rendus* (1992), pp. 515–42.

Erlande-Brandenburg 1998. Alain Erlande-Brandenburg. *Notre-Dame de Paris.* New York, 1998.

Erlande-Brandenburg 1999a. Alain Erlande-Brandenburg. "La porte du cimetière à l'abbatiale de Saint-Denis dite 'Porte des Valois': L'emplacement originel, déplacement, datation." *Académie des Inscriptions et Belles-Lettres, Comptes rendus* (1999), pp. 189–217.

Erlande-Brandenburg 1999b. Alain Erlande-Brandenburg. "Le portail de l'ancienne abbatiale de Saint-Germain-des-Prés, à Paris. Emplacement. Déplacement. Datation." In *Pierre, lumière, couleur: Études d'histoire de l'art du Moyen Âge en l'honneur d'Anne Prache*, edited by Fabienne Joubert and Dany Sandron, pp. 51–65. Paris, 1999.

Erlande-Brandenburg and Kimpel 1978. Alain Erlande-Brandenburg and Dieter Kimpel. "La statuaire de Notre-Dame de Paris avant les destructions révolutionnaires." *Bulletin Monumental* 136, no. 3 (1978), pp. 213–66.

Evans et al. 2001. Helen C. Evans, Melanie Holcomb, and Robert Hallman. "The Arts of Byzantium." *Metropolitan Museum of Art Bulletin* 58 (Spring 2001).

Falk 1991–93. Birgitta Falk. "Bildnisreliquiare: Zur Entstehung und Entwicklung der metallenen Kopf-, Büsten- und Halbfiguren-reliquiare im Mittelalter." *Aachener Kunstblätter* 59 (1991–93), pp. 99–238.

Farmer 1987. David Hugh Farmer. "The Cult and Canonization of St. Hugh." In *St. Hugh of Lincoln: Lectures Delivered at Oxford and Lincoln to Celebrate the Eighth Centenary of St. Hugh's Consecration as Bishop of Lincoln*, edited by Henry Mayr-Harting, pp. 75–87. Oxford, 1987.

Favière 1992. Jean Favière. *L'hôtel de Jacques Coeur à Bourges.* Paris, 1992.

Fittschen 1977. Klaus Fittschen. "Siebenmal Maximinus Thrax." *Archäologischer Anzeiger* 92, no. 2 (1977), pp. 319–26.

Fittschen and Zanker 1985. Klaus Fittschen and Paul Zanker. *Katalog der römischen Porträts in den Capitolinischen Museen und den anderen kommunalen Sammlungen der Stadt Rom*, vol. 1, *Kaiser- und Prinzenbildnisse*. Mainz, 1985.

Fleury 1977. Michel Fleury. "Comment la façade de Notre-Dame retrouve une partie de ses sculptures." *Archéologia* 108 (July 1977), pp. 20–35.

Fliche 1961. Augustin Fliche. *Aigues-Mortes et Saint-Gilles*. Paris, 1961.

Fliegel 1990. Stephen N. Fliegel. "A Little-Known Celtic Stone Head." *Bulletin of the Cleveland Museum of Art* 77, no. 3 (1990), pp. 82–103.

Florence 1980. *Notre-Dame de Paris: Il ritorno dei re*. Exh. cat. Florence, Santa Maria Novella, April 4–July 10, 1980. Florence, 1980.

Flushing 1959. *The World as a Symbol*. Exh. cat. Flushing, Paul Klapper Library, Queens College, April 15–May 22, 1959. Flushing, N.Y., 1959.

Foerster 1893. Richard Foerster, ed. *Scriptores physiognomonici graeci et latini.* 2 vols. Leipzig, 1893.

Fonseca 1997. Cosimo D. Fonseca, ed. *Itinerari federiciani in Puglia: Viaggio nei castelli e nelle dimore Federico II di Svevia*. Bari, 1997.

Fontevraud 2001. *L'Europe des Anjou: Aventure des princes angevins du XIIIe au XVe siècle*. Exh. cat. by Guy Massin Le Goff et al. Abbaye Royale de Fontevraud, June 15–September 16, 2001. Paris, 2001.

Forsyth 1945. William H. Forsyth. "A Head from a Royal Effigy." *Metropolitan Museum of Art Bulletin* 3, no. 9 (May 1945), pp. 214–19.

Forsyth 1967. William H. Forsyth. "Byzantine Bust of a Woman (Metropolitan Museum of Art)." *The Burlington Magazine* 109 (May 1967), p. 304, ill. facing p. 307.

Forsyth 1968. William H. Forsyth. "A Group of Fourteenth-Century Mosan Sculptures." *Metropolitan Museum Journal* 1 (1968), pp. 41–59.

Forsyth 1978. William H. Forsyth. "A Gothic Doorway from Moutiers-Saint-Jean." *Metropolitan Museum Journal* 13 (1978), pp. 33–74.

Foucart 1980. Jacques Foucart. "L'église Saint-Firmin-le-Confesseur et la cathédrale d'Amiens." *Cahiers Archéologiques de Picardie*, no. 7 (1980), pp. 301–10.

Franciscono 1962. R. B. Franciscono. "A Problematic Twelfth-Century Head in the Metropolitan Museum of Art." Master's thesis, Institute of Fine Arts, New York University, 1962.

Franken 1994. Norbert Franken. *Aequipondia: Figürliche Laufgewichte römischer und frühbyzantinischer Schnellwaagen*. Bonn, 1994.

Frazer 1935. James George Frazer. *The Golden Bough*, part I, vols. 1–2, *The Magic Art and the Evolution of Kings*. 3d ed. New York, 1935.

Friedman 1981. John Block Friedman. *The Monstrous Races in Medieval Art and Thought*. Cambridge, Mass., 1981.

Furtwängler 1910. Adolf Furtwängler. *Beschreibung der Glyptothek König Ludwig's I. zu München*. 2d ed. Munich, 1910.

Gaborit 1998. Jean-René Gaborit, ed. *Sculpture française. II, Renaissance et temps modernes*, vol. 2, *Goujon-Warin et anonymes*. Paris, 1998.

Gaborit 2001. Jean-René Gaborit, ed. *Michel Colombe et son temps*. Paris, 2001.

Gaborit et al. 2005. Jean-René Gaborit, Danielle Gaborit-Chopin, and Jannic Durand. *L'art roman au Louvre*. Paris, 2005.

Gallois 1847. Léonard Gallois, ed. *Réimpression de l'ancien Moniteur*. 32 vols. Paris, 1847.

Gandolfo 1995. Francesco Gandolfo. *Ravello*. Milan, 1995.

Gandolfo 1999. Francesco Gandolfo. *La scultura normanno-sveva in Campania*. Rome, 1999.

Geanakoplos 1984. Deno John Geanakoplos, comp. *Byzantium: Church, Society, and Civilization Seen through Contemporary Eyes*. Chicago, 1984.

Gelao 1990. Clara Gelao. *Stefano da Putignano nella scultura pugliese del Rinascimento*. Fasano di Brindisi, 1990.

Gelao 2004. Clara Gelao, ed. *Scultura del Rinascimento in Puglia: Atti del convegno internazionale, Palazzo Municipale, 21–22 marzo 2001*. Bari, 2004.

Gelfand 2002. Laura D. Gelfand. "Negotiating Harmonious Divisions of Power: A New Reading of the Tympanum of the Sainte-Anne Portal of the Cathedral Notre-Dame de Paris." *Gazette des Beaux-Arts* 144 (November 2002), pp. 249–60.

Gigante 1979. Marcello Gigante, ed. *Poeti bizantini di Terra d'Otranto nel secolo XIII*. 2d ed. Naples, 1979.

Gil and Nys 2004. Marc Gil and Ludovic Nys. *Saint-Omer gothique: Les arts figuratifs à Saint-Omer à la fin du Moyen Âge, 1250–1550*. Valenciennes, 2004.

Gilbert 1833. A. P. M. Gilbert. *Description historique de l'église cathédrale de Notre-Dame d'Amiens*. Paris, 1833.

Gillerman 1977. Dorothy Gillerman. *The Clôture of Notre-Dame and Its Role in the Fourteenth Century Choir Program*. New York, 1977.

Gillerman 1981. Dorothy Gillerman. "The Arrest of Christ: A Gothic Relicf in the Metropolitan Museum of Art." *Metropolitan Museum Journal* 15 (1981), pp. 67–90.

Gillerman 1989. Dorothy Gillerman, ed. *Gothic Sculpture in America*, vol. 1, *The New England Museums*. New York, 1989.

Gillerman 2001. Dorothy Gillerman, ed. *Gothic Sculpture in America*, vol. 2, *The Museums of the Midwest*. Turnhout, 2001.

Gimpel 1966. René Gimpel. *Diary of an Art Dealer*. Translated by John Rosenberg. New York, 1966.

Giscard d'Estaing et al. 1977a. François Giscard d'Estaing, Alain Erlande-Brandenburg, and Michel Fleury. *Les rois retrouvés*. Paris, 1977.

Giscard d'Estaing et al. 1977b. François Giscard d'Estaing et al. "Les statues de Notre-Dame de Paris." *Archéologia* 108 (July 1977), pp. 6–51.

Givens 2005. Jean A. Givens. *Observation and Image-Making in Gothic Art*. Cambridge, 2005.

Gnoli 1908. Umberto Gnoli. *L'arte umbra alla mostra di Perugia*. Bergamo, 1908.

Gnudi 1981. Cesare Gnudi. "Le Sculture di Notre-Dame recentemente riscoperte." In *Études d'art medieval offertes à Louis Grodecki*, edited by Sumner McK. Crosby et al., pp. 185–218. Paris, 1981.

Gombrich 1982. Ernst H. Gombrich. *The Image and the Eye: Further Studies in the Psychology of Pictorial Representation*. Ithaca, N.Y., 1982.

Goodman 1968. Nelson Goodman. *Languages of Art: An Approach to a Theory of Symbols*. Indianapolis, 1968.

Goodman 1972. Nelson Goodman. "Seven Strictures on Similarity." In *Problems and Projects*, edited by Nelson Goodman, pp. 437–46. Indianapolis, 1972.

Gouron 1951. Marcel Gouron. "Saint-Gilles-du-Gard." *Congrès Archéologique de France* 108 (1951), pp. 104–19.

Gramaccini 1994. Norberto Gramaccini. "Eine Statue Vergils im Strassburger Prophetenportal." In *Studien zur Geschichte der europäischen Skulptur im 12./13. Jahrhundert*, edited by Herbert Beck and Kerstin Hengevoss-Dürkop, vol. 1, pp. 739–61, vol. 2, pp. 491–507. Frankfurt am Main, 1994.

Green 1995. Miranda J. Green, ed. *The Celtic World*. London, 1995.

Greenblatt 1980. Stephen Greenblatt. *Renaissance Self-Fashioning: From More to Shakespeare*. Chicago, 1980.

Greenhill 1967. Eleanor Greenhill. "The Provenance of a Gothic Head in the Art Institute of Chicago." *Art Bulletin* 49, no. 2 (1967), pp. 100–110.

Grivot and Zarnecki 1960. Denis Grivot and George Zarnecki. *Gislebertus, sculpteur d'Autun*. Paris, 1960.

Grössinger 1975. Christa Grössinger. "English Misericords of the Thirteenth and Fourteenth Centuries and Their Relationship to Manuscript Illuminations." *Journal of the Warburg and Courtauld Institutes* 38 (1975), pp. 97–108.

Grössinger 1997. Christa Grössinger. *The World Upside-Down: English Misericords*. London, 1997.

Guibert 1911–14. Joseph Guibert. *Les dessins d'archéologie de Roger de Gaignières, publiés sous les auspices et avec le concours de la Société de l'Histoire de l'Art Français*. 3 vols. Paris, 1911–14.

Guilhermy 1848. François Baron de Guilhermy. *Monographie de l'église royale de Saint-Denis.* Paris, 1848.

Guillaume 1894. James Guillaume, ed. *Procès-verbaux du Comité d'instruction publique de la Convention nationale,* vol. 2, *3 juillet 1793–30 brumaire an II (20 nov. 1793).* Paris, 1894.

Gurevich 1988. Aron Gurevich. *Medieval Popular Culture: Problems of Belief and Perception.* Cambridge, 1988.

Halm and Berliner 1931. Philipp Maria Halm and Rudolf Berliner, eds. *Das hallesche heiltum: Man. Aschaffenb. 14.* Berlin, 1931.

Halm and Lill 1924. Philipp Maria Halm and Georg Lill. *Die Bildwerke des Bayerischen Nationalmuseums,* vol. 1, *Die Bildwerke in Holz und Stein vom XII. Jahrhundert bis 1450.* Augsburg, 1924.

Hamann 1955. Richard Hamann. *Die Abteikirche von St. Gilles und ihre Künstlerische Nachfolge.* 3 vols. Berlin, 1955.

Hamann-Mac Lean and Schüssler 1993. Richard Hamann-MacLean and Ise Schüssler. *Die Kathedrale von Reims.* Stuttgart, 1993.

Hamburger 1998. Jeffrey G. Hamburger. *The Visual and the Visionary: Art and Female Spirituality in Late Medieval Germany.* Cambridge, Mass., 1998.

Hannestad forthcoming. Niels Hannestad. "Late Antique Mythological Sculpture: In Search of a Chronology." In *Statuen und Statuensammlungen in der Spätantike,* edited by Franz Alto Bauer and Christian Witschel. Wiesbaden, forthcoming.

Harrison 1986–92. R. Martin Harrison. *Excavations at Saraçhane in Istanbul.* 2 vols. Princeton, 1986–92.

Harrison 1989. R. Martin Harrison. *A Temple for Byzantium: The Discovery and Excavation of Anicia Juliana's Palace-Church in Istanbul.* Austin, 1989.

Hausmann 1990. Ulrich Hausmann. "Zur Bedeutung des römischen Kaiserbildes im Mittelalter." *Mitteilungen des Deutschen Archäologischen Instituts, Römische Abteilung* 97 (1990), pp. 383–93.

Haussherr 1968. Reiner Haussherr. Review of Willibald Sauerländer: *Von Sens bis Strassburg. Kunstchronik* 10 (1968), pp. 302–21.

Havemeyer 1930. *The H. O. Havemeyer Collection [Metropolitan Museum of Art].* Edited by Edward Robinson. New York, 1930.

Havemeyer 1958. *The H. O. Havemeyer Collection [Metropolitan Museum of Art].* New ed., rev. Edited by James J. Rorimer. New York, 1958.

Heinrichs-Schreiber 1997. Ulrike Heinrichs-Schreiber. *Vincennes und die höfische Skulptur: Die Bildhauerkunst in Paris, 1360–1420.* Berlin, 1997.

Heintze 1970. Helga von Heintze. "Ein spätantikes Frauenbüstchen aus Elfenbein." *Berliner Museen, Berichte aus den Staatliches Museen* 20 (1970), pp. 51–61.

Helbing 1930. *Sammlung antiker Kunst: Marmorskulpturen, Bronzen, Terracotten, Vasen, Gläser: Aus dem Nachlass des verewigten Freiherrn Max von Heyl.* Sale cat. Munich, Galerie Hugo Helbing, October 30, 1930. Munich, 1930.

Héliot 1966. Pierre Héliot. "La collégiale Saint-Nicolas d'Amiens et l'architecture picarde." In *Mélanges offerts à René Crozet,* edited by Pierre Gallais and Yves-Jean Riou, vol. 2, pp. 985–92. Poitiers, 1966.

Henwood-Reverdot 1982. Annie Henwood-Reverdot. *L'Église Saint-Étienne de Beauvais: Historie et architecture.* Beauvais, 1982.

Hersey 1973. George L. Hersey. *The Aragonese Arch at Naples, 1443–1475.* New Haven, 1973.

Higgitt 1973. J. C. Higgitt. "The Roman Background to Medieval England." *Journal of the British Archaeological Association* 36 (1973), pp. 1–15.

Hildburgh 1928. Walter L. Hildburgh. "Some Unusual Medieval English Alabaster Carvings." *Antiquaries Journal* 8 (1928), pp. 54–68.

Hildburgh 1933. Walter L. Hildburgh. "Iconographical Peculiarities in English Medieval Alabaster Carvings." *Folk-Lore* 44 (1933), pp. 32–56, 123–50.

Hilpert 1981. Hans-Eberhard Hilpert. *Kaiser- und Papstbriefe in den Chronica Majora des Matthaeus Paris.* Stuttgart, 1981.

Hindman 1998. Sandra Hindman. *Things: The Object Past and Present.* Paris, 1998.

Holbert et al. 2001. Kelly M. Holbert, Donna Strahan, and Lore L. Holmes. "Inside and Out: Two Gothic Heads Reveal Their Secrets through Technical Analysis." *Journal of the Walters Art Museum* 59 (2001), pp. 29–44.

Holladay 1997. Joan A. Holladay. "Relics, Reliquaries, and Religious Women: Visualizing the Holy Virgins of Cologne." *Studies in Iconography* 18 (1997), pp. 67–118.

Holmes and Harbottle 1994. Lore L. Holmes and Garman Harbottle. "Compositional Fingerprinting: New Directions in the Study of the Provenance of Limestone." *Gesta* 33, no. 1 (1994), pp. 10–18.

Holmes et al. 1986. Lore L. Holmes, Charles T. Little, and Edward V. Sayre. "Elemental Characterization of Medieval Limestone Sculpture from Parisian and Burgundian Sources." *Journal of Field Archaeology* 13 (1986), pp. 419–38.

Holum 1982. Kenneth G. Holum. *Theodosian Empresses: Women and Imperial Dominion in Late Antiquity.* Berkeley, 1982.

Hope 1890. W. H. St. John Hope. "On Sculptured Alabaster Tablets Called St. John's Heads." *Archaeologia* 52 (1890), pp. 669–708.

Horn 1937. Walter Horn. *Die Fassade von St. Gilles: Eine Untersuchung zur Frage des Antikeneinflusses in der südfranzösischen Kunst des 12. Jahrhunderts.* Hamburg, 1937.

Horst 1982. Kathryn Horst. "Romanesque Sculpture in American Collections. XX. Ohio and Michigan." *Gesta* 21, no. 2 (1982), pp. 111–13.

Hoving 1963. Thomas Hoving. "The Face of St. Juliana: The Transformation of a Fourteenth Century Reliquary." *Metropolitan Museum of Art Bulletin* 21 (January 1963), pp. 173–81.

Hoving 1965. Thomas Hoving. "Italian Romanesque Sculpture." *Metropolitan Museum of Art Bulletin* 23 (June 1965), pp. 345–48.

Howard and Crossley 1917. Frank E. Howard and Frederick H. Crossley. *English Church Woodwork: A Study in Craftsmanship During the Mediaeval Period A.D. 1250–1550.* London, 1917. 2d ed., London, 1933.

Huard 1938. Georges Huard. "Communication (statues de la Vierge du XIVe siècle à Saint-Germain-des-Prés . . . et à Magny-en-Vexin)." *Bulletin de la Société Nationale des Antiquaires de France,* séance du 16 février, 1938, pp. 95–103.

Hudson 1924. Henry A. Hudson. *The Mediaeval Woodwork of Manchester Cathedral.* Manchester, 1924.

Hugo 1993. Victor Hugo. *Notre-Dame de Paris* (1832). Translated by Alban Krailsheimer. Oxford, 1993.

Huygens 1985. R. B. C. Huygens, ed. *Apologiae duae.* With an introduction by Giles Constable. Turnhout, 1985.

Idzerda 1954. Stanley J. Idzerda. "Iconoclasm during the French Revolution." *American Historical Review* 60 (October 1954), pp. 13–26.

İnan and Rosenbaum 1966. Jale İnan and Elisabeth Rosenbaum. *Roman and Early Byzantine Portrait Sculpture in Asia Minor.* London, 1966.

İnan and Alföldi-Rosenbaum 1979. Jale İnan and Elisabeth Alföldi-Rosenbaum. *Römische und frühbyzantinische Porträtplastik aus der Türkei: Neue Funde.* 2 vols. Mainz, 1979.

Ithaca–Utica 1968. *A Medieval Treasury.* Exh. cat. by Robert G. Calkins. Ithaca, Andrew Dickson White Museum of Art, Cornell University, October 8–November 3, 1968; Utica, Munson-Williams-Proctor Institute, November 10–December 8, 1968. Ithaca, N.Y., 1968.

Jacobus da Varagine 1993. Jacobus da Varagine. *The Golden Legend: Readings on the Saints.* 2 vols. Translated by William Granger Ryan. Princeton, 1993.

Johnson and Wyss 1995. Danielle V. Johnson and Michaël Wyss. "Actualité." *Bulletin Monumental* 153 (1995), pp. 101–3.

Jung 2000. Jacqueline E. Jung. "Beyond the Barrier: The Unifying Role of the Choir Screen in Gothic Churches." *Art Bulletin* 82 (2000), pp. 622–59.

Kalinowski 1999. Lech Kalinowski. "Entre Reims et Ravello: Diffusion ou convergence?" In *Pierre, lumière, couleur: Études d'histoire de l'art du Moyen Âge en l'honneur d'Anne Prache*, edited by Fabienne Joubert and Dany Sandron, pp. 231–42. Paris, 1999.

Kantorowicz 1931a. Ernst Kantorowicz. *Frederick the Second, 1194–1250.* London, 1931.

Kantorowicz 1931b. Ernst Kantorowicz. *Kaiser Friedrich der Zweite, Ergänzungsband.* Berlin, 1931. Reprint, Düsseldorf, 1963.

Katz 2000. *Daniel Katz: European Sculpture.* London, 2000.

Keller 1937. Harald Keller. "Die Bauplastilk des Sieneser Doms: Studien zu Giovanni Pisano und seiner künstlerischen Nachfolge." *Römisches Jahrbuch für Kunstgeschichte* 1 (1937), pp. 139–221.

Kenaan-Kedar 1986. Nurith Kenaan-Kedar. "Les modillons de saintonge et du Poitou comme manifestation de la culture laïque." *Cahier de Civilisation Médiévale* 29 (1986), pp. 311–30.

Kenaan-Kedar 1992. Nurith Kenaan-Kedar. "The Margins of Society in Marginal Romanesque Sculpture." *Gesta* 31, no. 1 (1992), pp. 15–25.

Kenaan-Kedar 1995. Nurith Kenaan-Kedar. *Marginal Sculpture in Medieval France: Towards the Deciphering of an Enigmatic Pictorial Language.* Aldershot, 1995.

Kennedy 1989. Emmet Kennedy. *A Cultural History of the French Revolution.* New Haven, 1989.

Kessler 2006. Herbert L. Kessler. "Gregory the Great and Image Theory in Northern Europe during the Twelfth and Thirteenth Centuries." In *A Companion to Medieval Art: Romanesque and Gothic in Northern Europe*, edited by Conrad Rudolph, pp. 151–72. Malden, Mass.: Blackwell, 2006.

Kiilerich 1993. Bente Kiilerich. *Late Fourth Century Classicism in the Plastic Arts: Studies in the So-Called Theodosian Renaissance.* Odense, 1993.

Kimpel 1971. Dieter Kimpel. *Die Querhausarme von Notre-Dame zu Paris und ihre Sculpturen.* Bonn, 1971.

Kitzinger 1978. Ernst Kitzinger. "The Cleveland Marbles." In *Atti del IX Congresso internazionale di archeologia cristiana, Roma 21–27 settembre 1975*, pp. 653–75. Rome, 1978. Reprinted in *Art, Archaeology, and Architecture of Early Christianity*, edited by Paul Corby Finney, vol. 2, pp. 117–39. New York, 1993.

Klaniczay 1990. Gábor Klaniczay. "Le culte des saints dynastiques en Europe centrale (Angevins et Luxembourg au XIVe siècle)." In *L'église et le peuple chrétien dans les pays de l'Europe du centre-est et du nord, XIVe–XVe siècles: Actes du colloque, Rome, 27–29 janvier, 1986*, pp. 221–47. Rome, 1990.

Klaniczay 2002. Gábor Klaniczay. *Holy Rulers and Blessed Princesses: Dynastic Cults in Medieval Central Europe.* Cambridge, 2002.

Kovács 1964a. Éva Kovács. "Le chef de Saint Maurice à la cathédrale de Vienne (France)." *Cahiers de Civilisation Médiévale* 7 (1964), pp. 19–26.

Kovács 1964b. Éva Kovács. *Kopfreliquiare des Mittelalters.* Leipzig, 1964.

Krauss 1993. Rosalind Krauss. *Cindy Sherman, 1975–1993.* New York, 1993.

Kreytenberg 2003. Gert Kreytenberg. "Eine Frage des 'Stils': Zuschreibung und Methode über ein Hauptwerk der Sieneser Skulptur des frühen Trecento in Castello Gallico." *Arte Medievale*, n.s. 2 (2003), pp. 107–11.

Krohm 1976. Hartmut Krohm. *Spätmittelalterliche Bildwerke aus Brabant: Figuren heiliger Frauen von e. Grablegung Christi.* Berlin, 1976.

Kurmann 1987. Peter Kurmann. *La façade de la cathédrale de Riems.* 2 vols. Lausanne, 1987.

Laclotte 2003. Michel Laclotte, ed. *The Art and Spirit of Paris.* Vol. 1. New York, 2003.

Ladner 1965. Gerhart B. Ladner. *"Ad Imaginem Dei": The Image of Man in Mediaeval Art.* Latrobe, Pa., 1965.

Laird 1986. Marshall Laird. *English Misericords.* London, 1986.

Lalore 1875. Abbé Charles Lalore. *Le trésor de Clairvaux du XIIe au XVIIIe siècle.* Troyes, 1875.

Langmead 2003. Alison Langmead. "The Architectural Landscape of Eleventh- and Twelfth-Century South-Central France." Ph.D. diss, Columbia University, 2003.

Lanselle 1923. M. Le Docteur Lanselle. "Découverte archéologique à Saint-Omer." *Bulletin Historique, Société des Antiquaires de la Morinie* 16 (1923), p. 80.

Lasteyrie du Saillant 1902. Robert-Charles, comte de Lasteyrie du Saillant. *Études sur la sculpture française au moyen âge.* Paris, 1902.

Lavin 1970. Irving Lavin. "On the Sources and Meanings of the Renaissance Portrait Bust." *Art Quarterly* 33 (1970), pp. 207–26.

Lawley 1880–83. Stephen W. Lawley, ed. *Breviarum ad usum insignes ecclesiae Eboracensis (1493).* 2 vols. Surtees Society Publications 71, 75. London, 1880–83.

Leeds 2002–3. *Wonder: Painted Sculpture from Medieval England.* Exh. cat. by Stacy Boldrick, David Park, and Paul Williamson. Leeds, Henry Moore Institute, October 3, 2002–January 5, 2003. Leeds, 2002.

Lemaître 1987. Alain J. Lemaître. *L'art roman en Alsace.* Rennes, 1987.

Leone de Castris 1986. Pierluigi Leone de Castris. *Arte di corte nella Napoli angioina.* Florence, 1986.

Lesage 2000. Christiane Lesage. "Notes archéologiques sur quelques édifices du Pas-de-Calais." *Bulletin de la Commission Départementale d'Histoire et d'Archéologie du Pas-de-Calais* 18 (2000), pp. 107–28.

Levin 2005. William R. Levin. "'Tanto goffe e mal fatte…dette figure si facessino…belle': The Trecento Overdoor Sculptures for the Baptistry in Florence and Their Cinquecento Replacements." *Studies in Iconography* 26 (2005), pp. 205–42.

Lewis 1997. Flora Lewis. "The Wound in Christ's Side and the Instruments of the Passion: Gendered Experience and Response." In *Women and the Book: Assessing the Visual Evidence*, edited by Lesley Smith and Jane H. M. Taylor, pp. 204–29. Toronto, 1997.

Liechtenstein 1954. *A Catalogue of Seven Marble Sculptures of the Italian Trecento and Quattrocento from the Collection of His Highness, the Prince of Liechtenstein, Jacques Seligmann and Co.* New York, 1954.

Lightbown 1988. Ronald W. Lightbown. "Portrait or Idealization: The Ravello Bust." *Apollo* 127 (1988), pp. 108–12.

Lindley 1997. Phillip Lindley. "Absolutism and Regal Image in Ricardian Sculpture." In *The Regal Image of Richard II and the Wilton Diptych*, edited by Dillian Gordon et al., pp. 61–83. London, 1997.

Little 1987. Charles T. Little. "Romanesque Sculpture in North American Collections. The Metropolitan Museum of Art. Part VI. Auvergne, Burgundy, Central France, Meuse Valley, Germany." *Gesta* 26, no. 2 (1987), pp. 153–68.

Little 1994. Charles T. Little. "Searching for the Provenances of Medieval Stone Sculpture: Possibilities and Limitations." *Gesta* 33 (1994), pp. 29–37.

Little 1999. Charles T. Little. "Monumental Gothic Sculpture from Amiens in American Collections." In *Pierre, lumière, couleur: Études d'histoire de l'art du Moyen Âge en l'honneur d'Anne Prache*, edited by Fabienne Joubert and Dany Sandron, pp. 243–53. Paris, 1999.

Little et al. 1987. Charles T. Little, Leslie Bussis, and David L. Simon. "Romanesque Sculpture in North American Collections. XXV. The Metropolitan Museum of Art. Part V. Southwestern France." *Gesta* 26, no. 1 (1987), pp. 61–76.

Lombard-Jourdan 1997. Anne Lombard-Jourdan. "L'invention du 'Roi fondateur' à Paris au XIIe siècle: De l'obligation morale au thème sculptural." *Bibliothèque de l'École des Chartes* 155 (1997), pp. 485–542.

London 1987–88. *The Age of Chivalry: Art in Plantagenet England, 1200–1400.* Exh. cat. Edited by Jonathan Alexander and Paul Binski. London, Royal Academy of Arts, November 6, 1987–March 6, 1988. London, 1987.

London 1989–90. *Celtic Stone Sculptures.* Exh. cat. Introduction by Martin Petch. London, Karsten Schubert Ltd., December 10, 1989–January 20, 1990. London, 1989.

London 2000. *The Image of Christ.* Exh. cat. by Gabriele Finaldi et al. London, National Gallery, February 20–May 7, 2000. London, 2000.

L'Orange 1984. Hans Peter L'Orange. *Das Spätantike Herrscherbild von Diokletian bis zu den Konstantin-Söhnen 284–361 n. Chr.* Berlin, 1984.

Los Angeles–Chicago 1970. *The Middle Ages: Treasures from The Cloisters and The Metropolitan Museum of Art.* Exh. cat. by Vera K. Ostoia. Los Angeles County Museum of Art, January 18–March 29, 1970; Chicago, Art Institute, May 16–July 5, 1970. Los Angeles, 1969.

Losito 2003. Maria Losito. *Castel del Monte e la cultura arabo-normanna in Federico II.* Bari, 2003.

Ludden 1955. Franklin Monroe Ludden. "The Early Gothic Portals of Senlis and Mantes." Ph.D. diss., Harvard University, 1955.

Macek 1986–88. Pearson M. Macek. "An English Boss of Four Faces." *Bulletin of the University of Michigan Museum of Art and Archaeology* 8 (1986–88), pp. 5–26.

Mâle 1972. Émile Mâle. *The Gothic Image: Religious Art in France of the Thirteenth Century.* Reprint of 1913 ed. New York, 1972.

Mâle 1984. Émile Mâle. *Religious Art in France: The Thirteenth Century. A Study of Medieval Iconography and Its Sources* (1898). Princeton, 1984.

Mâle 1986. Émile Mâle. *Religious Art in France: The Late Middle Ages.* Princeton, 1986.

Mallion 1964. Jean Mallion. *Chartres: Le jubé de la cathédrale.* Chartres, 1964.

Mantes 2000–2001. *Mantes médiévale: La collégiale au coeur de la ville.* Exh. cat. Edited by Alain Erlande-Brandenburg. Mantes-la-Jolie, Musée de l'Hôtel-Dieu, December 17, 2000–May 31, 2001. Paris, 2000.

Marks and Williamson 2003. Richard Marks and Paul Williamson, eds. *Gothic: Art for England, 1400–1547.* London, 2003.

Marrou 1956. Henri-Irénée Marrou. *A History of Education in Antiquity.* New York, 1956.

Mathews 1993. Thomas F. Mathews. *The Clash of the Gods: A Reinterpretation of Early Christian Art.* Princeton, 1993.

Maxon 1970. John Maxon. *The Art Institute of Chicago.* New York, 1970.

Maxwell 2004. Robert A. Maxwell. "Parthenay (deux sèvres): Découverte d'une tête, provenant de Notre-Dame-de-la-Couldre?" *Bulletin Monumental* 162, no. 3 (2004), pp. 185–89.

Maxwell et al. 2005. Robert A. Maxwell, Lore L. Holmes, and Garman Harbottle. "The Dispersed Sculpture of Parthenay and the Contributions of Nuclear Science." *Journal of Medieval Archaeology* 49 (2005), pp. 247–80.

McClanan 2002. Anne L. McClanan. *Representations of Early Byzantine Empresses: Image and Empire.* New York, 2002.

Meier and Schürmann 2002. Hans-Rudolf Meier and Dorothea Schwinn Schürmann, eds. *Schwelle zum Paradies: Die Galluspforte des Basler Münsters.* Basel, 2002.

Meischner 2001. Jutta Meischner. *Bildnisse der Spätantike, 193–500: Problemfelder, die Privatporträts.* Berlin, 2001.

Mellini 1996. Gian Lorenzo Mellini. "Una nuova scultura Federiciana?" *Labyrinthos* 29 (1996), pp. 22–34.

Mellini 1998. Gian Lorenzo Mellini. "Per Nicola di Bartolomeo da Foggia." *Labyrinthos* 33/34 (1998), pp. 3–31.

Mellinkoff 1970. Ruth Mellinkoff. *The Horned Moses in Medieval Art and Thought.* Berkeley, 1970.

Mellinkoff 1981. Ruth Mellinkoff. *The Mark of Cain.* Berkeley, 1981.

Mellinkoff 2004. Ruth Mellinkoff. *Averting Demons: The Protective Power of Medieval Visual Motifs and Themes.* Los Angeles, 2004.

Mercier 1994. Louis-Sébastien Mercier. *Le nouveau Paris.* Edited by Jean-Claude Bonnet. Paris, 1994.

Meredith 1994. Jill Meredith. "Romancing the Stone: Resolving some Provenance Mysteries of the Brummer Collection at Duke University." *Gesta* 33, no. 1 (1994), pp. 38–46.

Mesplé 1961. Paul Mesplé. *Toulouse—Musée des Augustins—Les sculptures romanes.* Paris, 1961.

Mexico City 1993. *Tesoros medievales del Museo del Louvre.* Exh. cat. by Françoise Baron. Mexico City, Museo del Palacio de Bellas Artes, 1993. Mexico City, 1993.

Middeldorf 1976. Ulrich Middeldorf. *Sculptures from the Samuel H. Kress Collection.* New York, 1976.

Middeldorf Kosegarten 1984. Antje Middeldorf Kosegarten. *Sienesische Bildhauer am Duomo Vecchio: Studien zur Skulptur in Siena 1250–1330.* Munich, 1984.

Milliken 1922. William M. Milliken. "Two Marble Heads: The School of Michel Colombe." *Cleveland Museum of Art Bulletin* 9 (January 1922), pp. 2–6.

Molina Hipólito 1962. José Molina Hipólito. *Guía de Ubeda.* Madrid, 1962.

Molinier 1894. Émile Molinier. *Collection Émile Gavet: Catalogue raisonnée.* Paris, 1894.

Mommsen 1883. Theodor Mommsen. *Inscriptiones Bruttiorum, Lucaniae, Campaniae, Sicilae, Sardinae Latinae.* Berlin, 1883.

Montfaucon 1729–33. Bernard de Montfaucon. *Les monumens de la monarchie françoise.* 5 vols. Paris, 1729–33.

Montgomery 1997. Scott B. Montgomery. "Mittite capud meum … ad matrem meam ut osculetur: The Form and Meaning of the Reliquary Bust of Saint Just." *Gesta* 36, no. 1 (1997), pp. 48–64.

Morpurgo 1983. Piero Morpurgo. "Federico II e la fine dei tempi nella profezia del Cod. Escorialense f.III 8." *Pluteus* 1 (1983), pp. 135–67.

Moscow–Saint Petersburg 1990. *Dekorativno-prikladnoe iskusstvo ot pozdnei antichnosti do pozdnei gotiki: iz sobranii muzeia Metropoliten, Niu Ĭork i Khudozhestvennogo Instituta, Chikago* (Medieval Art from the Late Antique through Late Gothic from the Metropolitan Museum of Art and Art Institute of Chicago). Exh. cat. Edited by E. R. Kankovskaia. Moscow, Pushkin Museum; Saint Petersburg, State Hermitage. Moscow, 1990.

Moskowitz 1981. Anita F. Moskowitz. "Donatello's Reliquary Bust of Saint Rossore." *Art Bulletin* 63 (March 1981), pp. 41–48.

Moskowitz 1994. Anita F. Moskowitz. "A Neglected Tuscan Figure in the Medieval Collection." *Bulletin of the Cleveland Museum of Art* 81 (November 1994), pp. 366–75.

Moskowitz 1996. Anita F. Moskowitz. "Four Sculptures in Search of an Author: The Cleveland and Kansas City Angels, and the Problem of the Bertini Brothers." *Cleveland Studies in the History of Art* 1 (1996), pp. 98–115.

Moskowitz 2001. Anita F. Moskowitz. *Italian Gothic Sculpture, c. 1250–c. 1400.* New York, 2001.

Müller 1966. Theodor Müller. *Sculpture in the Netherlands, Germany, France, and Spain: 1400 to 1500.* Baltimore, 1966.

Mundt 1967. Barbara Mundt. "Der Zyklus der Chapelle de Rieux und seine künstlerische Nachfolge." *Jahrbuch der Berliner Museen* 9 (1967), pp. 26–80.

Murray 1996. Stephen Murray. *Notre-Dame Cathedral of Amiens: The Power of Change in Gothic.* Cambridge, 1996.

Namur 1993. *La sculpture mosane du XIVe siècle.* Exh. cat. by Robert Didier. Namur, Musée des Arts Anciens du Namurois, March 27–June 6, 1993. Namur, 1993.

New York 1930. *Sculptured Portraits: Comparative Exhibition: Egypt, Greece, Rome, Syria, Cyprus, China, Cambodge, France.* Exh. cat. Preface by Louis Réau. New York, Demotte Galleries, November 1–December 15, 1930. New York, 1930.

New York 1954–55. *Spanish Medieval Art: Loan Exhibition in Honor of Dr. Walter W. S. Cook.* Exh. cat. New York, The Cloisters, December 15, 1954–January 30, 1955. New York, 1954.

New York 1968–69. *Medieval Art from Private Collections.* Exh. cat. by

Carmen Gómez-Moreno. New York, The Cloisters, October 30, 1968–January 5, 1969. New York, 1968.

New York 1970. *The Year 1200.* 3 vols. Exh. cat. Edited by Konrad Hoffmann et al. New York, Metropolitan Museum of Art, February 12–May 10, 1970. New York, 1970–75.

New York 1977–78. *Age of Spirituality: Late Antique and Early Christian Art, Third to Seventh Century.* Exh. cat. Edited by Kurt Weitzmann. New York, Metropolitan Museum of Art, November 19, 1977–February 12, 1978. New York, 1979.

New York 1980. *Hair.* Exh. cat. New York, Cooper-Hewitt Museum, June 10–August 17, 1980. Washington, D.C., 1980.

New York 1980–81. *The Wild Man: Medieval Myth and Symbolism.* Exh. cat. by Timothy Husband. New York, Metropolitan Museum of Art, October 8, 1980–January 12, 1981. New York, 1980.

New York 1981. *The Royal Abbey of Saint-Denis in the Time of Abbot Suger (1122–1151).* Exh. cat. New York, The Cloisters, March 31–May 31, 1981. New York, 1981.

New York 1982. *Radiance and Reflection: Medieval Art from the Raymond Pitcairn Collection.* Exh. cat. by Jane Hayward, Walter Cahn, et al. New York, Metropolitan Museum of Art, February 25–September 15, 1982. New York, 1982.

New York 1987a. *Art Treasures of the Middle Ages.* Exh. cat. New York, Michael Ward, Inc., Spring 1987. New York, 1987.

New York 1987b. *Giovanni Pisano in Genoa: A Sculptor from the Epoch of Dante.* Exh. cat. by Max Seidel et al. New York, Metropolitan Museum of Art, October 30–December 6, 1987. Genoa, 1987.

New York 1993–94. *The Art of Medieval Spain, A.D. 500–1200.* Exh. cat. New York, Metropolitan Museum of Art, November 18, 1993–March 13, 1994. New York, 1993.

New York 1999. *Mirror of the Medieval World.* Exh. cat. Edited by William D. Wixom. New York, Metropolitan Museum of Art, March 9–July 18, 1999. New York, 1999.

New York 2002. *Collecting Treasures of the Past.* Exh. cat. New York, Blumka Gallery, January 22–February 8, 2002. New York, 2002.

New York–Cleveland 1979–80. *Sculpture from Notre-Dame, Paris: A Dramatic Discovery.* Exh. cat. by Carmen Gómez-Moreno. New York, Metropolitan Museum of Art, September 6–November 25, 1979; Cleveland Museum of Art, December 25, 1979–January 27, 1980. New York, 1979.

New York–Prague 2005–6. *Prague: The Crown of Bohemia, 1347–1437.* Exh. cat. Edited by Barbara Drake Boehm and Jiri Fajt. New York, Metropolitan Museum of Art, September 20, 2005–January 3, 2006; Prague Castle, February 16–May 21, 2006. New York, 2005.

Nodier et al. 1835. Charles Nodier, J. Taylor, and Alphonse de Cailleux. *Voyages pittoresques et romantiques dans l'ancienne France,* vol. 10, *Picardie.* Paris, 1835.

Noguier 1556. Antoine Noguier. *Histoire tolosaine.* Toulouse, 1556.

Oklahoma City 1985. *Songs of Glory: Medieval Art from 900–1500.* Exh. cat. Edited by David Mickenberg. Oklahoma City, Oklahoma Museum of Art, January 22–April 29, 1985. Oklahoma City, 1985.

Onians 1988. Richard Broxton Onians. *The Origins of European Thought about the Body, the Mind, the Soul, the World, Time and Fate.* 2d ed. Cambridge, 1988.

Ostoia 1965. Vera K. Ostoia. "'To Represent What Is as It Is.'" *Metropolitan Museum of Art Bulletin* 23 (June 1965), pp. 367–72.

Otavsky 1992. Karel Otavsky. *Die Sankt Wenzelskrone im Prager Domschatz und die Frage der Kunstauffassung am Hofe Kaiser Karls IV.* Bern, 1992.

Panofsky 1955. Erwin Panofsky. *Meaning in the Visual Arts.* New York, 1955.

Panofsky 1979. Erwin Panofsky, ed. *Abbot Suger on the Abbey Church of St.-Denis and Its Art Treasures.* 2d ed. Princeton, 1979.

Parguez 1914. Henri Parguez. *VIIe centenaire de saint Louis: Saint Louis et Poissy, sa naissance, son baptême, ses charités, ses miracles, son culte à Poissy, 1214–1914.* Saint-Germain-en-Laye, 1914.

Paris 1928. *Exposition de sculpture: Sculpture comparée de l'antiquité, du moyen âge et de la Renaissance, organisée par M. Arthur Sambon dans son hôtel particulier, Square de Messine, 7, au profit de l'Union des Arts (fondation Rachel Boyer).* Exh. cat. Paris, March 16–April 16, 1928. Paris, 1928.

Paris 1965. *Les trésors des églises de France.* Exh. cat. Introduction by Jean Taralon. Paris, Musée des Arts Décoratifs, 1965. Paris, 1965.

Paris 1981–82. *Les fastes du gothique: Le siècle de Charles V.* Exh. cat. Paris, Galeries Nationales du Grand Palais, October 9, 1981–February 1, 1982. Paris, 1981.

Paris 1991. *Le trésor de Saint-Denis.* Exh. cat. by Danielle Gaborit-Chopin. Paris, Musée du Louvre, March 12–June 17, 1991. Paris, 1991.

Paris 2004. *Paris 1400: Les arts sous Charles VI.* Exh. cat. by Elisabeth Taburet and François Avril. Paris, Musée du Louvre, March 22–July 12, 2004. Paris, 2004.

Paris 2005. *La France romane au temps des premiers Capétiens (987–1152).* Exh. cat. Edited by Danielle Gaborit-Chopin. Paris, Musée du Louvre, March 10–June 6, 2005. Paris, 2005.

Paris 2006. *Oeuvres nouvelles, 1995–2005.* Exh. cat. by Elisabeth Taburet-Delahaye et al. Paris, Musée National du Moyen Âge—Thermes et Hôtel de Cluny, May 10–September 25, 2006. Paris, 2006.

Paris–New York 1995–96. *Enamels of Limoges, 1100–1350.* Exh. cat. Paris, Musée du Louvre, October 23, 1995–January 22, 1996; New York, Metropolitan Museum of Art, March 5–June 16, 1996. New York, 1996.

Pastoureau 1985. Michel Pastoureau. "L'effervescence emblématique et les origines héraldiques du portrait au XIVe siècle." *Bulletin de la Société Nationale des Antiquaires de France* (1985), pp. 108–15.

Peeters 1985. Cornelis J. A. C. Peeters. *De Sint Janskathedraal te 's-Hertogenbosch.* 's-Gravenhage, 1985.

Perkinson 2005. Stephen Perkinson. "From 'Curious' to Canonical: 'Jehan Roy de France' and the Origins of the French School." *Art Bulletin* 87, no. 3 (2005), pp. 507–32.

Perkinson forthcoming. Stephen Perkinson. "Likeness, Loyalty, and the Life of the Court Artist: Portraiture in the Calendar Scenes of the *Très Riches Heures.*" *Quaerendo* (forthcoming).

Picard 1910–13. Étienne Picard. "La dévotion de Philippe le Hardi et de Marguerite de Flandre." *Mémoires de l'Académie des Sciences, Arts et Belles-Lettres de Dijon* 12 (1910–13), pp. 1–116.

Piponnier 1970. Françoise Piponnier. *Costume et vie sociale: La cour d'Anjou, XIVe–XVe siècle.* Paris, 1970.

PL 1844–91. *Patrologiae cursus completus . . . Series latina.* Edited by Jacques-Paul Migne. 221 vols. Paris, 1844–91.

Plagnieux 1989. Philippe Plagnieux. "Le portail du XIIe siècle de Saint-Germain-des-Prés à Paris: État de la question et nouvelles recherches." *Gesta* 28 (1989), pp. 21–29.

Podlaha and Šittler 1903. Antonin Podlaha and Eduard Šittler. *Chrámový poklad u sv. Víta v Praze.* Prague, 1903. German translation: *Der Domschatz in Prag.* Prague, 1903.

Pope-Hennessy 1966. John Pope-Hennessy. *The Portrait in the Renaissance.* New York, 1966.

Porter 1923. A. Kingsley Porter. *Romanesque Sculpture of the Pilgrimage Roads.* 10 vols. Boston, 1923.

Portland 2002. *What Is a Man? Changing Images of Masculinity in Late Antique Art.* Exh. cat. by Natalie Boymel Kampen, Elizabeth Marlowe, and Rebecca M. Molholt. Portland, Ore., Douglas F. Colley Memorial Art Gallery, Reed College, April 12–June 17, 2002. Seattle, 2002.

Poupardin 1905. René Poupardin, ed. *Monuments de l'histoire des abbayes de Saint-Philibert.* Paris, 1905.

Prache 1983. Anne Prache. *Île-de-France romane.* Pierre-qui-Vire, Yonne, 1983.

Pradalier-Schlumberger 1998. Michèle Pradalier-Schlumberger. *Toulouse et le Languedoc: La sculpture gothique (XIIIe–XIVe siècles).* Toulouse, 1998.

Pradalier-Schlumberger 2002. Michèle Pradalier-Schlumberger. "La Cathédrale Saint-Étienne de Toulouse: La cathédrale gothique." In *Congrès archéologique de France, Toulousain et Comminges, 154e session 1996*, pp. 215–23. Paris, 2002.

Pradel 1953. Pierre Pradel. *Michel Colombe: Le dernier imagier gothique.* Paris, 1953.

Pressouyre 1969. Léon Pressouyre. "Sculptures retrouvées de la cathédrale de Sens." *Bulletin Monumental* 127, no. 2 (1969), pp. 107–18.

Pressouyre 1972a. Léon Pressouyre. "Deux têtes de rois provenant du jubé de Chartres, actuellement aux États Unis." *Bulletin de la Société des Antiquaires de France* (1972), pp. 171–80.

Pressouyre 1972b. Léon Pressouyre. "De nouveaux fragments pour le jubé de Chartres." *Archéologia* 50 (1972), pp. 71–74.

Pressouyre 1973. Léon Pressouyre. "Une tête gothique et son 'double.'" *Revue de l'Art*, no. 21 (1973), pp. 32–39.

Pressouyre 1976. Léon Pressouyre. "Une tête de reine du portail central de Saint-Denis." *Gesta* 15 (1976), pp. 151–60.

Pressouyre 1986. Léon Pressouyre. "Did Suger Build the Cloister at Saint-Denis?" In *Abbot Suger and Saint-Denis: A Symposium*, edited by Paula Lieber Gerson, pp. 229–44. New York, 1986.

Prin 1976. Maurice Prin. "La sculpture à Toulouse à la fin du XIIIe et au début du XIVe siècle." In *Actes du 96e Congrès national des sociétés savantes (Toulouse, 1971)*, vol. 2, pp. 175–88. Paris, 1976.

Providence 1969. *The Renaissance of the Twelfth Century.* Exh cat. Edited by Stephen K. Scher. Providence, Museum of Art, Rhode Island School of Design, May 8–June 22, 1969. Providence, 1969.

Provoost 1994. Arnold Provoost. "De Cleveland-beeldengroep: Bestemd voor een graftuin?" In *Bild- und Formensprache der spätantiken Kunst: Hugo Brandenburg zum 65. Geburtstag*, edited by Martina Jordan-Ruwe and Ulrich Real, pp. 187–201. Münster, 1994.

Quirini-Poplawski 2002. Rafal Quirini-Poplawski. "Ancora una glossa sul cosiddetto Torso di Barletta." In *Medioevo: I modelli: Atti del convegno internazionale di studi Parma, 27 settembre–1 ottobre 1999*, edited by Arturo Carlo Quintavalle, pp. 381–404. Milan, 2002.

Raleigh 1967. *Sculpture and Decorative Art: A Loan Exhibition of Selected Art Works from the Brummer Collection of Duke University.* Exh. cat. by Robert C. Moeller III. Raleigh, North Carolina Museum of Art, May 7–July 2, 1967. Raleigh, 1967.

Randall 1962. Richard H. Randall. "The Case of the Calcite Font." *Metropolitan Museum of Art Bulletin* 20, no. 10 (June 1962), pp. 317–24.

Ravello 1984. *Ravello: Il Duomo e il Museo.* Salerno, 1984.

Réau 1955–59. Louis Réau. *Iconographie de l'art chrétien.* 3 vols. Paris, 1955–59.

Réau 1959. Louis Réau. *Les monuments détruits de l'art français: Histoire du vandalisme*, vol. 1, *Du haut Moyen Âge au XIXe siècle.* Paris, 1959.

Recht 1987. Roland Recht. *Nicolas de Leyde et la sculpture à Strasbourg, 1460–1525.* Strasbourg, 1987.

Reid 1897. Francis Nevile Reid. *Ravello.* Naples, 1897. New ed. Edited by E. Allen and C. C. Lacaita. Sarno, 1997.

Reinhardt 1972. Hans Reinhardt. *La cathédrale de Strasbourg.* Paris, 1972.

Remensnyder 1990. Amy G. Remensnyder. "Un problème de cultures ou de culture? La statue-reliquaire et les joca de sainte Foy de Conques dans le Liber miraculorum de Bernard d'Angers." *Cahiers de Civilisation Médiévale* 33 (1990), pp. 351–79.

Remnant 1969. G. L. Remnant. *A Catalogue of Misericords in Great Britain.* Oxford, 1969.

Ricci 1913. Ettore Ricci. *Donna Ermelinda Montesperelli e il reliquiario di Santa Giuliana.* Perugia, 1913.

Richard 1879. Jules-Marie Richard. "Le tombeau de Robert l'Enfant aux Cordeliers de Paris." *Mémoires de la Société de l'Histoire de Paris et l'Île-de-France* 6 (1879), pp. 209–304.

Richmond 1935. Ian Richmond. *Trajan's Army on Trajan's Column.* London, 1935. Reprint, London, 1982.

Rogers 1947. Meyric R. Rogers. "Medieval Sculpture in the Buckingham Collection." *Connoisseur* 120 (September 1947), pp. 50–54.

Romanini 1980. Angiola Maria Romanini, ed. *Federico II e l'arte del Duecento italiano: Atti della III Settimana di studi di storia dell'arte medievale dell'Università di Roma, 15–20 maggio 1978.* 2 vols. Galatina, 1980.

Rome 1984. *I paesaggi di Nicolas-Didier Boguet e i luoghi tibulliani.* Exh. cat. Edited by Giulia Fusconi. Rome, Villa della Farnesina, May 13–June 13, 1984. Rome, 1984

Rome 1995–96. *Federico II e l'Italia: Percorsi, luoghi, segni e strumenti.* Exh. cat. Rome, Palazzo Venezia, December 25, 1995–April 30, 1996. Rome, 1995.

Rorimer 1931. James J. Rorimer. *Ultra-Violet Rays and Their Use in the Examination of Works of Art.* New York, 1931.

Rorimer 1936. James J. Rorimer. "Recent Gifts in the Department of Medieval Art." *Metropolitan Museum of Art Bulletin* (October 1936), pp. 198–200.

Rorimer 1940. James J. Rorimer. "A 12th-Century Head of King David from Notre-Dame." *Metropolitan Museum of Art Bulletin* 35, no. 1 (January 1940), pp. 17–19.

Rorimer 1942. James J. Rorimer. "The Restored Twelfth Century Parthenay Sculptures." *Technical Studies in the Field of Fine Arts* 10, no. 3 (1942), pp. 123–30.

Rorimer 1944. James J. Rorimer. "Forgeries of Medieval Stone Sculpture." *Gazette des Beaux-Arts* 26 (1944), pp. 195–210.

Rorimer 1963. James J. Rorimer. *The Cloisters: The Building and the Collection of Medieval Art in Fort Tryon Park.* 3d ed., rev. New York, 1963.

Rorimer and Forsyth 1954. James J. Rorimer and William H. Forsyth. "The Medieval Galleries." *Metropolitan Museum of Art Bulletin* 12, no. 6 (1954), pp. 121–44.

Rose 2000. Marice Rose. "The Iconography of Female Adornment in Late Antiquity." Ph.D. diss., Rutgers University, 2000.

Rosenfeld 1986. Jörg Rosenfeld. "Die Weissenburger Büsten von Niclaus von Leiden und seiner Strassburger Werkstatt." Master's thesis, Universität Hamburg, 1986.

Rosenfeld 1995. Jörg Rosenfeld. "Niclaus Gerhaert von Leiden in Strassburg." *Jahrbuch der Staatlichen Kunstsammlungen in Baden-Württemberg* 32 (1995), pp. 13–32.

A. Ross 1986. Anne Ross. *The Pagan Celts.* Totowa, N.J., 1986.

M. Ross 1940. Marvin Chauncey Ross. "Monumental Sculptures from St.-Denis." *Journal of the Walters Art Gallery* 3 (1940), pp. 91–107, with appendix, pp. 108–9.

Rostand 1932. André Rostand. "La documentation iconographique des Monumens de la Monarchie françoise de Bernard de Montfaucon." *Bulletin de la Société d'Histoire de l'Art Français* (1932), pp. 104–49.

Rotterdam 2001. *Hieronymus Bosch: The Complete Paintings and Drawings.* Exh. cat. by Jos Koldeweij, Paul Vandenbroeck, and Bernard Vermet. Rotterdam, Museum Boijmans Van Beuningen, September 1–November 11, 2001. Rotterdam, 2001.

Rouen 1954. *Jumièges: Vie et survie d'une abbaye normande.* Exh. cat. Rouen, Musée des Beaux-Arts, June 11–August 30, 1954. Rouen, 1954.

Rudolf 1977. Karl Rudolf. "Die Tartaren 1241/1242: Nachrichten und Wiedergabe: Korrespondenz und Historigraphie." *Römische Historische Mitteilungen* 19 (1977), pp. 79–107.

Rudolph 1990. Conrad Rudolph. *The "Things of Greater Importance": Bernard of Clairvaux's Apologia and the Medieval Attitude Toward Art.* Philadelphia, 1990.

Rumpler 1965. Marguerite Rumpler. *L'art roman en Alsace.* Strasbourg, 1965.

Rupin 1890. Ernest Rupin. *L'oeuvre de Limoges.* Paris, 1890.

Rupprecht 1984. Bernhard Rupprecht. *Romanische Skulptur in Frankreich.* 2d ed. Munich, 1984.

Ruskin 1884. John Ruskin. "The Bible of Amiens." In *"Our Fathers Have Told Us": Sketches of the History of Christendom for Boys and Girls Who*

Have Been Held at Its Fonts. Orpington, 1884. Reprinted in *Collected Works*, vol. 33. London, 1908.

Russo 2001. Renato Russo. *Santa Maria Maggiore, la cattedrale di Barletta.* Barletta, 2001.

Saint-Saturnin 1854. *Monographie de l'insigne basilique de Saint-Saturnin.* Paris, 1854.

Salavin 1973. *Sculptures et objets d'art: Collection de M. L. Salavin.* Sale cat. Paris, Hôtel Drouot, November 14, 1973. Paris, 1973.

Salmon 1861. Charles Salmon. *Histoire de Saint Firmin: Martyr, premier évêque d'Amiens, patron de la Navarre et des diocèses d'Amiens et de Pampelune.* Amiens, 1861.

Sambon 1931. Arthur Sambon. *Aperçu générale de l'évolution de la sculpture depuis l'antiquité jusqu'à la fin du XVIe siècle.* Paris, 1931.

Santi 1985. Francesco Santi. *Galleria nazionale dell'Umbria: Dipinti, sculture e oggetti dei secoli XV–XVI.* Rome, 1985.

Sauerländer 1958. Willibald Sauerländer. "Die Marienkrönungsportale von Senlis und Mantes." *Wallraf-Richartz Jahrbuch* 20 (1958), pp. 115–62.

Sauerländer 1966. Willibald Sauerländer. *Von Sens bis Strassburg: Ein Beitrag zur kunstgeschichtlichen Stellung der Strassburger Querhausskulpturen.* Berlin, 1966.

Sauerländer 1971. Willibald Sauerländer. "Exhibition Review: The Year 1200." *Art Bulletin* 53 (1971), pp. 506–16.

Sauerländer 1972. Willibald Sauerländer. *Gothic Sculpture in France: 1140–1270.* New York, 1972.

Saunier 1899. Charles Saunier. "Las réclamations d'objets d'art par la fabrique Saint-Germain-des-Près, à l'époque du Concordat." *Bulletin de la Société Historique du VIe Arrondissement de Paris* 2 (1899), pp. 62–76.

Schade 2003. Kathrin Schade. *Frauen in der Spätantike, Status und Repräsentation: Eine Untersuchung zur römischen und frühbyzantinischen Bildniskunst.* Mainz, 2003.

Schapiro 1977. Meyer Schapiro. *Romanesque Art: Selected Papers, 1.* New York, 1977.

Scher 1966. Stephen K. Scher. "The Sculpture of André Beauneveu." Ph.D. diss., Yale University, 1966.

Schmidt 1971. Gerhard Schmidt. "Drei Pariser Marmorbildhauer des 14. Jahrhunderts." *Wiener Jahrbuch für Kunstgeschichte* 24 (1971), pp. 161–77.

Schmidt 1972. Gerhard Schmidt. Review of Willibald Sauerländer: *Gotische Skulptur in Frankreich 1140–1270,* Munich 1970. *Zeitschrift für Kunstgeschichte* 36 (1972), pp. 124–44.

Schmidt 1992. Gerhard Schmidt. *Gotische Bildwerke und ihre Meister.* Vienna, 1992.

J. Schmitt 1990. Jean-Claude Schmitt. *La raison des gestes dans l'Occident médiéval.* Paris, 1990.

O. Schmitt 1924. Otto Schmitt. *Gotische Skulpturen des Strassburger Münsters.* 2 vols. Frankfurt am Main, 1924.

Schnellbach 1931. Rudolf Schnellbach. *Spätgotische Plastik im unteren Neckargebiet.* Heidelberg, 1931.

Schnith 1974. Karl Schnith. *England in einer sich wandelnden Welt (1189–1259): Studien zu Roger Wendover u. Matthäus Paris.* Stuttgart, 1974.

Schreiber 2004. Susanne Schreiber. *Studien zum bildhauerischen Werk des Niclaus (Gerhaert) von Leiden.* Frankfurt am Main, 2004.

Schuyler 1976. Jane Schuyler. *Florentine Busts: Sculpted Portraiture in the Fifteenth Century.* New York, 1976.

Scott 1964. D. W. Scott. "A Restoration of the West Portal Relief Decoration of Saint-Sernin of Toulouse." *Art Bulletin* 46 (September 1964), pp. 271–82.

Sears 1986. Elizabeth Sears. *The Ages of Man: Medieval Interpretations of the Life Cycle.* Princeton, 1986.

L. Seidel 1981. Linda Seidel. *Songs of Glory: The Romanesque Façades of Aquitaine.* Chicago, 1981.

M. Seidel 2005. Max Seidel. *Italian Art of the Middle Ages and the Renaissance,* vol. 2, *Architecture and Sculpture.* Venice, 2005.

Settis 1984–86. Salvatore Settis, ed. *Memoria dell'antico nell'arte italiana.* 3 vols. Turin, 1984–86.

Seznec 1961. Jean Seznec. *The Survival of the Pagan Gods: The Mythological Tradition and Its Place in Renaissance Humanism and Art.* New York, 1961.

SHA. *The Scriptores historiae Augustae.* With an English translation by David Magie. 3 vols. Cambridge, Mass., 1921–32.

Shearer 1935. Creswell Shearer. *The Renaissance of Architecture in Southern Italy: A Study of Frederick II of Hohenstaufen and the Capua Triumphator Archway and Towers.* Cambridge, 1935.

Sheingorn 1995. Pamela Sheingorn, trans. and ed. *The Book of Sainte Foy.* Philadelphia, 1995.

Sheridan and Ross 1975. Ronald Sheridan and Anne Ross. *Gargoyles and Grotesques: Paganism in the Medieval Church.* Boston, 1975.

J. Smith 1975. John Colin Dinsdale Smith. *A Picture Book of the Misericords of Wells Cathedral.* Wells, 1975.

R. Smith 1999. R. R. R. Smith. "Late Antique Portraits in a Public Context: Honorific Statuary at Aphrodisias in Caria, A.D. 300–600." *Journal of Roman Studies* 89 (1999), pp. 155–89.

Snyder 1996. Janet Ellen Snyder. "Clothing as Communication: A Study of Clothing and Textiles in Northern French Early Gothic Sculpture." Ph.D. diss., Columbia University, 1996.

Sotheby's 2006. *Old Master Paintings: Including European Works of Art.* Sale cat. New York, Sotheby's, January 27, 2006. New York, 2006.

Souchal 1966. François Souchal. "Les bustes reliquaires et la sculpture." *Gazette des Beaux-Arts* 67 (1966), pp. 205–15.

Stirling 2005. Lea M. Stirling. *The Learned Collector: Mythological Statuettes and Classical Taste in Late Antique Gaul.* Ann Arbor, 2005.

Stocker 1987. David A. Stocker. "The Mystery of the Shrines of St. Hugh of Lincoln." In *St. Hugh of Lincoln: Lectures Delivered at Oxford and Lincoln to Celebrate the Eighth Centenary of St. Hugh's Consecration as Bishop of Lincoln,* edited by Henry Mayr-Harting, pp. 89–124. Oxford, 1987.

B. Stoddard 1975. Brooks W. Stoddard. "An Attribution for a Gothic Head of a King from the Bowdoin College Museum of Art." *Gesta* 14, no. 2 (1975), pp. 59–62.

W. Stoddard 1973. Whitney S. Stoddard. *The Façade of Saint-Gilles-du-Gard: Its Influence on French Sculpture.* Middletown, Conn., 1973.

Stone 1955. Lawrence Stone. *Sculpture in Britain: The Middle Ages.* Baltimore, 1955.

Strickland 2003. Debra Higgs Strickland. *Saracens, Demons, and Jews: Making Monsters in Medieval Art.* Princeton, 2003.

Stuebe 1968–69. Isabel Combs Stuebe. "The Johannisschüssel: From Narrative to Reliquary to Andachtsbild." *Marsyas* 14 (1968–69), pp. 1–16.

Stuttgart 1977. *Die Zeit der Staufer: Geschichte, Kunst, Kultur.* 5 vols. Exh. cat. Edited by Reiner Haussherr. Stuttgart, Altes Schloss und Kunstgebäude, March 26–June 5, 1977. Stuttgart, 1977–79.

Suckale 1971. Robert Suckale. "Studien zur Stilbildung und Stilwandel der Madonnenstatuen der Ile-de-France zwischen 1230 und 1300." Ph.D. diss., Universität München, 1971.

Sydenham 1952. Edward A. Sydenham. *The Coinage of the Roman Republic.* London, 1952.

Taburet-Delahaye 1990. Elisabeth Taburet-Delahaye. "Opus ad filum: L'ornement filigrané dans l'orfèvrerie gothique du centre et du sud-ouest de la France." *Revue de l'Art* 90 (1990), pp. 46–57.

Tavender 1946. Augusta S. Tavender. "English Alabasters: An Informal Study in Medieval Sculpture." *Art in America* 34, no. 3 (July 1946), pp. 127–42.

Taylor 1931. Francis H. Taylor. "Art of the Middle Ages." *Arts: Beaux-Arts, Littérature, Spectacles* 17 (April 1931), pp. 454–90.

Tenant de La Tour 1993. Philippe Tenant de La Tour. *Histoire de la ville de Saint-Yrieix-la-Perche et de son fondateur.* Limoges, 1993.

Testi Cristiani 1987. Maria Laura Testi Cristiani. *Nicola Pisano, architetto scultore: Dalle origini al pulpito del Battistero di Pisa.* Pisa, 1987.

Texier 1856. Jacques-Rémi-Antoine (Abbé) Texier. *Dictionnaire d'orfèvrerie, de gravure et de ciselure chrétiennes, ou de la mise en oeuvre artistique des métaux, des émaux et des pierreries.* Paris, 1856.

Thirion 2000. Jacques Thirion. "Le portail Sainte-Anne à Notre-Dame de Paris." *Cahiers de la Rotonde,* no. 22 (2000), pp. 5–43.

Thorndike 1965. Lynn Thorndike. *Michael Scot.* London, 1965.

Thurlby 1999. Malcolm Thurlby. *The Herefordshire School of Romanesque Sculpture.* Logaston, Herefordshire, 1999.

Tiemann 1930. Grete Tiemann. *Beiträge zur Geschichte der mittelrheinischen Plastik um 1500.* Speyer am Rhein, 1930.

Tock 2000. Benoît-Michel Tock. "Arras et Thérouanne au XIIe siècle: Deux évêchés vus au travers de leurs chartes." *Bulletin de la Commission Départementale d'Histoire et d'Archéologie du Pas-de-Calais* 18 (2000), pp. 3–14.

Todisco 1992. Luigi Todisco. "Il busto del museo di Barletta e le epigrafi CIL,IX,101*-102*." *Xenia Antiqua* 1 (1992), pp. 195–200.

Todisco 1997. Luigi Todisco. "Controversie federiciane." *Xenia Antiqua* 6 (1997), pp. 143–52.

Todisco 1998. Luigi Todisco. "Controversie federiciane 2." *Xenia Antiqua* 7 (1998), pp. 197–202.

Tollenaere 1957. Lisbeth Tollenaere. *La sculpture sur pierre de l'ancien diocèse de Liège à l'époque romane.* Gembloux, 1957.

Tommaseo 1838. Niccolò Tommaseo, ed. *Relations des ambassadeurs vénitiens sur les affaires de France au XVIe siècle.* 2 vols. Paris, 1838.

Tracy 1987. Charles Tracy. *English Gothic Choir-Stalls, 1200–1400.* Woodbridge, 1987.

Tracy 1988. Charles Tracy. *English Medieval Furniture and Woodwork.* London, 1988.

"Trésor" 1850. "Trésor de la Sainte-Chapelle de Bourges." *Annales Archéologiques* 10 (1850).

Tronzo 1994. William Tronzo, ed. *Intellectual Life at the Court of Frederick II Hohenstaufen.* Washington, D.C., 1994.

Umasugi 1978. Umasugi Muneo. "Sur l'iconographie des sculptures de la Porte des Valois de Saint-Denis." *Compte Rendu de l'Université des Beaux-Arts Musahino* (1978), pp. 43–61.

University Park 1996. *Medieval Art in America: Patterns of Collecting, 1800–1940.* Exh. cat. by Elizabeth Bradford Smith et al. University Park, Palmer Art Museum, Pennsylvania State University, 1996. University Park, 1996.

Vallance 1920. Aymer Vallance. *Old Crosses and Lychgates.* London, 1920.

Vallance 1947. Aymer Vallance. *Greater English Church Screens.* London, 1947.

Vallet de Viriville 1858. Auguste Vallet de Viriville. "Statue en cire du roi Charles VI, offerte par ce prince au tombeau de Saint-Pierre de Luxembourg à Avignon (novembre 1389)." *Archives de l'Art Français (Documents)* 5 (1858), pp. 344–45.

Van Cleve 1972. Thomas Curtis Van Cleve. *The Emperor Frederick II of Hohenstaufen: Immutator Mundi.* Oxford, 1972.

Vanuxem 1945. Jacques Vanuxem. "Autour du triomphe de la vierge du portail de la cathédrale de Senlis: Les portails détruits de la cathédrale de Cambrai et de Saint-Nicolas d'Amiens." *Bulletin Monumental* 103 (1945), pp. 89–102.

Vanuxem 1957. Jacques Vanuxem. "The Theories of Mabillon and Montfaucon on French Sculpture of the Twelfth Century." *Journal of the Warburg and Courtauld Institutes* 20 (1957), pp. 45–58.

Velden 2000. Hugo van der Velden. *The Donor's Image: Gerard Loyet and the Votive Portraits of Charles the Bold.* Turnhout, 2000.

Verzar 1999. Christine B. Verzar. "The Semiotics of the Public Monument in 13th- and 14th-Century City Squares: Civic Values and Political Authority. Vox Civitatis." In *Studi in honore di Angiola Maria Romanini,* edited by Antonio Cadei et al., vol. 1, pp. 257–67. Rome, 1999.

Verzar 2004. Christine B. Verzar. "Medieval Passageways and Performance Art: Art and Ritual at the Threshold." *Arte Medievale* 3, no. 2 (2004), pp. 63–74.

Verzar 2005. Christine B. Verzar. "Legacy and Memory of Matilda: The Semiotics of Power and Reform." In *Medioevo: Immagini e ideologie: Atti del convegno internazionale di studi, Parma, 23–27 settembre 2002,* edited by Arturo Carlo Quintavalle, pp. 432–47. Parma, 2005.

Villon 1982. François Villon. *The Poems of François Villon.* Translated and edited by Galway Kinnell. New ed. Hanover: University Press of New England, 1982.

Vissière 2000. Laurent Vissière. "L'éternel gambit: Thérouanne sur l'échiquier européen (1477–1559)." *Bulletin de la Commission Départementale d'Histoire et d'Archéologie du Pas-de-Calais* 18 (2000), pp. 61–106.

Vitry and Brière 1925. Paul Vitry and Gaston Brière. *L'église abbatiale de Saint-Denis et ses tombeaux.* 2d ed. Paris, 1925.

Volbach 1930. Wolfgang Friedrich Volbach. *Mittelalterliche Bildwerke aus Italien und Byzanz.* 2d ed. Berlin, 1930.

Wandel 1995. Lee Palmer Wandel. *Voracious Idols and Violent Hands: Iconoclasm in Reformation Zurich, Strasbourg, and Basel.* Cambridge, 1995.

Wentzel 1954. Hans Wentzel. "Ein gotisches Kapitell in Troia." *Zeitschrift für Kunstgeschichte* 17 (1954), pp. 185–88.

Wessel 1946–47. Klaus Wessel. "Römische Frauenfrisuren von der Severischen bis zur konstantinischen Zeit." *Archäologischer Anzeiger* 61–62 (1946–47), pp. 62–76.

West 2004. Shearer West. *Portraiture.* Oxford, 2004.

Wiggers and Wegner 1972. Heinz Bernhard Wiggers and Max Wegner. *Caracalla, Geta, Plautilla. Macrinus bis Balbinus.* Berlin, 1972.

Wilberg et al. 1953. Wilhelm Wilberg et al. *Forschungen in Ephesos V/1: Die Bibliothek.* Vienna, 1953.

Will 1951. Robert Will. "Aurait-on découvert le tête d'un roi Mage du portail intérieur de la chapelle Saint-Laurent." *Bulletin de la Société des Amis de la Cathédral de Strasbourg,* 2e série, no. 6 (1951), pp. 69–72.

Will 1955. Robert Will. *Répertoire de la sculpture romane de l'Alsace.* Paris, 1955.

Will and Haug 1982. Robert Will and Hans Haug. *Das Romanisches Elsass.* Würzburg, 1982 (1970).

Williams 2003. Steven J. Williams. "The Vernacular Tradition of the Pseudo-Aristotelian 'Secret of Secrets' in the Middle Ages: Translations, Manuscripts, Readers." In *Filosofia in volgare nel medioevo: Atti del Convegno della Società Italiana per lo Studio del Pensiero Medievale (S.I.S.P.M), Lecce, 27–29 settembre 2002,* edited by Nadia Bray and Loris Sturlese, pp. 451–82. Louvain-la-Neuve, 2003.

Williamson 1982. Paul Williamson. "The Fifth Head from Thérouanne, and the Problem of Its Original Setting." *Burlington Magazine* 124 (1982), pp. 219–20.

Williamson 1987. Paul Williamson. *The Thyssen-Bornemisza Collection: Medieval Sculpture and Works of Art.* London, 1987.

Williamson 1991. Paul Williamson. "Acquisitions of Sculpture at the Victoria and Albert Museum, 1986–1991." *Burlington Magazine* 133 (1991), p. 877.

Williamson 1996. Paul Williamson, ed. *European Sculpture at the Victoria and Albert Museum.* London, 1996.

Wirth 1989. Jean Wirth. *L'image médiévale: Naissance et développements (VIe–XVe siècle).* Paris, 1989.

Witte 1912. Fritz Witte, ed. *Die Skulpturen der Sammlung Schnütgen in Cöln.* Berlin, 1912.

Wixom 1967. William D. Wixom. "Early Christian Sculptures at Cleveland." *Bulletin of the Cleveland Museum of Art* 54, no. 3 (1967), pp. 67–88.

Wixom 1979. William D. Wixom. "Eleven Additions to the Medieval Collection." *Bulletin of the Cleveland Museum of Art* (March–April 1979), pp. 86–151.

Wixom 1988–89. William D. Wixom. "Medieval Sculpture at The

Cloisters." *Metropolitan Museum of Art Bulletin* 46, no. 3 (Winter 1988–89), pp. 3–64.

Wixom 2005. William D. Wixom. "Medieval Sculpture at the Metropolitan: 800–1400." *Metropolitan Museum of Art Bulletin* 62 (Spring 2005).

Wolf 1966. Gunther Wolf, ed. *Stupor Mundi: Zur Geschichte Friedrichs II. von Hohenstaufen.* Darmstadt, 1966.

Wolff 1983. Philippe Wolff. *Le Diocèse de Toulouse.* Paris, 1983.

Wolff 1988. Philippe Wolff, ed. *Histoire de Toulouse.* 4th ed. Toulouse, 1988.

Worcester 1937. *The Dark Ages: Loan Exhibition of Pagan and Christian Art in the Latin West and Byzantine East.* Exh. cat. Worcester Art Museum, February 20–March 21, 1937. Worcester, Mass., 1937.

Worcester 1985. *The Word Becomes Flesh: Radical Physicality in Religious Sculpture of the Later Middle Ages.* Exh. cat. by Joanna E. Ziegler. Worcester, Iris and B. Gerald Cantor Art Gallery, 1985. Worcester, Mass., 1985.

Wyss 2004. Michaël Wyss. "Le cloître medieval de l'abbaye de Saint-Denis." *Dossiers d'Archéologie* 297 (October 2004), pp. 84–92.

Wyss and Meyer-Rodrigues 2000. Michaël Wyss and Nicole Meyer-Rodrigues. "Nouvelle données archéologiques sur le cloître de l'abbaye de Saint-Denis." In *Utilis est lapis in structura: Mélanges offerts à Léon Pressouyre*, pp. 111–26. Paris, 2000.

Yasin 2005. Ann Marie Yasin. "Funerary Monuments and Collective Identity: From Roman Family to Christian Community." *Art Bulletin* 87, no. 3 (September 2005), pp. 433–57.

Young 1988. Bonnie Young. *A Walk Through The Cloisters.* New York, 1988.

Zanker and Ewald 2004. Paul Zanker and Björn Christian Ewald. *Mit Mythen leben: Die Bilderwelt der römischen Sarkophage.* Munich, 2004.

Zarnecki 1953. George Zarnecki. *Later English Romanesque Sculpture, 1140–1210.* London, 1953.

Index

Page numbers in **boldface** refer to catalogue entries, including their illustrations; page numbers in *italics* refer to figure illustrations. Works of art are generally referenced under country of origin (followed by city and/or church), subject or theme, object type, museum, and artist. American museums are indexed by city (if well known) or by state (followed by city).

Photography and Reproduction Credits

Unless stated otherwise below, photographs were provided by the owners of the works of art and are published with their permission; their courtesy is gratefully acknowledged.

Christina Acidini Luchinat, ed., *La Cattedrale di Santa Maria del Fiore a Firenze*, vol. 2 (Florence: Cassa di risparmio di Firenze, 1995): fig. 101

© The Art Institute of Chicago: cat. nos. 14 (photograph by Robert Hashimoto), 74

Marcel Aubert, ed., *Encylopedie Photographique de l'Art. Le musée du Louvre* (Paris: Éditions "Tel," 1948): fig. 18

Peter Barnet: fig. 70

Jacques Baudoin, *La Sculpture Flamboyante en Champagne, Lorraine* (Nonette: Créer, 1990): fig. 67

Bayerisches Nationalmuseum, Munich: cat. no. 79

Janetta Rebold Benton: fig. 69

T. Bethune: fig. 41

Bibliothèque Municipale de Lyon: fig. 26 (photograph by Didier Nicole)

Bibliothèque Municipale de Tours: fig. 104

Bibliothèque Nationale, Paris: figs. 28, 33, 78, 84

Bildarchiv Foto Marberg: fig. 71

Pamela Z. Blum: fig. 31

Bernhard Blumenkranz, *Le Juif médiéval au miroir de l'art chrétien* (Paris: Études Augustiniennes, 1966): fig. 21

Jacqueline Boccador, *Statuaire médiévale en France de 1400 à 1530*, vol. 2 (Zoug: Les Clefs du Temps, 1974): fig. 86

The Bodleian Library, Oxford University: fig. 10

Jacques Bouillart, *Histoire de l'abbaye royale de Saint-Germain-des-Prez* (Paris: Gregoire Dupuis, 1724): fig. 51

© The British Library, London: fig. 16

The Burrell Collection, Glasgow Museums: fig. 114

Caisse Nationale des Monuments Historiques et des Sites: fig. 103

William W. Clark: figs. 42, 44, 61

© The Cleveland Museum of Art: cat. nos. 8, 12, 47–52, 60, 61, 68, 70

Master and Fellows of Corpus Christi College, Cambridge University: fig. 22

Katharina Corsepius, *Notre-Dame-en-Vaux* (Stuttgart: Franz Steiner, 1997): fig. 72

Paul Deschamps, *La cathédrale d'Amiens* (Paris: Éditions "Tel," 1942): fig. 2

Dumbarton Oaks Research Library and Collection, Washington, D.C.: fig. 91

Federico II e l'Italia: percorsi, luoghi, segni e strumenti (Rome: Edizioni de Luca-Editalia, 1995): figs. 94, 97

Matt Flynn: cat. no. 43

© FMR / Luciano Romano: cat. no. 66

Foto Mas, Barcelona: fig. 109

Foto Rösch, Münster: fig. 112

Gesta XXVIII / 1 (1989): fig. 50

Marc Gil and Ludovic Nys, *Saint-Omer gothique: Les arts figuratifs à Saint-Omer à la fin du Moyen Age: 1250-1550* (Valenciennes: P.U.V., 2004): fig. 35

Denis Grivot and George Zarnecki, *Gislebertus, Sculpteur d'Autun* (Paris: Éditions Trianon, 1960): figs. 17, 58

Richard Hamann, *Die Abteikirche von St. Gilles und ihre Künstlerische Nachfolge*, vol. 1 (Berlin: Akademie-Verlag, 1955): fig. 30

Richard Hamann-Mac Lean and Ise Schüssler, *Die Kathedrale von Reims*, part 2, vol. 6 (Stuttgart: Franz Steiner, 1996): 6

Richard Hamann-Mac Lean and Ise Schüssler, *Die Kathedrale von Reims*, part 2, vol. 8 (Stuttgart: Franz Steiner, 1996): 11, 13

Hirmer Fotoarchiv, Munich: figs. 1, 3, 8, 9, 29

Lore L. Holmes: figs. 38, 39

Iconoclasme: Vie et mort de l'image médiévale (Paris: Éditions Somogy, 2001): fig. 27

Brigitte Kurmann-Schwarz and Peter Kurmann, *Chartres: La Cathédrale* (Saint-Léger-Vauban: Zodiaque, 2001): figs. 5, 24

Oi-Cheong Lee, The Photograph Studio, The Metropolitan Museum of Art: cat. nos. 9, 13, 15–17, 19–24, 31–33, 35–42, 44–46, 56, 58, 59, 62–64, 69, 71, 72, 75–78, 80, 81; figs. 74, 110

Charles T. Little: cat. no. 26; figs. 32, 57, 59, 63, 89, 90, 93, 95, 98, 100, 105, 111, 113

Jean Mallion, *Chartres: Le jubé de la cathédrale* (Chartres: Société archéologique d'Eure-et-Loir, 1964): fig. 65

Robert A. Maxwell: fig. 64

The Metropolitan Museum of Art, Department of Medieval Art and The Cloisters: figs. 34, 46, 47, 52, 82, 83, 106

Il Duomo di Modena: Atlante fotografico (Modena: Panini, 1985): fig. 76 (photograph by Cesare Leonardi)

Hans-Joachim Mrusek, *Drei sächsische Kathedralen: Merseburg, Naumburg, Meissen* (Dresden: VEB Verlag der Kunst, 1976): fig. 20

© Musée du Louvre, Département des Sculptures (photographs by Pierre Philibert): cat. 4; fig. 36

© 2006 Museum of Fine Arts, Boston: figs. 37, 87

© Board of Trustees, National Gallery of Art, Washington, D.C.: figs. 43, 66

Pedro de Palol and Max Hirmer, *L'Art en Espagne: du royaume Wisigoth à la fin de l'époque romaine*, Pierre Wirth, trans. (Paris: Flammarion, 1967): fig. 23

Powys County Archive Office, Llandrindod Wells, Wales: fig. 75

© Réunion des Musées Nationaux / Art Resource, NY: cat. nos. 6 (photograph by René-Gabriel Ojéda), 7 (photograph by Jean-Gilles Berizzi), 18 (photograph by Hervé Lewandowski), 27 (photograph by Martine Beck-Coppola), 29; fig. 45 (photograph by Gerard Blot / Christian Jean)

Filippo Rossi, *Capolavori di oreficeria italiana dall'XI al XVIII secolo* (Milan: Banca nazionale del lavoro, 1956): fig. 107

Willibald Sauerländer, *Gothic Sculpture in France: 1140-1270* (New York: Harry N. Abrams, 1972): fig. 48

Willibald Sauerländer, *Le siècle des cathédrales 1140-1260* (Paris: Éditions Gallimard, 1989): figs. 7, 12, 14, 56

Kathrin Schade, *Frauen in der Spätantike: Status und Repräsentation* (Mainz: Verlag Philip von Zabern, 2003): figs. 80, 81

Stephen K. Scher: figs. 85, 99

Otto Schmitt, *Gotische Skulpturen des Strassburger Münsters*, vol. 2 (Frankfurt am Main: Frankfurter Verlag, 1924): fig. 15

Ernst Schubert, *Der Magdeburger Dom* (Vienna / Cologne: Verlag Hermann Böhlaus Nachfolger, 1975): figs. 19, 25

Creswell Shearer, *The Renaissance of Architecture in Southern Italy* (Cambridge: W. Heffer and Sons, 1935): fig. 88

Le trésor de la Sainte-Chapelle (Paris: Réunion des Musées Nationaux, 2001): fig. 102

Unité d'Archéologie de la Ville de Saint-Denis: fig. 54

Christine Verzar: fig. 92

Antonio Viñayo González, *L'ancien royaume de León Roman* (La Pierre-qui-Vire: Zodiaque, 1972): fig. 4

Michaël Wyss: fig. 53

George Zarnecki, *The Early Sculpture of Ely Cathedral* (London: Alec Tiranti, 1958): fig. 68